MAYA TEXTILES OF GUATEMALA

THE GUSTAVUS A. EISEN COLLECTION, 1902
THE HEARST MUSEUM OF ANTHROPOLOGY,
THE UNIVERSITY OF CALIFORNIA AT BERKELEY

MAYA TEXTILES OF GUATEMALA

By MARGOT BLUM SCHEVILL

With a historical essay by CHRISTOPHER H. LUTZ

 UNIVERSITY OF TEXAS PRESS AUSTIN

Copyright © 1993, The Regents
of the University of California,
The Hearst Museum of Anthropology,
Berkeley, California
All rights reserved
Printed in Hong Kong
First edition, 1993

Requests for permission to
reproduce material from this work
should be sent to Permissions,
University of Texas Press,
Box 7819, Austin, TX 78713-7819.

ⓧ The paper used in this publication meets
the minimum requirements of American National
Standard for Information Sciences—
Permanence of Paper for Printed Library Materials,
ANSI Z39.48-1984.

This catalogue was supported in part by a grant
from the National Endowment for the Arts,
a federal agency.

Library of Congress Cataloging-in-Publication Data

Schevill, Margot.
 Maya textiles of Guatemala : the Gustavus A.
Eisen collection, 1902, the Hearst Museum of
Anthropology, the University of California at
Berkeley / by Margot Blum Schevill ; with a
historical essay by Christopher H. Lutz. — 1st ed.
 p. cm.
 Includes bibliographical references (p.) and
indexes.
 ISBN 0-292-75143-5 (alk. paper). —
 ISBN 0-292-77665-9 (pbk. : alk. paper)
 1. Mayas—Textile industry and
fabrics. 2. Indians of Central America—
Guatemala—Textile industry and
fabrics. 3. Eisen, Gustavus A., 1847–1940—
Ethnological collections. I. Lutz,
Christopher. II. Phoebe Apperson Hearst
Museum of Anthropology. III. Title.
F1435.3.T48S34 1993
746'.089'974—dc20 92-18640
 CIP

9490 791

Contents

To Jim and to my children, Sherifa and Paul

Acknowledgments

Since 1978, I have studied Maya textiles in museums and private collections in the United States and abroad. In Guatemala, I also spoke with Maya weavers about cloth production and clothing. I began the research for this book in 1988 during residence at the Lowie (now the Hearst) Museum of Anthropology. Staff members, Burton Benedict, Louise Braunschweiger, Dave Herod, Joan Knudsen, Paula Floro, Martha Muse, Therese Babineau, Alfred Brown, and Gene Prince aided and facilitated this project. Geoffrey Brown, Eugenia Andruchowicz, and Betty Goldberg all contributed to the initial research process, while Luz Ruiz was the inspired photographer. Frank Norick served as manuscript editor. He has been a constant supporter and has encouraged me to pursue Guatemalan textile research since we first met in 1978. The staff of the Haffenreffer Museum of Anthropology, Brown University, including Shepard Krech III, Barbara Hail, Joyce Smith, Thierry Gentis, Lyn Udvardy, Ethel Rudy, and Patricia Sanford, have assisted me and supported my Guatemalan textile projects during my ten-year association with the Haffenreffer Museum.

I am grateful to the National Endowment for the Arts and the National Endowment for the Humanities, without whose support this book would not be a reality. Under an NEA Fellowship for Museum Professionals I visited museum collections in the United States and abroad in order to study textiles of the same time frame as the Eisen collection. Those individuals who made their collections available to me included Lisa Whittall at the American Museum of Natural History; Candace Green and Felicia Pickering at the Smithsonian National Museum of Natural History; Kathleen Skelly, Gloria Greif, and Barbara Isaac at the Peabody Museum of Archaeology and Ethnology, Harvard University; Pamela Hearne and Lucy Williams at the University Museum of Archaeology and Anthropology, University of Pennsylvania; Wil Grewe-Mullins at the Field Museum of Natural History; Nancy Rosoff at the National Museum of the American Indian, Smithsonian Institution; Christian Feest at the Museum für Völkerkunde, Vienna; and curators at the Victoria and Albert Museum in London and at ethnology museums in Leipzig and Dresden. An NEH Travel to Collections grant enabled me to study the collections at the Museo Ixchel del Traje Indígena, Guatemala City, with curators Linda Asturias de Barrios and Rosario Miralbés de Polanco.

Archival sources were provided by Johan Kooy and Laurence Desmond at the California Academy of Sciences; Guillermo Náñez Falcón, Howard-Tilton Memorial Library, Tulane University; Sharon Hiigel, Fresno City & County Historical Society; Sally Pierce and Jody Randazzo at the Boston Athenaeum; and librarians at the Bancroft Library, University of California at Berkeley, The Smithsonian Institution Archives, and Gustavus Adolphus College.

Swedish sources for Eisen's correspondence included the University of Uppsala, the Royal Academy of Letters, History, and Antiquities, the Royal Swedish Academy of Sciences, and the Royal Library of the National Library of Sweden. Gulli Kula, a weaver and textile scholar, deserves special thanks for her translation of the Swedish material, as does Christopher Lutz, CIRMA (Centro de Investigaciones Regionales de Mesoamérica and Plumsock Mesoamerican Studies), who, in addition to contributing an essay, directed me to many sources that I otherwise might have overlooked.

Colleagues who read the manuscript in its various manifestations include Ann Hedlund, Marshal Bol, Janet Catherine Berlo, Sandra Niessen, Robert Carlsen, and Christopher Lutz. Mary Troeger, a weaver and editor, read and copyedited the manuscript and frequently offered suggestions that clarified the content. My husband, James Schevill, not only read the manuscript many times, but upon request delivered the perfect summing up of a difficult section in one poetic sentence! Scholars of Guatemalan textiles who commented on the textiles or photographs thereof are listed at the end of the bibliography. I am especially grateful to Krystyna Deuss, Cherri Pancake, Olga Arriola de Geng, and Robert Carlsen for their contributions.

The research and publication of *Maya Textiles of Guatemala* are partially funded by the National Endowment for the Arts Museum Programs and the L. J. and Mary C. Skaggs Foundation. Theresa May, Carolyn Cates Wylie, Nancy Warrington, and George Lenox of the University of Texas Press, and Helen Hyams, my copy editor, guided the manuscript to publication.

James Schevill, my children, Sherifa Zuhur and Paul and Nathalie Blum, and my granddaughter, Natasha Margot, are an integral part of my research and writing, which I share with them as they share their lives with me. Finally, the spirit that propels my work stems from Angela, María, Rafael, and Sebastiana, members of the Maya family in San Antonio Aguas Calientes, Guatemala, with whom I spent many afternoons learning to weave on a backstrap-loom. Our relationships continue to the present. This personal contact made it possible for me to study and write about Maya cloth, clothing, and textile production in Guatemala so that others also could appreciate the resilience and perseverance that characterize the Maya weavers. Today they carry on the traditions of the ancient Maya, their ancestors, while struggling to survive one of the most difficult economic and social periods in their long history.

Foreword

Burton Benedict
Director
Hearst Museum of Anthropology

The Hearst Museum of Anthropology is doubly fortunate. We have one of the finest collections of Guatemalan textiles in the world and one of the world's foremost experts on the subject to give us a book about them.

This work by Margot Schevill is no mere taxonomic exercise, classifying textiles by type or technique, but a study of the social and ceremonial contexts in which they were used. She looks at their use at a turning point in Guatemalan history when coffee was replacing cochineal as the principal cash crop and the western industrial economy was impinging on traditional ways of life.

She also pays attention to the collector Gustavus A. Eisen, by presenting a biographical essay of this unusual scholar who made such careful notes and photographs of what he was collecting. Finally she examines the techniques of manufacture and provides us with a catalogue raisonné of the entire Eisen collection.

Maya Textiles of Guatemala is a fine contribution to our knowledge of this important genre. We welcome its publication.

Preface

The Gustavus A. Eisen Guatemalan Ethnographic Collection, gathered in 1902, contains 365 objects. Two hundred twenty-two textiles and textile-related objects are the focus of this publication. The collection, housed in the Hearst Museum of Anthropology at the University of California at Berkeley, formerly the Lowie Museum, is the largest and best-documented group of nineteenth-century Guatemalan textiles extant.

Gustavus A. Eisen, a Swedish-American zoologist, was hired by Phoebe Apperson Hearst to make an expedition to Guatemala. Their goals were to determine if there was a local mineralogical source for ancient jades, to locate new sites for archaeological excavations, and to collect Indian clothing and objects. Eisen's skills as a photographer, archaeologist, and ethnographer and his knowledge of geological strata enabled him to make an unusual collection of several hundred mineral samples in addition to the ethnographic objects. The album of sixty photographs includes notes on each image and was presented with the collection to the Museum of Anthropology shortly after his return in 1903. Eisen never collected textiles again. For the rest of his life, he pursued art history projects. He died in New York at the age of ninety-three in 1940.

Because of the communicative potential of costume and textiles, looking at the collection as a whole reveals both the everyday and the ceremonial life of the Maya. But textiles stored on the shelves of a museum for almost a century are severed from the cultural context in which they originally functioned. Placing the textiles on mannequins and comparing them to contemporary examples help to put them in context. We realize that weavers created for sale as well as for home use due to the combination of used and unused textiles that Eisen acquired. Eisen wrote that he purchased only textiles and other ethnographic objects that were employed or worn by the Indians themselves or were similar to what they used. Included in the collection are some looms with works in progress and textile-related tools that illustrate special techniques practiced by Maya weavers.

Eisen's collection offers the viewer a look into indigenous life in Guatemala at a crucial period in history. Coffee had replaced cochineal and other crops as the major export. The Maya were the work force upon whom the *ladino* and European plantation owners depended. In many instances, the Indians' land was expropriated, as Christopher Lutz describes in his chapter. In spite of hardships suffered and the forces of acculturation felt by the migrant workers on the coast, these beleaguered native peoples held on to their traditions, which required beautiful and functional textiles as an expression of their ethnic identity and artistic abilities.

Although occasional pieces have been illustrated in articles and books, the Eisen collection has never been published in its entirety.

This publication allows scholars who are already versed in late twentieth-century Guatemalan textiles to become familiar with the styles of Maya cloth and clothing from the late nineteenth and early twentieth centuries. Many of the textiles seem new or unused, although Eisen gathered them almost one hundred years ago. Ranging from the brilliantly colored, technically intricate ceremonial serapes (3-1–3-4) worn by the *martooms* or *mayordomos* (ceremonial hosts who assist the chiefs or *alcaldes*) of Totonicapán, and the large group of lavishly ornamented blouses or *huipiles*, to the backstrap-woven bibs worn by babies, the collection is truly an artifact itself, and one that should be shared and enjoyed by the general public, who will learn through Maya textile art about indigenous life in late nineteenth-century Guatemala.

In order to expand on the format of a catalogue raisonné, I have organized *Maya Textiles of Guatemala* into six chapters: five essays precede the annotated catalogue section in which the 222 textile and textile-related objects are discussed in detail and illustrated. The first essay, Chapter 1, explores various notions about the communicative nature of cloth and clothing, including the textual, expressive, and transformational potential in Maya textiles and dress. In an attempt to reach out to contemporary textile researchers, I incorporate the results of my fieldwork and comments from the Guatemalan textile scholars into the discussion of the fashion impulse in Maya dress both past and present. I look at the act of collecting in Chapter 2, consider the fate of collections, and discuss the notion of a collection as an artifact itself. This leads to the biographical essay on the collector, Gustavus A. Eisen, in Chapter 3, which follows his intense interest in and involvement with Maya art, architecture, and cosmology from his early years to shortly before his death. Historian Christopher H. Lutz, in Chapter 4, places the Guatemalan Maya of the late nineteenth century into a historical context with background information about their lives during the colonial period, after independence, and throughout the Liberal Revolution.

Chapter 5 focuses on textile production, an essential component of an in-depth study of a textile collection, as it relates to the manufacture of the Eisen textiles. Looms, techniques, and materials including fibers and dyes are described. Writing about gender roles in textile production prompted me to reevaluate my own earlier assumptions and to explore the prevailing ideas about gender-specific roles. Two contemporary examples of crossovers in the generally accepted gender-defined roles of backstrap-loom and treadle-loom weaving support an alternative model for examining the relationships between textile production and gender roles. Again, as in the first essay, by using contemporary examples I hope to encourage researchers to look again at their data, to question the assumptions that have prevailed in the past, and to take into account, as I have, the flexible and contingent nature of the gendered division of labor in Maya textile production.

Chapter 6 is the catalogue raisonné of the Eisen textile collection. For the reader who is only interested in the textiles, the

annotated citations give full descriptions of the textiles as well as comments derived from published and unpublished sources and my own research findings. My hope is that such a reader, after experiencing the visual power of these objects, will want to place them in context and, therefore, be drawn to the essays. Appendix A presents the textiles and textile-related objects classified by function and type, such as all belts, all hats, and all blouses or *huipiles.* By comparing the Eisen textiles with examples from similar locations acquired in the 1970s–1980s, I was able to identify continuities, discontinuities, and transformations in specific design features, such as construction, materials, and techniques. I hope that my conclusions will be useful to textile scholars who work with more recent collections. Appendix B is a previously unpublished essay that Eisen wrote about the *cofradías* or religious organizations of the Indians of Guatemala. It focuses primarily on the religious organizations of the town of Totonicapán, where he collected a large number of textiles and photographed the Maya in their *cofradía* dress.

The Eisen Guatemalan textile collection presented here is an artifact of great beauty and cultural significance and will appeal, I hope, not only to scholars and to the general public, but to travelers who have enjoyed the remarkable landscape of Guatemala and its indigenous population, the Maya, for whom cloth is more than clothing. It is also the memory of their proud past and an integral part of their future.

MAYA TEXTILES OF GUATEMALA

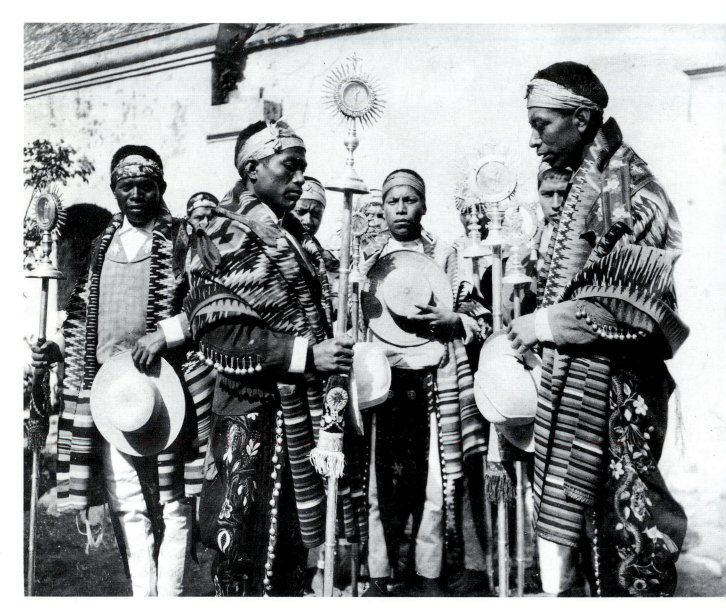

Figure 1.
Indian *martoom.* Totonicapán. Photo by
Gustavus A. Eisen. 1902.

The Communicative Nature of Cloth and Clothing

INTRODUCTION

Man is born naked but is everywhere in clothes (or their symbolic equivalents). We cannot tell how this came to be but we can say something about why it should be so and what it means.
—TERENCE S. TURNER (1980)

Clothes are inevitable. They are nothing less than the furniture of the mind made visible.
—JAMES LAVER (1949)

Cloth and clothing speak silently but expressively, while simultaneously signaling layers of meaning (Figures 1, 2). Dress and other forms of body adornment are universal phenomena and embody some of the more original aspects of human creativity and material culture. Clothing elements and ensembles serve as obvious, outward symbols of specific cultural identities and ideologies. Thus clothing is a readily observed form of nonverbal communication. The viewer must know the codes of meaning embedded in the wearer's costume or, in other words, be visually literate in order to engage in nonlinguistic discourse. Innovation and invention are dynamic components in design, materials, and techniques, for fashion in clothing is one aspect of everyday life that changes rapidly.[1] We adorn ourselves with decorative garb that may reflect individual aesthetic preferences but also reflects the collective or partial tastes of our society.

The cultural complex of indigenous peoples has been one of the foci of anthropology since its emergence as a social science in the late nineteenth century. The textile systems and clothing of indigenous peoples, however, were ignored by most anthropologists, who focused on the social structure and spoken language rather than on the symbolic language of dress or its visual grammar of meaning. The past ten years have seen an increased interest in the study of indigenous material culture, that is, cultural forms that result from the creative manipulation of materials in time and space. Of particular interest here is the complex that includes dress, adornment, coiffure, and cosmetics, all of which serve as expressive media and indicators of social structure, ritual patterns, economic networks, and a commitment to ethnic identity. Ronald A. Schwarz, clothing and textile scholar, commented that "clothing and adornment are universal features of human behavior, and an examination of what they reveal, and attempt to conceal, contributes to our knowledge about the fabric of cultures and to our understanding of the threads of human nature" (1979:1). Cloth can serve as a heuristic device for the observer and, for the observed, a representational code. Griselda Pollock suggests that "representation stresses something refashioned, coded in theoretical, textual or pictorial terms, quite distinct from its social existence" (1988:6). Clothing can indicate biographical details or signs of individuality, or it can serve as "silent oratory" (Helms 1981:64).[2]

Anthropologists, art historians, historians, fiber artists, writers, and textile clothing professionals are attempting to translate the silent languages or expressive codes communicated by textiles, which, by their very nature, may be one of the most complex and elusive forms of material culture extant. Symposia with titles such as "The Woven Word," "Textile as Text," "Costume as Communication," "Andean Aesthetics: Textiles of Peru and Bolivia,"

Portions of Chapter 1 are excerpted from "Living Cloth: 19th-Century Highland Mayan Huipiles—The Gustavus A. Eisen Collection," *Latin American Art*, vol. 1, no. 2, 1989 and reprinted by permission of Latin American Art Magazine, Inc., Scottsdale, Arizona, © copyright 1989.

and "Cloth and the Organization of Human Experience" have been held in the United States and Europe. The titles of papers presented at the symposia are provocative: "Translating Textiles: Ways of Writing on Clothing and Cloth," "Interpreting the Text of Guatemalan Indian Dress: Syntax and Semantics," "Textiles and Texts: Kin or Not?" "Attire and the Transformation of Identity," and "Does Clothing Have a Code? Empirical Findings and Theoretical Implications in the Study of Clothing as a Means of Communication." At a symposium that dealt with Latin American ethnographic cloth and costume, most scholars commented on the nature of change within the specific culture area where they worked.[3] Papers discussed local distinctions in dress; the fashion impulse; continuity, discontinuity, and transformation of costume styles and designs; textile technology; and materials. Ritual and social uses of cloth and its creation, gender roles in the clothing system, textile as text, and the commoditization of dress and adornment were also addressed.

How do textile scholars study dress and related textiles? Clothing and textile professionals who teach in departments that derived from home economics have focused on analyses of the construction of actual pieces of indigenous and Euramerican clothing, or what Roland Barthes categorized as "real" clothing.[4] Some of these scholars are now looking at clothing in its cultural context as well, enlarging the research potential from the more technically prescribed study that typified home economics studies prior to the 1970s.[5]

Fiber artists attracted by the cloth of indigenous peoples examine clothing in order to unlock the technical and creative devices involved in the construction and also to derive design inspiration. This information is then shared with colleagues in classes or in "how-to" articles written for commercial magazines.[6] Only rarely do these artists interact with the native weavers who are best qualified to explain the function and meaning of their cloth and the techniques involved.[7]

Art historians engaged in textile and clothing studies of native peoples endeavor to learn the "language" of the art or representation they study and set it in a specific time and place of origin. This recent strategy belies the "old," well-established art historical approach, which depended on stylistic or iconographic analysis from a historical or diachronic perspective, and which supported the concept of a universal art history and aesthetics. The "new" art history has borrowed the idea of contextualizing subject matter gained from anthropological fieldwork methods and scholarship.[8] Art historians, textile scholars, and writers are looking at "image" or iconic and "written" or verbal clothing for their research.[9] Without the information gained from firsthand participant observation in the field, however, scholars miss the multivocal exchange inherent in native dress. When they ignore native peoples' opinions, scholars lose the primary category of clothing analysis: native exegesis—how the garments are worn by native peoples in their own context, the multiple functions these textiles serve, and the messages encoded in them.

Until the 1980s, material culture studies or material anthropology was not pursued systematically by most anthropologists.[10] Scholars in the late nineteenth and early twentieth centuries working in the developing field of anthropology practiced a linear, diachronic mode of classification. This approach resulted in endless taxonomies of objects, stylistic attributes, and iconography abstracted from their context that proffered a historical unity of mankind, what we now call Victorian evolutionism.[11] The pendulum of scientific and artistic thought, however, swings back and forth. Franz Boas's culture theories that focused on the history of the diversification of mankind reversed the evolutionary trend. In recent years, material culture as social expression has been rediscovered as a research focus by structural and symbolic anthropologists and semioticians, who apply material culture categories, principles, and processes to the analysis of their data. These scholars are developing diachronic studies to include stylistic analyses of data—art historical processes—all combined with data collected in the field, while, for the past two decades, the "new" art historians have been integrating native exegesis into their findings.

Studies done by linguist and structural ethnographer Petyr Bogatyrev (1971); art historian Marie Jeanne Adams (1973); semiotician Roland Barthes (1983); and anthropologists Patricia Anawalt (1981), Jane Schneider, and Annette B. Weiner (Schneider 1987; Schneider and Weiner 1986; Weiner and Schneider 1989), among others, have contributed to an anthropology of cloth and clothing. Bogatyrev, in his pioneering work done in the 1930s on Moravian folk costume, pointed out the cultural categories communicated by clothing. Adams's study of Sumbanese clothing revealed the organizing cultural principles of that society. Weiner and Schneider commented on "the properties of cloth that underlie its social and political contributions, the ritual and social domains in which people acknowledge these properties and give them meaning, and the transformations of meaning over time" (1989:1). Anawalt's work on pre-Columbian and contemporary Mexican clothing confirmed the continuity, discontinuity, and transformation of certain prehistoric dress forms, and the use of clothing as an instrument of domination (1981, 1990).

TEXTILE AS TEXT

Can one "read" dress like a written document? Is there a language of clothing? Can we speak of a visual grammar of meaning? Some researchers (Herskovits and Herskovits 1934; Morris 1980, 1985; Morales Hidalgo 1982; Witherspoon 1987; Wilson 1991) translate iconographic images into a symbolic system or conceptual language with each image representing an entity or idea taken from the creator's world. Other scholars (Rodee 1987; Franquemont and Franquemont 1988; Niessen 1991) eschew this literal approach to the meaning of iconography and, without imposing ethnocentric

perspectives, attempt to learn the natives' point of view through observation and interaction in the field. Sally and Richard Price in their work on Afro-American arts of the Suriname rain forest concluded that "the meaning of any artistically designed object involves a complex integration of aesthetic, technical, functional, iconographic, historical and social considerations." One must view an object in terms of its general historical and cultural context (Price and Price 1980:193).

To place the theoretical notions about the communicative nature of cloth and clothing in the context of a Maya family in San Antonio Aguas Calientes, Guatemala, I turn to my fieldwork, which began in 1978 and is ongoing (Schevill 1980). On various occasions, I inquired about symbolism in the designs in the clothing or *traje* worn by San Antonio women. During numerous conversations with weavers during my weaving lessons and with women in their shops or on the bus, I asked about the designs and color choices in their textiles. Responses were humorous and varied. Spanish names existed that described the image literally. For example, I learned to weave a difficult pattern called *marimba*, the shape of which was derived from the musical instrument so popular in Guatemala. Another design resembled a hair comb and was called *peine*, the Spanish word for comb. Except to say that the use of purple might relate to mourning or *luto*, the San Antonio weavers offered no symbolic meanings or explanations.[12]

I participated in a photo session where a large private collection of older *huipiles* or blouses from San Antonio Aguas Calientes was photographed in black and white and in color. The session was part of a research plan set up by a colleague.[13] I subsequently showed a set of the black-and-white prints to my weaving teacher and her family. Comments on the photos produced no new information about the symbolic meaning implicit in the images. Native exegesis revealed that the San Antonio design repertoire is flexible and responsive to changes in fashion. These findings contrasted with my preconceived notion that the local designs were static and unchangeable. My teacher and her children recognized and named many of the designs but responded to the unknown ones with the words *"no se usa"* or "we don't do that one anymore." The grandmother, however, recognized them. Other designs were woven in the neighboring communities where the women wore *huipiles* that to the uneducated eye resembled the San Antonio style. I also learned that when the examination was limited to black-and-white prints, the family could pick out technical flaws and other details of interest.[14]

In addressing the subject of the metaphor of "clothing as a language code," anthropologist Grant McCracken suggested the rehabilitation of this metaphor, which has become a cliché in the critical literature, or its elimination (McCracken 1988:62). His research findings led him to conclude that "when clothing as a code is most like a language, it is least successful as a means of communication" (1988:64).[15]

The argument that *all* iconography can be translated into a symbolic system similar to a natural language code is not convincing,

although some elements such as design, color, and design layout may function on symbolic levels. Native exegesis from weavers in other highland communities has indicated that this is a possibility. My research on the Eisen Guatemalan textile collection, however, without benefit of firsthand information from weavers, except for Eisen's comments and the results of my own recent fieldwork, has confirmed the dynamic and communicative nature of Maya dress.[16]

GUATEMALAN TEXTILES AS AN EXPRESSIVE MEDIUM

Can the iconography of Guatemalan textiles be translated by methods derived from linguistic or formal language theory? One anthropologist, Linda Asturias de Barrios (1985, 1991), analyzed the women's costume of Comalapa, Guatemala, from a linguistic, semiotic perspective. The women offered their interpretations of *huipil* elements, which Asturias de Barrios equated with semiotic terminology. She concluded that Comalapan clothing, especially the *huipil*, signaled social structure, ritual patterns, and a commitment to community identity.

Cherri M. Pancake, computer scientist and Guatemalan textile scholar, has proposed an argument for a generative method of textile description that was derived from formal language theory and found suitable for computer analysis (1988). Few of the taxonomic studies produced over the past twenty years have attempted to consider the "deeper meaning" or symbolic level embedded in Maya cloth and clothing.[17] If, as Pancake suggests, town-specific dress styles may be perceived as linguistic dialects, then perhaps these particular textiles can be deciphered in the same way as language codes. The voice of the weaver, however, seems to be lost when the generative method of the computer is applied to textile research.[18] Although the weavers may not have the vocabulary to express symbolic meaning in design layouts, levels of meaning may, as I have suggested, exist on a nonverbal level. Sheldon Annis proposed that perhaps a community collective consciousness exists that weavers in the same town or group of towns share, and from which they draw upon subconsciously to create an appropriate and acceptable garment (Annis 1987 : 116). This suggestion is compatible with my research findings that the decision-making process regarding choice of dress style is community-specific and varies widely from town to town. As Pancake indicates, we may never grasp *all* the deeper meaning implicit in indigenous dress and adornment even with the aid of advanced computer technology.[19]

THE FASHION IMPULSE IN MAYA DRESS: "ONE COSTUME, ONE TOWN?"

The results of my research on a group of *huipiles* in the Gustavus A. Eisen collection support the notions of the communicative and expressive aspects of Maya clothing or *traje,* and

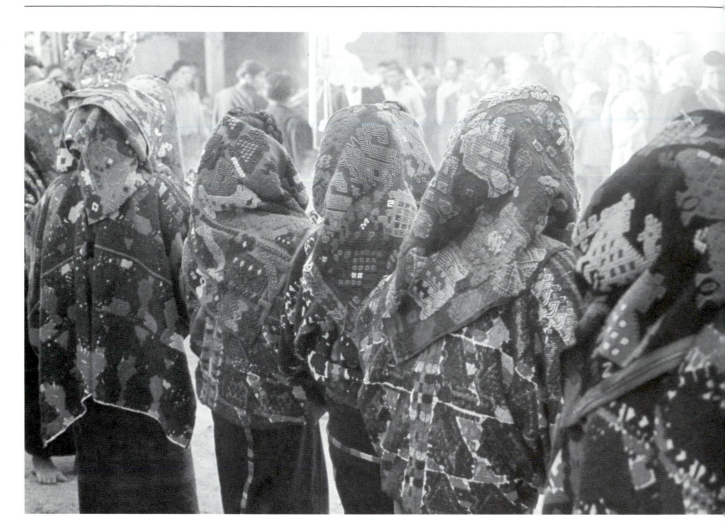

Figure 2.
Cofradía ceremonies in Santo Domingo Xenacoj,
Sacatepéquez. Photo by Maureen Tracy. 1970s.

the decision-making process, the creative skills, and the imagination
of the weavers and those who wear *traje*.[20] *Traje* can function as a
visual grammar of meaning and has the power to communicate to the
informed viewer. The ability of weavers to select new motifs and
design layouts associated with other communities and to combine
them with local stylistic elements implies what McCracken called
"combinatorial freedom," which is an essential process in the
creation of verbal language (McCracken 1988:66). Clearly, some
weavers and wearers of *traje* were freely combining costume
elements, designs, and design layouts in the nineteenth century, and
they continue to do so in contemporary times.

The textiles in the Eisen collection were woven at the end of the
nineteenth and beginning of the twentieth centuries. It was a
common practice then for weavers on occasion to borrow design
layouts and other stylistic elements from each other and from other
communities. The political and social upheavals experienced by the
Maya since their contact with the Europeans in the sixteenth century
have increased in intensity over the past twenty years. These
circumstances have accelerated the tempo of change, which in the

past was slower and more gradual. I hope to "rehabilitate" the metaphor of clothing as an expressive and unique communication system among the Guatemalan Maya of the last century by returning to some recent fieldwork findings with data gleaned from the textiles, Eisen's catalogue notes, and excerpts from his other writings, along with photographs of the same time period. The metaphor remains a viable and powerful way to perceive dress, one of the most radically creative aspects of indigenous material culture.

Before 1970, a literature search on Maya textiles of Guatemala would have revealed that most scholars adhered to the "one costume, one town" theory. This means that each location had its own dress code or distinctive clothing based on patterns, colors, and shapes. One's town or regional locale was expressed through costume and the way the costume elements were worn. Within one community several classes of *huipiles* could exist: One style for everyday wear, others for ceremonial and fiesta occasions. Taxonomic studies (Osborne 1935, 1965; O'Neale 1945; Pettersen 1976) gave the impression that dress styles functioned as "identity badges" that located the town of the wearer, and that these styles were static or frozen in time. Taxonomic organization at this first stage—one costume, one town—does not allow, however, for the inevitability of change and innovation in cloth and clothing that was ongoing within the highland Maya communities.

Designs and design layouts were shared by weavers in areas geographically distant from each other. The marketplace provided the opportunity for women to observe styles worn elsewhere. In some towns, weavers and embroiderers produced various town- or region-specific textiles for women who no longer wove. In the 1930s, Lila M. O'Neale (1945:110) found that in some highland communities women wore their own backstrap-woven *huipiles*, but for special occasions they wore those that were associated with neighboring towns, a suggestion that the locative message of the *huipil* was in flux even then.

Contemporary textile scholars who study the Maya textile complex of Guatemala are beginning to report on a kind of design sharing that they view as a recent phenomenon: the breakdown of the one costume, one town syndrome. The fashion impulse may be playing an important role in what Maya women choose to weave and wear. Carol Hendrickson's work in Tecpán demonstrates that custom no longer demands that a town-specific *huipil* be worn in order for a woman to be accepted by her community (Hendrickson 1991). On the contrary, in some areas the wearing of a *huipil* from a nearby community is a positive gesture or performative statement indicating knowledge of the outside world and giving the wearer a special status among her peers, who admire her for her innovative dress.

In 1988 in Nahualá, where men and women wear *traje*, I noticed a woman in a *huipil* associated with Patzún, a distant town. When asked why she was wearing a Patzún-style *huipil*, she responded that she had made it herself and asked me if I didn't think it was beautiful. She had exercised freedom of choice by wearing a non-Nahualá-style dress element with other Nahualá-style garments. Observing this

phenomenon in other towns made me realize that I had been applying the town-specific concept of clothing derived from the taxonomic method of analysis to my observation of Maya textiles worn in context.

SAN MARTÍN JILOTEPEQUE

The breakdown of the town- or community-specific *huipil* pattern was ongoing in the late nineteenth and early twentieth centuries. The resultant changes are present in some of the *huipiles* in the Eisen collection. When Gustavus A. Eisen was commissioned in 1902 by Phoebe Apperson Hearst to undertake an expedition to Guatemala, he set as one of his goals the task of collecting examples of native dress and other ethnological objects. Eisen traveled to San Martín Jilotepeque, a weaving center where women produced textiles for home use and for sale to other Maya women, sometimes from towns far away, and sometimes to foreigners. On that occasion, Eisen purchased nine *huipiles.*

As with most Guatemalan *huipiles,* the visual impact of these nine is powerful. Brilliantly colored motifs are woven into a white background. The backstrap-loom weaver chose hand-spun and hand-dyed cotton with silk floss of various colors. Silk was highly valued because it was imported and therefore expensive.[21] To produce a *huipil,* two long pieces of cloth, similar in design, were woven and then hand-sewn together with an opening left for the head. The San Martín design layout includes wide bands across the chest area, with small dots and motifs created by supplementary weft brocading.[22] No yarns are carried from one motif to another; each image floats in space. This technique is called *single-faced brocading.* The entire garment is covered with brocaded designs except for a large white area on the bottom. The front and back are identical (Figure 3).

The Eisen *huipiles* have variations in motif coloring and the configurations of motifs create wide central bands. Most images are abstract, and there are some noncharacteristic ones that may be the marks of individual weavers. The open-weave effect in the basic cloth is the result of wide spacing of hand-spun cotton warps and wefts. Certain features appear in all the Eisen examples from San Martín Jilotepeque. Several rows of red cotton wefts are inserted into the bottom selvedges of all the *huipiles.* Another similarity appears in the area called the joining. In all the adult *huipiles,* the joining is loosely and coarsely executed. These similarities may indicate that production was by one weaver and her extended family.

QUEZALTENANGO

Eisen purchased a *huipil* (3-64) in Quezaltenango—far to the west of San Martín Jilotepeque—that resembles the San Martín Jilotepeque–style *huipiles.*[23] It was refashioned and coded and thus communicates a new message (Figure 4). The *huipil* is backstrap-woven with single-faced supplementary weft brocading. The design layout and motifs are similar to those in the examples from San

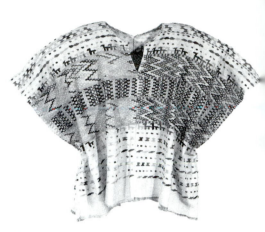

Figure 3.
San Martín Jilotepeque *huipil,* 3-46.

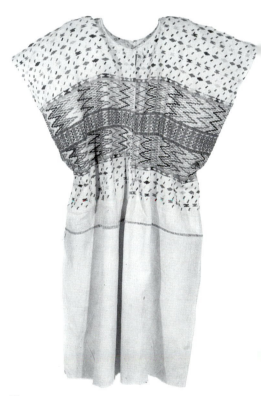

Figure 4.
San Martín–style *huipil* acquired in Quezaltenango, 3-64.

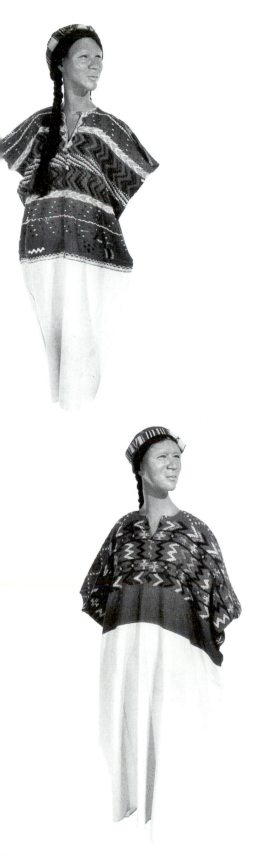

Martín. Several rows of red wefts are also woven into the bottom selvedges. There is, however, a basic and important difference in this *huipil*, which reflects the individuality of the woman who probably purchased the upper part from the same weavers as did Eisen. The Quezaltenango dress code required a longer *huipil*. (Other *huipiles* purchased by Eisen in Quezaltenango were produced on the treadle loom and consist of two long pieces sewn together.) One fashion-conscious woman sewed commercial treadle-loomed white cloth to her San Martín Jilotepeque *huipil* in order to create a town-specific garment, over which she wore a long pleated skirt. Since one piece of the *huipil* was longer than the other, she made a tuck at the bottom of the garment and then attached the treadle-woven cloth to the bottom selvedges. She thereby created a very special *huipil*, one that was acceptable to her community and also indicated her knowledge of other town or area styles. A further concession to local style is expressed by the silk neck piece sewn to the rounded neck opening.[24]

TOTONICAPÁN

Eisen spent several weeks in the town of Totonicapán, another well-known weaving center at that time, where he purchased ten *huipiles* for the collection. They represent several different styles in use. Two green *huipiles* have wide bands of geometric designs and small dots woven in single-faced and two-faced supplementary weft brocading (Figure 5). The design layout and simple neck treatment of these particular *huipiles* echo the San Martín style and contrast with some of the other Totonicapán styles. But the choice of green as the basic color differs from the style in San Martín. It might be locative to Totonicapán or *cofradía*-related. The cloth is balanced plain weave, while the San Martín Jilotepeque weavers created a more open-weave effect. Zigzag bands dominate, a design that has grown in popularity in other highland communities from the 1920s to the present. Hand-spun and hand-dyed cotton and wool with silk floss appear in the decorative motifs. As with the *huipil* collected in Quezaltenango (Figure 4), the garments have been altered to conform to the local fashions. Commercial treadle-woven white cloth was added to the bottom selvedges of these garments to create the longer style popular in Totonicapán.

A photograph acquired in 1901 portrays a woman wearing a San Martín Jilotepeque–style *huipil* (Figure 6). The dark background may be green, and it could relate to the Totonicapán style presented in Figure 5, but the *huipil* lacks the added treadle-woven cloth.[25] In a related photograph, which presents *cofradía* members, the women are wearing white and darkly colored San Martín–style *huipiles* (Figure 7). The exact provenance of these photographs is not known. The standard in the background, however, portrays St. Martín. Hence the provenance is probably San Martín Jilotepeque.[26] Other photographs from this period reveal that, for religious and secular functions, women wore *huipiles* associated with towns in which they did not live.

Two *huipiles* purchased in Totonicapán are related to the green examples and reflect the San Martín influence imitated and

Figure 5.
Two green San Martín–style *huipiles* acquired in Totonicapán, 3-59, 3-65.

interpreted by local treadle-loom weavers (Figure 8).[27] Each garment is made up of two pieces of treadle-loomed cloth with plain and twill weaves and single-faced supplementary weft brocading. Two horizontal bands of zigzag designs dominate the design layout. The surfaces are covered with small motifs or dots as in the San Martín examples. O'Neale noted that the two-color diamonds in one *huipil* (3-37) "represent more ambitious attempts by treadle-loom weavers in Totonicapán" (1945:73).

The weft yarns are a combination of hand-spun white cotton and the highly valued hand-spun brown cotton, native to Guatemala, known locally as *ixcaco* or *cuyuscate.* The individual geometric motifs of multicolored cottons and silk floss stand out against the brown background. The shimmer of the silk gives a luminous effect. The head holes have been cut out, hemmed, and decorated with taffeta pointed neck pieces, similar to those of the Quezaltenango *huipil* (Figure 4). The neck pieces are embroidered with floral designs.

Two more *huipiles* (Figure 9) purchased in Totonicapán reinforce the probability that this town was a weaving center where treadle-loom weavers were producing special textiles for distant towns. We

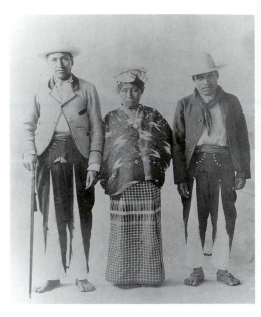

Figure 6.
Woman wearing a dark-colored San Martín–style *huipil.* George Byron Gordon photo archives, Peabody Museum of Archaeology and Ethnology, Harvard University. 1901. (N28297).

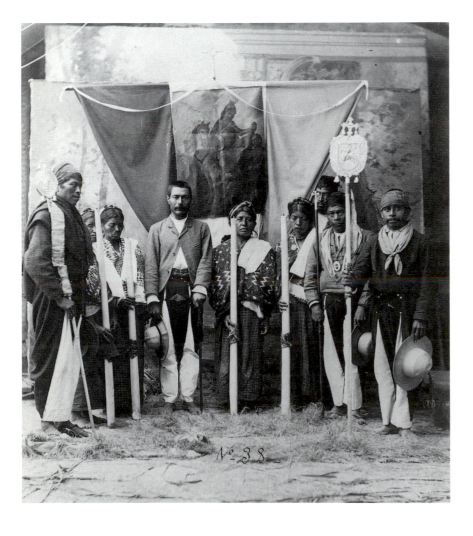

Figure 7.
Women members of the San Martín *cofradía,* wearing dark-colored and white San Martín–style *huipiles.* George Byron Gordon photo archives, Peabody Museum of Archaeology and Ethnology, Harvard University. 1901. (N28296).

might not associate these *huipiles* with those of Totonicapán unless we followed the evolution in *huipil* textile design from San Martín Jilotepeque to Quezaltenango, and then to Totonicapán. Certain similarities and dissimilarities are apparent. These treadle-loomed garments are in balanced plain and weft-faced twill weaves with single-faced supplementary weft brocading. Two identical pieces are produced and sewn together at the side seams. The brocading is only on the upper half since the style was to wear a full-length garment under a skirt. The neck treatment is similar to some of those already described: a rounded head hole is first cut out, and then pointed decorative neck pieces of commercial cloth are sewn on and embroidered with designs. The layout is dominated by wide horizontal bands of zigzag and lozenge designs on the chest.

Now for the dissimilarities: in contrast to the *huipiles* described already, the examples in Figure 9 contain lavish quantities of silk. The total effect is one of richness and wealth, or what the Maya call "*muy rico*" or "very rich." The colors are yellow, green, purple, and aqua—a rainbow effect. Some silk is combined with a single yellow cotton weft in one example (3-48). Narrow twill-woven bands of

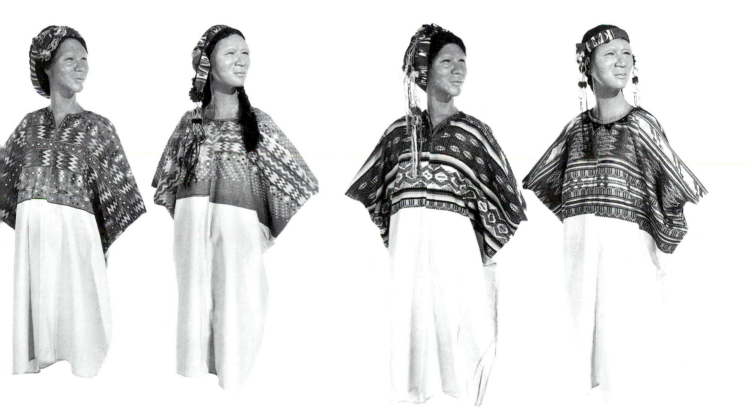

Figure 8.
San Martín–style brown *huipiles* acquired in Totonicapán, 3-37, 3-66.

Figure 9.
Two *huipiles* acquired in Totonicapán for use in Santa Lucía Utatlán, Sololá, 3-48, 3-42.

yellow, dark green, red, and orange set off the brocaded areas. Twill weaves in these colors were a special feature of Totonicapán textiles and are represented in many multipurpose cloths in the Eisen collection (3-24, 3-26–3-28). It has been suggested that this style of *huipil* was woven for the *cofradía* of Santa Lucía Utatlán in the department of Sololá, a town some distance away.[28] It is also possible that the San Martín influence may have affected weaving styles in many highland towns, thus creating a fashion model for that decade and years after.

SAN ANTONIO AGUAS CALIENTES

The style of *huipil* woven in San Antonio Aguas Calientes underwent a dramatic change in the early part of the twentieth century. The older style was of natural brown cotton with simple white warp stripes and a few double-faced supplementary weft motifs (Figure 10). *Huipiles* collected in the 1920s present a dramatic contrast to the earlier style with a dazzling image of bright colors in geometric motifs. How did such a transformation occur? Perhaps San Antonio women observed the San Martín style while attending the large regional market at Antigua. Certain elements in the design layout and motifs may have been slowly introduced by stimulus diffusion into the community until a new fashion was created and accepted. By the late 1980s, *huipiles* with different pattern bands, design layouts, and colors coexisted in San Antonio (Figure 11). Floral motifs were introduced in the 1940s, and weavers continue to create these designs with a double-faced supplementary weft technique called *marcador*. These various *huipil* styles still signal local identity to those who live in San Antonio. If outsiders or serious investigators hope to learn about the communicative and expressive mode of cloth and clothing in the Guatemalan highlands, they need a close association with Maya weavers and weavings in the context of community.

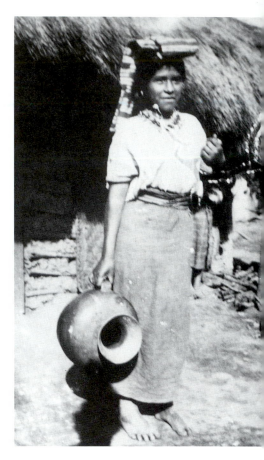

Figure 10.
Indigenous woman, San Antonio Aguas Calientes. CIRMA, Colección Yas, Antigua Guatemala. Late nineteenth century.

MAYA DRESS AS A TRANSFORMATIONAL MEDIUM

Barthes wrote of "the transformational myth which seems attached to all mythic reflection on clothing" (1983:256). A garment can magically transform the person, but the person also transforms the garment and is expressed through it. Thus there may be a dialectical exchange between person and garment, an awareness of the self and the transformed self simultaneously, representing the performative powers of dress in a ritual context.[29]

To wear dress associated with one's community of residence is an active and not a passive gesture, a statement that signals to the informed viewer locative identity. One may also choose to wear dress associated with another town whereby the wearer transforms the message implied by the garment and is transformed by it. The act of disguise is also implied by this choice.[30] John Cohen observed that the Quechua speakers of Q'eros in the Peruvian Andes use dress as a disguise. During the alpaca fertility ceremony called Palcha, a dance

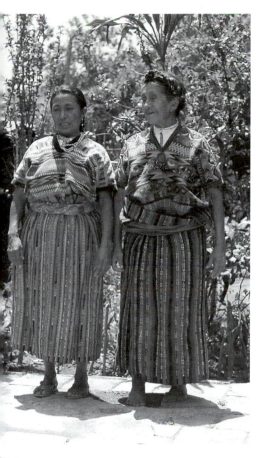

Figure 11.
Two women from San Antonio Aguas Calientes.
Photo by Margot Schevill. 1988.

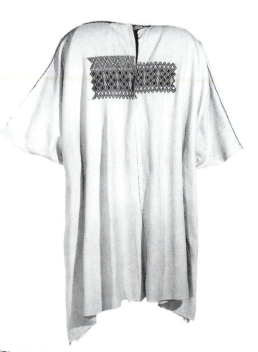

Figure 12.
A *huipil* acquired in Nahualá, Sololá, by Eisen,
3-38. 1902.

takes place on a high pass between Q'eros and the neighboring village Jaja Calla. Rather than wearing their own distinctive dress, the Q'eros villagers instead wear clothes of the style worn by *mestizos*, persons of mixed Spanish-Indian descent, and identical to the festival clothing worn by the inhabitants of Jaja Calla, although underneath they wear Q'eros dress. "Nothing of Q'eros was to be seen. The handwoven clothes had (presumably) been made by Q'eros women in imitation, or in exact duplication of the patterns of their neighbors, or else the fabrics had been purchased outside of Q'eros."[31] An outsider would never associate these dancers with Q'eros. A similar disguise is employed by the Q'eros men when they travel to the regional market at Ocongate. They cover their Q'eros dress with a dirty gray poncho and fade into the anonymous *altiplano* (high plateau) population of indigenous peoples and mestizos. Village identity is thus retained while a false face is presented to the outside world.[32]

The fashion-conscious woman from Quezaltenango referred to above, who transformed a *huipil* from another town to conform with styles worn within her community, did not purposely "disguise" herself. To wear this *huipil* was a performative act that communicated knowledge of styles elsewhere, and at the same time permitted her to maintain locative identity with Quezaltenango.

In contemporary highland Maya towns, women wear several styles of *huipiles* with different expressive implications. Eisen collected several textiles in Nahualá, a predominantly indigenous town, including a *huipil* (Figure 12). In the 1980s, some young women preferred an older style similar to that worn in the late nineteenth century. This choice demonstrates knowledge of, association with, and pride in the past. Other older women preferred the popular styles of elaborately decorated *huipiles* with designs adapted from *cofradía* textiles, which are a combination of sacred and secular. As already mentioned, some contemporary weavers create garments that are representative of other locations. This transformational act may indicate that the woman has family ties with another town, while her other dress elements indicate her connections with Nahualá, her town of birth.

With the increase of repression and civil war in the early 1980s, soldiers were instructed to be suspicious of people wearing textiles that were associated with regions or towns where guerrillas had been active. Some women have been forced to transform themselves by means of their dress—costume as a disguise. Photojournalist Jean-Marie Simon commented: "When army repression forced massive migration of Indians into Guatemala City, many Indian women abandoned traditional dress in order to hide their identities. Others still wore *huipiles*, but from distant areas to avoid regional identification by urban government forces. 'It's a form of a life insurance,' one husband explained" (Simon 1987:124).[33]

Gustavus Eisen was well aware of the power of Maya dress as a transformational medium. Eisen's aesthetic sensibilities were in tune with the beautiful landscape, flora and fauna, and Indian dress of Guatemala. In 1902, Eisen visited Totonicapán where he viewed for the first time the *cofradía* of San Miguel in their religious obser-

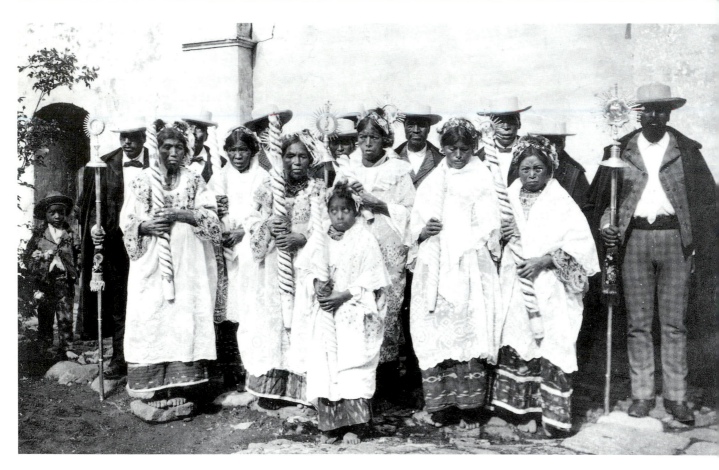

Figure 13.
"Alcaldes and *capitanes* of the church in their ceremonial robes" (Eisen 1902c). Totonicapán. Photo by Gustavus A. Eisen. 1902.

vances. He became fascinated by the religious life of the Indians, and he wrote a short essay, "The 'Cofradia' of the Indians of Guatemala."[34] Not only did he describe the costume of *cofradía* members in great detail, but he took photographs of the men's groups, the *alcaldes* (mayors) the *martooms* (assistants to the *alcaldes*), and the women's group called *capitanes*[35] (Figures 13, 14). About the *cofradía* of San Miguel he wrote:

> The Cofradia of San Miguel is however the most famous one in Central America. When a few minutes after my arrival in Totonicapan I passed the door of the church I was surprised to see half a dozen indians in picturesque costume lined up outside the entrance. Though I had seen many beautiful indian costumes, I had not yet encountered any which could approach those I now saw. The indians were all very young men, some even as yet boys, all evidently proud of their position and the attraction caused by their costume. The latter consisted of a kind of knee breeches, split open nearly to the hip along the exterior of each leg. These pantaloons were of dark color in shades of green and brown, and very tastefully, though loudly, embroidered with flowers, butterflies and lines while along the edges hung numerous small silver bells. With these pantaloons were worn jackets of the same material and of the same gay ornamentation, and the edges were similarly lined with silver bells. But the most interesting garment was a large zarape hung over the shoulders, covering breast and back.[36]

Eisen studied the Indians and their habits, and, in the morning around seven, "I was on hand with my little hand camera just as the bells were tolling and the devotees returned from mass" (Eisen 1903c). Eisen watched the ceremony and commented that "the whole ceremony was gone through with the greatest reverence, and the ecstatic expression on the faces of the martooms was most marked" (ibid.). These young men were magically transformed by the garments, which represented years of their own labor and, no doubt, future indebtedness to obtain. Their facial expressions of "ecstasy" were captured by Eisen on film (Figure 14). He was able to buy four of the serapes that he so admired as well as other costume elements. A visit to *cofradía* ceremonies in Chimaltenango resulted in more photographs of the *alcaldes*, who were not as elaborately dressed as in Totonicapán (Figure 15). Their faces also seem to express feelings of reverence, pride, and wonder.

Over a century of change, Maya dress continues to function on many expressive levels. In search of mythical reality, those in *traje* experience a sense of transformation or change related to their dress. What one wears and how it is worn are part of a performative process in an ongoing discourse among the Maya of Guatemala. Further scrutiny of the "real" clothing as it exists in the Eisen Guatemalan textile collection will help to reveal some of the messages encoded in the textiles almost a century ago.

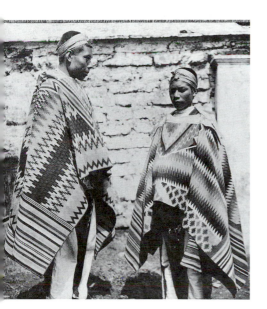

Figure 14.
"Indian *martooms*" (Eisen 1902c). Totonicapán.
Photo by Gustavus A. Eisen. 1902.

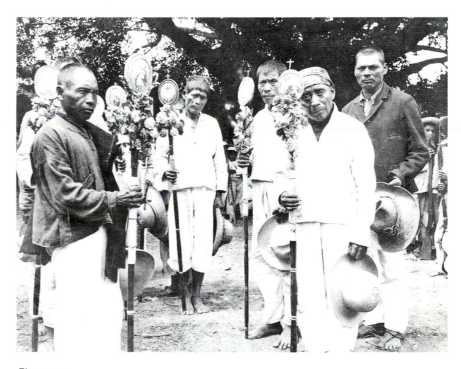

Figure 15.
"Indian *alcaldes*" (Eisen 1902c). Chimaltenango.
Photo by Gustavus A. Eisen. 1902.

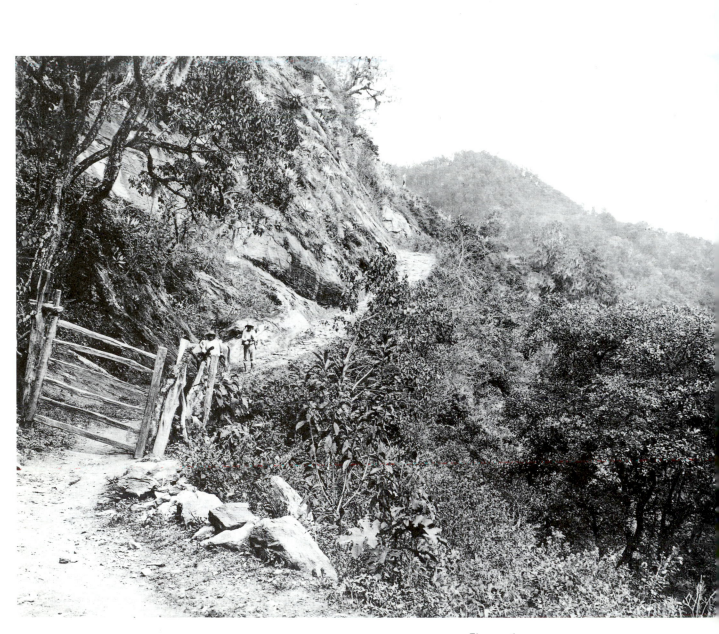

Figure 16.
At Cuesta Grande, Guatemala. Photo by
Gustavus A. Eisen. 1902.

The Eisen Guatemalan Textile Collection

A COLLECTION AS AN ARTIFACT

Research on a collection customarily focuses on the individual artifacts—in this case textiles and costume-related elements—rather than on the collection itself as an artifact. Recent publications on museum collections, however, have included ethnohistorical essays on the collector based on the collector's notes, journals, letters, published writings, and relevant visual material.[1] These publications have revealed that a collection may reflect the tastes, preferences, aesthetic or scientific sensibilities, goals, and perhaps gender of the collector.[2] A museum collection can provide a mirror of the attitudes and social customs of the times. James Clifford writes about the act of "collecting ourselves," our obsessions, recollections, curiosities, art, and evidence of our travels (1988:216).[3] We recontextualize these exotic objects, sometimes called curios, into our homes, museums, or public places and surround ourselves with accumulated property and goods. In this manner we appropriate for ourselves not only non-Western, "tribal" objects, but facts and meanings that relate to our forbidden, curious, and dark fantasies about the "Others."

Eisen's published and unpublished writings, the Eisen Guatemalan textile collection, and his photographs of the Maya comprise an artifact that reflects the nature of the collector and his time in history. As a young man, zoologist Gustavus A. Eisen collected scientific specimens in his native Sweden and in California and Baja California.[4] These collections were for study purposes and research, part of an ongoing scientific tradition in which Eisen was actively engaged.[5] The goals of his second Guatemalan expedition were also specific; one of these was "the collection of Indian dresses and objects."[6] Eisen, unlike some Victorian travelers who happened to collect en route, never referred to these objects as curios. The purpose behind procuring the collection was to provide material for exhibit and scientific research, a validation in his eyes for appropriating these textiles from the Maya.

Eisen made two year-long trips to Guatemala, one in 1882 and the other in 1902. The first trip was for study purposes, as he had become deeply interested in Maya hieroglyphs. He set specific goals for the second trip in addition to the collection of Indian dress and objects: to locate the source of local jade and sites for future excavations. Diffusion theories were popular in the late nineteenth century, and it was speculated that the ancient Maya may have been of Asian descent. If the jade that was associated with Maya funerary and religious complexes was similar to the Asian variety known as jadeite, then these theories would seem to be validated.[7]

Eisen's collecting preferences and powers of observation were informed by his aesthetic and scientific sensibilities, a balanced view that combined contextualist and formalist perspectives. Along with some other travelers who visited Guatemala, however, and like the local residents of European and North American origin, he shared a

prejudice against *ladinos*, persons of mixed, though mostly Hispanic descent.[8] Eisen's sentiments were affected by his admiration for the ancient Maya cultural complex,[9] for he stated that the indigenous peoples were more civilized than the *ladinos*, whom he called "Spanish horsemen." Eisen contrasted the contemporary Maya with the indigenous North Americans, whom he described as "savages," another prejudice caused by his lack of knowledge of the pre-Contact civilizations of indigenous North America.[10]

In particular, the outstanding and beautiful clothing of the indigenous peoples of Guatemala attracted Eisen's artistic eye, and he describes it in some detail several times in his travel writings. An opportunity to make a collection of Indian dress was offered to Eisen in 1902. Phoebe Apperson Hearst, a patron of the University of California at Berkeley, and mother of William Randolph Hearst, provided the funding for an expedition. Mesoamericanist Zelia Nuttall, a member of the advisory committee that had been organized to create the anthropology department at the university, recommended to Phoebe Hearst that Eisen undertake the expedition because of his prior knowledge of Guatemala and his scientific background that included minerology.[11] Eisen agreed to go to Guatemala as he needed a vacation. He also was recuperating from a "capital" operation.[12]

Although he carried revolvers and ammunition, Eisen was not interested in hunting wild animals as other foreigners might have been. Rather, he was concerned with systematically collecting flora and entomological specimens, in addition to textiles and other ethnographic objects. Contrary to the experiences of British archaeologist and Mayanist Sir Alfred P. Maudslay and his wife Anne Cary Maudslay, who in 1894 had difficulty in acquiring *huipiles* and other textiles in some towns, Eisen collected thirty-six *huipiles* from various towns (Maudslay and Maudslay 1899:71–72).[13] He purchased indigenous dress elements at regional weekly markets, weaving centers, or directly from the people. These central markets were arenas for the exchange and purchase of food, clothing, and other goods among *ladinos*, foreigners, and indigenous peoples, who often traveled great distances from remote villages and towns.

For part of the trip, Eisen was fortunate in having as a guide Manuel García Elgueta, a *ladino* and a native of Totonicapán. García Elgueta was knowledgeable about native culture and customs and fluent in the K'iche' language, and he took Eisen to a jade source, the Río Zaculeu [*sic*] in Totonicapán.[14] No doubt, García Elgueta mediated between Eisen and members of the *cofradía* of San Miguel, Totonicapán, which resulted in the purchase of the men's ceremonial clothing and some of the women's ceremonial *huipiles*. Perhaps some of the items were given to Eisen. García Elgueta probably introduced him to other important K'iche' Maya, who facilitated the purchase or gift of other special dress elements.

Travel writings were popular in the Victorian era. Although Eisen's works could be considered part of this genre, he was actually an ethnographer who wrote from a scientific perspective. He was

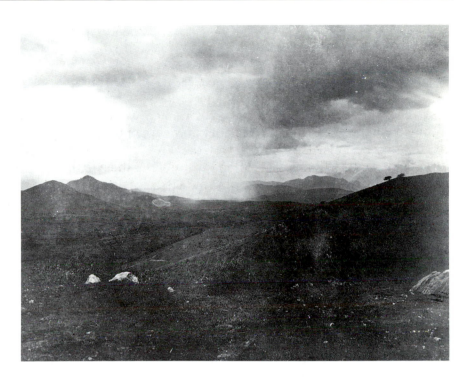

Figure 17.
Eruption of Santa María, Quezaltenango. Photo by
Gustavus A. Eisen. 1902.

attempting to "orient" his readers to the natural world and peoples of
the "exotic" others—the Maya of Guatemala. Eisen's travel writings
about his first trip were commissioned by a Swedish publication
(1886, 1887). En route by ship to Guatemala in 1902, Eisen reported
on the ecological changes that had taken place over the twenty years
between his two visits (1903b), and he also wrote about the devastat-
ing earthquake and eruption of the volcano Santa María that occurred
while he was there (1903a). Eisen actually photographed the eruption
(Figure 17). An unpublished piece describes some of the *cofradía*
ceremonies and clothing that Eisen observed and photographed during
his second trip (1903c).[15]

The Eisen Guatemalan textile collection communicates
important aspects of late nineteenth- and early twentieth-century
everyday and ceremonial life, town and regional identities, gender and
age categories, and textile and dress element production among the
Maya. The collection provides a baseline for comparative research
with contemporary town- or region-specific textile forms because
Eisen documented the provenance of each purchase. Continuities,
discontinuities, and transformations of the basic forms, design
layouts, motifs, and materials present in contemporary textiles are
revealed. Although Eisen's mandate was to collect Indian dress and
objects, some items, such as carrying cloths, shawls, and aprons, were
probably used by *ladinos* as well. The collector sometimes indicated
in his catalogue notes whether a textile was for a man, woman, or
child. Based on these notes and other forms of documentation, about
half of the collection comprises specifically women's dress elements,
one-fourth men's, and only 5 percent children's.[16]

THE FATE OF COLLECTIONS

What was the fate of collections made in the nineteenth and early twentieth centuries by travelers and scientists like Eisen? The majority, no doubt, were stored for a time and subsequently broken up, with items dispersed to interested parties such as museums, family members, antiquarians, private collectors, or curio shops. Some collections remained with the family of the collector and eventually were donated to museums, although not necessarily intact.[17] Other collections, or parts thereof, were acquired or traded with other collectors or museums.[18] Those destined for scientific purposes were not dispersed; they still exist as artifacts that reflect the goals and preferences of the collectors and the material culture in use at the time of acquisition.

The Eisen Guatemalan ethnological collection falls into two of these categories. At first the collection remained together. Eisen wrote to President Wheeler at the University of California from Guatemala City on September 1, 1902, about the collection:

> Enclosed you will find ship[p]ing papers for two boxes containing Indian dresses, and one box containing samples of rocks. The contents of the boxes have been collected by me through the courtesy of Phoebe A. Hearst, and through the suggestions of Mrs. Zelia Nuttall. Mrs. Hearst requested me to send the boxes to the University and to notify you of the fact.
> If agre[e]able to you and Mrs. Hearst I would prefer that the small box containing samples of rocks is left untouched until I come back to San Francisco, as no one else would understand its contents. Perhaps it would be best to leave all the boxes in the care of Mrs. Hearst until I have the opportunity to arrange and properly label the contents [1902a].[19]

Upon his return, Eisen catalogued the whole collection, which consisted of 550 specimens of Indian ethnological objects including the rocks he mentions above.[20] Entries include the object's name in English or Spanish, the provenance of the purchase, and occasional remarks about the items. Selections were exhibited in the Hearst (Women's Gym) building at the University of California at Berkeley for two weeks. In 1938, Eisen wrote to Edward Gifford, curator of the Museum of Anthropology, University of California at Berkeley, from New York City:

> Mrs. Hearst told me that her son intended to build and donate to the University, a large Museum where upon I presented the whole collection to that Museum. But as the Museum was not built, the collection was packed up in two large wooden cases, properly labeled and with the catalogue inside, all done by myself. Mrs. H. then sent the two cases to be stored in the large building of the United Colleges near the western end of Golden Gate Park, San Francisco, but not in the Park, but near a thick wood of Eucalyptus trees. That was the last I knew of it. I hope you have these valuable objects now in your museum [1938].[21]

In 1907 an arrangement was made between Alfred L. Kroeber of the Department of Anthropology, University of California, and Clark Wissler of New York's American Museum of Natural History

to exchange some textiles from the Eisen collection for Philippine material. Such exchanges were common practice in the early history of American museums.

The American Museum of Natural History had a large Guatemalan textile collection acquired by the Reverend Henry Th. Heyde, Apostolic Mission, in the 1890s. It numbered over three hundred items, and Heyde collected in many of the same highland departments as did Eisen. Unlike Eisen, Heyde did not keep the same accurate collection records. Many of the provenances of origin or purchase are vague or incorrect.[22] As a missionary, Heyde was seriously interested in the culture of indigenous peoples and the Maya in particular. Although he bought the collection for personal reasons, Heyde's financial circumstances forced him to sell it. In 1895, he began negotiations with Frederick W. Putnam, who was the director of the Peabody Museum at Harvard University and a curator at the American Museum of Natural History.[23] In 1901 the collection was accessioned, and it became a part of the Anthropology Department's holdings.

Kroeber, as curator of the new Museum of Anthropology at the University of California at Berkeley, wanted to add Philippine material culture to the collections. He negotiated with Wissler to obtain objects valued at $259.75, and he paid $200 in cash, a gift from Mrs. Hearst. The balance was to be paid with additional Guatemalan Indian material. This arrangement was acceptable to Wissler, who knew the problems with the Heyde documentation and that the Eisen collection had been systematically collected and well documented. Kroeber wrote: "I trust you will be satisfied with my selection, which is as systematic as possible. We have comparatively little material available for exchange other than textiles and garments, which is the reason that the range of classes of objects included is not wider. I have selected pieces from as many different localities as possible. If there are any specimens in the lot that you do not wish, kindly return them and we will substitute others" (1907).[24] Twenty-eight items were exchanged including a water cup that was subsequently exchanged with the Brooklyn Museum in 1942. The exchanged textiles were valued at $59.75.

Eisen collected some complete costumes. Unfortunately, Kroeber, who was not a Guatemalan textile scholar, selected textiles at random, and thus destroyed the unity of several of these costumes.[25] As a result of this transaction, the collection lost some of its value as an artifact, thus detracting from the goals, preferences, and skills of Eisen as a collector.

Lila M. O'Neale, anthropologist, associate curator in the Museum of Anthropology, and professor of decorative art at the University of California at Berkeley, integrated the majority of the Eisen textile collection into her comprehensive study of Maya cloth and clothing—*Textiles of Highland Guatemala* (1945)—as a means of comparing older styles and techniques with those of the 1930s. In 1936, O'Neale spent three months in the Guatemalan highlands as a member of a Carnegie Institution expedition that focused on Maya ethnology. She made a collection for the Decorative Art department,

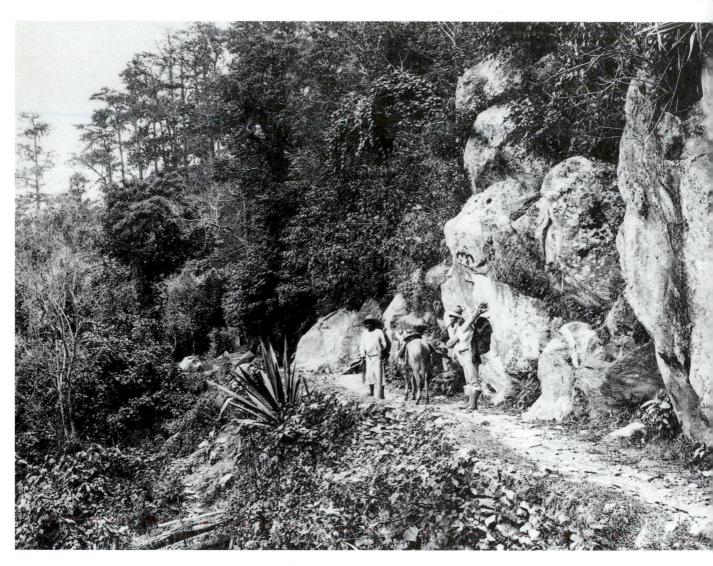

Figure 18.
Cuesta Grande, Guatemala. Photo by Gustavus A.
Eisen. 1902.

and each piece represented a particular technical process. O'Neale subsequently studied museum collections of the same time period in order to present a well-rounded picture of Maya dress. She quoted Eisen's writings when they were relevant to her presentations. While her focus was not principally on the ethnology of the Maya, she did devote a chapter to Maya weavers. O'Neale concentrated instead on textile materials, equipment, techniques, design motifs, and complete highland costumes including accessories. Many of the Eisen textiles and textile-related objects were pictured in black-and-white photographs. One of the four Totonicapán serapes (3-4) became part of the Decorative Art collections, and O'Neale and her colleagues used it for study purposes in their textile classes.[26]

The Eisen collection has been studied by other textile scholars over time, and individual textiles have been illustrated or discussed in various publications (Rowe 1981; Conte 1984; Carlsen and Wenger 1991; Schevill 1985). Presented here for the first time, the textiles and textile-related objects are an entity of social and historical signifi-

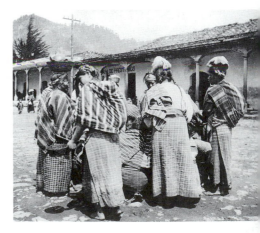

Figure 19.
Indian women buying corn on the plaza.
Totonicapán. Photo by Gustavus A. Eisen. 1902.

cance, and an artifact for aesthetic reflection and study purposes. In this way, the Eisen Guatemalan textile collection finally fulfills the goals of its collector, Gustavus A. Eisen, the sponsor of the expedition, Phoebe Apperson Hearst, and the Lowie Museum of Anthropology, now known as the Hearst Museum of Anthropology.

THE TRAVAILS OF COLLECTING

From March to December of 1902, Eisen collected primarily in the northwestern mountain villages and towns of Guatemala, the area most densely populated by the Maya Indians. Travel was difficult and slow along precipitous paths, across perpendicular ravines, and up and down hills (Figures 16, 18). Deep fissures in the roads caused by earthquakes had to be avoided. There were trains, but they connected with seaports and large plantations, which were not part of Eisen's itinerary. He walked or rode horseback with his guides, while carriers and mules transported his luggage and collections. In the travel writings, Eisen described the road and travel conditions, types of accommodations available, and, above all, the beauty and dramatic quality of the countryside. Other nineteenth-century travelers to Guatemala also wrote about the travails and adventures of their travels (Stephens 1841 and Maudslay and Maudslay 1899, among others). Gustav Ferdinand Von Tempsky traveled through Mexico, Guatemala, and Salvador in the years 1853 to 1855. He also commented about the road to Totonicapán, a town where Eisen spent considerable time, and about the differences between the mountains of Mexico and Central America: "Those [mountains] of Central America, and particularly at the approach to Guatemala, are marked by sudden chasms, fathomless rents, capricious peaks, a scattered, unconnected, and varied chaos of height and depth, bearing the unmistakable aspect of having been caused by the most violent and sudden paroxysms of volcanic action. Near Totonicapán, this character begins to be perceptible. The town straggles along precipices that mark the sudden ascent to the surrounding rim of mountains that encircle the plateau of Quezaltenango." (1858:316–317)[27]

In spite of the hazards of travel and natural disasters, Eisen managed to collect from fourteen different linguistic groups in nine departments. He obtained textile and textile-related objects from thirty-two towns and villages (Figure 20). The majority came from the departments of Totonicapán, Huehuetenango, Quezaltenango, and El Quiché. Eisen did not write in detail of this trip, but his correspondence is dated and place names are noted. Using this information, along with catalogue notes and publications, I have suggested the routes between cities, towns, and villages that Eisen might have taken (Figures 21–22).

Eisen bought new textiles direct from the loom as well as those used and worn by the Maya.[28] His photographs recontextualize the individual costume elements in the collection (Figure 19). As a result of Eisen's preferences, the collection is especially well balanced.

Baja Verapaz
Rabinal

Chimaltenango
Patzún
San Martín Jilotepeque

El Quiché
Chichicastenango
Nebaj
Santa Cruz del Quiché

Guatemala
Mixco
San Antonio Las Flores
San Juan Sacatepéquez

Huehuetenango
Aguacatán
Huehuetenango
Jacaltenango
San Juan Ixcoy
San Sebastián
Santa Barbara
Santa Eulalia
Soloma
Todos Santos Cuchumatán

Quezaltenango
Almolonga
Concepción Chiquirichapa
Quezaltenango

San Marcos
Comitancillo
Malacatán
San Miguel Ixtahuacán
Tutuapa

Sololá
Atitlán de la Laguna
(Santiago Atitlán)
Nahualá
San Lucas Tolimán
Sololá

Totonicapán
Momostenango
San Cristóbal Totonicapán
Totonicapán

Figure 20.
Departments *(in italics),* cities, and towns from which Eisen collected textiles and textile-related objects.

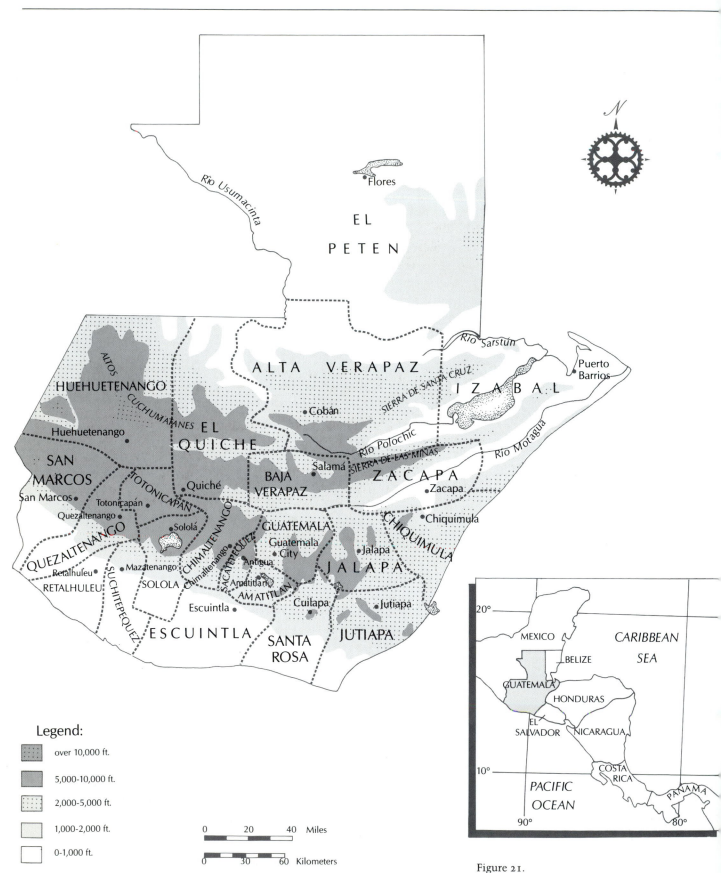

Figure 21.
Guatemala at the time of Eisen's trip in 1902.
Map by Lynn Malone; based on an 1898 "Railroad Map of Guatemala C. A."

Legend:

- over 10,000 ft.
- 5,000-10,000 ft.
- 2,000-5,000 ft.
- 1,000-2,000 ft.
- 0-1,000 ft.

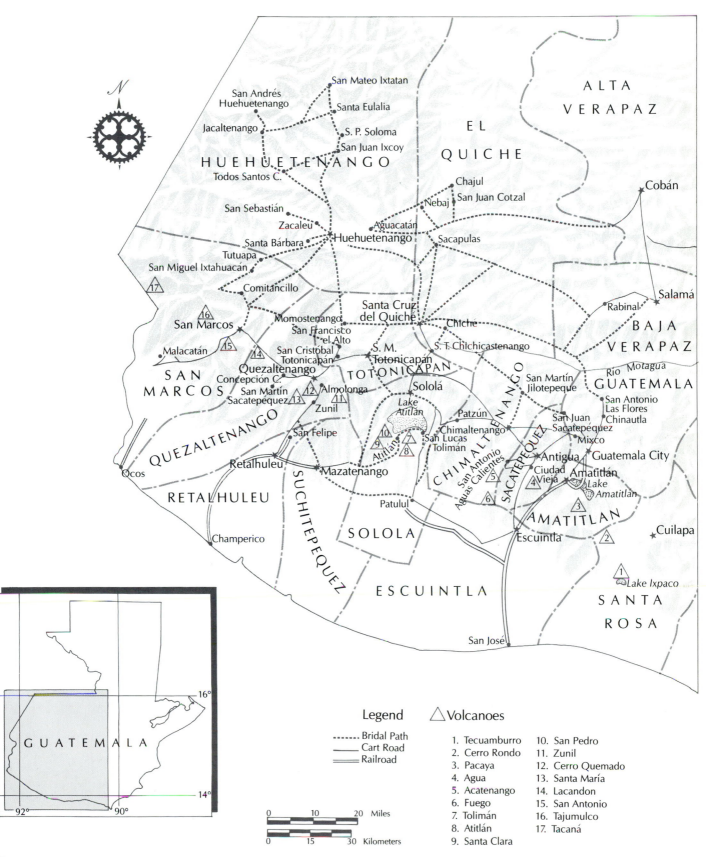

Legend

······· Bridal Path
—— Cart Road
═══ Railroad

△ Volcanoes

1. Tecuamburro
2. Cerro Rondo
3. Pacaya
4. Agua
5. Acatenango
6. Fuego
7. Tolimán
8. Atitlán
9. Santa Clara
10. San Pedro
11. Zunil
12. Cerro Quemado
13. Santa María
14. Lacandon
15. San Antonio
16. Tajumulco
17. Tacaná

Figure 22.
Suggested routes and towns visited by Eisen in
1902. Map by Lynn Malone.

Figure 23.
Gustavus A. Eisen, California Academy of
Sciences, 1898. Courtesy, The Bancroft Library,
University of California at Berkeley.

Gustavus A. Eisen: 1847–1940

INTRODUCTION

This great Swedish-American scientist perhaps ought to have been born in the sixteenth or seventeenth century when universal learning still was considered to be the ideal of humanity.
—S. G. HÄGGLUND (1941)[1]

At the respectable age of ninety-one, convalescing from a cancer operation, Gustavus A. Eisen was living in New York City dependent on the hospitality of art dealer Fahim Kouchakji and his wife Evelyn. Eisen had spent the past twenty-four years heavily involved in art historical projects. Responding to letters, Eisen recalled events of the past with clarity, humor, and bitterness.[2] He was frustrated and bitter because he had not received recognition for his principal achievements. Writing to the son of a friend in Fresno, California, a town where he had lived periodically from 1873 to the early 1900s, Eisen complained: "Today 1939 [I] have published in all about 130 papers, 6 or 7 books in 2 vols. each, newspaper articles not counted in . . . am displeased with life. Poor as a 'march hare.'"[3] Drawing upon his strong memory, Eisen listed names, occupations, and anecdotal comments about those he knew over sixty years ago and his principal achievements:

PRINCIPAL ACHIEVEMENT[S] FROM 1873–1939

1873–1874	Scientific explorations in California.
1874–1889	Raisin culture and wine in Fresno. Writing for newspaper.
1882–1890	Experiments on <u>Figs, discovered the nature and necessity of caprifigation,</u> laying thereby the foundation for the Fig industry in California—Roeding <u>tried</u> to steal my glory, and has the credit. I published the <u>first</u> book on Raisins in 1891; Books and papers on Figs—1895–1901, two or three published by U.S.A. Government.
1915–1924	The monumental work on the Great Chalice of Antioch (1st century A.D.). price $150 2 vols.
1929–	Monograph on Antique glass. 2 vols—$100 copy.
1932–	Monograph on the portraits of Washington. 2 vols price $100.
1895–	I made and published a map of Baja California, 1 Mexico (yet the best to date).

Eisen did not list, however, as "principal achievements" his experiences as a journalist, world traveler, photographer and co-owner of a photographic studio and gallery, scientific investigator, and author of several unpublished manuscripts. Still he included these experiences in a list of important dates and events in his life. Eisen's accomplishments and the breadth and range of his interests exemplify the combination of Old World training and disjunct American opportunities that shaped the life of this Swedish-American immigrant and Renaissance man.

THE EARLY YEARS

August Gustavus Eisen was born August 2, 1847, in Stockholm's Jakob's Parish.[4] His father, Frans August, from a family of old German

Figure 24.
A. B. Butler's Vineyard, Fresno, California. From a
lithograph by Carl Browne. 1885. Courtesy, The
Bancroft Library, University of California at
Berkeley.

origin, was a wholesale merchant. His mother was Amalia Hedvig
Aurora Markander; her family came from the eastern shores of the
Baltic. Confined to a sickbed as a young child, Eisen read constantly.[5]
A beautiful volume of natural history, given to him by his father,
fascinated the boy. By the time he was ten, Gustav had developed
interests in zoology, botany, and geology, as well as archaeology and
the art of the Middle Ages, that would remain with him through his
long life of ninety-three years.

Upon the advice of a physician and with the hope that the sea
air of Gotland would improve his son's health, Frans August sent
eleven-year-old Gustav to a public secondary school in Visby. The old
Hanseatic city was a laboratory rich in geology, anthropology, biology,
and history. Gustav spent five years there and returned to Stockholm
a strong and healthy young man. Entering the Lyceum, Eisen met
August Strindberg, two years his junior, and thus began a lifelong
friendship.[6]

In 1868 Eisen enrolled at the University of Uppsala, where he
studied miniature and watercolor painting along with the natural
sciences. Between 1868 and 1869, Eisen published scientific works on
oligochaefauna or earthworms, corresponding with Charles Darwin
who also was studying earthworms.[7] In 1873, he became a university
lecturer in zoology and graduated in the spring. After a summer
expedition to the west coast of Sweden with colleague Anton
Stuxberg, he journeyed to the United States on a state travel
scholarship. One of his goals was to collect marine animals for the
Swedish Museum of Natural History. Louis Agassiz, natural scientist
and professor at Harvard University, knew of Eisen's research and
invited him to become a member of his staff. However, Agassiz died

Figure 25.
Gustav Eisen, professor. From a lithograph by
Carl Browne with drawings of twenty-eight
prominent citizens of Fresno, California.
Courtesy, The Bancroft Library, University of
California at Berkeley. 1884.

suddenly in December 1873, so this appointment never materialized. Although he had no scientific appointment and his travel scholarship was exhausted, Eisen decided not to return to Sweden. Three of his brothers had settled in the San Francisco area. Francis T. Eisen, the only surviving sibling, owned land six miles east of Fresno and grew grapes. As many other immigrants were doing, Eisen headed west.

Arriving in San Francisco in 1874, Eisen immediately took the train to Fresno, then a town of sixteen buildings. In the distance loomed the Sierra Nevada mountains while nearby the valley terrain was covered with vineyards (Figures 24, 25). Over the next twenty years, Eisen pursued his scientific interests in both Fresno and San Francisco, where the California Academy of Sciences was located. In Fresno, he was able to support himself as a vineyard owner and manager while pursuing his horticultural experiments and exploring the mountains, where flora and fauna unknown to him were to be found. Because of his scientific publications, Eisen obtained a prompt research appointment at the Academy where he could engage in scientific studies and make professional contacts. Over the next sixteen years, he made numerous collecting expeditions for the Academy, including four trips to Mexico and the 1882 trip to Guatemala, where his lifelong fascination with the Maya began.

FRESNO, CALIFORNIA

Eisen's brother Francis was a physician and was not able to spend much time on his vineyard. Eisen assisted him and subsequently became manager of the Eisen Vineyard, where he produced the first wine in Fresno, began the raisin industry, and grew cotton as well.[8] In the 1880s he founded Fancher Creek Nursery and began experiments on Smyrna fig production, which had been unsuccessful in California due to lack of successful pollination. Eisen discovered that an Asiatic beetle was the key to the pollination of this variety of fig. At first, the U.S. Department of Agriculture refused to allow the importation of these beetles. By the late 1880s, the ban was lifted, and the California fig industry began to grow.[9]

In addition to his scientific studies, Eisen corresponded widely with other horticulturalists and became horticultural editor for the *Fresno Republican* and the *Fresno Expositor*, and later for the monthly publication *California*. In 1882, Eisen was granted American citizenship by Judge Campbell in Fresno.

During summers Eisen made trips on foot and horseback to the Sierra Nevada. Often he was accompanied by Swedish colleagues or by local men who knew the area. While a student at the University of Uppsala, Eisen had spent summers on scientific expeditions and had become a skilled woodsman and a mountaineer. There was no proper map of the Sierra Nevada, so Eisen made rough ones of the areas he explored. He also drew sketches of all coniferous trees and collected plants, earthworms, spiders, and multilegged animals or myriapods. Volcanology was another interest. On his treks north, he studied the craters near Mount Lassen and concluded that, contrary to common thought, the mountain was a volcano that had erupted recently.

Eisen's mountain expeditions also led him to the lands that would become Sequoia National Park.[10] Since the opening of the western frontier and the completion of the transcontinental railroad in the mid-nineteenth century, ruthless lumbering threatened the giant sequoia, *Sequoia gigante,* with extermination. Lecturing widely on the desirability of preserving the giant trees, Eisen drew maps and outlined the boundaries for a projected national park.[11] Grass-roots movements to save the trees also were underway. In 1890 the U.S. government established Sequoia National Park. According to Eisen, this was one of his "principal achievements."

THE CALIFORNIA ACADEMY OF SCIENCES

In 1874 Eisen became a member of the California Academy of Sciences and in 1883 he was made a life member. Eisen served as curator of biology from 1883 to 1890, when he was suddenly discharged from his position, an act that surprised and shocked him (Figure 23). In 1938, only two years before his death, the Academy reinstated him as an honorary member, the highest honor the institution awarded.

The first expedition Eisen undertook for the Academy was to the uninhabited Santa Catalina Island in southern California, where he spent the winter. James Lick, philanthropist, businessman, and real estate entrepreneur, intended to give the island to the Academy. Eisen explored and reported on the island and collected sea animals as well. Lick's offer of the island as a gift, which Eisen recommended for acceptance, was refused because of rivalry within Academy ranks.[12]

Eisen had recently completed a treatise on *Oligochaeta limicolide,* or earthworms whose habitat is mud, which he sent to Professor Spencer J. Baird, assistant secretary of the Smithsonian Institution, for possible publication.[13] The contact with Baird led subsequently to what Eisen interpreted as an offer of a position at the Smithsonian. Writing to Baird in 1881 about his upcoming trip to Guatemala, Eisen asked for letters of introduction. He offered to collect antiquities and closed with "thanking you for the prospect of a final home in the Smithsonian."[14]

Eisen's discharge from the Academy in 1890 probably was due to many factors. The Academy's official position was that his salary was needed for research on California Indians. Eisen, however, never doubted that his proposed plan for Sequoia National Park was the real cause for his dismissal. In addition to lecturing on the value of the park, Eisen advised members of the Academy of his plan, and they voted to support it. In spite of the Academy's decision, Eisen's plan would have interfered with the expansion of the Southern Pacific Railroad Company. Railroad magnates William Henry Crocker and Leland Stanford were both Academy members. Crocker also sat on the decision-making board of trustees, which was responsible for Eisen's discharge. If Eisen's plan had been realized, potentially valuable land would be irrevocably lost to the railroad's interest. In 1890, the U.S. government, nevertheless, did create Sequoia National Park, although on a smaller scale than Eisen had envisioned.

With the loss of his position, Eisen felt that a shadow had been cast on him and that his biological research had come to an end. In spite of his feelings of being rejected by the Academy, his scientific articles were published in the *Memoirs and Proceedings of the California Academy of Science* from 1888 to 1900.[15] Eisen's final exploration for the Academy took him to turquoise mines in San Bernardino County, California. With Will Sparks, he wrote a popular article for the *San Francisco Morning Call*; a scholarly version was deposited at the Academy.

THE MAYA

On January 4, 1882, Eisen sailed out of San Francisco Bay, down the coast of California, Baja California, and Mexico to San José, Guatemala.[16] His goals included scientific collecting for the Academy, observation of flora and fauna, volcanology, and the study of Maya ruins.[17] Eisen had obtained letters of introduction to various plantation owners to facilitate his travel.[18] The travel accounts of John Stephens with illustrations by Frederick Catherwood provided valuable information about the location of Maya sites and the travails of travel (Stephens 1841).[19] Eisen's travels in Mexico had prepared him for what was to be a difficult journey on foot through central, southern, and eastern Guatemala and western Honduras.[20] Coffee cultivation had just been introduced to Guatemala (see Chapter 4 of this volume). A few small railroad lines connected coffee plantations and seaports. Roads were under construction. Only footpaths and pack animal trails were available to the adventurous traveler.

Eisen was a vivid writer. His travel accounts are replete with rich descriptions of the vegetation, climate, geography, and people he encountered along the way. He met wealthy *ladino* landowners, poor *ladinos*, foreigners like himself, and the indigenous Maya whom he so admired. Along the road from Escuintla to Guatemala City, he saw "old, fat Ruffino Barrios," then president of the country, and his beautiful young wife who was riding a white horse.

In Guatemala City Eisen bought provisions and hired two *mozos* or carriers for his luggage. His travel routes brought him back to the capital on several occasions, where he would rest, write letters, and reprovision himself before setting out again.[21] Equipped with drawing materials, he sketched constantly.[22] One excursion led west to Antigua. Eisen climbed the volcano Agua near the indigenous town of Santa María de Jesús. Walking through Dueñas, he arrived at the coffee plantation Finca San Miguel Dueñas and was cordially received by the proprietor Guillermo Wild, a Guatemalan who was of English origin. From there Eisen traveled west to the *boca costa* (the piedmont area between the Pacific coastal plain and the highlands) through three climatic zones—cold, temperate, and, at the coast, warm. The vegetation was lush and the volcanos were in view. He commented that the people of Guatemala had not learned to appreciate or enjoy the beauty of their own country.

His next destination was the Finca Aguna near Santa Lucía Cotzumalguapa, Escuintla, where Maya ruins and other nearby sites

were located. He had a letter of introduction to the proprietor,
Guillermo Rodriguez. He spent several days in the hot sun drawing
the hieroglyphs, elegantly costumed figures, headless individuals
representing human sacrifice, animals, and other symbolic motifs
(Figures 26, 27). Comparing the facial features of individuals
represented on the ancient carvings, Eisen thought that there had
been a strong Mexican presence in this area.[23] En route to Lake
Atitlán, Eisen admired the giant ceiba tree, a member of the genus
Sequoia, represented in California by the *gigantea* variety. Visiting
towns on the return trip to Guatemala City, he noticed the variety of
facial features of the indigenous peoples. When special clothing was
worn by the Maya, Eisen described it in detail. Like rare flora and
fauna, Maya dress appealed to his artistic sensibilities.

Another excursion led in a northeast direction, through the
semiarid area of Salamá to the hill towns of Alta Verapaz. Stephens's
descriptions of old manuscripts in San Pedro Carchá and ruins near
Cobán aroused Eisen's interest. These towns were indirectly on the
way to the major Maya site of Copán, Honduras, his eventual
destination. While in Alta Verapaz, Eisen wished to collect a quetzal
bird for the Academy, and his descriptions of this lovely bird, now
almost extinct, are vivid. He thought that the forests were a great
resource for natural scientists.

Eisen arranged for boat travel on the Río Dulce to Livingston.
From there he traveled overland to another Maya site, Quiriguá,
described in detail by Stephens and illustrated by Catherwood. Eisen
noted that the road had improved since the time of Stephens's and
Catherwood's travels. The arid landscape resembled parts of
California. Eager to see the ruins, Eisen left his baggage in a nearby
village and took his drawing equipment and a rifle with him to
the site.

Stephens had written about a series of monoliths that existed in
1832. Since Stephens's visit, jungle vegetation had taken over, and
Eisen thought that the site, obscured by the growth, was much larger
than formerly perceived. He devoted eight pages to descriptions of
each feature—obelisks, pyramids, and hieroglyphs. He sketched some
of these sculptures (Figure 28). The Maya hieroglyphs, which he
assumed were a written language, fascinated him. The forms seemed
less elaborate and simpler than those at the Maya sites of Palenque
and Tikal, in the Yucatan and along the Usumacinta River. Eisen
thought that it would be possible to find the key to the understanding
of Maya hieroglyphs.

From Quiriguá, Eisen went to Zacapa and then to Copán, the
second Maya site of importance in Guatemala and the first in
Honduras. Since the middle of the sixteenth century, foreign travelers
had visited Copán. When he was in Guatemala City, however, Eisen
met a historian and a government minister, both of whom expressed
interest in antiquities. Neither of them had ever visited Copán.

Eisen drew the plan of the ceremonial city and individual
monuments and sculptures, which included large stele in the main
plaza, the staircase of hieroglyphs, and the pyramids (Figure 29, 30).
Eisen observed the facial features of these ancient Maya figures.

Figure 26.
Drawings of ancient carvings, Pantaleón,
Escuintla. Memoirs of the California Academy of
Sciences, San Francisco. Gustavus A. Eisen. 1888.

Figure 27.
Drawings of ancient carvings, Santa Lucía
Cotzumalguapa, Escuintla. Memoirs of the
California Academy of Sciences, San Francisco.
Gustavus A. Eisen. 1888.

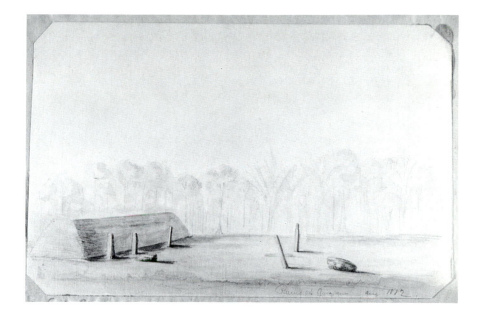

Figure 28.
Drawings of monoliths and a pyramid at Quiriguá, Izabal. Gustavus A. Eisen, 1882. The Erwin Paul Dieseldorff Archives, Mayan Studies papers, Part XI, The Howard-Tilton Memorial Library, Special Collections Department, Tulane University, New Orleans.

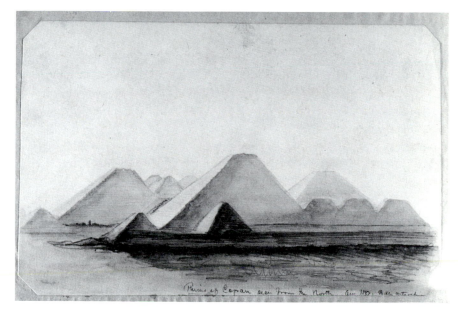

Figure 29.
The ruins of Copán, Honduras. Drawing by Gustavus A. Eisen. 1882. The Erwin Paul Dieseldorff Archives, Mayan Studies papers, Part XI, The Howard-Tilton Memorial Library, Special Collections Department, Tulane University, New Orleans.

Because some of the figures also were headless, he surmised that some of the altars must have served sacrificial purposes.

On the return trip to Guatemala City, Eisen visited the Sanctuary of El Sēnor de Esquipulas, where the black Christ crucifix was on view. Eisen arrived in the capital at the beginning of September, in time for the festivities that celebrated Guatemala's independence from Spain. He departed for California at the beginning of October.

Anxious about his future, Eisen wrote to Baird at the Smithsonian Institution from Guatemala City. He mentioned that he could barely make his living in "this stagnant country. If I stay longer, I may be too poor to write letters. Foreigners are here not liked and rather

Figure 30.
Map and plan of Copán, Honduras, by
Gustavus A. Eisen. 1882. The Erwin Paul
Dieseldorff Archives, Mayan Studies Papers, Part
XI, The Howard-Tilton Memorial Library, Special
Collections Department, Tulane University, New
Orleans.

hated. Especially Americans, as they are looked upon as people who
wish to annex Guatemala."[24] Eisen inquired again about a job. How
many hours a day would he have to work? Would there be sufficient
vacation time for him to join a scientific expedition? Would he have a
fixed salary adequate for a decent living? Would the position fluctuate
or be fixed? "I ask the latter because a man who gives his whole life
and time to study and investigation in Natural Sciences gradually
grows unable to attend to practical business for his livelihood."[25]

Alas, no job was forthcoming. Eisen returned to the United
States, dividing his time between Fresno and San Francisco. He
revised a paper on Central American antiquities and sent it to Baird
for his inspection. Included with the manuscript were maps and
various figures. In spite of the Guatemalans' attitude toward
foreigners, Eisen wanted to return to Central America and Mexico
because the antiquities "have for me an indescribable charm. If I this
time had had a thousand dollars at my disposal I could have collected
considerable of antiquities for your museum."[26] He believed that, if
casts could be made of the stela at Quiriguá and Copán, scholars
could learn to decipher the hieroglyphs.[27] His immediate goals were
to make enough money to allow him to return to archaeology and to
pursue further studies on earthworms.

The following summer Baird wrote to Eisen to acknowledge the
receipt of the paper on Central American and Mexican antiquities and
to inform him that it was to go to an examiner. Baird indicated that
he would like Eisen to collect for the museum, but at some future
date. He also asked if Eisen knew how much an expedition to
thoroughly survey Copán would cost. About the position, he wrote:
"I have not forgotten my suggestion that, at some future time, I may
be able to offer you a position in the National Museum, where your

accomplishments as a naturalist can be utilized. We are not yet prepared to make any definite suggestion as to this, but it is not impossible that within a year we may be in condition to do so."[28]

The Smithsonian budget depended on goodwill from Congress. Another letter to Eisen from Baird reported that the map was not with the manuscript. Other mishaps occurred that involved the loss of not only the map, but his drawings and watercolors.[29] After a year the manuscript itself was returned to Eisen. In 1938 he wrote, "In a fit of disgust and hatred, I cast the whole manuscript into the fire. I regret it now deeply." Eisen's ill treatment at the Academy alerted him to the possibility of similar intrigue at the Smithsonian. The rejection and mishandling of his manuscript added to his suspicion. When Baird died in August 1897, Eisen felt that the possibility of a Smithsonian appointment was eliminated.

J. T. GOODMAN AND MAYA HIEROGLYPHS

Back in Fresno in 1883, Eisen continued his Maya studies with Joseph T. Goodman, who owned a raisin vineyard in Fresno County. Before moving to Fresno for his health, Goodman had founded, owned, and run the *Territorial Enterprise*, a small newspaper in Virginia City, Nevada. Contributors to the paper were Mark Twain, Bret Harte, Sam Davies, and Arthur McEwen. Goodman visited Eisen at his home and encountered him poring over small photographs and drawings of Quiriguá and Copán stela. Eisen commented on the fact that the glyphs could never be read because the key to deciphering them was lost. Even though there had been widespread study for over fifty years, not much progress had been made. Goodman recorded the following conversation:

E. What a pity the glyphs can never be read!
J. T. Not at all. If they have not been read it is because students have not gone about the work the right way. I'm a believer in the proposition that human ingenuity can contrive nothing which human intelligence cannot unravel. I could read them if I tried.
E. Will you try?
J. T. Yes.[30]

Goodman thought it would be a diversion from the monotony of rural life, nothing more. He had a large house where he set aside a special room for Maya studies. Eisen installed his papers, drawings, and other reference materials. The two men began a manuscript entitled *The Archaic Writing of the Mayas. Their Hieroglyphs and Sculptures.* It was an ambitious collaboration that lasted for twelve years. After four years of study, Goodman telegraphed Eisen, who was away from Fresno, that the glyphs constituted a calendar. Eisen suggested that Goodman inform Alfred P. Maudslay of his findings. Maudslay invited Goodman to London, and they worked together for about a year.[31] Maudslay wanted the chronological tables put on record as a point of reference in the forthcoming *Biología Centrali-Americána* (Maudslay 1889–1902). Although Eisen's and Goodman's manuscript was never completed, Goodman alluded to it in the

preface to "The Archaic Maya Inscriptions" in the monumental
Biología Centrali-Americána. Writing about his contribution to this
larger publication on the archaeology of Central America, Goodman
stated that it was an incomplete subdivision of a much larger work
and the outgrowth of years of patient toil:

> The foregoing statement is made less in excuse of the imperfection of
> this book [Goodman's chapter] than to afford opportunity for doing
> justice to Dr. Gustav Eisen of San Francisco, the absence of whose name
> in conjunction with mine on the title page will be a source of surprise
> to many of his friends. He was the first to direct my attention to the
> Maya inscriptions. For twelve years he has been intimately associated
> with me in the study of them, collecting most of the material I have
> had to work upon, and encouraging me to persist at the times I grew
> most faint-hearted and ready to give up the apparently hopeless task.
> He has completed a series of careful drawings in which the glyphs are
> arranged in accordance with a plan of his own, and has in preparation
> an elaborate monograph on the Maya civilization [the manuscript
> submitted to the Smithsonian] and much other cognate matter—all
> of which will constitute an important feature of the complete volume
> we have in view, but would be quite aside from the purpose of this
> preliminary issue. (Ibid., p. iii).

Although Eisen's own Maya research was never published, his
influence on Goodman, which led to the discovery of the Maya
calendrical system, should be considered as one of his "principal
achievements."

THE LATER YEARS

PHOEBE APPERSON HEARST

After the second expedition to Guatemala (1902), which resulted
in the Eisen Guatemalan textile collection, Eisen returned to San
Francisco. No longer formally associated with the Academy or
involved with horticultural experiments in Fresno, he became a
professional photographer. His letterhead read "Bruguiere and Eisen.
Portrait Photographers. 1808 Franklin St., San Francisco."[32] In
addition, Eisen became president of the San Francisco Microscopical
Society and even invented a light filter arrangement for microscopy
that used ultraviolet light.

Eisen was frequently invited to lecture about his Guatemalan
trip. He illustrated his talk with glass slide projections. Two articles
he wrote about Guatemala were published in 1903. "The Earthquake
and Volcanic Eruption in Guatemala in 1902" (1903a) discussed the
eruption of the Santa María volcano. Eisen had been in Huehue-
tenango at the time and had traveled immediately to Quezaltenango
to observe firsthand the effects of this disaster. The other article,
"Notes during a Journey in Guatemala, March to December 1902"
(1903b), focused on the climatic conditions, rainfall, temperature, and
electric storms accompanied by circular lightning. Always conscious
of the landscape, Eisen noted ecological changes that had occurred

since his first visit in 1882. Although he did not write a narrative similar to the travel articles of 1883, Eisen described parts of his trip in a short article, "The 'Cofradia' of the Indians of Guatemala." (1903c).[33]

Upon his return from Guatemala, Eisen joined the social circle that surrounded Phoebe Apperson Hearst, a generous philanthropist and the sponsor of Eisen's 1902 Guatemalan expedition.[34] Other Swedish-Americans in the circle included Dr. and Mrs. Oscar Lindström, who directed the Swedish Medical Gymnastic Institute, and Carl Oscar Borg, a talented painter who enjoyed Phoebe Hearst's patronage.[35] Eisen sent to her trees and grapes for her garden and, upon her request, his account of the Indians of the Santa Barbara Islands. On one occasion, Eisen invited her to the opening of an exhibition of his photographs, which included many images from his Guatemalan trip.[36] An extremely generous woman, Phoebe Hearst partially supported various artists and scholars by encouraging lengthy stays at her ranch, funding expeditions and foreign travel, and providing letters of credit. She first sponsored Eisen's travels abroad in 1903–1904 and 1905–1906. He visited Spain and Morocco, among other countries, to collect folk tales about the Moors and the history of the Alhambra. Eisen was now in his late fifties and, because of his dismissal from his position at the Academy, was investigating other career possibilities. An experienced journalist and scientific writer, he hoped that his writing might provide some income.[37] Eisen documented his travels with photographs and long descriptive letters to Mrs. Hearst.[38]

While abroad, Eisen returned to Stockholm and visited Strindberg on two occasions, in 1904 and 1908. On each visit Eisen tried to persuade Strindberg to visit California, for Strindberg was fascinated by Eisen's descriptions of the people, the life, and the landscape. On the second visit Strindberg decided to accompany Eisen to California. Strindberg thought he would stay only a year and would write a new book there. A few days before their departure, Eisen visited him. Before he entered the apartment, Strindberg shouted to him: "I'm not going! My destiny has warned me. It said 'Don't go.' " On his walk, Strindberg had seen a torn piece of a poster on which he read the words "Do not go." Coincidentally Eisen had noticed the same poster, which actually read, "Do not go to the country before buying your luggage at . . ." (Meyer 1985:512–513).[39]

At this time of his life, Eisen was a formidable figure physically and intellectually (Figure 31). Phoebe Hearst selected him as an appropriate traveling companion for Carl Borg, thirty years his junior. Phoebe wanted Eisen to tutor Borg in archaeology, ancient history, and world religion. They traveled together and separately from 1910 to 1915 under her sponsorship, and a firm and enduring friendship developed between them. They arrived in Gibraltar in 1910 with cameras over their shoulders and Borg with his sketchbook. They then made their way to southern Spain and to the Alhambra. Eisen went on to Rome, where he remained for some time, while Borg opted for Paris. Eisen began art historical studies focusing on Greco-Roman archaeology, antique beads, glass, pottery, and early Christian art.

Figure 31.
Gustavus A. Eisen, 1902. Special Collections, California Academy of Sciences, San Francisco.

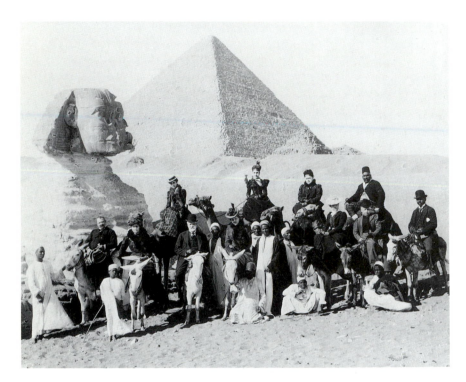

Figure 32.
Phoebe Apperson Hearst in Egypt with the
Reisner expedition (second from left, back row).
The Hearst Museum of Anthropology, University
of California at Berkeley.

In January 1911, these studies were interrupted by an
unexpected invitation from Phoebe Hearst to visit Egypt. She was
sponsoring a University of California expedition to Egypt, which was
headed by Dr. George A. Reisner, a Harvard professor. The purpose
behind the Egyptian excavations was to acquire material for the new
museum of anthropology to be established at the University of
California at Berkeley. Phoebe Hearst had visited Egypt and thought
that Borg and Eisen should travel there and observe the excavations
(Figure 32). She sent them a letter of credit and a letter of introduc-
tion to Reisner. Eisen and Borg stayed in Egypt for a month. Eisen
took six hundred photographs and collected folk tales while Borg
painted watercolors. Borg returned to Paris and Eisen to Rome.
Shortly after his return, Eisen wrote to a former colleague and close
friend at the Academy, Alice Eastwood, and complained about the
self-focused and indulgent nature of the Romans. He wondered if
perhaps he should return home.[40] Publishing problems made Eisen
question his writing efforts: "And I have frequently asked myself:
why write more, if nothing can be published."[41]

In the summer of 1913, for reasons that are unknown, Mrs.
Hearst discontinued her patronage of Eisen. In a long, sad, and bitter
letter asking for her help in finding him a job, he concluded: "How
can I start over at 66? Maybe I can start a postcard business."[42]

NEW YORK CITY

Figure 33.
Gustavus A. Eisen, 1930s. Special Collections,
California Academy of Sciences, San Francisco.

In 1915 Eisen arrived in New York City to start over. His reactions are reminiscent of those experienced by Claude Lévi-Strauss who, in 1941, saw the city as an anthropologist's dream, a vast selection of human culture and history in which "the anthropologist is bewildered and delighted by a landscape of unexpected juxtaposition" (Clifford 1988:237). For Eisen, American opportunity combined with Old World learning appeared in the form of a silver chalice that he saw in the window of Syrian art dealer Fahim Kouchakji's shop on Fifth Avenue. The meeting and ensuing relationship with Kouchakji and his wife, Evelyn, which lasted for the next twenty-five years, were pivotal for Eisen's life in New York. It was Kouchakji who presented an exhibition at his galleries of Eisen's art photographs from Egypt, Italy, and Spain. The silver chalice belonged to Kouchakji, who made it available to Eisen for analysis.

These years were profitable ones in terms of publications. Three of his "principal achievements" appeared: "The monumental work on the Great Chalice of Antioch (1st century A.D.). price $150, 2 vols; Monograph on Antique glass. 2 vols—$100 copy; Monograph on the portraits of Washington. 2 vols price $100." At eighty-five, Eisen began to study Babylonian seals and learned to read cuneiform characters and inscriptions. In 1935 he was honored by the Swedish government with the title of Commander in the Order of the North Star (Figure 33).

Eisen lived frugally and alone in the Bronx. Daily companions in Central Park were the squirrels whom he fed and named. In letters to Alice Eastwood, he expressed his feelings: "I know a little of everything and perhaps not enough of one thing to do me any good," and "It is a great privilege to be poor but able, and enjoying to talk."[43] A major occupation of his last years was proving his claims regarding his roles in the California raisin industry and fig caprification and in saving the giant sequoias. Eisen thought that he had been ignored by the Sierra Club and the California Horticultural Commission. His nephew, Albert Eisen, who lived in Sweden, was contacted by the *Svenskt Biografiskt Lexikon* (1949), which was preparing an entry on Eisen. Albert needed more information and exact dates concerning Eisen's activities in the United States. Alice Eastwood assisted by sending to Eisen his lecture notes and photostatic copies of the documents related to Sequoia National Park that Eisen had prepared for the Academy. Upon his ninetieth birthday, the chief of the U.S. Park Service in Washington, D.C., sent him a congratulatory letter in which he stated that Eisen's claim of having been the one to originate and establish the Sequoia National Park was clear-cut and indisputable. The chief understood that Eisen "started the ball rolling of saving national forests, that the Sequoia Park was the Second National Park in America and due to your 'foresight.' "[44]

In 1941, a year after Eisen's death, the U.S. Board on Geographical Names approved the Academy's request to have a mountain peak in Sequoia National Park named after Dr. Gustavus A.

Eisen. F. M. MacFarland, president of the Academy, communicated the news to Dr. Robert C. Miller, who was director of the Natural History Museum and the Steinhart Aquarium associated with the Academy: "[Mount Eisen] forms a lasting memorial to the pioneer conservationist and enthusiastic leader of the Academy in its fight to secure the establishment of the Sequoia National Park, and to preserve its wonderful forests."[45]

THE MAYA AGAIN

In 1938 Eisen moved into the Kouchakji's apartment. He had broken his leg in a car accident. Subsequently he underwent an operation for a cancerous tumor in his armpit. Still he continued his studies and correspondence. A Guatemalan medical researcher and Mayanist, Erwin Paul Dieseldorff, read one of Eisen's letters to Edward Gifford, then curator of the Museum of Anthropology, University of California, Berkeley. Dieseldorff knew of Eisen's relationship with J. T. Goodman and Eisen's interest in the Maya. He wrote to him:[46]

> So many old Maya researchers have joined the majority and are sitting perhaps with the Maya Chiefs in Heaven and smiling down on us. May I suggest that you will set down all about the great Maya talent J. T. Goodman on paper, in order to preserve it for History? You are the source, as Goodman confesses, how he came to take Maya research seriously and how you encouraged him to continue. . . . These things may become of importance in the future when the History of Mayan research will be written. It is undoubtedly of great value, as Maya research will command more and more attention being the only source from which one is able to gather the religion, the direction of thought, yes, even the History of the Mayan races. The foundation[s] of American Archaeology are the Mayan dates which Goodman worked on.[47]

In a series of letters, Eisen responded to Dieseldorff's questions. At age ninety-two he felt the vagaries of advanced years:

> That their [Maya] secrets have been revealed is to me the greatest marvel of all scientific results attained in my period of life. . . . I keenly recall the date, when, in July 1882, [I] started with 2 indians on my foot wandering which took me first to Santa Lucía Cotzumalguapa where I copied all the stone at the time found on the surface. . . . My greatest pleasure now in my extreme old age and "2nd childhood" is to know that the great mystery is solved, and *the one* who solved it finally. . . . I wonder why the Maya calendar and the kingdom as a whole ended about 1000 years before the Spaniards came. Epidemic? Climatic changes? . . . The two years I spent in Guatemala, 1882, 1902, were the happiest in my life. Wish I had remained.[48]

Eisen died on October 29, 1940, of cancer. He was cremated and his ashes were placed in a bronze Greek urn. The urn was taken to California where the ashes were interred on Mount Eisen in Sequoia National Park.

The Late Nineteenth-Century Guatemalan Maya in Historical Context: Past and Future Research

Christopher H. Lutz,
Plumsock Mesoamerican Studies

The Eisen textile collection provides a rich and unique view of Guatemalan Maya material culture of the late nineteenth century. Thanks largely to such foreign travelers to Guatemala as Gustav Eisen and Anne Cary and Alfred Percival Maudslay, we know more about Indian weaving of the period than we do about Indian pottery, household furnishings, or even domestic architecture.[1] Yet in and of themselves, the Eisen textiles are simply precious objects. Like a pre-Hispanic Maya vase pillaged from an ancient burial site, they are little more than sources of wonder and beauty when seen outside their cultural-historical context. How much deeper is our appreciation of the Maya textile when we know something of the culture that produced it. And how much deeper is our understanding of that culture when we begin to discern the broad outlines of the Maya past.

UPDATING OLIVER LA FARGE

First to guide the way was the U.S. ethnologist Oliver La Farge, who in 1940 devised a "sequence of cultures" to help delineate four centuries of Maya evolution from the time of the Spanish conquest of Guatemala in 1524.[2] Lacking important historical data but neither daring nor wisdom, La Farge remains a seminal figure for contemporary scholars of Guatemala despite new findings that refute his analysis. While others devoted their attention to the conquerer, La Farge focused his on the conquered.

La Farge's first stage, beginning with the Spanish conquest and lasting until 1600, was marked by the ruthless destruction of Maya culture by the invader. Unknown to La Farge was evidence, unearthed by scholars at the University of California at Berkeley within a decade, showing that the conquistador onslaught was nothing as compared with the Spanish-borne epidemics that felled over 80 percent of the indigenous people of Guatemala by 1600.[3]

Maya life during the colonial period (La Farge's second stage, 1600–1720) was dominated by the institutions of *encomienda*, which required Indian towns to pay tribute to Spanish colonists, and *repartimiento de indios*, an onerous forced-labor system under which Indians, at below-subsistence wages, performed duties ranging from cleaning latrines to cultivating wheat to carrying huge bundles of firewood on their backs. La Farge speculated correctly that "during this period Spanish and Christian elements were absorbed wholesale and somewhat altered; many Mayan elements were destroyed or mutilated, others greatly changed."[4] His blind spot was in assuming that Spanish legislation ending *encomienda* and *repartimiento* obligations in Mexico in 1720 also unburdened Guatemala's Maya. Not until a century later, in fact, would the yoke of tribute and labor obligations in Guatemala be lifted.[5]

Whereas La Farge saw a "slow relaxation of Spanish control" over Guatemala's Maya in the eighteenth century (his third stage covers the 1720–1800 period), it appears instead that the Bourbon monarchy imposed greater centralization. In the parishes of Guatemala, the Crown tried to replace the Dominican, Franciscan, and Mercedarian friars with secular priests. Successfully resisted by the regular orders in the western (Indian) highlands,[6] secularization took hold more quickly, beginning in the 1750s, around the capital and the surrounding highland valleys.[7] While the Church's assimilationist calls for Indians to "forget their languages, and only speak Spanish" went unheeded,[8] the ecclesiastical hierarchy wrested control of community and church funds from the regular orders as the Bourbon civil bureaucracy began to take control of local affairs.[9]

At the same time, Indian tribute came to be collected more in coin than in agricultural produce, forcing Indians to seek employment for cash. Thus debt peonage increased as the peasants' relative autonomy declined. Most ominous for the future—especially the late nineteenth and early twentieth centuries—Indian communal lands in lower-lying areas of indigo production (from the *xiquilite* plant) were seized by colonists eager to profit from this valuable export crop.[10] Had such data been available to him, La Farge most likely would not have suggested that "both Mayan and Spanish-Christian elements" were integrated "into a new pattern within which the Indian is comfortable with the resulting development of entirely or partly new forms."[11]

Laboring by now under successive misconceptions (as any pioneering theoretician is apt to do), La Farge said of the 1800–1880 period that "the integration becomes a smooth blend; well stabilized, it has the individuality and roundness that mark any culture, and its continued evolution is in the form of growth out of itself, rather than in response to alien pressures."[12] He gave scant attention to the independence Guatemala and its Maya inhabitants won from Spain in the early 1820s, in sharp contrast to the historian Miles Wortman, who notes with some irony that independence, rather than having an ameliorative effect, robbed the Maya of their two "greatest champions"—Church and Crown—and stripped the Indian pueblo of its meager power. To Wortman, independence meant that the Creole (New World–born Spanish descendant) "became colonial ruler of the Indian" and Indian "common lands could be invaded and abusive labor systems could develop without fear of state intervention."[13]

Not until 1880—the start of the fifth and final stage in his cultural sequence and three years after the promulgation of Liberal government land laws—does La Farge finally acknowledge the existence of a powerful and destabilizing "new tide of intervention in Indian life." "Much gentler than the conquest," this intervention was marked not by epidemiological or military assault but by what La Farge called the invasion of the "Machine Age and Spanish-American cultures."[14] Far from beginning during this period, as La Farge contended, "conflict and acculturation" quickened as economic opportunities for Guatemala's Spanish Creole elite and *ladinos* emerged in response to consumer demand for Guatemalan

agricultural exports in Western Europe and, later, throughout the North Atlantic.[15] The result for Guatemala's indigenous majority population was always burdensome and often catastrophic.

CORE AND PERIPHERY IN THE COLONIAL PERIOD

Murdo MacLeod has ably described the booms and busts of Guatemala's first two colonial centuries while others have begun to flesh out developments in the late colonial and early national periods.[16] MacLeod has also provided students of the colonial period with a useful model based on the country's division into an Indian west and a *ladino* east. More recently, inspired by his model and Carol Smith's work on the western highlands, George Lovell and I have examined Indian-Spanish relations in colonial Guatemala within the context of a cleft between a developed Spanish-*ladino* core and an underdeveloped Indian periphery.[17]

The core comprised all lands (highland and lowland) east and south of the long-time colonial capital of Santiago (known as Antigua Guatemala after establishment in the mid-1770s of a new capital, present-day Guatemala City). The periphery comprised lands west and north of Santiago (excluding those now part of the departments of Sacatepéquez and Chimaltenango, which formed a part of the Valley of Guatemala and provided most of the colonial capital's grain and labor) (Figure 34).

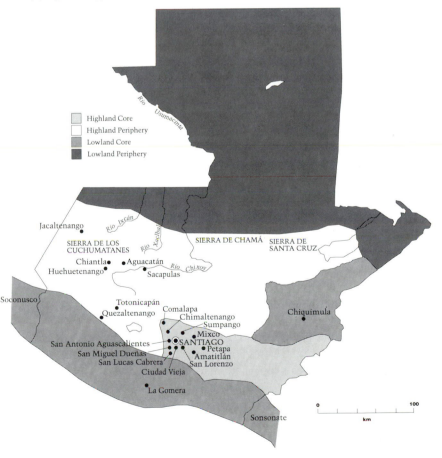

Figure 34.
Core and periphery in Colonial Guatemala. From Christopher H. Lutz and W. George Lovell, "Core and Periphery in Colonial Guatemala," in Carol A. Smith, editor, *Guatemalan Indians and the State: 1540–1988.* Austin. University of Texas Press, 1990, p. 37.

Due to a series of ecological, geological, climatological, and cultural factors, Spaniards, with their African slaves and *casta* (persons of mixed Spanish, Indian, and African descent) dependents in tow, were drawn to the lower and warmer highlands of the Valley of Guatemala, as well as to the Pacific coastal plain, lower eastern highlands, and eastern lowlands. Except in the highland core, where over seventy Indian communities (including urban barrios and some sixty pueblos) were situated, the primary attraction to these areas was not Indian labor, for Old World tropical diseases took their biggest toll here. It was, rather, the rich lands where sugarcane, grain, and tobacco could be grown, Indian cacao production commandeered, cattle raised, and indigo produced. Adding to Indian woes were difficult-to-measure population pressures imposed by the establishment of Spanish and *ladino* rancherias, haciendas, *ingenios de azúcar* (sugar estates), and *obrajes de tinte añil* (indigo dye works). Combined with Spanish and *ladino* settlement in Indian towns, interference in local and regional Indian trade, and race mixture (both in and out of wedlock), such pressures helped reduce the Indian population to a few scattered enclaves among a *ladino* majority by the end of the colonial period.[18]

The economic opportunities that attracted large numbers of Spaniards (and their African and mulatto slaves, plus free and dependent *castas*) to the core area were largely absent in the vast Indian highland periphery west and north of Santiago. Aside from occasional pockets of Spanish mining and ranching activity, Spanish- or *ladino*-controlled institutions designed to exploit the area's natural or human resources were few here.[19] Had gold or silver (or some other precious resource) been as plentiful in the mountainous Indian periphery as it was elsewhere in the Spanish-American empire, the western highlands would surely have suffered a different fate.

The Valley of Guatemala (the western section of the highland core) was a transitional area between lowland core and highland periphery. The presence of Spanish landholdings—wheat farms in the higher areas and Church- and privately owned sugar estates in the lower valleys—spurred Hispanicization and raised levels of Spanish-*ladino* intervention in Indian daily life, but the tropical diseases that decimated the Indian population of the lowland core generally spared the Kaqchikel and Poqomam speakers of the Valley of Guatemala.[20] Thus, while a number of Indian towns here were weakened numerically and economically, others survived and even prospered. Indians probably remained in the majority in the highland core longer (perhaps even into the nineteenth century) than they did in either the Pacific coastal plain or eastern lowlands, but their numerical dominance was greatest on the western and northern periphery, as it is today.[21]

The key variable, MacLeod concludes, is altitude. Reluctant to settle permanently in the colder, higher regions of Guatemala, Spaniards usually left lands over 5,000 feet above sea level under Indian control.[22] As a result, the western highlands remained part of the Indian periphery despite the influence of a number of Spanish friars and an even smaller, but still irksome, group of petty and

midlevel Spanish officials. Responsible for tribute collection and other administrative duties, these officials profited from the extralegal *reparto de efectos*,[23] a device whereby Indians were forced to buy such items as axes, farm implements, and mules at grossly inflated prices or to work for a pittance, say, cleaning cotton, spinning it into thread, weaving cloth, or sewing and embroidering a variety of garments for the market economy. Both Guatemalan and Spanish archives reveal that Spanish officials accepted *huipiles* and other items of clothing as tribute, putting them up for sale in the Guatemalan capital[24]—probably alongside the very *reparto* textiles they had "commissioned."

The Indian periphery, in sum, was characterized by a tributary or extractive economy that resulted from a lack of attractive exploitable resources for Spaniards and *ladinos*. Indian towns and culture, consequently, remained stronger and more intact in this region than anywhere else in Guatemala. It is no small irony that work and tribute obligations, at least those affecting textile production, encouraged and sustained Maya material culture in the periphery. Nor is it coincidental that Eisen purchased most of his textiles here.[25]

CORE AND PERIPHERY AFTER INDEPENDENCE

The core-periphery dichotomy underwent no significant production or territorial changes in the decades following independence. Lowland grain, cattle, cotton, sugar, and tobacco production continued unimpeded.[26] Only lowland indigo production suffered disruptions and declines, due to military conflict between Guatemala and El Salvador (beginning in 1827) and new competition from Bengal, India.

The highland core areas around Antigua and Amatitlán saw perhaps the greatest change. Here (and in pockets of eastern Guatemala) cochineal production was initiated around 1815 and quickly expanded when, with the breakup of the Central American Republic and the fall of the Liberals in 1840 after years of war and disease, Guatemala's Conservatives could no longer count on revenues from Salvadorean indigo. Cochineal—an insect raised on the prickly pear or nopal cactus, then harvested and processed as dye—was the highland core's first major export. Produced on many small and medium-sized nopal plantations (some of the small ones, in San Antonio Aguas Calientes, were owned by Indians; *ladinos* or whites ran the rest), cochineal was most profitable for the large white producers and merchants, who contracted for the harvests of the smaller growers.[27] Production depended on both free-labor and debt peonage arrangements with local Indian and *ladino* peasants, on whom growers imposed *mandamientos* (forced-labor drafts) whenever labor was in short supply.[28]

Cochineal production expanded (and ultimately peaked) under Rafael Carrera, the mestizo peasant guerrilla leader who led the Conservative overthrow of the early postindependence Liberal regime and reimposed the authority of the Church and landed oligarchy. To

this day controversy surrounds him and his thirty-year dictatorship. Scorned by establishment historians of the subsequent Liberal period (1871–1944), Carrera is now viewed more favorably by a number of Guatemalan and North American scholars, in part for improving the status of the Indian majority.[29]

Noting that "the [Guatemalan] army became nearly an Indian institution" under Carrera, one such revisionist, E. Bradford Burns, argues that the Guatemalan government was thus "Indianized."[30] Yet Burns also finds that Carrera "opened the political door for the Ladinos, who eventually dominated the government and economy." This contradiction aside, one wonders how using Indians as foot soldiers (while granting high commissions to *ladinos*) Indianizes a government or necessarily benefits Indians.[31] Burns, furthermore, refers to the Indians as the "once-conquered race"; here the happy (but erroneous) implication is that Indians under Carrera were no longer conquered or, by extension, oppressed or mistreated.[32] Finally, Burns claims that by reducing taxes, Carrera took the pressure off Indians to work on Creole-owned agricultural estates.[33] While this may have been true during the final years of cochineal production, the historian J. C. Cambranes has found persuasive evidence that coffee cultivation, begun under Carrera, had a profoundly negative impact on the Maya.[34]

Coffee cultivation expanded soon after the discovery of aniline dyes in Germany reduced demand for cochineal.[35] Coffee groves replaced nopal plantings, especially in the Valley of Antigua and around Guatemala City.[36] Some new lands were brought into coffee production in the 1850s and 1860s, from the *boca costa* in the south to Alta Verapaz in the northeast.[37] While coffee cultivation was less labor intensive than cochineal production, Cambranes has determined that the forced mobilization of the Maya for coffee planting, growing, and harvesting was both brutal and widespread under Carrera.[38]

Carrera nevertheless benefits from the revisionist comparison between his treatment of Indians during the peak cochineal years and the Indian policies of Justo Rufino Barrios and his Liberal successors during the coffee boom a few decades later. The disparity in labor and socioeconomic conditions renders the comparison useless and misleading.

THE LIBERAL REVOLUTION

Not until the accession of the Liberals under Justo Rufino Barrios (1873–1885) was the core-periphery dichotomy shattered. Maya lands, heretofore only lightly exploited for export production (except those from which Indians were sent as slaves in the early sixteenth century to the distant reaches of the Spanish-American empire), were thrown open to a rapacious coffee industry.[39] For the first time, export-crop cultivation dominated the fringe areas of the highland periphery and *boca costa*, largely because coffee, while often considered a lowland crop, could be raised with even better results

(and profits) in the lower highland valleys (Antigua, for example), at lower elevations in the rich volcanic soils of the Pacific piedmont, and in Alta and Baja Verapaz.[40] (Coffee was unsuited only to the *tierra caliente* [hot lowlands] and upper highlands of Guatemala.)

With the Liberal Revolution came new land laws permitting the expropriation of Indian communal lands in the Pacific piedmont and highland valleys. Historian David McCreery's preliminary conclusion—entirely consistent with evidence that the highland periphery was then lightly populated, relative to either the preconquest period or the present day[41]—is that Indian towns holding lands in the piedmont and highland valleys did not depend on them for their subsistence crops of maize and beans; instead, "highland residents traditionally had used [them] to supplement their 'cold' country [lands]."[42] It is therefore unlikely that inhabitants of the affected towns needed their communal lands for survival.

One can argue, however, that much of this land was fallow and thus only appeared unused to those who seized it. Since for centuries the Maya had hunted game and gathered food here, one can also argue that they intended to preserve it in its current state, or perhaps to turn it over to subsistence farming when Indian population pressures made that necessary. Unfortunately, such arguments were lost on *ladinos* and whites eager to grab a share of coffee profits. Emboldened by the power and authority of what Cambranes calls the Coffee State ("Estado cafetalero"), they aggressively turned lands declared *baldía* (vacant and, by extension, public) into coffee groves.[43] While this seemed perfectly natural to the new government and the late nineteenth-century elites—Indian towns, after all, lacked formal title to their lands[44]—the unrepresented Maya majority lost large amounts of their ancestral patrimony. Short of an agrarian revolution to turn the clock back a century or more, they continue to be without any means of recuperating their land.

Although the majority of highland Indian towns were apparently spared major territorial dislocations, this hardly diminishes the impact of such radical change on the many towns that lost land to the coffee monster, which by 1900 had gobbled up large areas of the highland periphery (Figure 35). Beyond areas affected directly by the coffee boom, large amounts of Indian-owned lands in both the highland periphery and the northern lowland periphery (Figure 34) were deemed *baldía*, then titled by *ladinos*. Even in *tierra caliente*, Indians who traditionally raised subsistence crops on ancestral lands were forced to choose between entering into sharecropping arrangements with *ladino* landlords (often absentee) or farming illegally.[45]

Suffice it to say that virtually all regions of Indian Guatemala felt the impact of Liberal agrarian policy. Even the highlands, largely untouched by land losses, were nevertheless affected by the state-run mobilization of coffee *finca* (plantation) labor. McCreery has calculated that by the 1880s "at least one hundred thousand" highland workers migrated to the *boca costa* coffee *fincas* each year (Figure 36).[46] Lest one think this figure insignificant, it represents roughly one in twelve Guatemalans, one in eight Indians, and perhaps

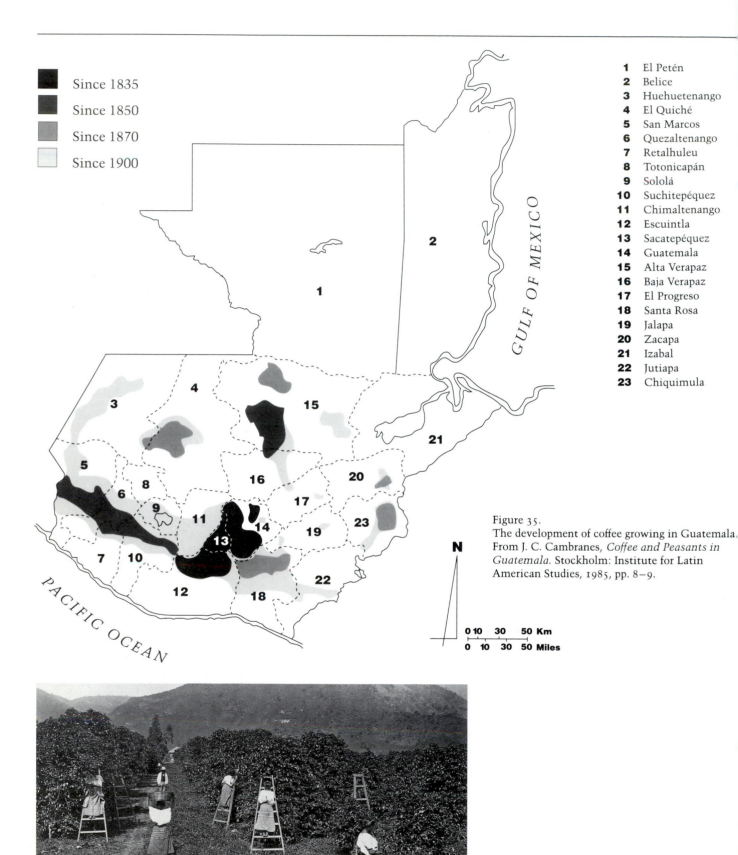

Since 1835
Since 1850
Since 1870
Since 1900

1 El Petén
2 Belice
3 Huehuetenango
4 El Quiché
5 San Marcos
6 Quezaltenango
7 Retalhuleu
8 Totonicapán
9 Sololá
10 Suchitepéquez
11 Chimaltenango
12 Escuintla
13 Sacatepéquez
14 Guatemala
15 Alta Verapaz
16 Baja Verapaz
17 El Progreso
18 Santa Rosa
19 Jalapa
20 Zacapa
21 Izabal
22 Jutiapa
23 Chiquimula

GULF OF MEXICO

PACIFIC OCEAN

N

0 10 30 50 Km
0 10 30 50 Miles

Figure 35.
The development of coffee growing in Guatemala.
From J. C. Cambranes, *Coffee and Peasants in
Guatemala.* Stockholm: Institute for Latin
American Studies, 1985, pp. 8–9.

Figure 36.
Coffee picking on a coffee plantation. Photo by
Eadweard J. Muybridge. Boston Athenaeum. 1875.

as many as one in five highland Indians.[47] Dislocation, it is clear, entailed human and territorial losses that are difficult to calculate but that left their mark indelibly.

NEW APPROACHES

Not until the early 1970s did Guatemalan and foreign scholars even begin the first detailed, monographic work on the Maya of the late nineteenth century.[48] Accordingly, while the exploitation of indigenous labor, Indian debt servitude (achieved under the threat of forced recruitment and outright *mandamientos*), and Indian land loss have started to receive scholarly attention,[49] many subjects relating to the Maya of this period remain untouched, *tierra incognita.*

Most needed now is research into Maya daily life at the turn of the century, a difficult task, but one that has produced inspired and stimulating results, not so much by historians, but by anthropologists. Especially valuable, and deserving of more attention as models for future historical research, are Carol Smith's work on market systems and the impact of the coffee boom on their development, and Robert M. Carmack's archive-based work on the K'iche'.[50] Carmack is in addition now finishing a study on the K'iche' *municipio* (township) of Santiago Momostenango from preconquest times to the recent past; a work of major scope and importance, it will demonstrate the kind of local research that can be carried out to reconstruct the history of a major Indian town.

Another anthropologist, John Swetnam, recently wrote a thought-provoking study examining, from the Indian perspective, alternatives to labor migration.[51] His is a strong theoretical work that pays special attention to the findings of early ethnologies and other published sources. By asking some of the questions and testing the hypotheses of these and other scholars, we historians can greatly expand our knowledge and understanding of Indian life late in the nineteenth century.[52]

The data to analyze Indian life are ample, despite assertions that such evidence is trivial or unimportant. The Liberal accession, which brought better communication and transportation to Guatemala, also brought tighter administrative procedures and better record keeping. Civil registers for births, deaths, and marriages were introduced to supplement Church parish records.[53] Land titles and litigation, byproducts of strictly enforced land legislation, fill various archives. The sheer quantity and relative disorganization (compared with indexed archives for the colonial period) of available material make the historian's task both a joy and a nightmare.[54]

Travel accounts (and other descriptions by non-Indians), published and unpublished, have indeed been used by historians but can be more carefully gleaned for insights into nineteenth-century Indian society.[55] One such account from the early Barrios period—that of José María Navarro, parish priest of San Miguel Dueñas[56]—illustrates this point with a wealth of information about late nineteenth-century Indian life; other details may of course never

be retrieved, while still others will turn up only through painstaking archival research.

The Parish of San Miguel Dueñas comprised six towns or pueblos, including San Antonio Aguas Calientes, famous for its backstrap weaving. Atypical of most highland Indian towns—if indeed a "typical" town existed—these small communities shared many characteristics with each other.[57] All were located southwest of Antigua beneath the nearly conical Agua volcano, the violent Fuego volcano, and its dormant twin peak, Acatenango. The majority remained overwhelmingly Indian in population and culture in the latter decades of the nineteenth century, though each sat squarely in the original Spanish highland core. Each was governed by a *cabildo* (council) that met in a public building (also called a *cabildo*) situated on the town's central plaza.[58] Attached to the *cabildo* were several jail cells for holding those accused of criminal acts, most often drunk-and-disorderly conduct.

Separate schoolrooms for Indian boys and girls were either annexed to the *cabildo* building or built nearby. Rural schools were generally poorly equipped, understaffed, and capable of teaching little more than the three Rs in Spanish. For a variety of reasons—teacher bigotry and absenteeism; Indian distrust, indifference, and labor obligations—attendance was poor. If every eligible child had attended school regularly, the classrooms provided would have been filled to overflowing. In San Antonio, Navarro suggested, the girls were lucky to have a "woman teacher . . . skillful in sewing, embroidery and branches of education of the fair sex."

Each town built a small church on its central plaza; Dueñas, the parish center, also provided a rectory for the parish priest. *Cofradías* (religious lay sodalities) were active throughout the parish—two each in the smallest communities; six and seven, respectively, in the largest, San Antonio and Dueñas. It is not inconceivable that Navarro listed the *cofradías* without further comment because they diluted his authority and influence, if indeed he still enjoyed much of either.

That three of the seven *cofradías* in Dueñas were *ladino* fits the town's population profile, 53 percent Indian and 47 percent *ladino*. Navarro thought that all of the parish's remaining towns were predominantly Indian except San Lorenzo El Cubo, whose proximity to the *ladino* centers of Ciudad Vieja and Antigua accounted for its large *ladino* population and, in the opinion of the padre, for its "vicious" inhabitants.[59] Navarro noted that San Lorenzo resembled the other towns of his parish, "with the difference that [its people] very much like Ladino dress and the Castilian language." Using the criteria of many mid-twentieth-century anthropological writings on Guatemala, one could thus reason that San Lorenzo was gradually "ladinoizing"; recent Maya writing on the subject suggests, however, that adopting aspects of Western culture (in effect "modernizing") does not necessarily result in a loss of Maya identity.[60]

As persons familiar with these towns today might expect, Navarro focused on San Antonio (and, to a lesser degree, San Lorenzo) in discussing textile production and local dress. Given a late twentieth-century emphasis on the San Antonio *huipil*, it is

noteworthy that Navarro paid greater attention to male dress there than he did to women's apparel.[61] Clearly Indian housing interested him more. In Dueñas, for example, where *ladinos* accounted for nearly half the population, the padre wrote that 327 of 369 houses were of "Indian-type construction," 34 had adobe walls and thatch roofs, and only 8 were of adobe with tile roofs. Such numerical evidence suggests that, while ladinoization may have been a factor in the parish seat, gentrification was not. Indian houses in the other parish towns, Navarro observed, were made of cane walls with thatch roofs (the Indian construction referred to above) and set back from the street; walls of plantings marked lot boundaries, both on the street and between neighbors at the rear and on either side.

While Navarro called the Indian custom of sleeping on the ground a *pésima costumbre* (bad habit), he failed to mention that Indians generally used locally woven *petates* (mats) to protect themselves from the cold, hard ground. The padre supplied abundant evidence of a widespread thyroid condition (goiters), of malaria in the parish towns by the shore of a shallow lake, and of a variety of other diseases. As for the Maya medical beliefs and folk practices designed to combat such afflictions, it is obvious that the priest put his faith elsewhere.

Given his apparent proclivity for data gathering and the predominantly agricultural nature of the pueblos to which he ministered, it is not surprising that Navarro supplied detailed information about the size of each town's public lands and the amounts of land dedicated to each crop, as well as the number of pigs, beehives, and beasts of burden in each town. What *is* surprising is that our informant barely mentioned local coffee estates, a possible oversight but more likely a sign that in the mid-1870s coffee producers had yet to make their presence felt in his parish. By 1890, small Indian coffee producers abounded in all of the parish towns except Dueñas, where *ladino finqueros* controlled most of the land and coffee groves.[62]

Navarro's description is marvelously comprehensive in some respects but frustratingly limited in others, particularly in the subjects a historian or ethnohistorian would find most useful and interesting—religious practices, socioeconomic activities, and labor relations with *ladino finca* owners, to name a few. It is in this latter sense typical of both other travel accounts (including those by visiting Europeans and North Americans) and the rarer and more unyielding archival resources now being explored by a handful of foreign and national scholars.[63]

Yet it is precisely from such documents that persistent ethnohistorians can reconstruct the daily lives of Guatemala's late nineteenth-century Indian population—their work, trade, migratory habits, social conditions, and material culture. These reconstructions can enrich and, reciprocally, be enriched by the more careful study and contextualization of Indian textiles of the period. Similarly, photographic records, when combined with written archival records and the Indian textiles themselves, can open up new possibilities for understanding Indian life of a century ago.

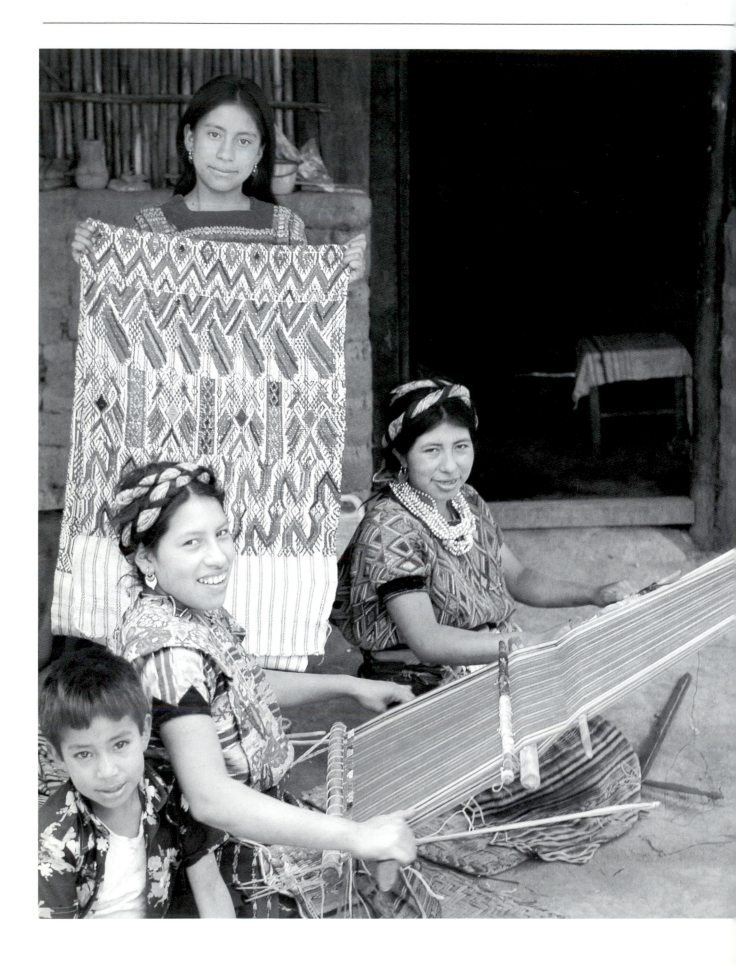

Textile Production

INTRODUCTION

The textiles comprising the Eisen collection are a microcosm of techniques and materials used by Maya weavers in the late nineteenth and early twentieth centuries and a synchronic view of the dress repertoire available to Eisen in towns on his travel route.[1] Well represented are textiles woven on the backstrap, treadle or floor, ribbon, and water-powered looms, along with pieces that are knotted, plaited, embroidered, or knitted by hand. Backstrap-woven textiles account for over 50 percent of the collection while treadle-loomed textiles make up over 25 percent.[2] Some textiles combine both backstrap- and treadle-loomed cloth. Examples of looms with work in progress and of spindles further contribute to our understanding of cloth production. Hand-spun and commercially spun animal and vegetal fibers were hand-dyed and commercially dyed with natural and synthetic dyes.

The collection of 222 textiles and textile-related objects serves as a miniature model for research purposes. Claude Lévi-Strauss wrote that a reduced model allows a knowledge of the whole to precede the knowledge of the parts—a reversal of the usual process of knowing (Lévi-Strauss 1966:23). This small collection is thus less formidable for study, but it is nevertheless sufficient to impart an accurate impression of the richness and diversity of highland Maya dress at the time of Eisen's visit.

THE LOOMS

THE BACKSTRAP LOOM

The backstrap loom (Figures 37, 38) has been in use in Mesoamerica for over two millennia. This loom, also known as the stick or *palito*, hipstrap, waist, belt, or girdle loom, is a weaving apparatus with a continuous warp supported by two bars. The front bar is tied to a support while the back bar is attached to a strap around the weaver's body. Tension is controlled by backward or forward movement of the weaver's body. This controlled tension, along with the insertion of the batten or *espada*, a smooth piece of swordlike hardwood, allows shed openings for the insertion of the weft or horizontal threads into the vertical or warp threads, which produces the cloth. Other weaving implements include various sticks and shuttles of wood or bamboo and, in some towns, a bone needle. The loom itself appears to be a simple device. When the cloth is completed, nothing remains of the loom except a pile of sticks. The late Junius Bird, noted textile authority, however, called the backstrap loom a complex device, more responsive to the weaver's creative impulses than the modern treadle loom (Broudy 1979:76). The

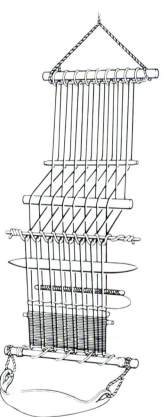

Figure 37.
Backstrap loom. The Guatemalan Indian Centre, London. Photo courtesy of Krystyna Deuss. 1981.

Figure 38.
Woman at the backstrap loom. Santa María de Jesus, Sacatepéquez. Photo by Margot Schevill. 1978.

weaver is encircled by the loom and becomes a part of it; on the other hand, the treadle-loom weaver sits outside the loom and acts upon it. Furthermore, backstrap weavers can improvise as they go along, while treadle-loom weavers are more committed to prescribed patterns created during the threading process.

The first step in the weaving process is the warping of the loom.[3] The yarn is plied and made into balls. Next the weaver prepares the warp on a horizontal warping board with wooden pegs or sticks that are pounded into the earth. The warp is placed on the loom sticks. Heddles are looped around alternating warp threads that are then attached to shed rods. In this way, two sheds are created. The weaving process is as follows: there are two primary sheds. With the warp under tension, one shed stick is pushed forward adjacent to the other shed stick. A small opening appears, and the batten is inserted and turned vertically to open the shed. The weft yarn is inserted and beaten into place by the batten. The other shed is more difficult to create and requires the inverse movement of the body.[4] The weaver leans forward to release the tension on the warp, then pulls up on the shed rod, inserts the batten, and proceeds.

A great advantage of this loom is that one can weave cloth with four loom-finished selvedges. The textiles are stable and do not require finishing. A disadvantage is that the backstrap-loom setup limits the width and length of the finished product. The width cannot be wider than the weaver can reach, which is approximately twenty-four inches. Since the woven cloth is rolled around the stick in front of the weaver, five yards seems to be the maximum length produced. Loom-finished cloth is seldom cut and tailored. Garments of rectangular or square cloths are worn draped or wrapped, rather than fitted to reveal the contour of the body. When a piece wider than twenty-four inches is required, the weaver includes in the warp length enough for two of the same size; then the piece is cut and sewn together. The seam can be embellished with colored yarn and embroidery stitches; the finished decorative joining is called a *randa*.

The backstrap-woven textiles in the Eisen collection are balanced plain, warp- and weft-faced, and twill weavings (see the Glossary). Most of the cloth is warp-predominant, which creates a solid-colored or striped background for decorative motifs accomplished by brocading supplementary weft patterns. These patterns are the result of floating wefts on the surface of the cloth. There are three different types: single-faced, two-faced, and double-faced. Single-faced designs appear on only one side of the cloth; in two-faced brocading, the yarn floats on the reverse side between pattern areas, forming an inverse of the design. Textiles with double-faced brocading have identical motifs on both sides of the cloth.

Single- and double-faced brocading techniques were practiced by pre-Columbian weavers. The *Popol Vuh*, the ancient sacred book of the Maya, relates that the gods assigned images to those who founded the three leading matrilineages. Animals were represented on their cloaks. The figures were placed *chuwach*, "on the face," or in

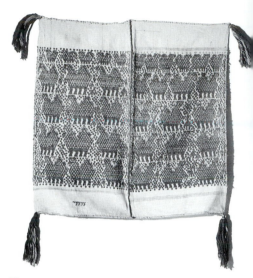

Figure 39.
Weaver's mark in lower left corner in a headcloth or *tzute* from Chichicastenango, 3-36.

single-faced brocading, or *chupam*, "on the inside," or in double-faced brocading (Tedlock and Tedlock 1985:124).

Some weavers use a bone needle to assist in the time-consuming pickup process, while others add extra shed sticks for patterning. Brocading can cover the full width of a textile in bands, or the weaver can insert individual motifs wherever desired. Sometimes weavers work a personal motif or design into the cloth, which identifies to the informed viewer the creator of the cloth (Figure 39).

THE TREADLE LOOM

At the time of the conquest in 1524, male treadle-loom weavers in Spain were producing yardage for the fashionable fitted garments. The Maya backstrap loom, however, was not suitable for long pieces of yardage since the woven material is wound on the front bar of the loom and would be too bulky to allow the weaver to work easily. The Spaniards introduced counterbalance treadle looms (Figures 40, 41) to Guatemala and taught Maya men how to weave on them. In contrast to backstrap-loom textile production, which takes place within the home in the midst of child and animal care and meal preparation, treadle-loom workshops were established where men wove full time on a regular and rigorous schedule. Treadle-loomed fabric also satisfied the demand of the Maya women for yardage for skirts and larger textiles such as bed coverings. This yardage, which could be cut and sewn into fitted garments for both men and women that were similar to those of the Spanish but in Maya adaptations, eventually replaced some of the backstrap-woven material.

The Guatemalan treadle loom, which is an upright, stationary wooden structure, is a counterbalance type with either two or four harnesses tied by ropes to a roller at the top of the loom.[5] The harnesses are long, narrow frames that contain the heddles of maguey or cotton fiber. Each heddle is centered with a loop called an eye. Warps pass through the eyes and are drawn down simultaneously by a foot-activated treadle. Warps extend over the back and front beams and are held in rigid tension. The warping process is more time consuming on the treadle loom than on the backstrap variety. Once this process is over, however, weaving proceeds rapidly. Although many design decisions are determined before weaving by means of threading and treadle tie-up, design decisions still can be made. Two primary advantages of the treadle loom over the backstrap loom are the speed of operation and the creation of longer and wider cloth.

The same basic weaves appear in treadle-loomed textiles as in backstrap-woven ones. Two-faced supplementary weft brocading is a common decorative technique. Single-faced and double-faced techniques are done by hand and were not adopted by treadle-loom weavers although, on certain textiles like tablecloths, individual design motifs may be inserted into the background cloth by hand. Weft-faced tapestry weaving, which completely covers the warps, allows the weaver to change colors and shapes within the prescribed width of the textile.

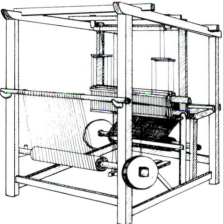

Figure 40.
Counterbalance treadle loom used in Guatemala.
Drawing by Rip Gerry.

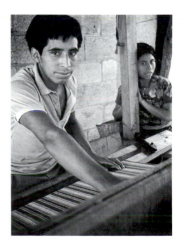

Figure 41.
Counterbalance-treadle-loom weaver, Santa María de Jesús, Sacatepéquez. Photo by Margot Schevill. 1978.

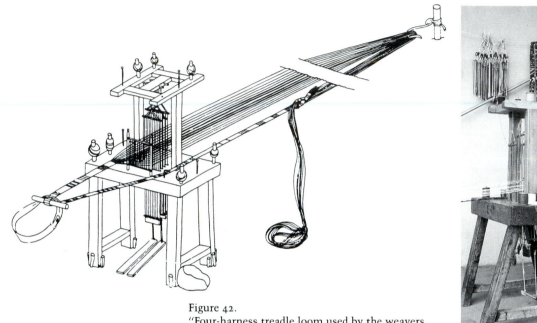

Figure 42.
"Four-harness treadle loom used by the weavers of Totonicapán-type headbands" (O'Neale 1945: Fig. 19h). Drawing by Lucretia Nelson.

Figure 43.
Headband-loom weaver from Totonicapán. The Guatemalan Indian Centre, London. Photo courtesy of Krystyna Deuss. 1970s.

THE HEADBAND LOOM

The origin of this unusual loom[6] is unknown, but certain unique features suggest that it may have been developed in Guatemala. It combines the features of the Spanish-introduced counterbalance loom with two or four harnesses pedaled by foot along with the use of the backstrap (Figures 42, 43).[7] Narrow headbands called *cintas* of weft-faced plain weave are woven on this loom. In order to create animal and other rounded shapes, the weaver, using an eccentric tapestry technique, manipulates the wefts at angles other than right angles.

OTHER TEXTILE TECHNIQUES REPRESENTED IN THE EISEN COLLECTION

EMBROIDERY

Pre-Columbian weavers were skilled in embroidery, a technique of decorative yarn stitchery done with a needle on a ground fabric. New techniques, such as the cross-stitch, were taught by the Spanish nuns. Twenty-two textiles have embroidered decorations.[8]

KNOTLESS NETTING

There are eight knotless netted or linked bags of agave or *pita* fiber in various sizes. This technique has an ancient history among native peoples worldwide because of its simplicity and usefulness.

One can produce a stretchable texture that is suitable for nets for snaring animals or for catching fish. Knotless netting is a single-element technique that must by its structural nature be made with a yarn or strand of limited length. The bags consist of a series of variously connected loops that rely on adjoining loops to maintain their orientation and preserve the textile unit (Dickey 1964:7–8). Eisen collected the beginning of a bag in order to show the process (3-267). The untwisted *pita* fiber is plied by the maker and then looped.

BRAIDING

Hats are made of twisted palm fiber that is then braided in a herringbone pattern into strips. A northeast lowlands palm called *palmilla* is most commonly used. The work starts at the center of the crown. The quality of the hat depends upon the number of palm strands woven into the strips, which are hand-stitched with cotton thread. In addition to the knotless netting example, Eisen also purchased a rolled length of palm leaf braid (3-276). This object illustrates how the twisted strands looked before they were made into a hat. In his catalogue notes, Eisen commented that the hatmaker kept the palm leaves in one of the smaller knotless-netted bags (3-257) while making the hats.

SPRANG

Related to knotless netting or linking, sprang is known worldwide as a way of manipulating a set of taut threads.[9] O'Neale called it finger weaving or freehand and picked-in weaving (O'Neale 1945:60–61). Like knotless netting, sprang is a source for stretch fabric. The weft yarns are inserted or interlaced with no weaving aids other than the fingers, pins, or cactus spines. In other words, the fabric is constructed by manipulating a set of parallel yarns that are fixed at both ends or wound continually around two poles (Kent 1983:298). Twelve examples of sprang include men's sashes and straps of men's bags and saddle bags. Osborne describes a netted-weave sash worn in Rabinal calling it *pax*, which may be the Achí word for this technique (Osborne 1965:162).

KNITTING

Knitting is an interlooping technique using a single element in a series of loops that is manipulated by pointed rods or needles. This technique, along with crocheting, may have been taught to the Maya by the Spaniards (Conte 1984:19). One of the two examples is of wool and the other of two-ply *pita*.

FOLDING

Folded hatbands were in style at the time of Eisen's visit, but are no longer produced. A specialist plaited two palm fiber strips and then folded them together in an intricate pattern.

MATERIALS

FIBERS

Vegetal: Both vegetal and animal fibers are spun and dyed by the
Maya.[10] Some of these fibers come from wild plants and shrubs while
others, like cotton, are cultivated. Leaf fibers from monocotyledonous
plants produce yarn with either smooth or harsh, prickly character-
istics. Eisen describes the vegetal-fiber textiles as being of *pita*, which
is a common term for maguey. O'Neale employs the term *maguey*,
which is a generic name for a variety of monocotyledonous fibers
obtained from the leaves of the agave plant. Maguey fibers, such as
sisal (*Agave sisalana*) and henequen (*Agave fourcroydes*), are
generally hand-twisted and used for cordage.[11] A special spindle type,
however, was developed for agave fibers. Called the whirl spindle, it
consists of a small hook rotating on a hand-held shaft.

Cottonseed-pod fibers are the most widely used of all textile
yarns in Guatemala. The plant is indigenous to the New World.
Two strains are represented in the collection: long-staple white
(*Gossypium hirsutum*) and shorter-staple, natural light brown
(*Gossypium mexicanum*), called *cuyuscate* in Spanish and *ixcag* or
ixcaco in the Maya languages. Preparation for spinning cotton is
laborious and time consuming because the seeds must be removed by
hand from the pods. The fibers are fluffed out, spread on a flat surface,
and beaten. The white variety can be commercially spun because of
the long staple, while the natural brown type must be hand-spun with
a supported spindle resting on the ground or in a small bowl. The
makeup of the cotton is single-, two-, and occasionally three-ply.
Commercially spun, mercerized cotton is called *mish*. It is generally
available and can be purchased by the skein in town shops. Other
types of cotton yarn are imported for decorative purposes. For
imported yarn like *sedalina* (pearl cotton) or *lustrina* (mercerized
embroidery cotton), one must take a trip to the regional market.

Animal: Although cotton textiles far outnumber them, woolen
examples do exist in the Eisen collection. Wool was quickly adopted
by Maya weavers after the Spaniards introduced sheep not long after
the conquest. Black, brown, gray, and white wool can be plied
together to create new shades of these basic colors. In colder
mountain towns and regions, wool is popular for men's and women's
garments. Raw wool is first washed and then carded with a pair of
boards with wire bristles. It can be spun with a drop spindle (see
3-281, 3-287, Aguacatán, Huehuetenango) or a spinning wheel. Spun
wool is available at the Momostenango marketplace, the center
of highland wool trade, which may have been in operation during
Eisen's trip.

Silk is also a highly valued import of the Maya. Before the
conquest, wild silk may have been spun and woven into cloth (Sayer
1985:127).[12] Shortly after the conquest, the Spaniards introduced the
domesticated Asiatic silkworm, *Bombyx mori*, into Mexico. A small
industry thrived for a short period but subsequently was banned

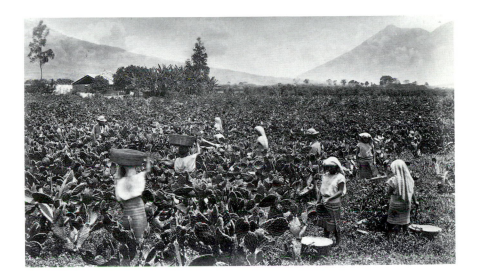

Figure 44.
A cochineal harvest on a cactus plantation.
Photo by Eadweard J. Muybridge. 1875. Boston
Athenaeum.

by royal decree, because the silk industry in Spain was fearful of competition (Sayer 1988:18). Silk came to Guatemala via the Manila galleons en route to South America. Two types were available: unreeled waste silk called floss or *filo*, which is unplied and used primarily for embroidery for tassels and in headbands from Totonicapán, and the two-plied variety used for fringes and in embroidery.

DYES

There are two classes of dyes, natural and synthetic. Prior to the European invention of aniline dyes in 1856, all colored yarn was prepared with natural dyes.

Natural: There are three natural dyes that appear in the Eisen collection textiles: indigo, *Indigofera suffruitcosa guatemalensis*; cochineal, *Dactylopius coccus*; and the mollusk *Purpura patula pansa*. Other dyes may be represented since leaves, fruits, flowers, and barks all provide coloring. O'Neale lists wood dyes for wool that produce a variety of colors (O'Neale 194:28).[13]

Indigo, also known as *piedra de añil*, is a plant that originates in El Salvador. It is imported to the highlands of Guatemala in large pieces, which are ground down into a fine powder. The indigo is then mixed with a mordant or firing agent, in this case the native plant *sacatinta*. Both cotton and wool textiles are dipped into the dye bath and then allowed to dry so that oxidization can take place. With each exposure to the air, the blue color deepens. Other shades including green, the product of indigo and various mordants, can be created.

Cochineal is a delicate insect that feeds on the nopal, a prickly pear cactus. Domesticated cochineal derives from nopal farms that thrived around Antigua and Amatitlán in the mid-nineteenth century (Figure 44).[14] Wild cochineal is also collected from untended cacti, but the product is inferior to the domesticated variety. Pregnant female insects are settled on the joints of the plant. After one hundred days the new parasites are harvested. New females are retained for

the next cycle. After sun-drying or toasting the insects, weavers grind them to powder. Various mordants, such as lime, lemon, or alum, produce different shades of red that may range from pink to near-black and purple. Vegetal fibers like cotton are not receptive to cochineal dyeing in the same way as are animal fibers such as wool and silk. In the nineteenth century, cochineal was Guatemala's most important export product. It was replaced by coffee in the latter part of the century.

Purpura patula pansa is a mollusk that lives along the shores of the Gulf of Tehuantepec, Mexico, and on the coasts of Nicaragua and Costa Rica. Lavender-purple yarn is obtained by squeezing the mollusk's glands until a foamy, colorless secretion appears. This liquid permeates natural white cotton or silk floss, which eventually turns a mauve shade that is highly valued by the Maya.

Anthropologist Robert Carlsen analyzed thirty-three textiles from the Eisen collection.[15] He tested predominantly blue, red, and purple vegetal and animal fibers to determine whether the dyes were natural or synthetic. Natural red dye appears in twenty-six textiles, natural blue in four, and natural purple in eight.[16]

Synthetic: After their invention in 1856, aniline dyes became available worldwide. In Guatemala, weavers bought packaged dyes or predyed and commercially spun yarn in highland markets and in the capital. Formerly skirts were of indigo-dyed cloth. A few examples in the Eisen collection (3-51, 3-187, 3-219) of aniline-dyed, brightly colored cotton contrast with the more somber indigo-dyed style in fashion. Other synthetic dyes also became available, such as an indigo-like aniline dye imported from Germany. Some weavers stopped using the more expensive Salvadorean indigo in favor of the synthetic dye. They continued to combine *sacatinta* with the new dye to produce the same color as natural indigo. Others combined natural and synthetic dyes.[17]

Carlsen and Wenger discovered that weavers were dyeing cotton yarns a pinkish-red with alizarin, a reddish-yellow crystalline compound, which was associated with madder. At first, the investigators thought that this color originated from true madder, a name for a group of related plants that yield medicines and dyes. A particular plant of the madder-producing genus *Galium* does grow in Guatemala. The occurrence, however, is restricted. If it had been widely exploited, the plant would have become extinct (Carlsen and Wenger 1991). Synthetic madder or alizarin, a coal-tar-based dye, was patented in 1871 and was henceforth available to Maya weavers who eagerly integrated it, as they did other new materials, into their cloth production.[18]

Ikat or *Jaspeado:* By the turn of the nineteenth century, *ikat* or *jaspe* yarn was woven into cloth for skirts and shawls. There is no evidence as to the exact origin of this technique, which takes its name from the Indonesian word *menigikat,* meaning "to tie." It may have been in place at the time of the conquest.[19] Known to Maya weavers as *jaspeado,* it could have been introduced by the Spaniards

or derived from textiles that came on the Manila galleons from Southeast Asia, where *ikat* is a common practice.

Jaspe yarn is patterned before the weaving process takes place. Skeins of natural white cotton or wool are tied with string at specific intervals and then dipped into the dye bath. These white or undyed areas are "reserved." The most common yarn in the Eisen collection is of two colors—indigo and white, red and white, and other combinations. Additional effects can be obtained by tying the dyed areas and dyeing the "reserved" ones. In the time period of the Eisen collection, *jaspe* yarns appear only in weft bands. Some weavers may choose to work their names into the cloth (3-61, 3-184) by tie-dyeing letters. Geometric and figurative forms that are created with these dyed yarns are characterized by the blurred outlines that occur when the dye penetrates the reserved areas. *Jaspe* yarn appears more often in cotton textiles than in woolen ones. Both backstrap- and treadle-loom weavers enjoy producing cloth with *jaspe* patterns.[20]

RELATIONSHIPS BETWEEN TEXTILE PRODUCTION AND GENDER ROLES

PREVAILING IDEAS ABOUT GENDER-SPECIFIC ROLES

Until the late 1980s, there was a body of published information about gender-specific roles in textile production that was generally accepted by most textile scholars including myself.[21] It tended "to attribute gender categories on the basis of incomplete or misleading information," a process Cherri Pancake refers to as "gender-ization" (1991:1). This entrenched part of the literature attempted to pigeonhole men and women into specific tasks and thus create neat categories for analysis. This type of ethnocentric categorization relates to pinning down the locative nature of Maya dress already discussed in Chapter 1—the "one costume, one town" notion. The literature has at its center the technology-gender syndrome, in which technology is described as "simultaneously material, social and symbolic" (Pfaffenberger 1988:236), and gender roles are considered to be socially constructed. Gender is basic to the human psyche; we will use here Hess and Feree's definition of "a principle organizing social arrangements, behavior and even cognition," and "a system for dividing people into distinct, non-overlapping categories despite their natural variability on any particular characteristic" (1987:16). The need for well-defined categories seems to come from our own society's androcentric, dualistic, ingrained sense and not from the patterns of the group under scrutiny (Pancake 1991:3). Rigid, inflexible categories or taxonomies, however, that relate specificity of technology to one gender lead to models of occupational segregation or a dual-spheres model. Within this model the sole actors in the public sphere are men while only women are the actors in the private or domestic sphere. That is to say, in textile production, men weave on the treadle loom for the outside world while women weave on the backstrap loom for the domestic sphere.

For the late nineteenth and early twentieth centuries there exists little published information on gender-specific roles in textile production. Although the Eisen textile collection gives us insights into the tastes, aesthetic and scientific sensibilities, and goals of the collector, Eisen's writings and photographs, unfortunately, do not provide information about gender-defined textile production. None of Eisen's forty-eight photographs taken during the 1902 expedition present women or men weaving or engaged in any type of textile production.[22] It may be that future research by scholars who are questioning some of the stereotypic assumptions about gender in the creation and use of cloth and clothing by the Maya will reveal crossovers in textile production roles, such as men working on the backstrap loom and women on the treadle loom, as an ongoing phenomenon when Eisen was in Guatemala.[23]

I suggest that there is an alternative to the categorized generalizations, a view that could accommodate the fluid and changing relationships between textile production and gender roles. It also could address the motivations involved in cloth production. This alternative perspective relates to the discussion of gender by Michelle Zimbalist Rosaldo and Louise Lamphere, who propose that "the behavioral possibilities of the sexes are rich and variable. That human males and females have fixed, significant, and necessarily distinct behavioral propensities is far from clear" (Rosaldo and Lamphere 1974:6). Lynn Stephen also commented that "the content of masculinity and femininity in a two-gender system is flexible and reconstructed in relation to ever-shifting cultural, political, economic, and social contexts. Masculinity and femininity are not essentialist 'natural' qualities, but are contingent and inseparable from other qualities of identity such as age, race, ethnicity, and class. As a gender institution, the gendered division of labor is also flexible and contingent" (Stephen 1991:1).

WOMEN AND CLOTH PRODUCTION: A COSMOLOGICAL VIEW

In pre-Columbian Mesoamerica, spinning and weaving were associated with goddesses of conception, birth, and weaving. Spindle whorls were elaborately decorated with motifs related to these deities. The attendant priestesses knew herbal methods for conception and contraception. Through female discourse, women learned to control fertility and childbirth. Spinning and weaving helped to define femininity. A woman who spun but never wove was equated with infertility (McCafferty and McCafferty 1991). The Maya believed that the goddess Ixchel invented weaving. She was known as "Rainbow Lady" and was also the goddess of medicine and childbirth (Figure 45). A woman was expected to weave for herself and her family, and to produce ceremonial clothes for use in temples and as offerings. Although the extant historical and mythological sources for Mesoamerica associate women, not men, with cloth production, it may be that the androcentric perspective of the historians, fixed upon a preconceived notion of man as warrior-farmer and woman as mother-weaver, could not accommodate information that did not fit their expectations.[24]

Figure 45.
Ixchel, the Maya goddess of weaving. Drawing by Carolyn Shapiro.

Figure 46.
The Tz'utujil Maya loom. Drawing by Martin Prechtel.

In contemporary Santiago Atitlán, Sololá, an important element of Maya worldview is the belief in regeneration. Weaving is viewed as a regenerative or birthing process. Loom parts are anthropomorphized (Figure 46). The sticks reflect aspects of thirteen female deities. The midwife uses them to aid the mother in labor and to facilitate the head-first position of the baby within the womb. The motions of the warping process are defined in relationship to the movements of childbirth. Other aspects of cloth production, such as types of yarn used, dye colors, design motifs, how the garment is worn, and the weaver herself, become part of the metaphor for regeneration. For the Tz'utujil speakers of Santiago Atitlán, backstrap-woven cloth is "born" while treadle-loomed cloth is "made" (Prechtel and Carlsen 1988:122–132).

GENDER-TECHNOLOGY CLASSIFICATIONS

Until the late 1980s, it was generally assumed by anthropologists, historians, and travelers that the tasks of textile production as well as other occupational tasks were strictly differentiated by sex.[25] Writing about San Pedro La Laguna, Lois Paul emphasized the social and economic segregation of the sexes accompanied by male dominance (Paul 1974). A number of other researchers, such as Lila M. O'Neale (1945), Lilly de Jongh Osborne (1935, 1965), Marilyn Anderson (1978), and Krystyna Deuss (1981), addressed the notion that only women wove on the backstrap loom and only men on the treadle loom.[26] They organized other tasks and materials by gender; only men spin wool and ply *pita* cording; only women spin and ply cotton.

Contemporary observers conversant with the literature expect to see women backstrap-weaving and men on the treadle loom and are surprised to see crossovers in what they thought were gender-specific occupations. The reality is that gender roles in textile production appear to vary from town to town. For example, in weaving workshops in Antigua both men and women prepare the cotton yarn and weave the yardage for women's skirts and tablecloths that they will sell.[27] Men are the sole headband weavers in Santiago Atitlán and San Sebastián Huehuetenango, but both women and men produce the *cintas* in Totonicapán (O'Neale 1945:37–38; Anderson 1978:167–171; Deuss 1981:66).

The spinning and plying of monocotyledonous fibers by men, women, or children implies another community-specific model. For this task it may be the implement that determines who performs the task. Women spin cotton with the supported spindle and occasionally they spin wool with the wheel. Men use the drop spindle and the spinning wheel for wool and the indigenous whirl spindle when working with maguey. Both men and women ply fibers by hand (Pancake 1989).

Another important aspect of textile production—the marketing of textiles within Guatemala—provides a model for a flexible two-gender system responsive to cultural, political, economic, and social pressures. Men and women sell their wares, not only in small

shops or *tiendas* in their towns but also in regional markets, in the capital, and abroad. These wares may include textiles produced by the weaver's family and friends as well as by people from other communities with whom the weaver has contacts. If a woman is too occupied with child care and domestic activities, the men in her family may take her textiles to the capital to sell to an entrepreneur. A family in Santa María de Jesus combines the production and marketing of treadle- and backstrap-loomed textiles. The women sell in the home and in the local market, while the men have contracts for yardage to be sent to the United States and Europe.[28]

AN ALTERNATIVE VIEW OF THE RELATIONSHIP BETWEEN TEXTILE PRODUCTION AND GENDER ROLES: 1980–1990

Closer scrutiny reveals that cloth-producing Maya Indians have choices that may or may not be culturally or economically constrained but are not necessarily gender-specific.[29] The decision-making process concerning textile production involves a number of considerations such as time involved, the recipient for the products, type of implement employed, and flexibility of community-sanctioned roles. Instead of categorizing inflexibly by gender and task, one should ask, Who is the audience for the textile? What are the economic and personal reasons for women weaving on the backstrap loom and men on the treadle loom? What happens when the roles are reversed? I agree that one must view the relationship of textile production to gendered divisions of labor "within historically and culturally specific contexts as part of the construction and reconstruction of gender" (Stephen 1991:21).

A large proportion of the highland Maya male population spends several months at a time on the coast or the Piedmont as seasonal laborers in export commodities such as coffee. The work provides cash, and the Maya are part of the cash economy of Guatemala. But there is a lower return from seasonal jobs than from labor spent in one's community, working on a *milpa* or field used for growing corn, beans, squash, and other vegetables, combined with weaving or other income-producing tasks. A treadle-loom male weaver may spend several days weaving sufficient textiles for sale, such as tablecloths, linens, blankets, and skirt yardage. Additional time is spent marketing the textiles in faraway markets. Skirt yardage woven in Salcajá, Quezaltenango, is marketed at fiesta time in distant highland towns because women desire new clothing for these celebrations. Then, at crucial times of the year for farming, the weaver can devote his time to his crops.

Textile activities are the primary source of cash income for women. Other sources include making tamales, selling homegrown fruits and vegetables, or, in a few towns, teaching weaving to foreigners. Women who either do not like to weave or are involved in other activities may commission a full-time weaver to produce textiles for them. The hired weaver may be paid in cash or by barter.

Backstrap weaving can be integrated into household tasks and child care. Some of the decorative techniques practiced by the weavers are more suitable for one-of-a-kind garments like *huipiles*, multipurpose cloths, and belts. *Huipiles* are labor-intensive and may take three months to produce. The woman backstrap weaver, because of other family responsibilities, works only a few hours at a time. For cash, another class of textiles, such as small or large backstrap looms with partially woven textiles in process called *telarcitos*, are created and marketed by the weavers themselves or by vendors who only sell elsewhere.

Another consideration is the intent of the weavers and their response to their customers. Weavers may produce only for domestic use, but this does not bring in cash income. Now, as when Eisen visited Guatemala, weaving centers or cooperatives exist where weavers produce a variety of textiles for sale to neighbors, *ladinos*, or foreigners. Weavers also may market their goods through cooperatives, but their profits are diminished by a percentage subtracted from the expected price to cover the overhead.[30] They take pride in creating a well-woven textile with the latest designs, and fine work is admired. The creator is acknowledged and gains prestige within the community. When, however, an innovator from the community proposes a project that will enhance the incomes of weavers, community-sanctioned roles may be altered. Weavers make choices for economic and personal reasons, as the following two examples will illustrate.[31]

SAN ANTONIO AGUAS CALIENTES

In 1978, arriving at the home of my weaving teacher, Angela,[32] in the predominantly indigenous town of San Antonio Aguas Calientes, I was surprised to see a young man of sixteen weaving on a backstrap loom alongside his older sister and mother. This was an anomaly, a reversal of what I had expected. Even their manner of sitting differed (Figure 47). Rafael sat on a small stool while Maria knelt on mats on the ground. Angela's mother, Sebastiana, was also present, which means that three generations of women lived together (Figure 48). During the hours I was there, weaving was the dominant activity. Although the women lay down their looms from time to time for various activities, Rafael wove solidly eight hours a day with an hour break for lunch, accompanied by the *dramas* or serials on the radio.

Jaime, Angela's second husband and the father of Rafael and another younger son, appeared in the background, seemingly shy and retiring. The men in San Antonio Agua Calientes now dress in Western-style clothing, while women still wear *traje*. I learned that Jaime had lost his inherited land to his brother and, therefore, had no *milpa* from which his family could expect basic foods. Occasionally he worked as a day laborer for extremely low wages. San Antonio is a relatively rich community, and land is an index for wealth. A landless person like Jaime, particularly one who lost inherited wealth, has

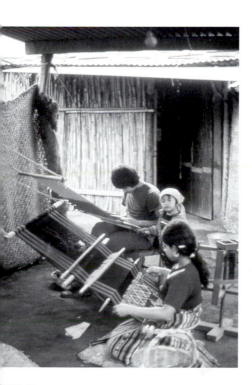

Figure 47.
[Ra]fael and María backstrap-loom weaving in [th]eir courtyard. San Antonio Aguas Calientes, [Sac]atepéquez. Photo by Margot Schevill. 1978.

little or no status, even though he serves in the *cofradía* from time to time. He could not serve as a role model for Rafael. The family was supported by Angela's efforts as weaver, teacher, and vendor.

Rafael learned to weave as a child. He showed exceptional skill and enjoyed weaving. Other boys in his extended family learned by watching Angela and their mothers and sisters. When Rafael attained sufficient skill to produce complete pieces, he wove garments for his family and other textiles for sale. I commissioned Angela to weave a special *huipil* for the Haffenreffer Museum collections, and it was Rafael who wove the garment. He contributes most of the money earned from the sale of his weavings to his mother, but keeps a small amount for himself. Rafael weaves for economic reasons, and the family counts on this income. In San Antonio Aguas Calientes, a male backstrap weaver performs a community-sanctioned role, although I do not know if a fine male weaver has the same prestige within the community as does a woman weaver. I met other men who told me that they too wove on the backstrap loom, but I did not see them weave.[33]

Since my first contact with the family, Rafael has studied tourism in Guatemala and in the United States. Nevertheless, to earn money he teaches Spanish in a language school in nearby Antigua and continues to weave textiles in the courtyard of his home for the family and for sale.[34]

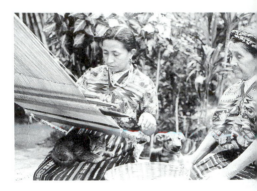

Figure 48.
Angela and her mother, Sebastiana, at the backstrap loom. San Antonio Aguas Calientes, Sacatepéquez. Photo by Margot Schevill. 1978.

SAN JUAN LA LAGUNA

In the past, San Juan lost its nearby agricultural land to neighboring San Pedro, and men must now travel far to their *milpas.* The community became dependent on tourism and marketing of textiles for cash income. The continuing repressive actions of the Guatemalan army have affected tourism and the economy of Maya weavers in certain areas of Guatemala including Lake Atitlán, where San Juan is located. Because travel in Guatemala may be dangerous, tourism drops off. Backstrap weavers who produce textiles for sale face severe competition within their own country for a very limited market. Commercial buyers from abroad take advantage of the weavers' inability to market their products satisfactorily. Unfortunately, the quality of textiles deteriorates and prices drop.

In the late 1980s, the people of San Juan La Laguna, in response to these economic and social pressures, formed a cooperative called Los Artesanos de San Juan, which markets through Pueblo to People and other outlets abroad.[35] One of the founders, Bartolomé, a master weaver, studied indigenous crafts at a government-sponsored school, now closed, in Chinautla, Huehuetenango. One of his skills is building looms, and he designed a new style of treadle loom for producing yardage. A group of young women, who also are backstrap weavers, learned to work on these looms and are producing yardage (Figure 49). Work goes faster on the treadle loom, which enables them to weave the longer and wider pieces of cloth that are required for the popular export, the San Juan–style jacket (Figure 50). Weaving on the new loom is more comfortable than on the backstrap loom.

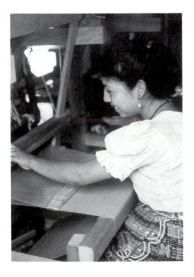

Figure 49.
Treadle-loom weaver in San Juan La Laguna, Sololá. Photo by Susan Redlich. 1988.

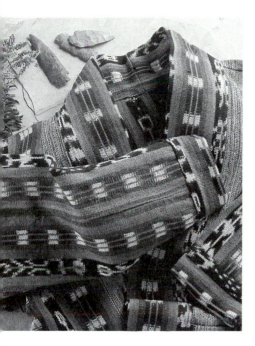

Figure 50.
San Juan–style tailored jacket. Pueblo to People.
Photo by David Crossley. 1990.

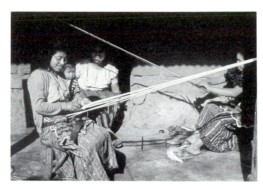

Figure 51.
Backstrap-loom weavers in San Juan La Laguna,
Sololá. Photo by Susan Redlich. 1988.

By the end of the cooperative's first year, membership grew to 150, mostly women. It now has 200 members, including weavers and sewers. Motivated by economic reasons, women take pride in good work, which is now done collaboratively instead of individually. Textiles are checked for uniformity in quality. Buying materials and equipment and shipping in bulk lowers costs. The organization also provides a place where women can learn new skills. Since women now can contribute financially to their family's needs, they have a happier home life and improved relations with their husbands. Backstrap weaving and bracelet weaving continue alongside this new cottage industry (Figure 51).

What are the men's roles in this enterprise? Bartolomé, formerly the president of the cooperative, is now the manager. Other men hold offices, and there is a male accountant. Some men also are weaving on the treadle loom. One man does simple *jaspe* dyeing, while other men market the textiles outside of San Juan. Women are still tied down with family responsibilities but plan to become involved with marketing when a day-care center is available to them. Success has brought a small UNESCO grant to assist in building ten more treadle looms. Furthermore, a new school, funded by a Christian organization, has taken over a tiny store for a classroom. Weaving is taught there along with other courses. Shoppers purchase yarn or finished goods in a communally run shop. A dental program is in place. The directorate of the cooperative is composed of eight members, both women and men, who are concerned that all cooperative members continue to play an important role in the direction and decisions of Los Artesanos de San Juan.[36]

The San Juan case is a success story and a dynamic response to new technology—floor looms—and markets abroad. National Public Radio focused a short segment on this distant textile production venture. The San Antonio Aguas Calientes case presents options that a Maya family can choose for economic reasons while working within the domestic sphere. These cases demonstrate that men and women can learn new technology that heretofore has been considered gender-specific, and that there are community-specific roles in the Guatemalan textile industry to better serve all Maya who ply their trade in the production and marketing of textiles.

The Eisen Guatemalan Textile Catalogue

INTRODUCTION

The annotated citations of 222 textiles and textile-related objects are accompanied by color and black-and-white photographs. Each one is identified by its Hearst Museum of Anthropology catalogue number, for example, 3-130. If the citations included only the textile analyses, Eisen catalogue notes, and additions made by scholars who have worked with the collection, one would have little sense of the context in which these Guatemalan textiles were produced or worn at the turn of the nineteenth century.

Aldona Jonaitis discussed the notion of "wrapping" a text put forth by the literary theorist and critic Frederic Jameson (Jonaitis 1992).[1] In the literary sense he is referring to a hermeneutic process of layering or "wrapping" new interpretations on or around an old text, thus creating a new entity without destroying the old one. In the "Comments" section of each citation, I have attempted to "wrap" or to add layers of information to the basic description of the textile and textile-related objects, thus creating a multivocal ethnography. This process adds a second dimension to the analytical data. A more profound understanding of these objects results from "wrapping" the primary analysis.

There is a paucity of published references that focus on cloth and its creation, however, for late nineteenth- and early twentieth-century Guatemala. One must look elsewhere. Other sources include Eisen's fine photographs as well as those of a few other nineteenth-century photographers who were interested in the Maya. These historic photographs accompany, when appropriate, photographs of the objects themselves. One published text is Lila M. O'Neale's excellent study of Maya dress and textile production in the mid-1930s (O'Neale 1945). She knew the Eisen collection well and, in preparation for her manuscript, she read his letters, which contained references to specific textiles and to some of the collection circumstances. As discussed already, in addition to O'Neale, other Guatemalan textile scholars have noted change and evolution in textile design, materials, and techniques over time. Following the published references, I have added my comments and the personal communications of Guatemalan textile scholars.

In Appendix A, the classification of textiles and textile-related objects, I compare the textiles in the Eisen collection with those in use in the 1980s by looking at continuities, discontinuities, and transformations in textile types and *huipil* styles. This process enabled me, as a contemporary textile scholar, to engage in a dialogue with materials, objects, and ideas about Maya dress created almost a century ago. Annotating the Eisen catalogue citations with O'Neale's and other researchers' observations provided me with perspectives from the 1930s to the 1980s. As a museum anthropologist, I have learned that we can neither understand nor interpret contemporary material culture without knowledge of what came before.

CATALOGUE ORGANIZATION AND CITATION FORMAT

The catalogue is organized alphabetically by department, within the department by town, and within the town by object (i.e., blouse, cloth, etc.). The annotated citations present the following information:

DEPARTMENT: State where Eisen acquired the object.

TOWN: In addition to the department, Eisen frequently listed town of purchase.

LINGUISTIC AFFILIATION: Over twenty Maya languages are spoken in Guatemala as well as Spanish.

HEARST MUSEUM CATALOGUE NUMBER: All objects from Mexico and Central America are preceded with the number 3-.

OBJECT: The English name is listed first followed by the Spanish or Maya name; for the most part I draw upon Eisen's textile identifications in his notes.

DIMENSIONS: The length is listed first, then the width. Sleeve measurements are not included. For hats, the depth of the crown indicates the length; the diameter of the brim is the width. For ponchos, overshirts, and women's blouses, the length from shoulder to hem is recorded, or one-half of the actual length of the textile.

YARN MAKEUP: Several indexes are listed: the type of yarn, ply, and color, and the warp, weft, and supplementary weft count. All the yarn is hand-spun unless otherwise indicated. It was not possible to determine which fibers were hand-dyed and which were commercially dyed. Color is created by synthetic dyes unless otherwise noted.

WARP, WEFT, AND SUPPLEMENTARY WEFT COUNT: The sett is given in inches and centimeters: epi and epc mean ends (warps) per inch and ends per centimeter; ppi and ppc mean picks (wefts) per inch and picks per centimeter. Supplementary weft is described as "over 1 – 4 warps," for example.

FABRICATION: The construction of the garment is described, including the method used to create the textile. If embroidery is part of the construction, it is described in this section.

ICONOGRAPHY: Textile patterns and motifs are described, including weavers' marks if present.

COMMENTS: Eisen's catalogue notes, comments from other textile researchers, personal communications, and primary and secondary sources are presented. If there is another similar object or textile, the reader is referred here to information given in the other citation. The voice of the author appears at the end of this section.

REFERENCES CITED: Published or manuscript references and personal communications are listed by last names.

INTERNAL REFERENCES: Textiles or features thereof that are similar to those of the object cited are listed. Unless otherwise noted, the object referred to is located in the same town as the one cited.

Eisen purchased textiles in the following departments:

Baja Verapaz
Chimaltenango
El Quiché
Guatemala
Huehuetenango
Quezaltenango
San Marcos
Sololá
Totonicapán

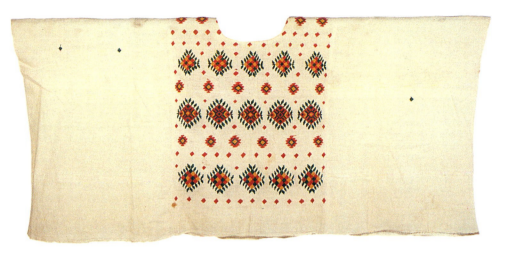

BAJA VERAPAZ
Rabinal
ACHÍ

-130
LOUSE, *huipil*
9" x 40" 48 CM X 102 CM

Warp: cotton, singles, white; 3 singles,
white; 40 epi, 16 epc
Weft: cotton, singles, white; 45 ppi, 18 ppc
upplementary weft: cotton, 3 singles, red
(alizarin), yellow, green, blue-green; over
−14 warps

Backstrap-loomed, balanced plain, widely
spaced weave, two-faced supplementary
weft brocading; three pieces, end-selvedges
loom-finished, front, back, and underarm
seams hand-sewn; head hole cut out and
hemmed.

Various diamond-shaped designs both large
and small. White-on-white weft stripes at
regular intervals. Weaver's mark on side
panels—very small diamonds.

Rare piece!" (Lehmann). Red is dyed with
alizarin (Carlsen). "This style is still woven
and worn by old women in Tucuru, Alta
Verapaz, with a red wraparound skirt. Not
tucked in" (Deuss). Probably purchased in
Rabinal. Coloring similar to examples from
Tactic, Alta Verapaz, collected in 1883 and
donated to the Smithsonian National
Museum of Natural History by the
Guatemalan government, 92985a, b. (See
figure 52.)

Lehmann 1962; Carlsen, pers. com. 1987,
Deuss, pers. com. 1988

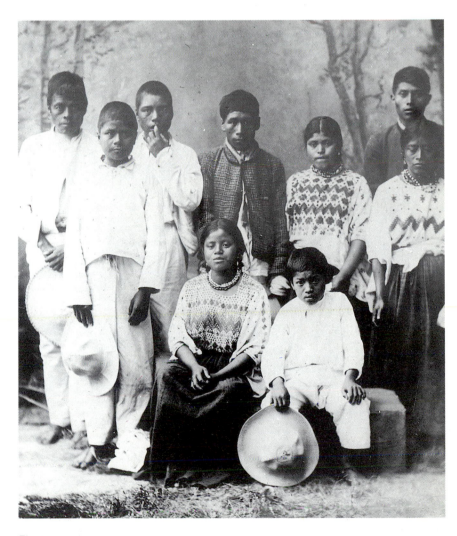

Figure 52.
A group of Maya. The women are wearing
huipiles similar to 3-130 acquired in Rabinal, Baja
Verapaz. George Byron Gordon photo archives,
Peabody Museum of Archaeology and Ethnology,
Harvard University. 1901. H8472.

CHIMALTENANGO
Patzún
KAQCHIKEL

3-241
BLOUSE, *huipil*
25" X 45" 63.5 CM X 114.3 CM

Warp: cotton, 2 singles, white, red (alizarin), yellow, green; 43 epi, 17 epc
Weft: cotton, 2 singles, white; 19 ppi, 8 ppc
Embroidery: silk floss, white, aqua, yellow, purple, red

Backstrap-loomed, warp-predominant plain weave; two pieces, four end-selvedges loom-finished, joined down front, back, and sides by buttonhole-stitched *randa*; head hole cut out, silk taffeta neck piece and ½" medallions on front and back; embroidered with silk floss in stem stitch.

Warp stripes; supplementary silk floats in warp and weft may be weaver's mark.

"Flecking with colored silks at various places" (O'Neale: Fig. 93c). Unused textile. Red dye is alizarin (Carlsen). (See Figure 53.)

O'Neale 1945; Carlsen, pers. com. 1987

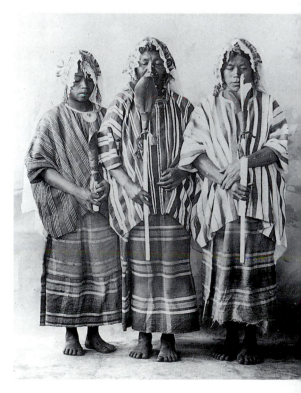

Figure 53.
Cofradía members, Patzún, Chimaltenango. George Byron Gordon photo archives, Peabody Museum of Archaeology and Ethnology, Harvard University. 1901. H8538.

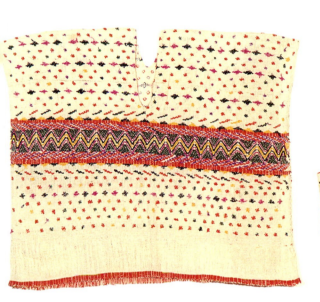

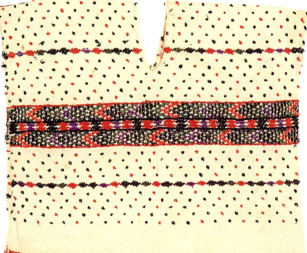

3-144
BLOUSE, GIRL'S, *huipil*
18½" x 20" 47 CM X 51 CM

Warp: cotton, singles; 28 epi, 13 epc
Weft: cotton, singles and 2 singles, white;
16 ppi, 11 ppc
Supplementary weft: cotton, 3–5 singles,
red, green, yellow, dark blue; silk floss,
magenta, purple; over 1–8 warps

Backstrap-woven, balanced plain weave,
single-faced supplementary weft brocading;
one piece, all end-selvedges loom-finished,
joined at side seams; hemmed opening for
head hole.

One center band with arch (half-diamond)
designs. Evenly spaced dots and geometric
forms on rest of *huipil*. Multiple white
wefts inserted in three rows at irregular
intervals creating raised effect. Red and
indigo wefts at bottom selvedges (mark of
weaving workshop).

Design layout, weaves, colors replicated in
other *huipiles* 3-46, 3-64, 3-243, 3-244,
3-245, 3-246, 3-249. Joining coarsely woven.
Similar example in Smithsonian National
Museum of Natural History, 72943, donated
before 1883. Design band similar but motifs
larger and in hourglass and four-sided
horizontal rectangular shapes. Relates in
coloring to child's *huipil* collected by
George Byron Gordon in 1901 in the
Peabody Museum, Harvard University,
91-4020/C-3013. For comments see 3-240.

See 3-246, 3-247

3-246
BLOUSE, GIRL'S, *huipil*
16" x 18" 40.5 CM X 46 CM

Warp: cotton, singles, white; 36 epi, 14 epc
Weft: cotton, singles, white; 28 ppi, 12 ppc
Supplementary weft: cotton, 3–6 singles,
red, green, dark blue; silk floss, purple; over
1–8 warps

Backstrap-woven, balanced plain weave,
single and two-faced supplementary weft
brocading; one piece, all end-selvedges
loom-finished, joined at side seams; opening
for head hole, hemmed.

One center band with zigzags and geometric
forms. One band of diamonds below
shoulders. Evenly spaced dots on rest of
huipil. Red wefts at bottom selvedges (mark
of weaving workshop).

The yarns have fulled because the textile
has been washed and, therefore, the weave is
denser than other Jilotepeque *huipiles*.
Coarsely woven joining. For comments see
3-240 and 3-144.

See 3-144, 3-247

CHIMALTENANGO
San Martín Jilotepeque
KAQCHIKEL

3-247
BLOUSE, GIRL'S, *huipil*
15½" x 20½"　40 CM X 52.5 CM

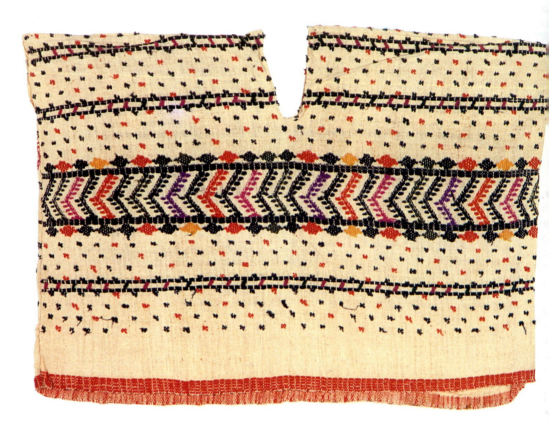

Warp: cotton, singles, white; 32 epi, 12 epc
Weft: cotton, singles, white; 24 ppi, 10 ppc
Supplementary weft: cotton, 3–6 singles, red, green, yellow, dark blue; silk floss, magenta, purple; wool, 3 singles, magenta, green; over 1–8 warps

Backstrap-woven, balanced plain weave, single-faced supplementary weft brocading; one piece, all end-selvedges loom-finished, joined at side seams; opening for head hole, hemmed.

One central band of widely spaced zigzags; diamond shapes above and below band; two bands of geometric forms, one on shoulder, one below large central band. Evenly spaced dots on rest of *huipil*. Red wefts at end-selvedges (mark of weaving workshop).

Joining is loosely woven. Relates in center design to child's *huipil* in the Peabody Museum, Harvard University, collected by George Byron Gordon in 1901, 01-4020/C-3013. For comments see 3-240 and 3-144.

See 3-144, 3-246

Warp: cotton, singles, white; 46 epi, 16 epc
Weft: cotton, singles, white; 31 ppi, 13 ppc
Supplementary weft: cotton, 3–8 singles,
red, dark blue, light blue, peach; silk floss,
magenta, light gold; over 1–7 warps

Backstrap-loomed, balanced plain weave,
single-faced supplementary weft brocading;
two pieces, all end-selvedges loom-finished,
joined at front, back, and sides; head hole
cut, rolled, and hemmed, slit at front.

One central band of geometric designs; two
side bands of zigzags on each side of this
band; small animal figures below lower
zigzag band; evenly spaced dots and
geometric designs on rest of *huipil*. Red
wefts at bottom selvedges (mark of weaving
workshop).

An individual weaver's mark is apparent on
back side of garment: a small patch of
magenta silk floss next to one animal
design. Densely brocaded over chest area in
bands that are divided by five rows of block
designs. Joining loosely woven. San Martín
Jilotepeque *huipil*-style brocading adapted
by other villages such as Totonicapán and
San Antonio Aguas Calientes in early
nineteenth century. Some of the figure
initials for the San Martín Jilotepeque
huipiles are incorrect in O'Neale (Fig. 86);
correct figure is 86e. See 3-240 for
comments. (See Figure 54.)

O'Neale 1945

See 3-240, 3-243–3-245, 3-249

3-46
BLOUSE, *huipil*
24½" x 32½" 61 CM X 82.6 CM

CHIMALTENANGO
San Martín Jilotepeque
KAQCHIKEL

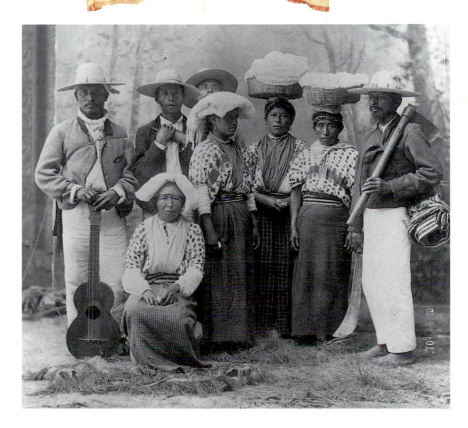

Figure 54.
group of Maya from San Martín Jilotepeque,
Chimaltenango. George Byron Gordon photo
archives, Peabody Museum of Archaeology and
Ethnology, Harvard University. 1901. H8592.

CHIMALTENANGO
San Martín Jilotepeque
KAQCHIKEL

3-240
BLOUSE, *huipil*
22" x 32" 55.9 CM x 81.3 CM

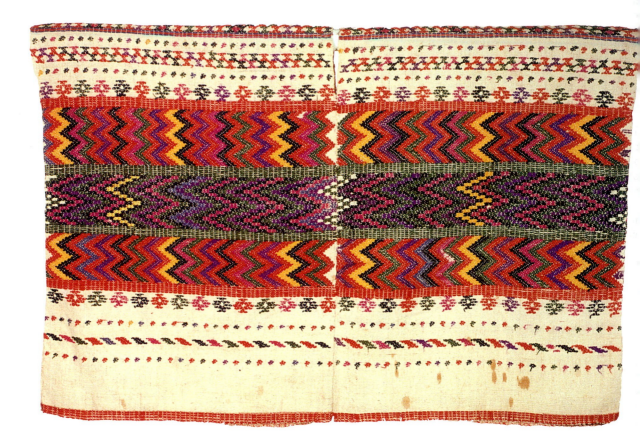

Warp: cotton, singles, white; 40 epi, 16 epc
Weft: cotton, singles, white; 2 singles, red
(alizarin); 23 ppi, 9 ppc
Supplementary weft: cotton, 3–6 singles,
red (alizarin), green, dark blue, medium
blue; wool, 2 singles, pink, purple; silk floss,
yellow, purple; over 1–11 warps

Backstrap-loomed, warp-predominant plain
weave, single-faced weft brocading; two
pieces, all end-selvedges loom-finished,
joined along front, back, and sides; opening
for head hole.

Three bands of zigzag and other geometric
designs; geometric forms over entire *huipil*;
red wefts at bottom selvedges (mark of
weaving workshop).

Eisen located the purchase of these textiles
and others (3-46, 3-144, 3-243–3-247, 3-249)
in San Martín Sacatepéquez; O'Neale
corrected the provenance to San Martín
Jilotepeque: "... from one town noted for

weavings. Trade center. Warp and wefts set
slightly apart, but not open weave. *Huipils*
characterized by dotted fields for wide bands
of geometric motives" (O'Neale: Fig. 86).
"Brocading of fine small details completely
hides basic web in some bands and makes
them a background for larger allover
patterns in others. ... General character-
istics: separate motives simple—dots,
steps, triangles, chevrons, hour glass forms,
etc. ... each zone a compact massing of
one or another of small geometric motives
favored in this locality, any and all colors,
wools and silk yarns predominating. ... One
noteworthy feature: the bands of red or blue
cotton brocading at extreme lower edges
in designs unrelated to those used in body
huipil" (ibid.: 267). Red cotton yarns dyed
with alizarin (Carlsen). Incorrectly identified
in O'Neale; correct figure is 86f.

O'Neale 1945; Carlsen, pers. com. 1987

See 3-46, 3-243, 3-244, 3-245, 3-249

Warp: cotton, singles, white; 48 epi, 19 epc
Weft: cotton, singles, white; 2 singles, red (alizarin); 20 ppi, 8 ppc
supplementary weft: cotton, 4–6 singles, red (alizarin), dark blue, yellow, green; silk floss, purple, royal blue; over 1–5 warps

Backstrap-loomed, warp-predominant plain weave, single-faced supplementary weft brocading; two pieces, all end-selvedges loom-finished, joined along front, back, and sides; opening for head hole.

Thick band of chevrons, small triangles, and diamonds across front and back; evenly spaced "dots" on rest of *huipil*; red wefts at bottom selvedges (mark of weaving workshop).

Incorrectly identified in O'Neale; correct figure is 86c. See 3-240 for comments.

O'Neale 1945

See 3-46, 3-240, 3-244, 3-245, 3-249

3-243
BLOUSE, *huipil*
23" x 30½" 58.5 CM X 77.5 CM

CHIMALTENANGO
San Martín Jilotepeque
KAQCHIKEL

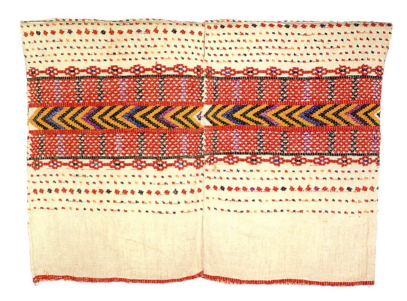

Warp: cotton, singles, white; 43 epi, 17 epc
Weft: cotton, singles, white; 2 singles, red (alizarin), dark blue; 32 ppi, 13 ppc
supplementary weft: cotton, 4–6 singles, dark blue, yellow, green; silk floss, magenta, purple; over 1–5 warps

Backstrap-loomed, warp-predominant plain weave, single-faced supplementary weft brocading; two pieces, all end-selvedges loom-finished, joined along front, back, and sides; opening for head hole.

One wide band of diamond designs across front and back; evenly spaced "dots" all over textile. Dark blue and red wefts along bottom edge at bottom selvedges (mark of weaving workshop).

Unlike other women's *huipiles* it has no zigzags in center panel. Little red is utilized; perhaps it is a mourning (*luto*) *huipil*. Coloring resembles child's *huipil* collected by George Byron Gordon in 1901 in the Peabody Museum, Harvard University, 01-020/C-3016. For comments see 3-240. Incorrectly identified in O'Neale; correct figure is 86b.

O'Neale 1945

See 3-46, 3-240, 3-243, 3-245, 3-249

3-244
BLOUSE, *huipil*
20" x 34" 50.8 CM X 86.4 CM

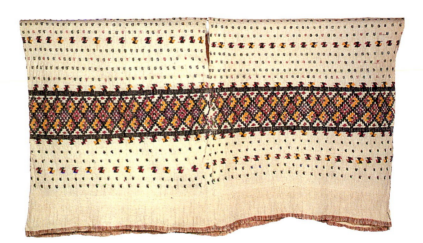

CHIMALTENANGO
San Martín Jilotepeque
KAQCHIKEL

3-245
BLOUSE, *huipil*
22" x 34½" 55.9 CM X 87.7 CM

Warp: cotton, singles, white; 34 epi, 13 epc
Weft: cotton, singles, white, red (alizarin);
16 ppi, 7 ppc
Supplementary weft: cotton, 3–6 singles,
red (alizarin), green, yellow, dark blue; wool,
singles, peach; silk floss, purple; over 1–5
warps

Backstrap-loomed, warp-predominant plain
weave, single-faced supplementary weft
brocading; two pieces, all end-selvedges
loom-finished, joined along front, back, and
sides; opening for head hole.

Wide horizontal bands of zigzags. Red wefts
at bottom selvedges (mark of weaving
workshop). Nearly all of *huipil* is covered
with designs.

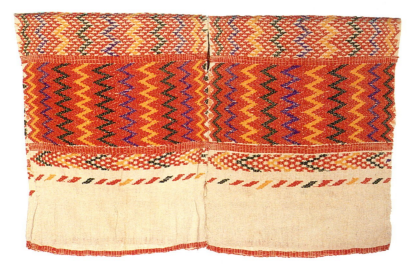

Especially wide central band, predominantly
red. Incorrectly identified in O'Neale;
correct figure is 86d. For comments see
3-240.

O'Neale 1945

See 3-46, 3-240, 3-243, 3-244, 3-249

3-249
BLOUSE, *huipil*
21½" x 32¼" 54.6 CM X 81.3 CM

Warp: cotton, singles, white; 31 epi, 13 epc
Weft: cotton, singles, white; 2 singles, red
(alizarin); 26 ppi, 11 ppc
Supplementary weft: cotton, 3–13 singles,
red (alizarin), green, yellow, dark blue; silk

floss, magenta, purple, medium blue; over
1–7 warps

Backstrap-loomed, balanced plain weave,
single-faced supplementary weft brocading;
two pieces, all end-selvedges loom-finished,
opening for head hole.

One thick band of zigzags across the front
and back; the rest is decorated with small
circles and parallelograms of supplementary
weft brocading. Several random designs and
red wefts at bottom selvedges (mark of
weaving workshop).

The joining area at the bottom is loosely
woven. Occasional thicker white wefts
create ridges above joining. A similar textile,
3-250, was exchanged with the American
Museum of Natural History (65-3280) in
1907. Resembles a *huipil* collected by
George Byron Gordon in 1901 in the
Peabody Museum, Harvard University,
01-4020/C-3012. Incorrectly identified
in O'Neale; correct figure is 86a. For
comments see 3-240.

O'Neale 1945

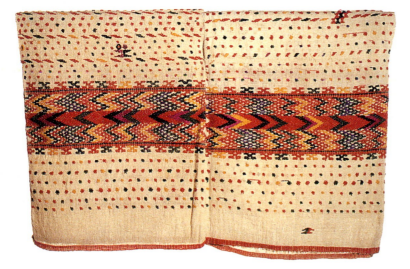

See 3-46, 3-240, 3-243, 3-244, 3-245

-158

AG, *matate*

7¾" x 17½" 45 CM X 44.5 CM

Warp: 2-ply *pita* cording, natural tan

Knotless netting; three pieces; hourglass pattern, two sprang straps attached, short strap has coiled-loop ending, longer strap is tapered; no seams.

Well used. For comments see 3-67 (Sololá, Sololá).

Warp: top—cotton, singles, red (alizarin), dark blue; bottom—singles, white, red (alizarin), dark blue, 2 singles, dark blue; 100 epi, 37 epc

Weft: top—cotton, 2 singles, red (alizarin); bottom—singles, white, medium blue, yellow, *jaspe*—white and dark blue, white and light blue; 2 singles, light green; 38 ppi, 25 ppc

Supplementary weft: cotton, 5–6 singles, orange, yellow; over 3–12 warps

Top: backstrap-loomed, warp-predominant plain weave, supplementary weft brocading; two pieces joined by buttonhole-stitched silk *randa*, warps cut and sewn to bottom; head hole cut out, sewn with tape. Bottom: backstrap-loomed, warp-predominant plain and twill weaves; two pieces, cut warps at both ends.

Top: thin warp stripes, bird and geometric forms. Bottom: weft and warp stripes.

An example of recycling a worn textile: top was probably a man's *tzute*, similar to 3-52. Bottom is of two pieces with a large patch. The cloth is worn badly on one of the bottom pieces. A well-used textile!

Carlsen, pers. com. 1987

3-155
BLOUSE, CHILD'S, *huipil*
17" x 24" 43 CM X 61 CM

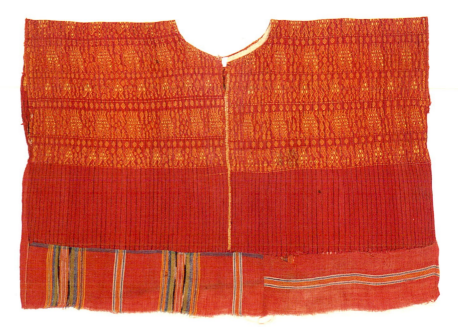

EL QUICHÉ
Chichicastenango
K'ICHE'

3-17
BLOUSE, *huipil*
31" X 38" 77 CM X 96.5 CM

Warp: cotton, singles, white; 32 epi, 12 epc
Weft: cotton, singles, white; 32 ppi, 12 ppc
Supplementary weft: silk, floss; gold, red (cochineal); over 1–3 warps

Backstrap-loomed, warp-predominant plain weave, two-faced supplementary weft brocading; three pieces, four loom-finished selvedges; head hole cut out, dark blue taffeta triangles around neck and two dark blue taffeta medallions on shoulders are outlined with gold and red silk chain stitch; three pieces are joined by dark blue cotton buttonhole stitch; underarm seams are joined.

Double-headed eagles in geometric borders are brocaded on upper front and back. Animals, birds, geometric forms on shoulders.

"Upper part of white *huipil*. Brocading by finger-weaving techniques in red and yellow yarns. Texture velvety. Black taffeta points at neckline and disks on shoulders" (O'Neale: Fig. 90a). Red silk dyed with cochineal (Carlsen). On one side, silk colors have bled onto white. Because of lavish use of silk, 3-17 may have been a ceremonial *huipil* used for *cofradía*. Similar *huipil*, 3-146, exchanged with American Museum of Natural History, 65-3274, in 1907. Part of a woman's costume: 3-35, 3-86, 3-94.

O'Neale 1945; Carlsen, pers. com. 1987

See 3-145

arp: cotton, singles, *ixcaco*; 60 epi, 23 epc
eft: cotton, singles, *ixcaco*, white; 21 ppi,
ppc
upplementary weft: cotton, 5–10 singles,
d (alizarin), orange, yellow; silk floss, light
ue, aqua, ivory, magenta (faded); over 1–3
arps

3-145
BLOUSE, *huipil*
28″ x 37¼″ 71.2 CM X 94.7 CM

EL QUICHÉ
Chichicastenango
K'ICHE'

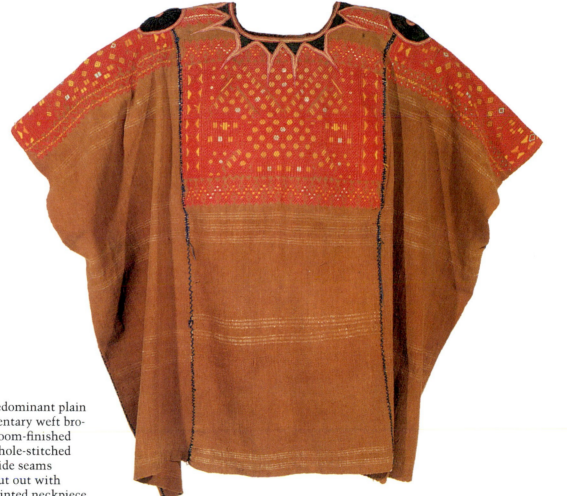

ckstrap-woven, warp-predominant plain
eave, two-faced supplementary weft bro-
ding; three pieces with loom-finished
lvedges joined by buttonhole-stitched
nda on front and back; side seams
nd-stitched; head hole cut out with
nbroidered silk taffeta pointed neckpiece,
medallion on each shoulder.

upplementary weft brocading creates
uble-headed eagles on front and back
nter panel, abstract designs on shoulder
eas. White wefts may be weaver's mark.

. . natural brown cotton *huipil* cross-
rded with pairs of white wefts" (O'Neale:
g. 90b). Red cotton colored with alizarin,
ded magenta silk floss, synthetic dye
arlsen).

'Neale 1945; Carlsen, pers. com. 1987

e 3-17

EL QUICHÉ
Chichicastenango
K'ICHE'

3-86
HEADBAND, *cinta*
133" x ⅝" 337.8 CM X 1.9 CM

Warp: cotton, commercially spun, 2 singles,
white; 24 epi, 11 epc
Weft: cotton, singles, ivory; 2 singles, red,
green; wool, singles, red; 87 ppi, 31 ppc

Treadle-headband-loomed, double-faced
twill weave; one piece, both warps cut, tied;
silk floss tied at ends.

Thick weft bands of different colors;
magenta and gold silk floss attached to ends
of *cinta*.

Woven in Totonicapán for use in
Chichicastenango. Part of a woman's
costume, 3-17, 3-35, 3-94.

3-36
HEADCLOTH, MAN'S, *tzute*
23" x 23½" 58.5 CM X 60 CM

Warp: cotton, singles, white; 80 epi, 28 epc
Weft: cotton, singles, white; 2 singles, red;
28 ppi, 11 ppc
Supplementary weft: cotton, 8–14 singles,
red, orange, yellow; over 3–9 warps

Backstrap-loomed, warp-predominant plain
weave, two-faced supplementary weft
brocading; two pieces joined by cotton
thread in buttonhole-stitched *randa*, all
warps cut and hemmed; red and orange
6" tassels attached to four corners in
buttonhole stitch.

Weft stripes. Large humpbacked,
multilegged animals, geometric fillers, and
little animals in horizontal rows, placed
randomly. One human motif. Abstract form
may be weaver's sign.

Weaver's sign is embroidered in purple
(cochineal) silk (Carlsen). See 3-35 for Eisen
notes. Listed as a woman's shawl or
headcloth. However, tassels indicate a man'
tzute. One *tzute*, 3-15, was exchanged with
American Museum of Natural History, 65-
3272, in 1907.

Carlsen, pers. com. 1987

See 3-41, 3-52, 3-56, 3-142

41

HEADCLOTH, MAN'S, *tzute*

23" x 25½" 58.5 CM X 64 CM

EL QUICHÉ
Chichicastenango
K'ICHE'

Warp: cotton, singles, white; 8 epi, 32 epc
Weft: cotton, singles, white; 44 ppi, 17.5 ppc
Supplementary weft: cotton, 5–6 singles,
red, yellow, orange; silk floss, purple
(synthetic dye), turquoise; over 2–18 warps

Backstrap-loomed, warp-predominant plain
weave, two-faced supplementary weft
brocading; two pieces joined by silk thread
in buttonhole-stitched *randa*, two end-
selvedges loom-finished, other warps cut
and hemmed; red cotton 11½" tassels
attached to four corners by silk thread in
buttonhole stitch.

Two large double-headed eagles with
multiple wings and claws within geometric
borders dominate the center; horizontal
rows of small birds, two- and four-legged
large and small animals, some randomly
placed. Weaver's mark may be a small bird of
lavender silk and red cotton. Arrangement of
motifs is not the same on both sides.

"*Tzute* folded on diagonal, folded edge
crosses forehead loosely, side corners tied
over back corner in large knot" (O'Neale:
56). In 1936 O'Neale noted that headcloths
were still worn by many men of middle age
and older. Silk floss joining the two pieces is
colored with a synthetic purple dye
(Carlsen). Colored yarns delicately placed
within motifs makes this textile alive and
exciting.

O'Neale 1945; Schevill 1985:29–30;
Carlsen, pers. com. 1987

See 3-36, 3-52, 3-56, 3-142

EL QUICHÉ
Chichicastenango
K'ICHE'

3-52

HEADCLOTH, MAN'S, *tzute*
22" X 24½" 56 CM X 62.2 CM

Warp: cotton, singles, white, red (alizarin);
108 epi, 43 epc
Weft: cotton, singles, red (alizarin); 25 ppi,
10 ppc
Supplementary weft: cotton, 6 singles,
yellow, orange; silk floss, red, peach; over
3–6 warps

Backstrap-loomed, warp-predominant plain
weave, two-faced supplementary weft
brocading; two pieces joined by silk
buttonhole-stitched *randa*, warps cut and
hemmed. Four 5" lavender silk tassels
attached to each corner.

Warp stripes; bird and animal forms.

"Within the wide white stripe on the right
side, the personal mark of the weaver
appears—a little silk bird" (Schevill: 31).
Red silk colored with natural cochineal dye,
red cotton with alizarin (Carlsen). Out of six
tzutes in the Eisen collection, this is the
only red example.

Schevill 1985; Carlsen, pers. coms. 1987,
1989

See 3-36, 3-41, 3-56, 3-142

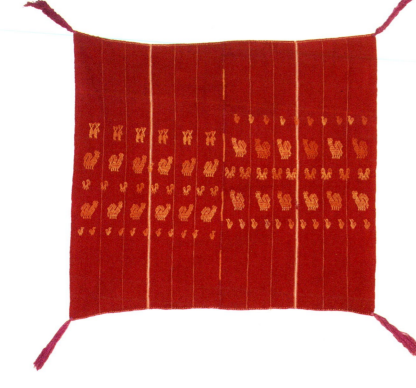

3-56

HEADCLOTH, MAN'S, *tzute*
19½" X 22" 48.3 CM X 56 CM

Warp: cotton, singles, white; 57 epi, 22 epc
Weft: cotton, singles, white, red; 29 ppi, 12
ppc
Supplementary weft: cotton, 4–5 singles,
red, orange; over 3–6 warps

Backstrap-loomed, warp-predominant plain
weave, two-faced supplementary weft
brocading; two pieces joined by buttonhole-
stitched *randa*, warps cut and hemmed; four
6" tassels attached at each corner.

Bird, animal, and geometric forms.

". . . free-standing brocaded silk motifs
similar to those in women's blouses still
worn as headcloths by many men of middle
age and older" (O'Neale: 256).

O'Neale 1945

See 3-36, 3-41, 3-52, 3-142

-142
HEADCLOTH, MAN'S, *tzute*
7" X 20" 43.5 CM X 50.9 CM

Warp: cotton, singles, white; 80 epi, 32 epc
Weft: cotton, singles, white; silk floss, gold;
5 ppi, 18 ppc
Supplementary weft: cotton, 3–4 singles,
ed, yellow; over 2–6 warps

Backstrap-loomed, warp-predominant plain
weave, two-sided supplementary weft
brocading; two pieces joined by buttonhole-
stitched *randa*; warps cut and hemmed with
gold silk floss and cotton yarns; a magenta
and gold silk 7" tassel attached to each of
the four corners.

various animal and bird forms; gold silk
weft stripes and a double hexagonal form
may be the weaver's mark.

"Near Quiché" (Eisen). Eisen called 3-142
cap or *xute* also used around the neck.
Birds and animals similar to those woven
today" (O'Neale: Fig. 108b). Lehmann
corrected the identification calling 3-142
man's *tzute*. The magenta and gold silk
re colored with synthetic dyes (Carlsen).
ze of *tzute* and use of silk indicates a
ceremonial textile.

isen 1902b; O'Neale 1945; Lehmann 1962;
arlsen, pers. com. 1987

ee 3-36, 3-41, 3-52, 3-56

EL QUICHÉ
Chichicastenango
K'ICHE'

3-11
OVERSHIRT, *cotón*
17½" X 21" 44.5 CM X 53.3 CM

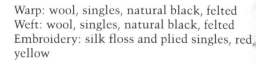

Warp: wool, singles, natural black, felted
Weft: wool, singles, natural black, felted
Embroidery: silk floss and plied singles, red, yellow

Treadle-loomed, twill weave; three pieces, five ends cut and hand-stitched; head hole cut out, rectangular standing collar; silk embroidery on collar, around head hole, on front, cuffs, and bottom edges; head hole an center of sun motif lined with blue silk taffeta; one ½" plied silk fringe on back bottom; cut warps at back end create a 1" fringe.

Sun motif with dark blue silk taffeta center embroidered with red and yellow silk floss at center front of textile. Curvilinear embroidery in silk floss (red and yellow) on side seams and cuffs.

"Ornamentation ancient" (Eisen). New textile. Cut-and-sewn garment. Standing collar is of dark blue wool. Unable to obtain a warp and weft count because of felting. Se 3-154 for comments.

Eisen 1902b

See 3-10

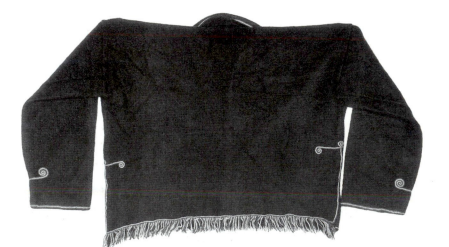

Warp: wool, singles, natural black; 32 epi,
3 epc
Weft: wool, singles, natural black; 36 ppi,
4 ppc
Embroidery: silk floss, 2-ply, orange and
magenta (faded), looks silver

Treadle-loomed, twill weave; three pieces,
head hole cut out, rectangular standing
collar, embroidered with silk floss in chain
stitch on collar around head hole, on cuffs,
and on front; back end fringed with silk;
cotton pocket on underside; other warps cut
and hemmed; cut warps and knotted warps
at back end create a ¾" fringe.

Sun motif with blue silk taffeta center
embroidered in (faded) orange and magenta
silks at center front of textile.

"Another valuable object was a costume of a
Quiché Indian embroidered with the 'Sun of
Quiché' procured with assistance of the
Governor of Quiché at that time. It was very
old and not made to order" (Eisen). "Lines of
chain-stitch embroidery following edges and
seams characteristic; garments of men
important in life of community; may have
sun motive embroidered in red and yellow
silks at center front; young men favor floral
and bird motives" (O'Neale: 257). Large
patch pockets of muslin or gingham are
sewn on underside of short overshirts. Well-
worn textile. Cut-and-sewn garment.
Standing collar of dark blue wool.

Eisen 1938; O'Neale 1945

See 3-150

3-154
OVERSHIRT, *cotón*
20½" x 21" 52.1 CM X 53.3 CM

EL QUICHÉ
Chichicastenango
K'ICHE'

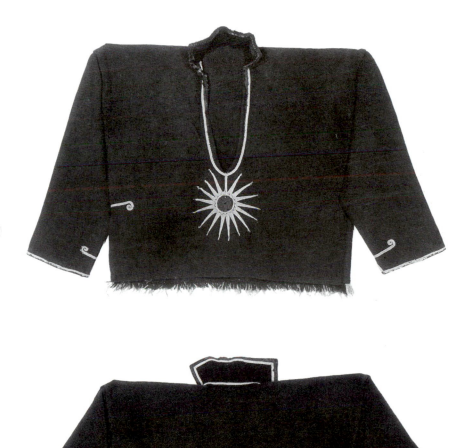

EL QUICHÉ
Chichicastenango
K'ICHE'

3-10
PANTS, *pantalón*
25" X 27" 63.6 CM X 68.6 CM

3-150
PANTS, *pantalón*
26" X 31" 66.1 CM X 78.8 CM

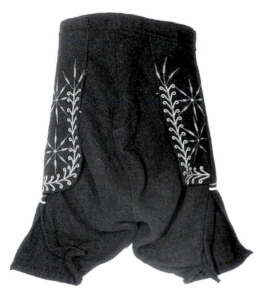

Warp: wool, singles, natural black; 16 epi,
6.5 epc
Weft: wool, singles, natural black; 16 ppi,
6.5 ppc
Embroidery: silk floss and plied singles,
yellow, red

Treadle-loomed, twill and plain weaves;
eight pieces; hand-sewn together.

Plants and suns embroidered in yellow and
red silk floss on side flaps.

"The cut is ancient ornamentation Spanish
type" (Eisen). New textile. Cut-and-sewn
garment. No apparent clasp or button for
closure on waistband. Collar is plain weave,
not as highly fulled as other pieces. See
3-150 for comments.

Eisen 1902b

See 3-11

Warp: wool, singles, natural black; 31 epi,
12 epc
Weft: wool, singles, natural black; 31 ppi,
12 ppc
Embroidery: silk floss, orange, magenta
(faded); looks silver

Treadle-loomed, twill weave; eight pieces;
hand-stitched seams.

Plants, suns, deer, and birds embroidered
in orange and magenta (faded) silk on side
flaps.

". . . Short brownish black wool trousers,
like nothing else in highland costumes;
three features set them apart: the cut . . . the
flaps or 'ears' at sides, and embroidery on
them; main motive sun symbol with many
rays; position and size indicates age of
wearer according to explanation given; some
embroidery elaborate, much simple, many
trouser flaps decorated" (O'Neale: 257). Cut-
and-sewn garment. Well worn; patched at
the knees from the inside with a large piece
of black felted wool; waistband closed with
French brass button; silk overcast-stitched
clasps hold seams under side flaps together.

O'Neale 1945

See 3-154

-35
SHAWL/HEADDRESS, WOMAN'S,
zute
9½" x 34½" 75 CM X 88 CM

Warp: cotton, singles, white, brown (*ixcaco*),
dark blue; 2 singles, red; 45 epi, 18 epc
Weft: cotton, singles, white; 2 singles,
yellow, white; 22 ppi, 9 ppc
supplementary weft: cotton, red, yellow,
orange, green, faded light blue, and dark
blue; silk floss, white; over 1–5 warps

Backstrap-loomed, warp-predominant plain
weave, two-faced supplementary weft
brocading; two pieces joined with
buttonhole-stitched cotton *randa*, all warps
cut and hemmed.

Warp stripes; large, multilegged animals,
small birds, double-headed eagles, monkeys
in horizontal rows and randomly placed.

"The xute is used by both men and women.
Wrapped around the head, when large
enough around the shoulders" (Eisen).
However, 3-35 has no tassels, an important
feature of men's *tzutes*. O'Neale's informant
called 3-35 an old time *servilleta*.
"Headcloth seemingly the one article of
costume through which weaver can express
her individuality to the fullest" (O'Neale:
257). Silk floss and dark blue cotton used
sparingly in supplementary weft brocade.
Two red-lavender warp threads on each half
of cloth, no visible start or end points. Part
of a woman's costume, 3-17, 3-86, 3-94.

Eisen 1902b; O'Neale 1945

EL QUICHÉ
Chichicastenango
K'ICHE'

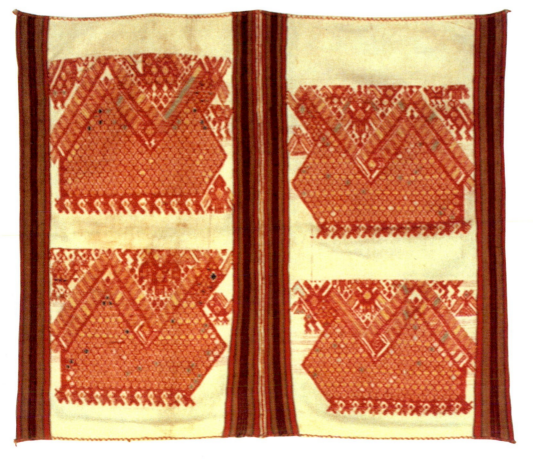

EL QUICHÉ
Chichicastenango
K'ICHE'

3-121
SHOULDER BLANKET, *chamarro*
78" X 33–36" 198 CM X 83.9–91.5 CM

Warp: wool, singles, natural black; 20 epi,
8 epc
Weft: wool, singles, natural white, black,
dark blue (indigo), red (cochineal); 2 singles,
white; 14 ppi, 5 ppc

Treadle-loomed, twill, plain weft-faced,
and interlocked tapestry weaves; one piece,
cut and plied warps at both ends create
8" fringes.

Tapestry-woven geometric designs: checks,
arrow points, diamonds. Rest of textile is
checkered (dark brown and white) with thin
black-brown stripes at regular intervals.

"Indian *zarape* or *chamarro*" (Eisen). "Large
heavy weaving of natural dark brown and
white wool. Borders of red and blue squares,
lozenges, and motives similar to arrow
points all in tapestry techniques. Later

blankets of solid color with borders. Borders
unchanged" (O'Neale: 127). "This locally
woven accessory to costume famous for
distinctive design and coloring; sizes vary,
but rectangles about 64" to 75" by 34"
typical; shape never regular owing to change
in technique from plain weave to vigorously
battened tapestry weave of end borders
which are spread in process of making;
foundation color, black or brownish black
of wool is left natural; motives like arrow
points, checks, and diamonds in deep rose-
red, bright blue, white, fringes very long
and heavy much in evidence in walking.
Blankets carried over tops of bags, or hung a
back across tumpline or from strap crossing
chest" (ibid.: 257). Dark blue wool is dyed
with indigo and the red wool with cochinea
(Carlsen). Part of men's costumes: 3-107,
3-56, 3-29, 3-10, 3-11, 3-158.

Eisen 1902b; O'Neale 1945; Carlsen, pers.
com. 1987

See 3-12, 3-122

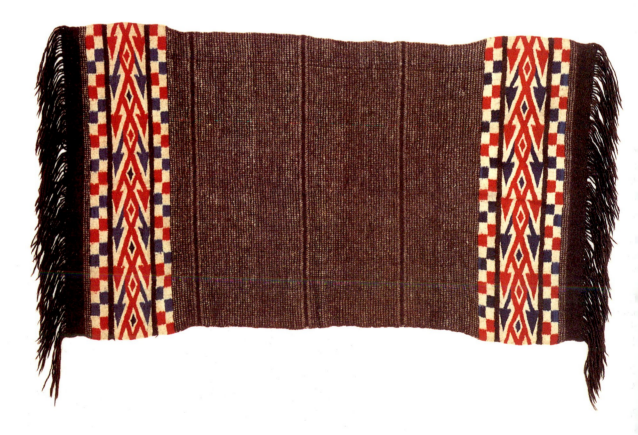

Warp: wool, singles, natural black; 16 epi,
 epc
Weft: wool; singles, natural white and black,
ed (cochineal), dark blue (indigo); 2 singles,
atural white; 15 ppi, 6 ppc

Treadle-loomed, twill, plain weft-faced,
nd interlocked tapestry weaves; one piece,
ut and plied warps at both ends create
o" fringes.

Tapestry-woven, geometric, checkered,
iamond, and arrow-point designs. Rest of
extile is checkered with thin stripes of
rown and white at regular intervals.

Chamarro of native. . . . Ornamentation
ncient" (Eisen). *Chamarros* still woven
n 1988. Another *chamarro*, 3-13, was
xchanged with the American Museum of
Natural History, 65-3271. Dark blue wool
s dyed with indigo and red wool with
ochineal (Carlsen). Part of men's costumes:
-10, 3-11, 3-29, 3-56, 3-107, 3-158. For
omments see 3-121.

Eisen 1902b; Carlsen, pers. com. 1987

ee 3-121, 3-122

3-12
SHOULDER BLANKET, *chamarro*
98" x 34½–37½" 249 CM X 86.4–
95.3 CM

EL QUICHÉ
Chichicastenango
K'ICHE'

Warp: wool, singles, natural black; 20 epi,
 epc
Weft: wool, singles, white, natural black,
ark blue (indigo), rose-red (cochineal);
 singles, white; 15 ppi, 6 ppc

Treadle-loomed, twill, plain weft-faced,
nd interlocked tapestry weaves, one piece,
ut and plied warps create 9" fringes.

Tapestry-woven designs; checks, arrow
oints, diamonds. Rest of textile is
heckered (black-brown and white) with
hin black-brown stripes at regular intervals.

Dark blue wool is dyed with indigo and the
ed wool with cochineal (Carlsen).

Part of men's costumes: 3-10, 3-11, 3-29,
-56, 3-107, 3-158. For comments see 3-121.

Carlsen, pers. com. 1987

See 3-12, 3-121

3-122
SHOULDER BLANKET, *chamarro*
82" x 32–35" 208.3 CM X 82.5–
88.9 CM

EL QUICHÉ
Chichicastenango
K'ICHE'

3-107
SOMBRERO, *sombrero*
3⅛" x 13" 8.25 CM x 33 CM

Fiber: twisted palm leaves

Twill plaiting of layered strips, hand-stitched in spiral to form flat crown.

Top of crown filled in with very small (1" circumference) palm leaf fiber in spiral design hand-stitched to plaiting. Black silk ribbon hatband, 1½" wide, pinned to base of crown.

This is the only hat in the collection labeled by Eisen as "Sombrero of Native Indian" (Eisen). Part of a man's costume: 3-10, 3-11, 3-12, 3-29, 3-56, 3-158.

Eisen 1902b

See 3-312 (Jacaltenango, Huehuetenango)

3-29
WAISTBAND, MAN'S, *faja*
108" x 6½" 274.4 CM x 16.5 CM

Warp: cotton, 2 singles, red, yellow; 69 epi, 28 epc
Weft: cotton, 2 singles, red; 29 ppi, 11 ppc

Backstrap-loomed, warp-faced plain weave; one piece, cut and twisted warps create two 5½" fringes on both ends.

Warp-faced stripes.

"Belts long enough to go twice around waist; ends meeting in front, turn about each other, and each draw away to tuck under folds at sides . . ." (O'Neale: 257). Part of a man's costume: 3-10, 3-11, 3-12, 3-56, 3-107, 3-158.

O'Neale 1945

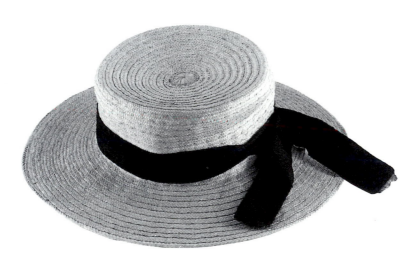

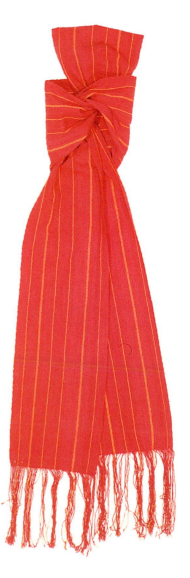

-93
VAISTBAND, WOMAN'S, *faja*
10" X 1½"　282 CM X 4 CM

3-94
WAISTBAND, WOMAN'S, *faja*
122" X 2"　310 CM X 5.1 CM

EL QUICHÉ
Chichicastenango
K'ICHE'

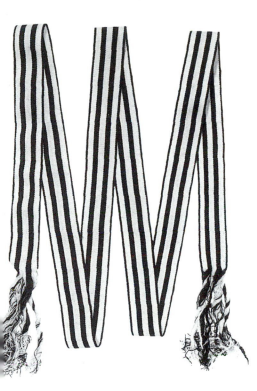

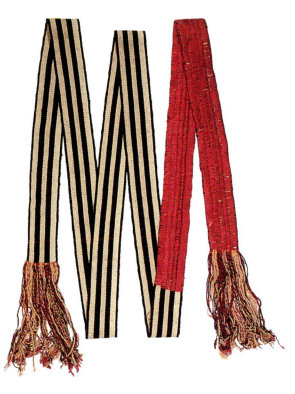

Varp: wool, single 2-ply, white, black;
7 epi, 40 epc
Veft: wool, single 2-ply, black; 19 ppi, 8 ppc

ackstrap-belt-loomed, warp-faced plain
veave; one piece, cut warps at both ends
wisted to create two 6½" fringes.

Varp stripes.

The Chichi belts in tight little rolls are
old without embroidery or fringe. Prices
egin at 10 cents" (O'Neale: 160). Unused
extile. Belts are woven by men, sold all over
he highlands; town-specific belts are
dentified by their embroidered motifs.

)'Neale 1945

ee 3-94; 3-124 (San Antonio Las Flores,
;uatemala)

Warp: wool, single 2-ply, white, black;
74 epi, 30 epc
Weft: wool, single 2-ply, black; 15 ppi, 6 ppc
Embroidery: red silk (cochineal) floss

Backstrap-belt-loomed, warp-faced plain
weave, cut warps at both ends; silk threads
twisted with warps to create 6" and 7"
fringes; overcast silk embroidery covers
a 31½" section of the textile.

Warp stripes; embroidery is simple overcast
stitch.

"Very simple embroidery in silk floss.
Stripes guide to embroiderer who works
without patterns" (O'Neale: Fig. 122e). Red
silk dyed with cochineal (Carlsen). Part of
a woman's costume: 3-17, 3-35, 3-86, and
3-18, a skirt exchanged with American
Museum of Natural History, 65-3273, in
1907. Gold and red silk yarns twisted with
black-and-white wool warps create rich and
decorative fringes.

O'Neale 1945; Carlsen, pers. com. 1987

See 3-93; 3-124 (San Antonio Las Flores,
Guatemala)

EL QUICHÉ
Nebaj
IXIL

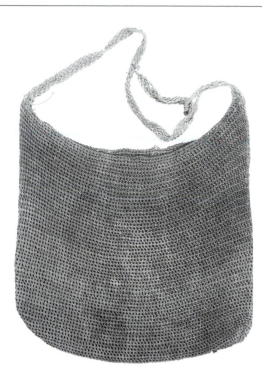

3-265
BAG, *bolsa*
17⅛" x 20" 43.5 CM X 51 CM

Warp: 2-ply *pita*, natural tan (darkened by age or use)

Knotless netting, loop and twist pattern; three pieces, two straps attached to body, short strap has coiled loop ending; longer strap is tapered. No seams.

"Used by men in Aguacatán . . . probably from Nebaj" (Eisen).

Eisen 1902b

See 3-158 (Chichicastenango); 3-159 (Santa Cruz del Quiché); 3-257 (Santa Eulalia, Huehuetenango)

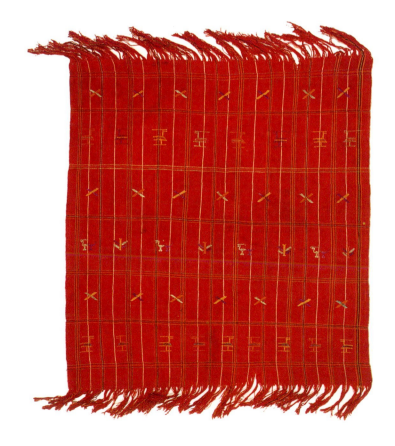

3-217
HEADCLOTH, MAN'S, *servilleta/ tzute*
39½" x 29" 100.3 CM X 73.7 CM

Warp: cotton, 2 singles, white, red (alizarin), orange, green (indigo plus), yellow; 58 epi, 24 epc
Weft: cotton, 2 singles, red (alizarin); 31 ppi, 13 ppc
Supplementary weft: cotton, 2–8 singles, orange, yellow-green; silk floss, aqua, purple; over 2–4 warps

Backstrap-loomed, warp-predominant plain weave, single-faced supplementary weft brocading; cut warps at both ends twisted into 4" fringes.

Thin warp and supplementary weft stripes create plaid patterns. Various animals and geometric forms.

"Brocaded figures in onlay and soumak techniques" (O'Neale: Fig. 114b). Red cotton is dyed with alizarin; plus indicates that other dye element is present (Carlsen). Supplementary weft floats create a streamer effect.

O'Neale 1945; Carlsen, pers. com. 1987

-33
WAISTBAND, MAN'S, *faja*
05" X 10½" 266.5 CM X 27 CM

3-34
WAISTBAND, MAN'S, *faja*
106½" X 11½" 270 CM X 29.5 CM

EL QUICHÉ
Nebaj
IXIL

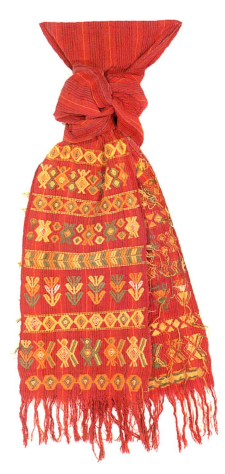 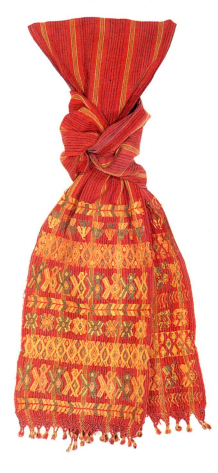

Warp: cotton, 2 singles, red, yellow, dark
blue; 53 epi, 22 epc
Weft: cotton, 2 singles, red; 30 ppi, 12 ppc
Supplementary weft: cotton, 6–8 singles,
yellow, orange, green; silk floss, white; over
–39 warps

Backstrap-loomed, warp-faced plain weave,
two-sided supplementary weft brocading;
one piece, cut warps at ends create two
' fringes.

Warp stripes. Supplementary weft brocaded
birds, plant forms, and geometric units.

This specimen and 3-34 were "possibly
woven by same woman . . . work noticeably
at by comparison with today's brocading"
O'Neale: 282). "Woven in San Juan Cotzal
nd used by men and women" (Deuss).

O'Neale 1945; Deuss, pers. com. 1988

See 3-34

Warp: cotton, 2 singles, red, dark blue,
yellow, green, orange; 82 epi, 30 epc
Weft: cotton, 2 singles, red; 22 ppi, 9 ppc
Supplementary weft: cotton, 8–10 singles,
yellow, orange, green; over 5–34 warps

Backstrap-loomed, warp-faced plain weave,
two-sided supplementary weft brocading;
one piece, cut warps at ends knotted and
braided into two 1½" fringes.

See iconography of 3-33.

For comments see 3-33.

See 3-33

EL QUICHÉ
Nebaj
IXIL

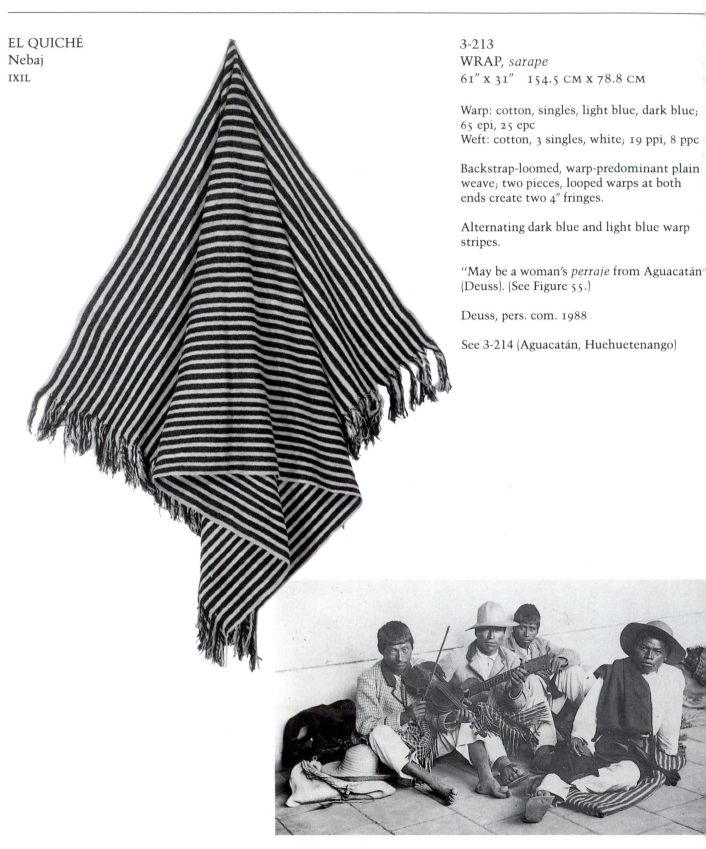

3-213
WRAP, *sarape*
61″ x 31″ 154.5 CM X 78.8 CM

Warp: cotton, singles, light blue, dark blue;
65 epi, 25 epc
Weft: cotton, 3 singles, white; 19 ppi, 8 ppc

Backstrap-loomed, warp-predominant plain
weave; two pieces, looped warps at both
ends create two 4″ fringes.

Alternating dark blue and light blue warp
stripes.

"May be a woman's *perraje* from Aguacatán"
(Deuss). (See Figure 55.)

Deuss, pers. com. 1988

See 3-214 (Aguacatán, Huehuetenango)

Figure 55.
Maya men from Nebaj, El Quiché. George Byron
Gordon photo archives, Peabody Museum of
Archaeology and Ethnology, Harvard University.
1901. H8461.

-159
AG, *matate*
6" x 12" 43 CM X 31 CM

arp: 2-ply *pita* cording, natural tan

notless netting; three pieces, hourglass
ttern; two straps are in sprang technique,
tached to body; short strap has coiled loop
ding, longer strap is tapered, no seams.

ell worn. For comments see 3-67 (Sololá,
olá).

e 3-158 (Chichicastenango); 3-265 (Nebaj);
257 (Santa Eulalia, Huehuetenango)

3-149
GARMENT, *delantal*
38" x 26" 96.6 CM X 66.1 CM

Warp: cotton, 2 singles, white; 35 epi, 14 epc
Weft: cotton; 2 singles, white, red, yellow,
dark blue, turquoise (faded), medium blue;
silk floss, aqua, purple; 54 ppi, 22 ppc

Treadle-woven, balanced plain and diamond
twill weaves; one piece, warps cut at both
ends; weft yarns carried up one side
selvedge.

Weft stripes of varying colors and widths.
Variations of diamond twill create unusual
patterns.

May have been used as an apron. Plain
weave only on ends. Diamond twill weaves
create a textile of great interest.

EL QUICHÉ
Santa Cruz del Quiché
K'ICHE'

EL QUICHÉ
Santa Cruz del Quiché
K'ICHE'

3-156 *(left)*
WAISTBAND, WOMAN'S, *faja*
42½" x 1¼" 108 CM X 3.2 CM

Warp: cotton, singles, white, red, green,
yellow; 86 epi, 32 epc
Weft: cotton, 8–10 singles, white; 17 ppi,
7 ppc

Backstrap-belt-loomed, warp-faced plain
weave, one piece, cut and braided warps at
both ends create two 3½" fringes.

Weft stripes of alternating colors.

"All stiff belt looms are warped in same
manner. White yarns alternate with the one
or two colors used. Belt loom is the regular
stick loom with all the standard parts plus
pattern stick and a supplementary heddle.
The pattern stick is inserted under every
other odd-numbered one (the colored ones)"
(O'Neale: 68–69). "Still in use in the
highlands" (Deuss).

O'Neale 1945; Deuss, pers. com. 1988

See 3-157

3-157 *(right)*
WAISTBAND, WOMAN'S, *faja*
54½" x 1½" 137.2 CM X 3.8 CM

Warp: cotton, singles, white, red, green,
yellow, black; 81 epi, 30 epc
Weft: cotton, two 4-ply, white; maguey,
multiple singles, natural color; 14 ppi, 6 pp

Backstrap-belt-loomed, warp-faced plain
weave; one piece, cut and braided warps at
both ends create two 4" fringes.

Weft stripes of alternating colors, warp
stripes.

"Woven by professional weavers at
Totonicapán, Huehuetenango, and San Ped
Sacatepéquez, San Marcos. Cotton-maguey
combination makes a strong belt with good
body" (O'Neale: 158). "Style still in use"
(Deuss). Two braids on one end, three on th
other. Maguey wefts strengthen and thicke
the textiles.

O'Neale 1945; Deuss, pers. com. 1988

See 3-156

-239
LOUSE, *huipil*
7" x 40" 68.2 CM X 101.6 CM

GUATEMALA
Mixco
POQOMAM

arp: cotton, 3 singles, white; 33 epi, 13 epc
eft: cotton, 3 singles, white; 18 ppi, 7 ppc
upplementary weft: cotton, two 2-ply
ngles, purple (*Purpura patula*); 6 singles,
ark blue; over 4–9 warps

ackstrap-woven, warp-predominant plain
eave, single-faced supplementary weft
rocading; two pieces, four end-selvedges
om-finished, joined along front and back,
de seams open; no head hole cut out but
dicated with an unbrocaded square.

upplementary weft brocading covers top
alf of *huipil* on front and back; various
ometric designs in horizontal bands.

style of patterning suggests use of warp-
ting devices" (O'Neale: Fig. 85b). "Four
rments analyzed white with heavily
rocaded sections in colors; decorated areas,
ther in broad bands front and back or in

bands separated by plain color stripes, are
built up through repetition of geometric
patterns: lozenge forms, oval dot with long
'streamers', vertical zigzags in contrasting
colors and steps of small squares; in old
specimen brocaded patterns of same type
testify to the fairly constant adherence
to simple motives and arrangements"
(O'Neale: 278). O'Neale also suggests that
extra pattern sheds may be in use. Eisen
attributed provenance of 3-239 to San
Martín Sacatepéquez; Lehmann corrected
it to Mixco (Lehmann). Purple dye is
Purpura patula (Carlsen). Similar to 3-248,
exchanged with the American Museum of
Natural History, 65-3291, in 1907. (See
Figure 56.)

O'Neale 1945; Lehmann 1962; Carlsen,
pers. com. 1988

See 3-242

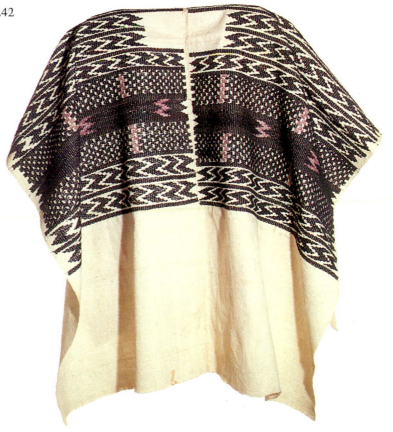

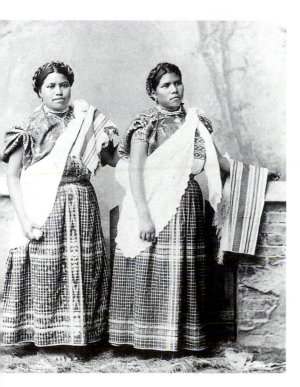

gure 56.
aya women from Mixco, Guatemala. George
ron Gordon photo archives, Peabody Museum
Archaeology and Ethnology, Harvard
niversity. 1901. H8554.

GUATEMALA	3-242	Warp: cotton, 3 singles, white; 23 epi, 9 epc
Mixco	BLOUSE, *huipil*	Weft: cotton, 3 singles, white; 23 ppi, 9 ppc
POQOMAM	26" x 37½" 66.1 CM X 95.3 CM	Supplementary weft: cotton, 4–6 singles, dark blue, red, orange, green; over 2–10 warps

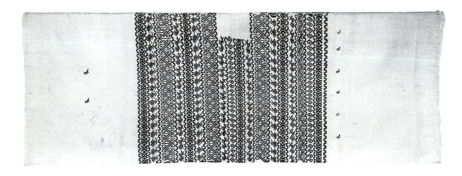

Backstrap-woven, balanced plain weave, two-faced supplementary weft brocading; two pieces, four end-selvedges loom-finished, joined along front and back, side seams open; no head hole cut out but indicated by an unbrocaded square.

Supplementary weft brocading covers top half of *huipil* on front and back; geometric and animal and bird designs (deer or rabbit); one row of red supplementary weft brocade at bottom of one side contrasts with dark blue brocading; six multicolored motifs may be weaver's marks.

"Finer weaving techniques" (O'Neale: Fig. 85a). Not as densely brocaded as 3-239; individual motifs stand out. For comments see 3-239.

O'Neale 1945

See 3-239

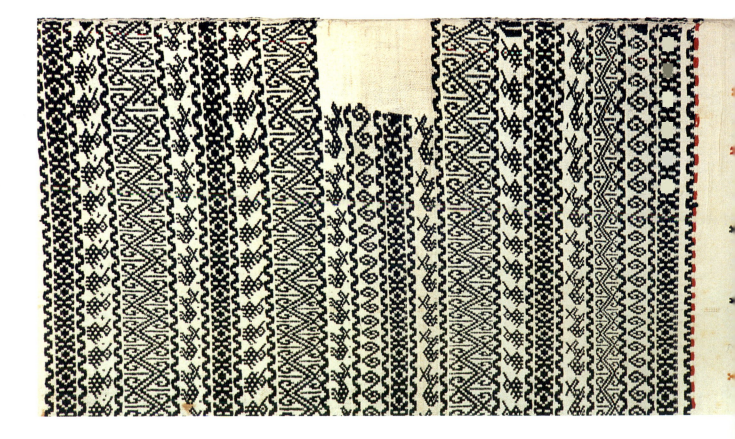

-131
HEADBAND, *cinta*
38″ x ¼″ 604.5 CM X 0.6 CM

iber: wool, natural black

Handspun, one piece, felted.

"Used to wind in woman's hair" (Eisen).
Eisen specimen known as *cordon*, a felted
ord of black wool . . . usually worn wrapped
round hanging hair, then all piled on top
f head" (O'Neale: 253). "Worn in Santa
ulalia, *altiplano*, Huchuetenango . . . also
s a drawstring" (Deuss).

isen 1902b; O'Neale 1945; Deuss, pers.
om. 1988

ee 3-215 (San Juan Ixcoy, Huehuetenango)

-124
WAISTBAND, WOMAN'S, *faja*
18″ x 2¼″ 300 CM X 5 CM

Warp: wool, single 2-ply, white, black;
6 epi, 32 epc
Weft: wool, single 2-ply, black; 18 ppi, 7 ppc
mbroidery: wool, singles, red (synthetic),
lue, orange; silk floss, purple

ackstrap-belt-loomed, warp-faced plain
eave; cut warps at both ends, red wool
arn twisted with warps, additional blue,
range, red yarns added; embroidered with
ed wool at both ends.

Warp stripes; geometric forms in solid rows;
ne 5″ row of purple silk stitches, may be
eaver's mark.

For a woman" (Eisen). Red wool dyed with
ynthetic dye (Carlsen). Belt woven in
hichicastenango, embroidered in San
ntonio Las Flores. Embroidery densely
pplied.

isen 1902b; Carlsen, pers. com. 1987

ee 3-93, 3-94 (Chichicastenango, El Quiché)

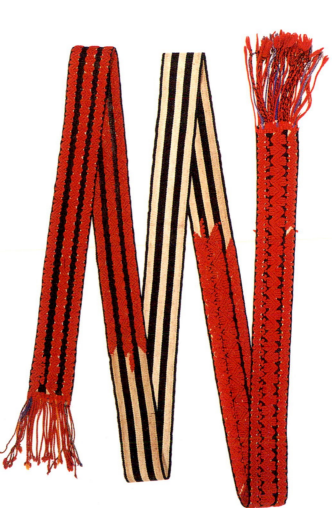

GUATEMALA
San Juan Sacatepéquez
KAQCHIKEL

3-141
BLOUSE, *huipil*
26" x 47½"　66.1 CM X 120.6 CM

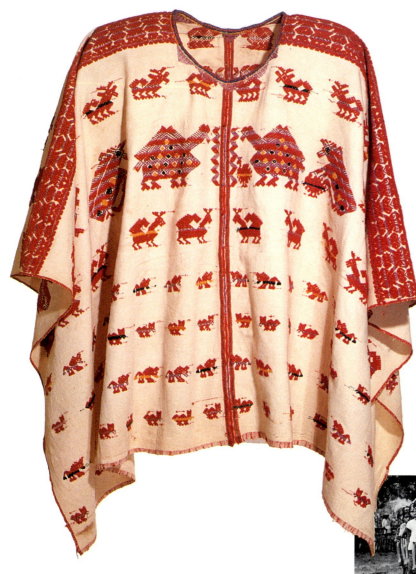

Warp: cotton, 2 singles, white; 6 singles, green, red (alizarin); 43 epi, 18 epc
Weft: cotton, 2 singles, white; 6 singles, red (alizarin); 29 ppi, 12 ppc
Supplementary weft: cotton, 2–12 singles, red (alizarin), yellow, orange, blue-green, purple (*Purpura patula*); over 2–6 warps
Embroidery: yellow silk, red, blue (indigo)

Backstrap-loomed, warp-predominant plain weave, two-sided supplementary weft brocading; two pieces, four end-selvedges loom-finished; joined along the center in back stitch, side seams open; head hole cut out and sewn in whipping stitch.

Large and small bird and animal forms; geometric bands on shoulder, warp stripes on side-selvedges.

"Plain whipping stitches over neckline edge" (O'Neale: Fig. 81t). "Important piece; changed completely; design from Chichicastenango" (Lehmann). "A wedding *huipil* from Santo Domingo Xenacoj, Sacatepéquez" (Arriola de Geng). The purple, blue, and red yarns are dyed with *Purpura patula*, indigo, and alizarin respectively (Carlsen). Supplementary weft yarns loosely laid in, tightly beaten; creates effect of looped pile.

O'Neale 1945; Lehmann 1962; Carlsen, pers. com. 1987; Arriola de Geng, pers. com. 1989

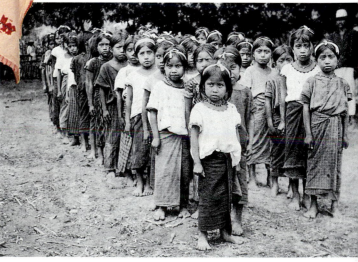

Figure 57.
"Indian girls in the fiesta of Minerva. San Miguel" (Eisen 1902c). *Huipiles* resemble 3-199 acquired in Aguacatán, Huehuetenango. Photo by Gustavus A. Eisen. 1902.

Warp: cotton, singles, white; 40 epi, 17 epc
Weft: cotton, singles, white; 44 ppi, 16 ppc

Treadle-loomed *manta*, balanced plain
weave; four pieces; head hole and V neck cut
out; commercial cloth trim at neck and
cuffs; all seams and trim machine-stitched.

3-200
BLOUSE, CHILD'S, *huipil*
10½" x 12" 27 CM X 30.5 CM

HUEHUETENANGO
Aguacatán
AWAKATEKO

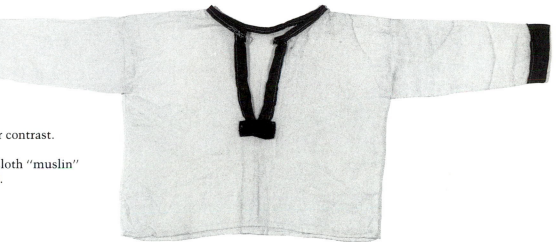

Trim creates design in color contrast.

O'Neale calls commercial cloth "muslin"
(O'Neale: Fig. 43b). Unused.

O'Neale 1945

See 3-199, 3-202

3-199
BLOUSE, *huipil*
20" x 25" 50.8 CM X 63.5 CM

Warp: cotton, singles, white; 43 epi, 17 epc
Weft: cotton, singles, white; 40 ppi, 16 ppc

Treadle-loomed *manta*, balanced plain
weave; two pieces, warps cut and sewn into
joints; side seams joined; head hole cut out,
pointed neck piece in appliqué; all seams
machine-stitched.

Pointed appliqué at neck, similar to that of
3-202, which is embroidered but not filled
in. Bottom finished in points.

"Near Huehuetenango" (Eisen). ". . .
identical with those worn in 1936"
(O'Neale: 250). *Manta* different type than
that utilized for 3-202. Yarn looks hand-
spun although O'Neale calls the cloth
commercial. (See Figure 57.)

Eisen 1902b; O'Neale 1945

See 3-202, 3-200

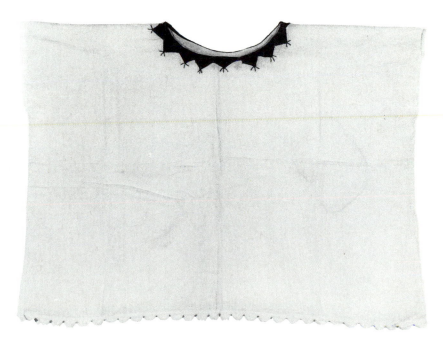

HUEHUETENANGO
Aguacatán
AWAKATEKO

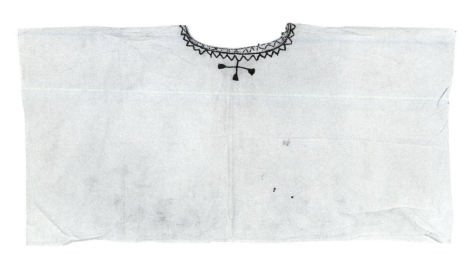

3-202
BLOUSE, *huipil*
15" x 28½" 38.1 CM X 72.4 CM

Warp: cotton, commercially spun, singles, white; 62 epi, 25 epc
Weft: cotton, commercially spun, singles, white; 60 ppi, 24 ppc

Treadle-loomed *manta,* balanced plain weave; two pieces, warps cut; side seams joined, head hole cut out and embroidered in pointed designs; all seams machine-stitched

Embroidered points around head hole and embroidered cross on front and back.

Used and soiled textile. *Manta* may be commercially woven on a power loom.

See 3-199, 3-200

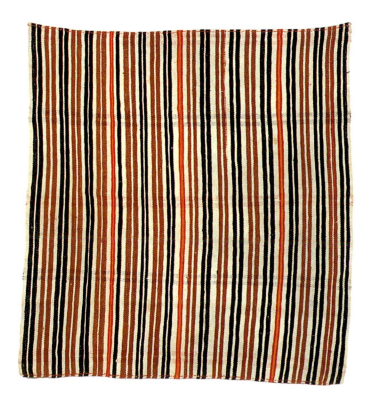

3-216
CLOTH, *servilleta*
27½" x 25" 69.9 CM X 63.5 CM

Warp: cotton, 2 singles, white, natural brown (*ixcaco*), dark blue, red, yellow; 49 epi, 19 epc
Weft: cotton, 2 singles, white, red, dark blue; 17 ppi, 7 ppc

Backstrap-loomed, warp-predominant plain weave; one piece, warps cut and hemmed.

Warp stripes, subtle weft stripes in contrasting colors create a shadow effect.

"For wrapping child" (Eisen). "Old-time woman's shawl for wrapping around child" (O'Neale: Fig. 103c).

Eisen 1902b; O'Neale 1945

See 3-214; 3-213 (Nebaj, El Quiché)

-235
HEADBAND, *cinta*
o" x 2¼" 162 CM X 6 CM

Warp: cotton, 2-ply, singles, white; 2 singles,
ed; 59 epi, 24 epc
Weft: cotton, 2 singles, red, yellow, green;
3 ppi, 12 ppc

ackstrap-loomed, warp-faced plain weave;
ne piece, both end-selvedges loom-finished;
olded back into triangular shapes and hand-
titched.

Warp stripes on sides, three striped weft
ands in contrasting colors repeated at
egular intervals.

For woman's hair" (Eisen). "Band similar to
hat worn at Sacapulas braided in with hair,
vound coronet-fashion around the head.
ed cotton with onlay brocade figures"
O'Neale: 250). "Onlay (brocading): also
alled inlay and laid-in weaving. Simplest
orm of brocading. Weaver inserts decorative
arns in same shed with basic wefts" (ibid.:
15). The weft bands in contrasting colors
o not seem to be "inlaid" as no red wefts
re placed with the yellow and green wefts.

isen 1902b; O'Neale 1945

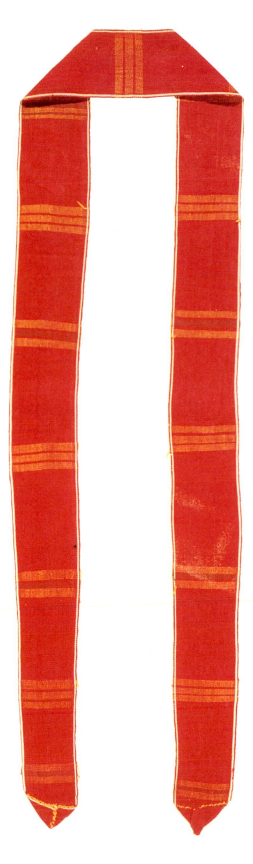

HUEHUETENANGO
Aguacatán
AWAKATEKO

HUEHUETENANGO
Aguacatán
AWAKATEKO

3-292
LOOM, *telar*
88½" x 23½" 209 CM X 59 CM

Warp: cotton, 2 singles, dark blue (indigo);
26 epi, 12 epc
Weft: cotton, 2 singles, dark blue (indigo);
20 ppi, 8 ppc

Woven cloth (72") and unwoven warps;
backstrap-loomed, warp-faced plain weave.

"Loom for weaving" (Eisen). "Blue cotton;
plain weave, (heddle displaced)" written on
the brown paper wrapped around loom,
probably added by a researcher. Probably
three *varas* for a skirt (a *vara* is roughly
three feet). Six sticks: two end sticks, two
sets of shed sticks, batten, shuttle, two roll
sticks. Some (five) old wood, others (three)
bamboo. Web attached to end sticks with
pita-twined cords; selvedges would have
been loom-finished. Warps stiffened with
sizing (*atole*), which has left white specks
on cloth.

Eisen 1902b

See 3-128 (Todos Santos); 3-171, 3-278,
3-288 (Huehuetenango)

3-281 *(far left)*
SPINDLE, *malacate*
17¾" x 9½" 45.2 CM X 24.2 CM

Fiber: wool

Hand-carved hardwood, wooden whorl.

"For twisting *pita*" (Eisen). "Spindle:
smooth, slender stick of various lengths
with weight (whorl) near lower end"
(O'Neale: 316). "Whorl . . . a disk of wood
(on wool spindle) which steadies revolving
spindle" (ibid.: 317). This type of spindle is
called a drop spindle and is used for spinning
wool and *pita*. The dimension of the width
is the circumference of the spindle whorl.

Eisen 1902b; O'Neale 1945

See 3-287

3-287 *(left)*
SPINDLE, *malacate*
12¾" x 3" 32.4 CM X 7.6 CM

Fiber: wool

Hand-carved hardwood, hand-painted
ceramic bead attached to spindle with tar.

"For twisting wool" (Eisen). A spindle for
spinning wool. For comments see 3-281.

Eisen 1902b

See 3-281

-234
VAISTBAND, WOMAN'S, *faja*
0" x 2½" 177.8 CM X 6.4 CM

Varp: wool, 2-ply singles, natural black;
4 epi, 22 epc
Veft: wool, 2-ply singles, natural black;
4 ppi, 6 ppc

Backstrap-belt-loomed, warp-faced plain
veave; one piece, looped and plied warps at
both ends create two 3½" fringes.

Very thin warp stripes.

For comments see 3-233.

See 3-233

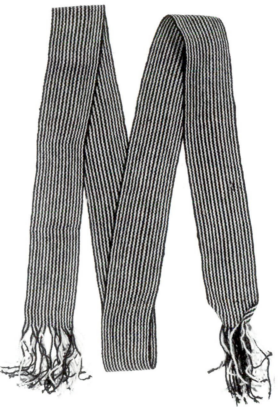

HUEHUETENANGO
Aguacatán
AWAKATEKO

-233
VAISTBAND, WOMAN'S, *faja*
25" x 2¾" 317.5 CM X 7 CM

Varp: wool, 2-ply singles, white, natural
black; 65 epi, 28 epc
Veft: wool, 2-ply singles, natural black;
3 ppi, 5 ppc

Backstrap-belt-loomed, warp-faced plain
veave; one piece, looped warps at both ends
create a 2" and a 3¼" fringe.

Very thin warp stripes.

"Girdle" (Eisen). "The warp setup is four
white, four black, four white, and so on. . . .
These belts are without decoration of any
kind" (O'Neale: 160). "Women weave wool
belts but not in the village itself, it's the
aldea [small town] people on the *altiplano*
who are offsprings of migrants from San
Francisco El Alto, Momostenango" (Deuss).
Resembles black-and-white belts from
Chichicastenango.

Eisen 1902b; O'Neale 1945, Deuss, pers.
com. 1989

See 3-234

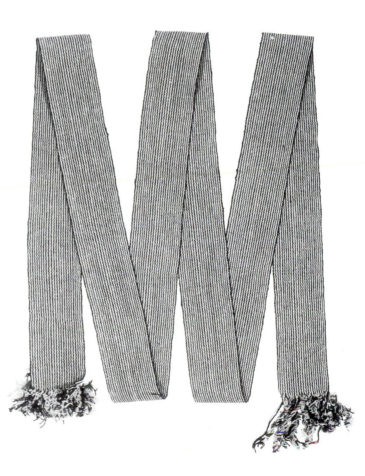

HUEHUETENANGO
Aguacatán
AWAKATEKO

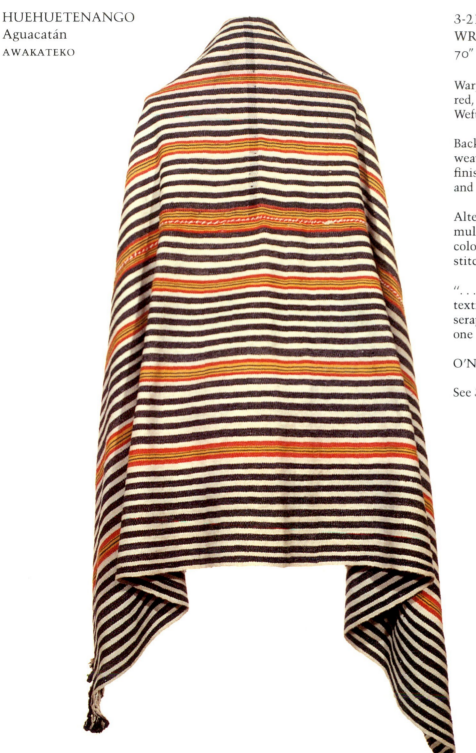

3-214
WRAP, WOMAN'S, *sarape*
70" X 41½" 177.8 CM X 105.4 CM

Warp: cotton, 2 singles, white, dark blue,
red, yellow, green; 36 epi, 14 epc
Weft: cotton, 2 singles, white; 18 ppi, 7 ppc

Backstrap-loomed, warp-predominant plain
weave; two pieces, both end-selvedges loom-
finished with looped warps that create a 3"
and a 5½" fringe.

Alternating blue and white warp stripes,
multicolored warp stripes in contrasting
colors create a shadow effect; overcast-
stitched *randa* as a decorative element.

". . . striping characteristic of village
textiles" (O'Neale: 250). May be a man's
serape because of its large size. Large darn at
one end.

O'Neale 1945

See 3-213 (Nebaj, El Quiché)

-129
APRON, *delantal*
44½" x 28½" 113 CM X 72 CM

Warp: cotton, singles, red; 40 epi, 16 epc
Weft: cotton, singles, dark blue, red,
jaspe—dark blue and white; 2 singles,
white, lavender, yellow, green; 80 ppi,
2 ppc

Treadle-loomed, twill weave; three pieces,
cloth cut and machine-stitched together;
collar and armhole faced; front full length,
open at back; bib-like back 13" long; wefts
carried up on side-selvedge.

Gold-colored and *jaspe* stripes of varying
widths.

Apron with bib projection above waistband
best classified as type worn by local
"*ladinas*" (O'Neale: 266). "Possibly made for
use in Huehuetenango" (Lehmann). An
elaborately cut-and-sewn garment; tucks in
back and front for fit.

O'Neale 1945; Lehmann 1962

See 3-185, 3-205

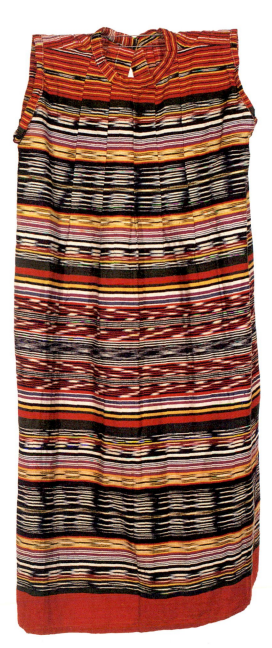

HUEHUETENANGO
Huehuetenango
MAM

3-134
APRON, *delantal*
37" x 32" 94 CM X 81.3 CM

3-176
APRON, *delantal*
32½" x 27½" 82.6 CM X 70 CM

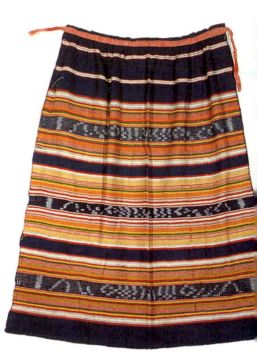

Warp: cotton, 2 singles, white; 39 epi, 16 epc
Weft: cotton, 2 singles, white, dark blue, light green, red, yellow; 34 ppi, 14 ppc
Supplementary weft: cotton, 2 singles, red, dark blue; over 2–10 warps

Treadle-loomed, balanced plain weave and weft-faced twill weaves, two-faced supplementary weft brocading; one piece, cut warps at both ends create 1" fringe; colored supplementary wefts carried up one side-selvedge.

Solid-colored stripes, checkerboard patterns with supplementary weft floats.

Weft-faced stripes: white-on-white floats in all three sections. For comments see 3-23A.

See 3-23A, 3-184, 3-186, 3-188, 3-237

Warp: cotton, singles, dark blue; 42 epi, 16 epc
Weft: cotton, singles, *jaspe*—white and dark blue; 2 singles, white, dark blue, light blue, red, yellow, green, *jaspe*—white and dark blue; 35 ppi, 14 ppc

Treadle-loomed, balanced plain and weft-faced twill weaves; one piece, warps cut and hemmed; weft yarns carried up one side-selvedge; pocket hand-sewn, waistband sewn onto pleated top edge of apron.

Weft stripes of varying widths; *jaspe* creates abstract geometric designs; additional wefts placed between *jaspe* yarns, expand pattern.

"Important. *Ikat* not done here anymore" (Lehmann). However, it is possible that 3-176 may have been woven in Totonicapán for sale in Huehuetenango. Threading mistakes create vertical ridges; waistband different material from body. Cut-and-sewn garment. Pocket is possibly placed on the inside of the apron; opening of pocket on top.

Lehmann 1962

See 3-178

-177
PRON, *delantal*
1½" X 30" 80 CM X 76.2 CM

3-178
APRON, *delantal*
33" X 34½" 84 CM X 87.7 CM

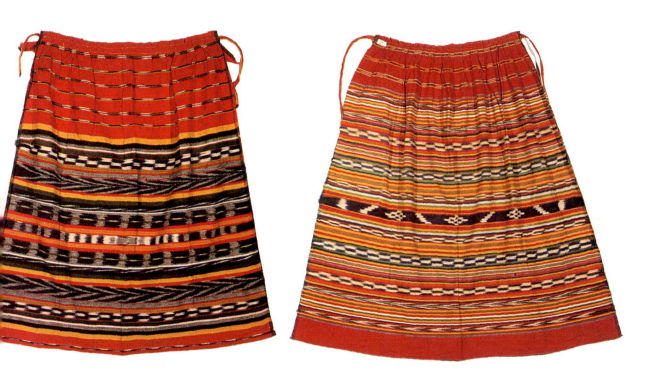

arp: cotton, singles, red; 2 singles, blue;
5 epi, 18 epc
Veft: cotton, singles, red, dark blue,
spe—white and dark blue; 2 singles,
hite, yellow, green; 52 ppi, 21 ppc

readle-loomed, balanced plain and weft-
ced twill weaves; one piece, warps cut, one
d hemmed with machine-stitching, one
lded over; weft yarns carried up one side-
lvedge.

eft stripes of varying widths, *jaspe* creates
rious geometric designs; checkerboard
ock designs; *jaspe* and solid-colored
ripes alternating.

r comments see 3-176.

e 3-181, 3-177

Warp: cotton, singles, red (alizarin); 2
singles, blue; 47 epi, 19 epc
Weft: cotton, singles, white, red (alizarin),
yellow, blue, *jaspe*—white and dark blue; 2
singles, green; 50 ppi, 20 ppc

Treadle-woven, balanced plain and weft-
faced twill weaves; one piece, warps cut, one
end hemmed; pocket attached to side;
waistband attached to pleated top edge of
apron.

Weft stripes of varying widths and *jaspe*
checkerboard designs.

Red dye is alizarin (Carlsen). It is not
apparent on which side (inside or outside)
the pocket was placed.

Carlsen, pers. com. 1987

See 3-176, 3-181

HUEHUETENANGO
Huehuetenango
MAM

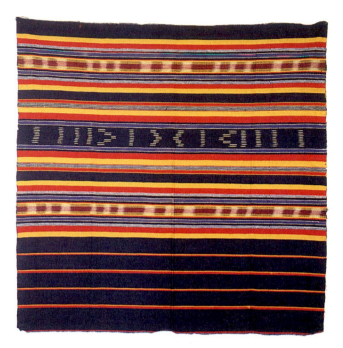

3-183
APRON, *delantal*
35½" x 36" 90.2 CM X 91.5 CM

Warp: cotton, singles, dark blue; 41 epi, 16 epc
Weft: cotton, singles, white, red, *jaspe*—white and dark blue; 2 singles, yellow, medium blue; 53 ppi, 21 ppc

Treadle-loomed, balanced plain, basket, and weft-faced twill weaves; one piece, cut warps at both ends; weft yarns carried up one side-selvedge.

Weft stripes of varying widths, geometric *jaspe* designs.

Unused textile; if an apron, probably tucked into belt; could have been skirt yardage.

See 3-180 (Quezaltenango, Quezaltenango)

3-206
APRON CLOTH, *delantal*
35" x 28" 89 CM X 71.2 CM

Warp: cotton, singles, red; 2 singles, dark blue; 34 epi, 14 epc
Weft: cotton, 2 singles, white, red, yellow, dark blue, gray; 50 ppi, 21 ppc

Treadle-loomed, weft-predominant plain weave; one piece, cut warps at both ends; weft yarns carried up one side-selvedge.

Bands of weft stripes.

Unused textile.

207
PRON CLOTH, *delantal*
₃″ x 29½″ 83.4 CM X 75 CM

arp: cotton, 2 singles, dark blue, medium
ue; 37 epi, 15 epc
eft: cotton, 2 singles, white, dark blue,
edium blue, red, green; 30 ppi, 12 ppc
upplementary weft: cotton, 2 singles, red,
llow

readle-loomed, balanced plain and twill
eaves, two-faced supplementary weft
rocading; one piece, cut warps at both
ads; red and green weft yarns carried up
e side-selvedge.

eft bands of colored twill with floats, two
arps of medium blue on each side.

extile unused. Similar in design layout to
23A, 3-184, 3-186, 3-188, and 3-237 except
r background color. A similar textile, 3-203,
as exchanged with the American Museum
Natural History, 65-3267, in 1907.

e 3-209

209
PRON CLOTH, *delantal*
₂½″ x 29″ 82.6 CM X 73.7 CM

arp: cotton, singles, medium blue; 41 epi,
epc
eft: cotton, 2 singles, white, medium blue,
d, yellow; 28 ppi, 11 ppc

readle-loomed, warp-predominant plain
d twill weaves; one piece, cut warps at
oth ends; colored weft yarns carried up one
de-selvedge.

olored weft bands; twill and plain weaves
eate contrasting patterns on dark
ackground.

nused textile. See comments for 3-207.

e 3-207

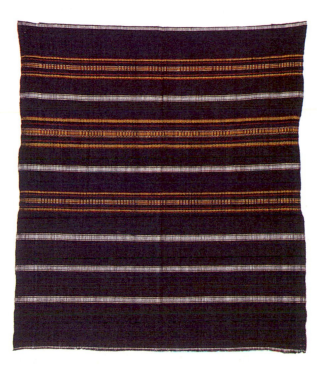

HUEHUETENANGO
Huehuetenango
MAM

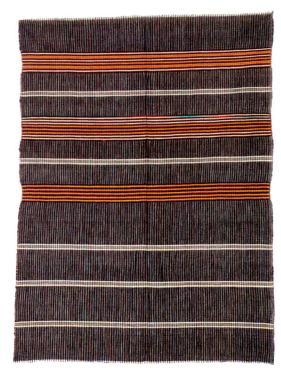

3-236
APRON CLOTH, *delantal*
32" X 23" 81 CM X 58 CM

Warp: cotton, singles, white, dark blue;
40 epi, 16 epc
Weft: cotton, singles, white, yellow; 2
singles, dark blue, red; 35 ppi, 14 ppc

Treadle-loomed, balanced plain and twill
weaves; one piece, cut warps at both ends;
weft yarns carried up one side-selvedge.

Warp and weft stripes.

Unused textile.

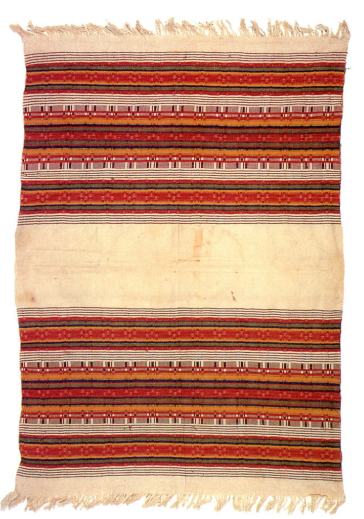

3-186
CLOTH, *toalla*
47½" X 31" 120.7 CM X 78.8 CM

Warp: cotton, 2 singles, white; 39 epi, 16 ep
Weft: cotton, 2 singles, white, red, yellow,
medium blue, light green; 36 ppi, 14 ppc
Supplementary weft: cotton, 2 singles,
white, red, medium blue; over 2–10 warps

Treadle-loomed, balanced plain and twill
weaves, two-faced supplementary weft
brocading; one piece, cut warps at both end
create 1¾" fringes; colored weft yarns
carried up one side-selvedge.

Solid and multicolored horizontal bands,
checkerboard patterns of supplementary
weft floats in colors and white-on-white.

"Woman's cloth for wrapping tortillas"
(Eisen). Used textile. The supplementary
weft–brocaded bands contain two singles of
different colors, red and medium blue,
which create an effect of *jaspe*.

Eisen 1902b

See 3-23A, 3-134, 3-184, 3-188, 3-237

3-140
BED COVERING, *sábana*
160″ X 37″　406.5 CM X 94 CM

HUEHUETENANGO
Huehuetenango
MAM

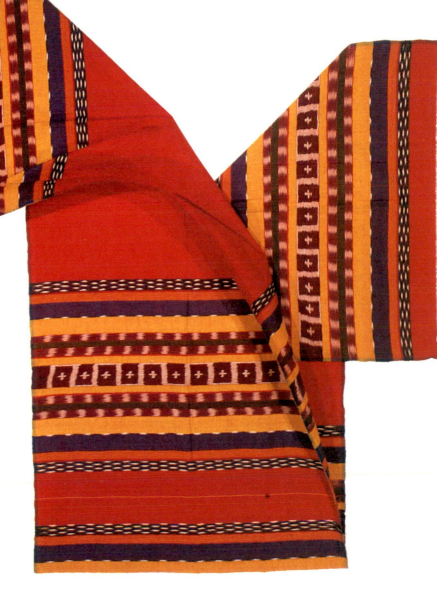

arp: cotton, singles, red, blue; 33 epi,
3 epc
eft: cotton, singles, red, green, yellow,
spe—white and dark blue; 2 singles, blue;
5 ppi, 25 ppc

readle-loomed, weft-predominant plain
eave; one piece, cut warps at both ends;
eft yarns carried up one side-selvedge.

eft stripes of varying widths, *jaspe* yarns
reate geometric designs.

sen identified this textile as a "delamilla";
e probably meant *sábana*, which is a sheet
bed covering. This yardage, purchased in
uehuetenango, may have been used as a
rte or skirt in various highland villages
cluding San Andres Sajcabajá, El Quiché,
at was woven in Totonicapán (Deuss).
ain-weave red and green stripes
terspersed with *jaspe* yarns expand the
idth of the *jaspe* designs.

euss, pers. com. 1988

HUEHUETENANGO
Huehuetenango
MAM

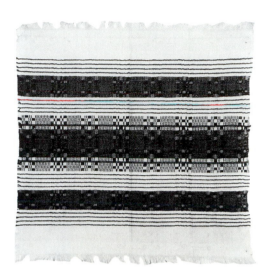

3-194
CLOTH, *servilleta*
16½″ x 16½″ 42 CM X 42 CM

Warp: cotton, singles, white; 2 singles, white; 39 epi, 16 epc
Weft: cotton, 2 singles, white, dark blue; 38 ppi, 15 ppc
Supplementary weft: cotton, 2 singles, white, dark blue; over 2–10 warps

Treadle-loomed, balanced plain and twill weaves, two-faced supplementary weft brocading; one piece, cut warps at both ends; supplementary weft yarns carried up one side-selvedge.

Narrow weft bands, checkerboard weft floats, bands of twill and checkerboard designs.

Same construction and weave as other Huehuetenango cloths. Supplementary weft, however, is predominantly dark blue with some white. May be village-specific.

See 3-23A, 3-134, 3-184, 3-186, 3-188, 3-237

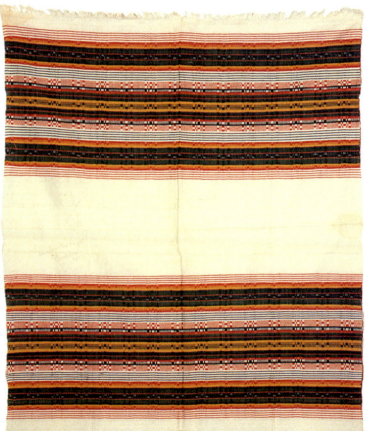

3-188
CLOTH, *toalla*
40½″ x 33¾″ 102.9 CM X 85.8 CM

Warp: cotton, singles, white; 2 singles, white; 38 epi, 15 epc
Weft: cotton, 2 singles, white, red, dark blue, green, yellow; 37 ppi, 15 ppc
Supplementary weft: cotton, 2 singles, white, red, dark blue; over 2–10 warps

Treadle-loomed, balanced plain and twill weaves, two-faced supplementary weft brocading; one piece, cut warps at both ends create 1″ fringes; colored weft yarns carried up one side-selvedge.

Colored weft bands; checkerboard patterns with weft floats.

"Used by women for wrapping tortillas" (Eisen). "Huehuetenango, Guatemala, 1902 written on the textile, probably by Eisen.

Eisen 1902b

See 3-23A, 3-134, 3-184, 3-186, 3-237

-205
GARMENT, CHILD'S, *gavacha*
22½" x 12½" 57.2 CM x 31.8 CM

Warp: cotton, singles, red; 2 singles, dark
blue; 48 epi, 18 epc
Weft: cotton, singles, red, *jaspe*—white and
blue; 2 singles, yellow; 48 ppi, 18 ppc

Treadle-loomed, balanced plain weave; two
pieces, both ends cut and trimmed;
armholes and head hole cut out; ties in
back, pocket on front, pleated, yellow weft
yarns carried up one side-selvedge; all seams
machine-stitched.

Thin weft stripes of yellow and *jaspe* yarns;
commercial cloth trims on bottom, collar,
armholes, and pocket; pointed trim on front.

Made in Salcajá or Totonicapán for
"Huehuetenango" (Lehmann). Cut-and-sewn
garment. Unused textile. Relates in
construction to 3-129, 3-185.

Lehmann 1962

-185
GARMENT, *gavacha*
49½" x 35" 125.7 CM x 89 CM

Warp: cotton, singles, red; 2 singles, red;
5 epi, 18 epc
Weft: cotton, singles, white, red, dark blue,
yellow, green; *jaspe*—white and dark blue;
20 ppi, 20 ppc

Treadle-loomed, balanced plain and twill
weaves; three pieces; edge trimmed with
commercial cloth; commercial cloth pocket
on inside of skirt; opening in front, gathers
at waist; head hole cut out and decorated
with a ruffled cotton neck piece; open in
back, top half of garment fastened with
brass hooks and eyes.

Weft stripes of plain-weave *jaspe*
interspersed with solid-colored stripes create
various geometric designs.

Cut-and-sewn garment. For comments see
3-129.

See 3-129, 3-205

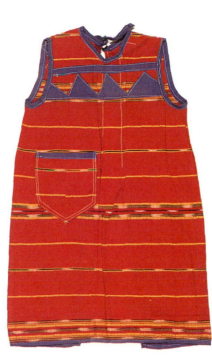

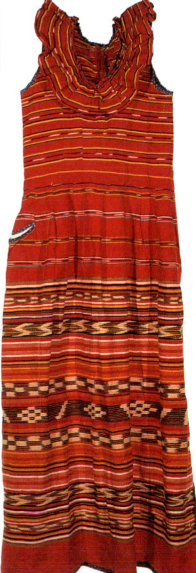

HUEHUETENANGO
Huehuetenango
MAM

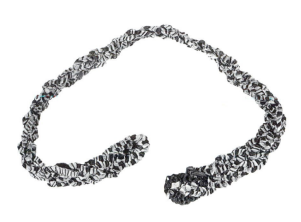

3-167
HATBAND, *cinta de sombrero*
24½" x 1¼" 62.3 CM X 3 CM

Fiber: palm leaf, part natural color, part dye[?] purple

Cut-and-folded palm fiber strip made of two[?] strands intricately braided.

Braided with purple-colored fiber at one end[?] band stitched to keep the end in place.

"For male Indian" (Eisen). Intricate folding and braiding done by a specialist (Osborne).

Eisen 1902b; Osborne 1965

See 3-168

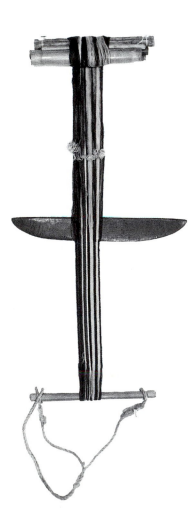

3-171
LOOM, *telar*
50" X 2" 127 CM X 5 CM

Warp: cotton, 2 singles, white, yellow, medium blue, gray, red, purple; 95 epi, 38 epc
Weft: maguey, multiple strands, natural; 14 ppi, 6 ppc

Woven (10") and unwoven warps, backstrap-loomed, warp-faced plain weave.

Warp stripes.

"For weaving waistbands for women" (Eisen). "Heddle and shed roll displaced" written on brown paper wrapping, probably by a researcher. Eight sticks: two end sticks with looped warps; batten and shuttle hard, heavy wood; two bamboo and two wood shed sticks; string heddles; *pita* cording attached to one end. Relates to belt, 3-192.

Eisen 1902b

See 3-278, 3-288; 3-128 (Todos Santos); 3-292 (Aguacatán)

3-278 *(opposite page)*
LOOM, *telar*
180" X 7½" 456 CM X 19 CM

Warp: cotton, commercially spun and hand-plied, 3-ply, white, red, dark blue; 5-ply yellow; 32 epi, 14 epc
Weft: cotton, two 3-ply, red; 12 ppi, 5 ppc

Backstrap-loomed and hand-manipulated warp-predominant plain weave and sprang; woven warps (3½", 3¼"), sprang warps (30", 28½"), and unwoven warps.

Warp-striping.

"Loom for making *faja*. . . . Indians of Huehuetenango" (Eisen). "Twisting technique" written on brown paper wrapping by researcher. Fine ethnographic specimen that provides a means for analyzing sprang technique. Four sticks: two[?] end sticks, two shed sticks; one batten of hardwood. Bunches of warps tied around shed sticks on both ends. Warps looped around end sticks. Thread heddles. Batten and end stick held together by thin wire. *Pita* cording tied to both ends. Similar coloring to 3-222.

Eisen 1902b

See 3-171, 3-288; 3-128 (Todos Santos); 3-292 (Aguacatán)

-168
HATBAND, *cinta de sombrero*
2" x 2½" 56 CM x 6.4 CM

iber: natural palm

Cut-and-folded natural palm fiber strip
made of two strands intricately braided and
hand-stitched together with string to form a
ircle.

raided patterns.

or comments see 3-167.

ee 3-167

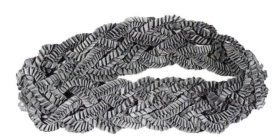

HUEHUETENANGO
Huehuetenango
MAM

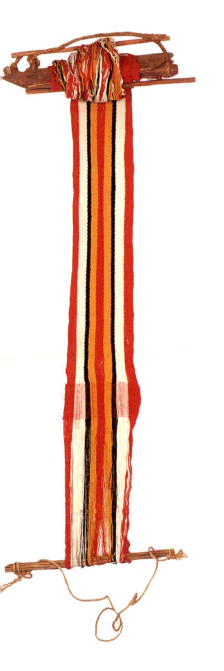

3-288
LOOM, *telar*
64" x 2¼" 162 CM x 6 CM

Warp: cotton, 2 singles, white, blue,
lavender; 100 epi, 40 epc
Weft: maguey, multiple singles, natural,
lavender; 20 ppi, 8 ppc

Backstrap-loomed, warp-faced plain weave.
Woven warps (17") and unwoven warps.

Warp-striping.

"For making *fajas*" (Eisen). "All loom parts
properly placed" written on brown paper
wrapping by researcher. Excellent study
specimen. Eight sticks: three end sticks of
old wood with looped warps, four shed
sticks (one bamboo), hardwood batten,
string heddles. String inserted for cross; *pita*
cording attached to both ends. Warps
stiffened with sizing (*atole*). Relates to belt,
3-229.

Eisen 1902b

See 3-171, 3-278; 3-128 (Todos Santos);
3-292 (Aguacatán)

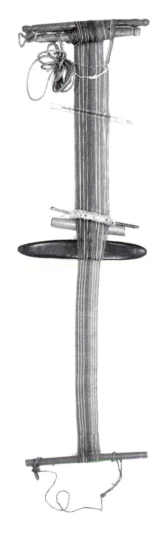

HUEHUETENANGO
Huehuetenango
MAM

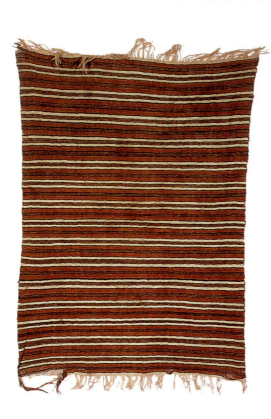

3-135
NAPKIN, *toalla*
30" X 19" 76.2 CM X 48.2 CM

Warp: cotton, singles, white; 19 epi, 7 epc
Weft: cotton, singles, white, dark blue;
2 singles, brown (*ixcaco*); 31 ppi, 12 ppc

Backstrap-loomed, plain and weft-faced twill
weaves; one piece, warps cut to create two
2" fringes; wefts carried up one side-selvedge.

Weft stripes of varying widths.

Although Eisen listed this textile as
purchased in Huehuetenango, it relates to
those purchased and in use in Totonicapán.
(See Figure 58.)

See 3-26, 3-27, 3-28, 3-32 (Totonicapán)

3-184 *(opposite page)*
NAPKIN, *toalla*
48" X 32" 122 CM X 81 CM

Warp: cotton, 2 singles, white; 40 epi, 16 epc
Weft: cotton, 2 singles, white, red, medium
blue, light green, yellow; *jaspe*—white and
dark blue; 34 ppi, 14 ppc
Supplementary weft: cotton, 2 singles,
white, red, medium blue, light green; over
2–10 warps

Treadle-loomed, balanced plain and twill
weaves, two-faced supplementary weft
brocading; one piece, cut warps at both ends
create two 2" fringes; colored weft yarns
carried up one side-selvedge.

Colored weft bands, colored and white
checkerboard patterns in supplementary
weft floats. Two *jaspe* bands: the name
"Martin Vasquez" created by *jaspe* yarns.

Most complex in color and patterns of six
white-ground cloths from Huehuetenango.
The two *jaspe* bands are different; one
is plain white-and-blue *jaspe* while the
other is mixed with red wefts. Some
supplementary weft–brocaded bands
contain two singles of different colors (one
red, one blue).

See 3-23A, 3-134, 3-186, 3-188, 3-237

Figure 58.
Market on the *finca* Chocola, Suchitepéquez.
Women wearing striped *perrajes de jaspe* and
tzutes. George Byron Gordon photo archives,
Peabody Museum of Archaeology and Ethnology,
Harvard University. 1901. H8693.

8-181
OVERGARMENT (APRON), *gavacha*
43″ x 33″ 109 CM x 83.9 CM

Warp: cotton, singles, red; 2 singles, dark
blue; 41 epi, 17 epc
Weft: cotton, singles, red, *jaspe*—white and
dark blue; 2 singles, white, yellow, medium
blue, green; 48 ppi, 19 ppc

Treadle-woven, balanced plain and weft-
faced twill weaves; two pieces, warps cut
and machine-sewn; bib and waistband
attached, two 20″ ties attached to top of bib.

Warp and weft stripes, some with *jaspe*; two
different *jaspe* patterns.

Complex cut-and-sewn garment; 12″ x 7″
bib is smocked; ties are commercial cloth
with buttonholes on ends; treadle-loomed
waistband is lined with commercial cloth;
an iron hook and eye are sewn to ends of
waistband; one glass and one white shell
button on each end; ¼″ plaited trim sewn
onto front of bib.

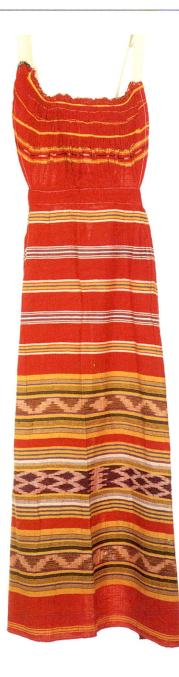

HUEHUETENANGO
Huehuetenango
MAM

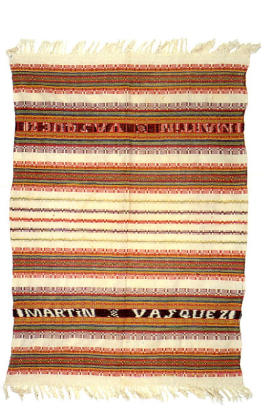

HUEHUETENANGO 3-126
Huehuetenango RAINCOAT, *soyacal*
MAM 43″ x 70″ 109 CM x 178 CM

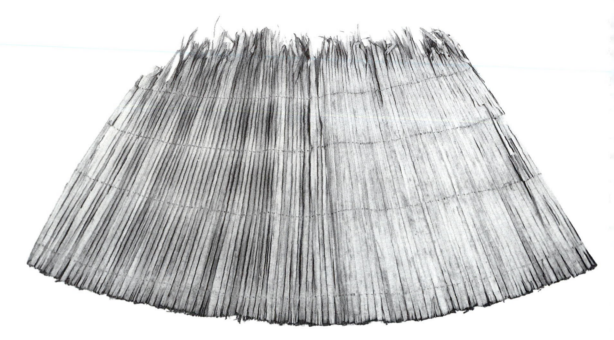

Fiber bulrushes

Strips of bulrushes 1″ wide arranged
lengthwise in semicircle, hand-stitched
together with 2-ply *pita* fiber; four rows of
stitches joining strips.

Eisen identified the fibers as bulrushes.
They are very fragile and dry. He bought
three other raincoats: two from San Mateo
Ixtatán and one more from Huehuetenango.
Because of the fragility of the raincoats, only
one of the four was analyzed. (See Figure 59.)

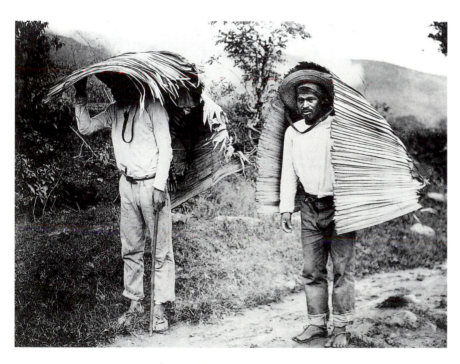

Figure 59.
"Indians with tutes. Mixco" (Eisen 1902c). Photo
by Gustavus A. Eisen. 1902.

3-201
SHAWL, *rebozo/mantilla*
92" x 29½" 234 CM X 75 CM

Warp: cotton, singles, red, light blue; 50 epi,
20 epc
Weft: cotton, singles, red; 41 ppi, 17 ppc

Treadle-loomed, balanced plain weave; one
piece, cut warps at both ends are knotted
into two macramé fringes 10" long.

Narrow and wide warp stripes with
alternating warps of red and light blue.

"Used by *ladinos* of Huehuetenango"
(Eisen). Probably purchased in
Huehuetenango, but 3-218, a similar piece,
was purchased in Comitancillo, San Marcos,
or Comitán, Chiapas, Mexico. The entry
was corrected after the initial cataloguing to
read Comitán, Chiapas. (See Figure 63.)

Eisen 1902b

See 3-218 (Comitancillo, San Marcos)

HUEHUETENANGO
Huehuetenango
SPANISH

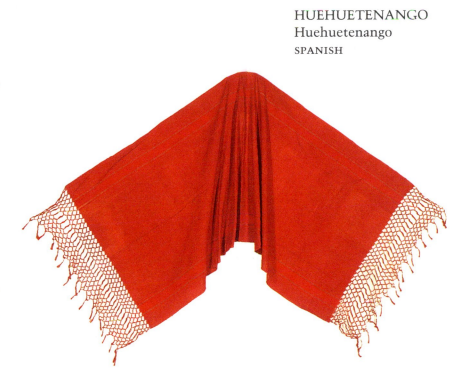

3-219
SKIRT, *enagua*
58¾" x 32" 403.2 CM X 81.3 CM

Warp: cotton, singles, red; 2 singles, dark
blue; 40 epi, 16 epc
Weft: cotton, singles, red, *jaspe*—white and
blue; 2 singles, yellow, green; 40 ppi, 16 ppc

Treadle-woven, balanced plain and twill
weaves; one piece, cut warps at both ends;
colored weft yarns carried up one side-
selvedge.

Fine *jaspe* and solid-colored stripes.

Eisen identified this textile as a "*nagua*"
(Eisen). "Foot loom woven; red ground with
wide and narrow cross stripings in yellow,
green, and blue-and-white *jaspe* yarns;
repeated sequence regularly maintained"
(O'Neale: 266). Unused textile. Purchased in
Huehuetenango but is similar to 3-187. For
comments see 3-187 (Soloma).

Eisen 1902b; O'Neale 1945

See 3-187 (Soloma)

HUEHUETENANGO
Huehuetenango
MAM

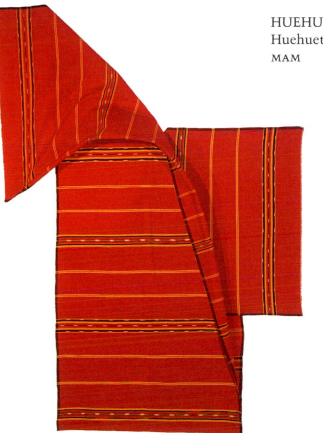

HUEHUETENANGO
Huehuetenango
MAM

3-172
THREAD HOLDER, *malacate*
13¾" x 3" 35 CM X 7.6 CM

Fiber: cotton

Hand-carved hardwood; ceramic bead attached to spindle with tar; bead and 2" of spindle end hand-painted.

"Spindle: smooth, slender stick of various lengths with weight (whorl) near lower end" (O'Neale: 316). "Whorl: weight of pottery or clay in form of a ball (on cotton spindle). . . ." (ibid: 317). Color of ceramic bead is white painted over with brown. White cotton singles spun onto spindle. The dimension of the width is the circumference of the spindle whorl.

O'Neale 1945

See 3-173, 3-174

3-173
THREAD HOLDER, *malacate*
14" x 3" 35.6 CM X 7.6 CM

Fiber: cotton

Hand-carved hardwood, hand-painted ceramic bead attached to spindle.

For comments see 3-172.

See 3-172, 3-174

3-174
THREAD HOLDER, *malacate*
12¾" x 3½" 32.5 CM X 8.3 CM

Hand-carved hardwood; hand-painted ceramic bead attached to spindle with tar.

No yarn on spindle. For comments see 3-172.

See 3-172, 3-173

3-175
THREAD HOLDER, *malacate*
16½" x 8½" 42 CM X 21.6 CM

Hand-carved hardwood, wooden whorl.

For spinning wool. O'Neale writes that the actual provenance of 3-175 is Santa Cruz de Quiché (O'Neale: Fig. 75b2). For comments see 3-281 (Aguacatán).

O'Neale 1945

See 3-281 (Aguacatán)

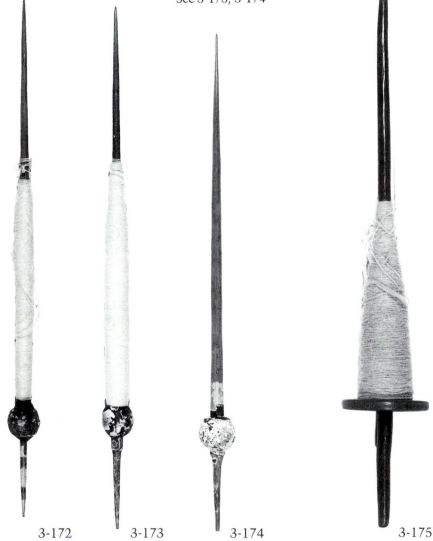

3-172 3-173 3-174 3-175

3-23A
TOWEL, *toalla*
43" x 34" 109 CM X 86 CM

Warp: cotton, 1 and 2 singles; white; 40 epi,
16 epc
Weft: cotton, 2 singles; white; 40 ppi, 16 ppc
Supplementary weft: cotton, 2 singles,
white, red, dark blue, yellow, green; over
2–12 warps

Treadle-loomed, balanced plain and twill
weaves, two-faced supplementary weft
brocading; one piece, cut warps create two
2" fringes. Colored supplementary weft
yarns carried along one side-selvedge. Two
rows of white supplementary weft brocading
at each end.

Horizontal bands, checkerboard patterns
with supplementary weft floats, solid-
colored bands.

A multipurpose cloth also called *servilleta*
or *tzute*. Resembles example in American
Museum of Natural History collected by
Reverend Heyde in 1895, 65-2247, also from
Huehuetenango. Unused textile. A similar
textile, 3-232, was exchanged with the
American Museum of Natural History, 65-
2270, in 1907.

See 3-134, 3-184, 3-186, 3-188, 3-237

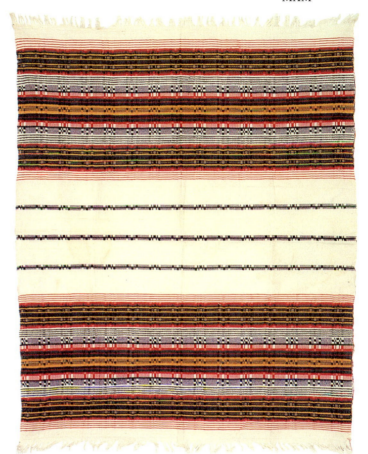

3-237
TOWEL/NAPKIN, *toalla/servilleta*
26" x 25" 66 CM X 63.5 CM

Warp: cotton, singles, white; 47 epi, 19 epc
Weft: cotton, singles, white, red, dark blue,
gray, yellow; 50 ppi, 20 ppc
supplementary weft: cotton, singles, white,
red, dark blue; over 2–8 warps

Treadle-loomed, balanced plain and twill
weaves, two-faced supplementary weft
brocading; one piece, cut warps at both
ends, colored weft yarns carried up one side-
selvedge.

Weft bands of color; checkerboard designs
with weft floats.

Seems unused, but has one large stain.

See 3-23A, 3-134, 3-184, 3-186, 3-188

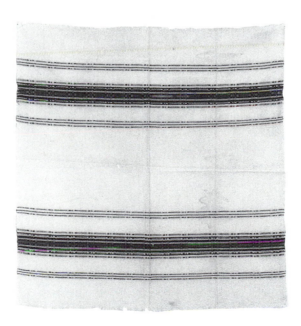

HUEHUETENANGO
Huehuetenango
MAM

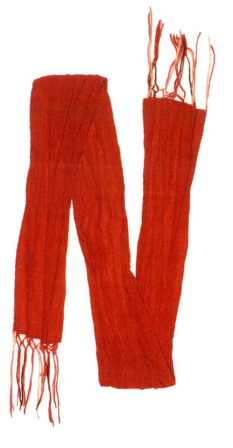

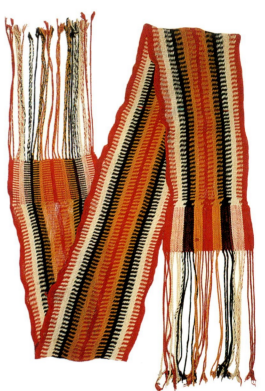

3-220
WAISTBAND, MAN'S, *faja*
80½" x 8" 204.4 CM X 20.3 CM

Warp: cotton, singles, red; 64 epi, 26 epc
Weft: cotton, singles, red; 63 ppi, 25 ppc
Fringe: commercially spun wool, 4-ply, solid
and space-dyed red, light and dark pink,
maroon

Treadle-loomed, balanced plain weave; one
piece, warps cut and hemmed; sides
hemmed, colored knotted wool yarns added
to create two 6" fringes.

Macramé decorative fringe.

The weave is very even, may be
commercially woven. Wool yarns are
commercially spun, 4-ply.

3-222
WAISTBAND, MAN'S, *banda*
82" x 6¾" 208 CM X 17 CM

Warp: cotton, commercially spun and
hand-plied, 4-ply, white; three 3-ply, red;
8 singles, yellow, dark blue; 38 epi, 12 epc
Weft: cotton, two 3-ply, red; 12 ppi, 5 ppc

Backstrap-loomed and sprang; one piece,
warps cut, twisted, and knotted to create
two 11" fringes at both ends.

Colored warp and weft stripes.

"Pattern, often quite intricate, effective
when belt is spread out, but when drawn
tightly around body, all semblance of design
lost" (O'Neale: 266). "Not used in
Huehuetenango now" (Deuss). One similar
example in the Smithsonian National
Museum of Natural History, 406287,
donated in the 1960s, was rolled up and used
as a hatband. Similar to those purchased by
Eisen in Quezaltenango. Must have been
generic man's belt. Still characteristic in
1936 when O'Neale was in Guatemala. For
comments see 3-87.

O'Neale 1945; Deuss, pers. com. 1989

See 3-227, 3-230; 3-87, 3-89 (Quezaltenango)

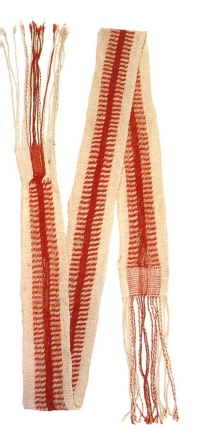

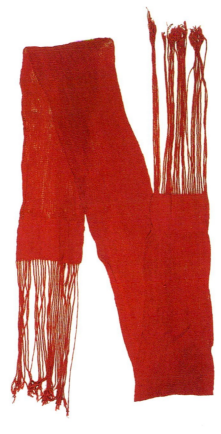

-227
WAISTBAND, MAN's, *banda*
3" x 3¾" 211 CM X 9 CM

Warp: cotton, commercially spun and hand-
lied, 3-ply, white; 3-ply, red; 50 epi, 18 epc
Weft: cotton, commercially spun and hand-
lied, two 3-ply, white; 14 ppi, 6 ppc

ackstrap-loomed and sprang; one piece,
varps cut, twisted, and knotted to create
wo 8½" fringes.

Warp and weft stripes; solid red stripe in
enter.

or comments see 3-222.

ee 3-222, 3-230; 3-87, 3-89 (Quezaltenango)

3-230
WAISTBAND, MAN'S, *banda*
80½" x 6" 204 CM X 15 CM

Warp: cotton, 3-ply, red; 32 epi, 12 epc
Weft: cotton, two 3-ply, red; 13 ppi, 6 ppc

Backstrap-loomed and sprang; one piece,
warps cut, twisted, and knotted to create
two 10½" fringes.

Solid color.

A similar belt was donated to the
Smithsonian National Museum of Natural
History in 1902, 214350. For comments see
3-87.

See 3-222, 3-227; 3-87, 3-89 (Quezaltenango)

HUEHUETENANGO
Huehuetenango
MAM

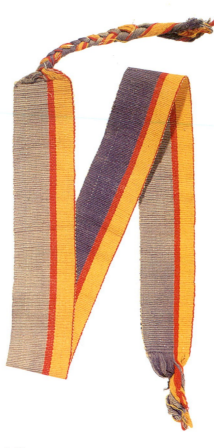

3-169
WAISTBAND, WOMAN'S, *faja*
42" X 2" 106.7 CM X 5.1 CM

Warp: cotton, 2 singles, medium blue, red, yellow; 72 epi, 29 epc
Weft: maguey, multiple singles; 19 ppi, 8 ppc

Backstrap-belt-loomed, warp-faced plain weave; one piece, braided looped warps at both ends create a 7" and a 4" braid.

Warp stripes, three solid-colored zones.

"Probably town specific" (Deuss). Blue area badly faded on one side.

Deuss, pers. com. 1988

See 3-189, 3-229

3-170
WAISTBAND, WOMAN'S, *faja*
55½" X 2" 141 CM X 5.1 CM

Warp: cotton, 2 singles, white, purple, aqua, royal blue, dark blue, red, yellow, green; 101 epi, 43 epc
Weft: maguey, multiple singles; 14 ppi, 6 ppc

Backstrap-belt-loomed, warp-faced plain weave, single-faced warp floats; one piece, braided looped warps at both ends create a ? and a 5" braid.

Two color zones divided by solid warp stripes; weft stripes of alternating colors; warp floats create human and geometric forms; side border checkered.

"Worn in Comitancillo, San Marcos" (Deuss). Purchased in Huehuetenango.

Deuss, pers. com. 1988

See 3-223

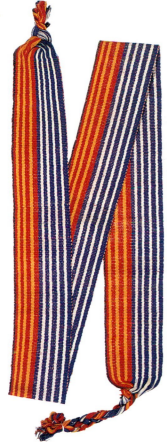

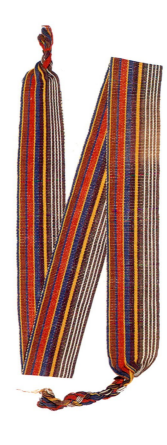

189

AISTBAND, WOMAN'S, *faja*

)" x 2¼" 127 CM X 5.7 CM

arp: cotton, 2 singles, white, medium
ue, red, yellow, dark gray; 70 epi, 25 epc
eft: maguey, multiple singles, natural
lor; 16 ppi, 7 ppc

ackstrap-belt-loomed, warp-faced plain
eave; one piece, braided looped warps at
th ends create two 5½" braids.

arp stripes. Two color zones: blue and
hite on one side, red and yellow on the
her side.

ome wind [belt] around waist several
nes" (O'Neale: Fig. 120e). "Woven by
en. Still in use" (Deuss). A similar textile,
190, was exchanged with the American
useum of Natural History, 65-3269,
1907.

'Neale 1945; Deuss, pers. com. 1988

e 3-169, 3-229

3-191

WAISTBAND, WOMAN'S, *faja*

49" x 2¼" 124.5 CM X 5.7 CM

Warp: cotton, 2 singles, white, dark gray,
purple, yellow, medium blue, red, maroon;
84 epi, 30 epc
Weft: maguey, multiple singles, natural;
18 ppi, 7 ppc

Backstrap-belt-loomed, warp-faced plain
weave; one piece, braided looped warps at
both ends create two 2½" braids.

Unusual distribution of warp stripes; gray
and white on one side, multicolored on the
other side.

For comments see 3-189.

See 3-192, 3-198

HUEHUETENANGO
Huehuetenango
MAM

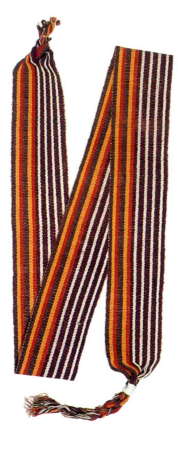

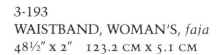

3-192
WAISTBAND, WOMAN'S, *faja*
49" x 2½" 124.5 CM X 6.4 CM

Warp: cotton, 2 singles, white, purple, red, yellow, dark gray; 70 epi, 30 epc
Weft: maguey, multiple singles, natural; 19 ppi, 8 ppc

Backstrap-belt-loomed, warp-faced plain weave; one piece, braided looped warps at both ends create a 5½" and a 2½" braid.

Warp stripes. Two color zones: purple and white stripes on one side; blue, red, and yellow on the other side.

For comments see 3-189.

See 3-191, 3-198

3-193
WAISTBAND, WOMAN'S, *faja*
48½" x 2" 123.2 CM X 5.1 CM

Warp: cotton, 2 singles, white, gray, violet, red, yellow; 95 epi, 38 epc
Weft: maguey, multiple singles, natural; 22 ppi, 9 ppc

Backstrap-belt-loomed, warp-faced plain weave; one piece, braided looped warps at both ends create a 2" and a 4" braid.

Warp stripes; white center section unusual

"Old style—no more" (Deuss). Similar example in Smithsonian National Museum of Natural History, 92986, donated in 1883 by the Guatemalan government. Provenance is identified as Tactic, Alta Verapaz. For comments see 3-231.

Deuss, pers. com. 1988

See 3-210, 3-225, 3-226, 3-231

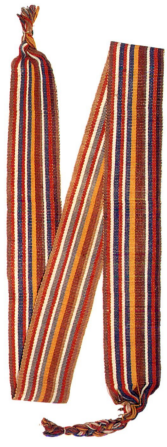

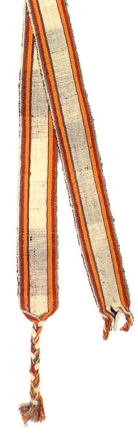

198
AISTBAND, WOMAN'S, *faja*
½" x 2¼" 128.3 CM X 5.6 CM

arp: cotton, 2 singles, white, gray, red,
rple, medium blue, maroon, yellow;
epi, 25 epc
eft: maguey, multiple singles, white;
ppi, 8 ppc

ckstrap-belt-loomed, warp-faced plain
eave; one piece, braided looped ends at
th ends create a 2½" and a 5½" braid.

iin warp stripes.

Voven by men" (Deuss). Colors faded on
e side. A similar textile, 3-228, was
changed with the American Museum of
itural History, 65-3285, in 1907.

uss, pers. com. 1988

e 3-191, 3-192

3-210
WAISTBAND, WOMAN'S, *faja*
41" X 2" 104.2 CM X 5.1 CM

Warp: cotton, 2 singles, white, purple,
yellow, red, light blue; 74 epi, 29 epc
Weft: cotton, 10–15 singles, white, red, dark
blue; 15 ppi, 6 ppc

Backstrap-belt-loomed, warp-faced plain
weave; one piece, braided cut warps at one
end create a 5½" braid; twisted looped warps
at the other end create a 2" fringe.

Thin colored warp stripes on sides, white
band down the center.

"Old style—no more" (Deuss). Red and blue
weft yarns are randomly used in 3-210. For
comments see 3-193 and 3-231.

Deuss, pers. com. 1988

See 3-193, 3-225, 3-226, 3-231

HUEHUETENANGO
Huehuetenango
MAM

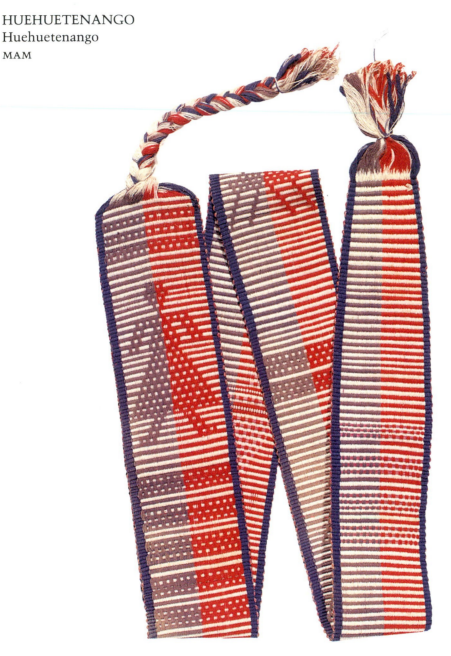

3-223
WAISTBAND, WOMAN'S, *faja*
46" x 2¼" 116.8 CM X 5.6 CM

Warp: cotton, 2 singles, white, red, medium
blue, gray-blue; 83 epi, 34 epc
Weft: maguey, multiple singles, purple;
14 ppi, 6 ppc

Backstrap-belt-loomed, warp-faced plain
weave, single-faced warp floats; one piece,
tied looped warps at one end create a 2"
fringe, braided looped warps at the other end
create a 5½" braid.

Two thin warp stripes at sides, weft stripes
of alternating colors down center (one half
gray-blue and white; other half red and
white); warp floats create checkered bands,
an animal form (deer) and three human
forms (women).

"Worn in Comitancillo, San Marcos"
(Deuss). Purchased in Huehuetenango.

Deuss, pers. com. 1988

See 3-170

-225
WAISTBAND, WOMAN'S, *faja*
4" x 2¾" 111.8 CM X 4.7 CM

Warp: cotton, 2 singles, white, dark blue,
d; 57 epi, 24 epc
Weft: cotton, 8 singles, white; 18 ppi, 7 ppc

Backstrap-belt-loomed, warp-faced plain
weave; one piece, braided looped warps at
both ends create a 2" and a 5½" braid.

Thin warp stripes, one white band down
center; weft stripes of alternating blue and
white create two checkered bands down
sides.

"Old style—no more" (Deuss). For
comments see 3-193 and 3-231.

Deuss, pers. com. 1988

See 3-193, 3-210, 3-226, 3-231

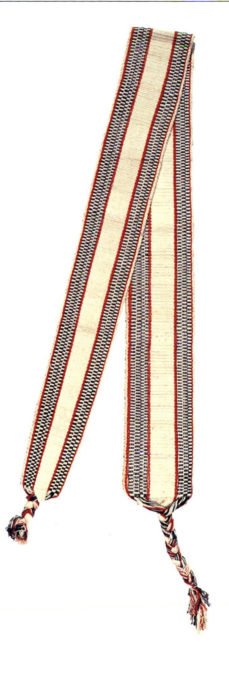

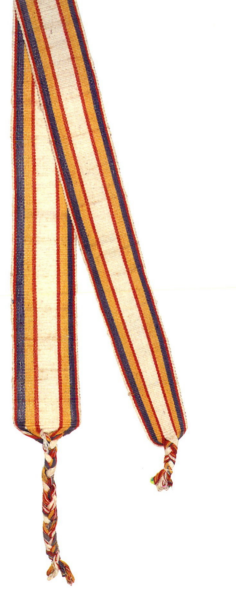

-226
WAISTBAND, WOMAN'S, *faja*
3½" x 2¼" 110.5 CM X 5.2 CM

Warp: cotton, 2 singles, white, red, medium
blue, yellow; 55 epi, 21 epc
Weft: cotton, 9 singles, white; 16 ppi, 6 ppc

Backstrap-belt-loomed, warp-faced plain
weave; one piece, braided looped warps at
both ends create a 2" and a 6" braid.

Colored warp stripes down sides, thick
white stripe down center.

"Old style—no more" (Deuss). For
comments see 3-193 and 3-231.

Deuss, pers. com. 1988

See 3-193, 3-210, 3-225, 3-231

HUEHUETENANGO
Huehuetenango
MAM

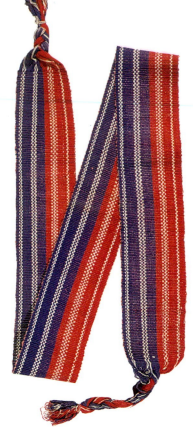

3-229
WAISTBAND, WOMAN'S, *faja*
44¾" X 2¼" 113.7 CM X 5.7 CM

Warp: cotton, 2 singles, white, red, medium blue; 61 epi, 23 epc
Weft: maguey, multiple singles, purple; 15 ppi, 6 ppc

Backstrap-belt-loomed, warp-faced plain weave; one piece, braided looped warps at both ends create a 3" and a 5" braid.

Two thick warp bands, four thin checkered warp bands.

"Still in use" (Deuss). A similar belt is in process on a loom, 3-288.

Deuss, pers. com. 1988

See 3-169, 3-189

3-231
WAISTBAND, WOMAN'S, *faja*
40" X 2¼" 101.6 CM X 5.2 CM

Warp: cotton, 2 singles, white, red, medium blue, purple; 3 singles, yellow; 72 epi, 29 ep
Weft: cotton and maguey, 9 singles, white; 13 ppi, 5 ppc

Backstrap-belt-loomed, warp-faced plain weave; one piece, braided cut warps at both ends create a 2" and a 5½" braid.

Thin colored warp stripes down sides, wide white stripe down center.

". . . characterized by strong color contrasts in stripings and block patterns, made long, some wind several times about waist" (O'Neale: Fig. 120b). "Old style—no more" (Deuss). For comments see 3-193.

O'Neale 1945; Deuss, pers. com. 1988

See 3-193, 3-210, 3-225, 3-226

-312
HAT, *sombrero*
¾" X 16¼" 17 CM X 41.25 CM

iber: palm leaf

'will plaiting of strips, hand-stitched in
piral to form slightly rolled brim and high
apered crown; top of crown crushed and
titched down.

.epeated V-shaped design stitched around
uter edges of brim made of six strands of
ray cotton thread; eight-strand twisted
otton cording around base of crown held
1 place by gray stitching; three cords of
wisted multiple strands of gray and natural
otton; four cords of gray multiple-strand
nd one cord of 2-ply finished natural
otton.

It has long been a custom for men and
vomen alike to wear a more or less ornate
eaddress, either as protection from heat or
old or perhaps to exhibit rank or position
1 the community" (Osborne: 290). "Hats
rom Santa Isabel Huehuetenango and
eighboring villages in the Cuchumatanes
nountains customarily have a high peaked
rown and a brim jauntily rolled a bit on
oth sides" (ibid.: 291).

)sborne 1965

ee 3-314

-315
IAT, *sombrero*
½" X 13" 9 CM X 33 CM

iber: palm leaf

'will plaiting of strips in spiral to form
ightly rolled brim and rounded crown.

op of crown filled in with flat (3¼") palm
:af fiber in spiral design stitched to plaiting;
eginning of coiled strip stitched to itself on
utside top; end of strip on brim sewn onto
receding strip, which is doubled over to
orm an outer edge.

Vomen from Todos Santos Cuchumatán
rear the same hats as do the men. They are
aade in Jacaltenango.

ee 3-316, 3-317

3-314
HAT, *sombrero*
4⅚" X 15¼" 12.25 CM X 38.5 CM

Fiber: palm leaf

Twill plaiting of strips, hand-stitched in
spiral to form slightly rolled brim; high
tapered rounded crown.

Tighter plaiting on brim than crown.
Rectangular plaited strip at top to cover
beginning of coil. Double V pattern stitched
first in four strands of gray yarn, then in four
strands of red yarn (XXXX, a design motif)
¾" from edge of brim. Hatband of twisted
strands of colored thread wound around flat
palm leaf fibers. Colors of thread
alternating—white, mauve, gray—with
solid gray. Fringed at each end.

For comments see 3-312.

See 3-312

HUEHUETENANGO
Jacaltenango
JAKALTEKO

HUEHUETENANGO
Jacaltenango
JAKALTEKO

3-316
HAT, *sombrero*
3¾″ x 14″ 9.5 CM X 35.5 CM

Fiber: palm fiber

Twill plaiting of strips stitched in spiral to form slightly rolled brim and rounded crown.

For iconography and comments see 3-315.

See 3-315, 3-317

3-317
HAT, *sombrero*
3½″ x 14½″ 8.75 CM X 36.75 CM

Fiber: palm leaf

Twill plaiting of strips, hand-stitched in spiral to form slightly rolled brim; tapered rounded crown.

Top of crown filled in with very small (¾″) palm leaf fiber in spiral design stitched to plaiting.

Finer plaiting than 3-315. For comments see 3-315.

See 3-315, 3-316

HUEHUETENANGO
San Juan Ixcoy
Q'ANJOB'AL

3-215
HEADBAND, *cinta*
149″ x ¾″ 378.5 CM X 1.9 CM

Warp: wool, natural black

One piece, felted.

"For braiding in woman's hair" (Eisen). ". . . width apparently achieved by folding small felted strands back and forth" (O'Neale: 266). "Worn in Santa María Chiquimula, Totonicapán" (Deuss).

Eisen 1902b; O'Neale 1945; Deuss, pers. com. 1988

See 3-131 (San Antonio Las Flores, Guatemala)

-252
HAWL, *mantilla*
21″ x 23″ 307.3 CM X 58.5 CM

Warp: wool, singles, natural white and
brown; 12 epi, 5 epc
Weft: wool, singles, natural white; 11 ppi,
 ppc

ackstrap-loomed, balanced plain weave;
ne piece, cut warp ends; one end tied in
nots, the other end loose.

lternating white and dark brown

Bought in Huehuetenango" (Eisen).

isen 1902b

HUEHUETENANGO
Santa Barbara
MAM

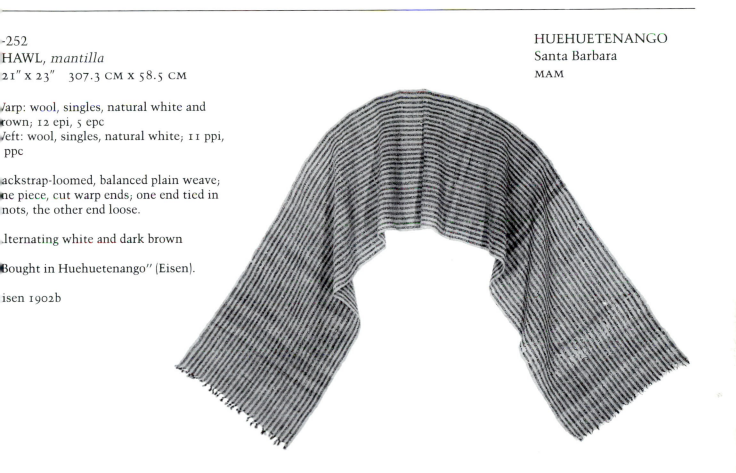

-267
OPE, *pita*
¾″ X 11¼″ 4.5 CM X 28.2 CM

iber: 2-ply and untwisted *pita* cording,
atural tan

Coil of untwisted *pita* with 2-ply *pita* rope
oiled around it; attached to *pita* is some
notless netted fibers, probably the bottom
f a *matate*.

For making *matate*" (Eisen). For comments
ee 3-67 (Sololá, Sololá).

isen 1902b

HUEHUETENANGO
San Sebastián
MAM

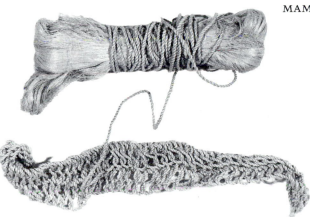

HUEHUETENANGO
Santa Eulalia
CHUJ Q'ANJOB'AL

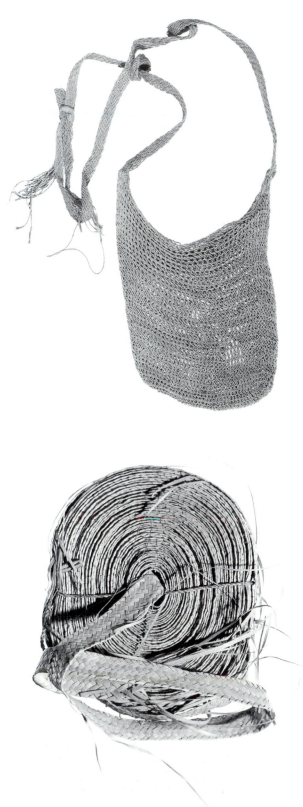

3-257
BAG, *matate/bolsa*
17" X 5¾" 65 CM X 14.5 CM

Fiber: 2-ply, *pita* cording, natural tan

Knotless netting, hourglass pattern; three pieces; two straps are sprang, attached to body of bag.

"Indians of Santa Eulalia de la Sierra. Used for keeping the palm leaves when making hats" (Eisen). "Finely divided strips of palm fiber are carried in small maguey bags which hang from the belt" (O'Neale: 178). Eisen purchased a braid of palm leaves, 3-276, that he wrote went with this example. Especially fine, silky quality of the *pita*, smallest loops of the group of *matates*. For comments see 3-67 (Sololá, Sololá).

Eisen 1902b; O'Neale 1945

See 3-276; 3-158 (Chichicastenango, El Quiché); 3-159 (Santa Cruz del Quiché, El Quiché); 3-265 (Nebaj, El Quiché)

3-276
BRAID OF PALM LEAVES, *galón de palmilla*
⅝" (WIDTH) 1.5 CM (WIDTH)

Fiber: palm leaf

Rolled length of plaited palm fiber.

Rolled and tied from center to outer edge.

"This goes with 3-257" (Eisen). "All palm leaves to be used for hats are cut during the three days before the full moon. The palm strands are separated by a knife or other sharp implement into the necessary widths which should be as uniform as possible. For a woven hat, the worker continually wets the strands with cloth saturated in clean water. The work is started at the center of the crown. The more strands woven into it, the better the quality of the hat" (Osborne: 296). The northeast lowlands palm most commonly used is the *palmilla*. Others are *palma de coyol* (lowlands) and *palma de petate*.

Eisen 1902b; Osborne 1965

See 3-257

3-112
OVERSHIRT, *kapishay*
42" X 29" 106.7 CM X 73.7 CM

Warp: wool, singles, natural dark brown;
11 epi, 5 epc
Weft: wool, singles, natural dark brown;
9 ppi, 4 ppc

Treadle-loomed, balanced plain weave; three
pieces, head hole cut out, sides folded and
hemmed; warps at both ends cut and
knotted, cut warps at back create a 6" fringe,
other warps cut and hemmed.

"For male Indian" (Eisen). "Long coats of
heavy dark wool materials. Fronts shorter
than backs; backs fringed with warp ends.
Side seams lacking. . . . Sleeves inserted
under edge of garment. . . . A satisfactory
arrangement for hot weather and cold. On
cold days man brings arms out of sleeves
and folds long pieces across his back"
(O'Neale: Fig. 54g). Unused textile. Knotted
warps at cuffs. Cut-and-sewn garment; not
sewn under arms. Part of a man's costume:
3-160, 3-195, 3-197, 3-313.

Eisen 1902b; O'Neale 1945

See 3-113

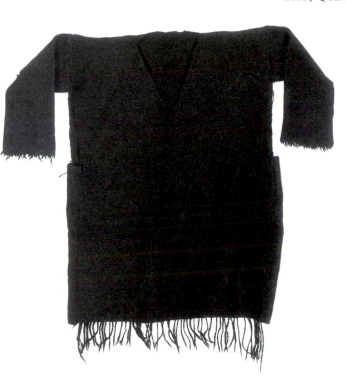

3-113
OVERSHIRT, *kapishay*
41" X 29½" 104.2 CM X 75 CM

Warp: wool, singles, natural dark brown;
10 epi, 4 epc
Weft: wool, singles, natural dark brown;
9 ppi, 4 ppc

Treadle-loomed, balanced plain weave; three
pieces, head hole cut out, sides folded and
hemmed, small rectangular collar attached
to head hole; warps at both ends cut and
knotted, cut warps at back create a 5" fringe;
other warps cut and hemmed.

Cut-and-sewn garment. Unused textile.
Garment not sewn at underarms. Warps
knotted at cuffs. V-shaped head hole. For
comments see 3-112.

See 3-112

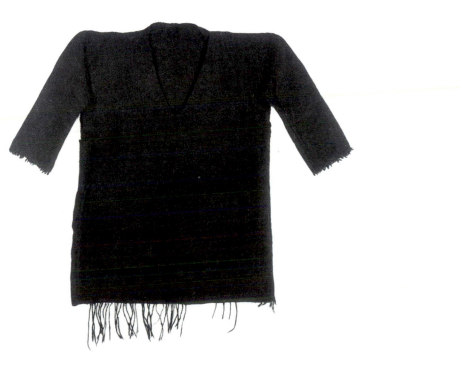

HUEHUETENANGO
Soloma
CHUJ Q'ANJOB'AL

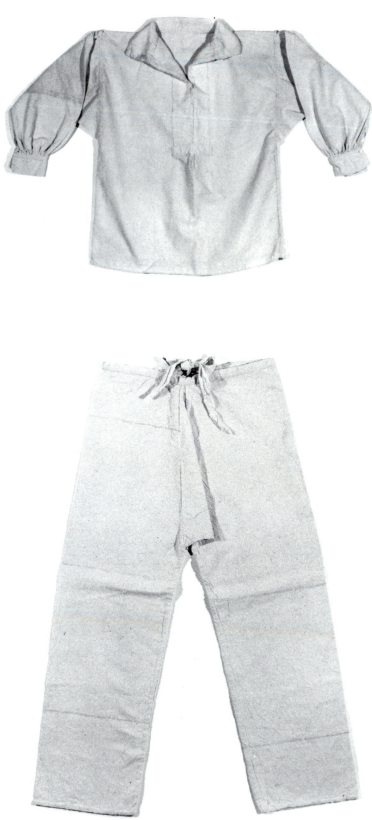

3-195
SHIRT, *camisa*
27" x 20" 68.6 CM X 50.8 CM

Warp: cotton, commercially spun, singles, white; 52 epi, 21 epc
Weft: cotton, commercially spun, singles, white; 46 ppi, 18 ppc

Treadle-loomed *manta*, balanced plain weave, fourteen pieces, hand-sewn together.

". . . cut in European style to extent of having standing collar and placket opening in the front; rectangular set-in sleeves with a few gathers across top; under the arm, triangular gusset about 6 inches on each side" (O'Neale: 300). Cut-and-sewn, tailored garment. Has a white glass button on each cuff and a black glass button on the collar. Part of a man's costume: 3-112, 3-160, 3-197, 3-313.

O'Neale 1945

See 3-197

3-197
PANTS, *pantalón*
36¼" x 28" 92.1 CM X 71.1 CM

Warp: cotton, commercially spun, singles, white; 52 epi, 21 epc
Weft: cotton, commercially spun, singles, white; 47 ppi, 19 ppc

Treadle-loomed *manta*, balanced plain weave; five pieces hand-sewn together, waistband with 16" ties.

"Style very European in appearance" (O'Neale: Fig. 55h). Cut-and-sewn, tailored garment. Part of a man's costume: 3-112, 3-160, 3-195, 3-313. Unused textile.

O'Neale 1945

See 3-195

3-187
SKIRT, *enagua*
136" X 37½" 345.4 CM X 95.3 CM

Warp: cotton, singles, red (alizarin);
, singles, dark blue; 33 epi, 14 epc
Weft: cotton, singles, red (alizarin), yellow,
jaspe—white and blue; 51 ppi, 21 ppc

Treadle-woven, weft-predominant plain
weave; five pieces joined to make a tube
shape, warps cut and sewn.

Fine *jaspe* and solid-colored stripes.

O'Neale locates this skirt in San Pedro
Soloma (O'Neale: Fig. 521). Red dye is
alizarin (Carlsen). "Made in Salcajá"
(Lehmann). "Foot-loomed in Huehuete-
nango; was used in Soloma, San Juan Ixcoy,
San Mateo, Santa Eulalia. Women buy two
varas, cut off the end and sew the pieces
into a long textile to make a tube shape"
(Deuss). Deuss saw a textile like 3-187
drying on a laundry line of an old woman.
No longer worn by Chuj Q'anjob'al–
speakers. Used textile. Eisen purchased
a *huipil* from Soloma: 3-196; it was
exchanged with the American Museum of
Natural History, 65-3293, in 1907.

O'Neale 1945; Lehmann 1962; Carlsen,
pers. com. 1987; Deuss, pers. com. 1988

See 3-219 (Huehuetenango)

3-313
SOMBRERO, *sombrero*
6" X 14¾" 15.3 CM X 37.5 CM

Fiber: palm leaf

Twill plaiting of layered strips, hand-
stitched in spiral to form slightly rolled
brim and high tapered crown.

Plaited strip begins at top of high crown—
not filled in with palm leaf fiber as in 3-315.

"Waterproof" (Eisen). Part of a man's
costume: 3-112, 3-160, 3-195, 3-197.

Eisen 1902b

See 3-315, 3-316 (Jacaltenango)

3-160
SHOULDER BAG, *matate*
21" X 13" 51.5 CM X 33 CM

Fiber: 2-ply cording, natural tan

Knotless netting, three pieces, body with
long tapered strap attached at one end;
coiled loop attached to body on other side.
Very loose hourglass pattern.

Part of a man's costume: 3-112, 3-195, 3-197,
3-313. Larger, looser knotting than in other
bags. For comments see 3-67 (Sololá, Sololá).

See 3-259 (Tutuapa, Guatemala)

HUEHUETENANGO
Soloma
CHUJ Q'ANJOB'AL

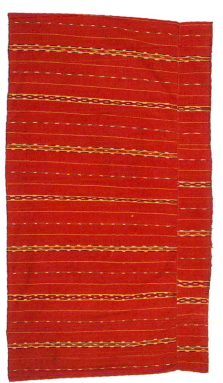

HUEHUETENANGO
Todos Santos Cuchumatán
MAM

3-128
LOOM, *telar*
53" X 11¼" 135 CM X 28½ CM

Warp: cotton, singles, white; 2 singles, red (alizarin), orange, green; 61 epi, 24 epc
Weft: cotton, 2 singles, white; 25 ppi, 11 ppc
Supplementary weft: cotton, 2 singles, red (alizarin), orange; over 4 warps

Backstrap-loomed, warp-predominant plain weave, single-faced supplementary weft brocading; woven (10") and unwoven (43") warp.

Warp and weft stripes create plaid pattern.

"For weaving colored cloth" (Eisen). Red dye is alizarin (Carlsen). Eight sticks of varying sizes made of soft wood; three sets of shed sticks; one set including brown string heddles; size indicates a child's *huipil* or pant leg. Warps stiffened with sizing (*atole*); ½" weaving on upper end. Web attached to end sticks with *pita* twining; cording used to secure loom to post or tree when weaving. Cloth on loom relates to 3-114, 3-115, 3-116.

Eisen 1902b; Carlsen, pers. com. 1987

See 3-171, 3-278, 3-288 (Huehuetenango); 3-292 (Aguacatán)

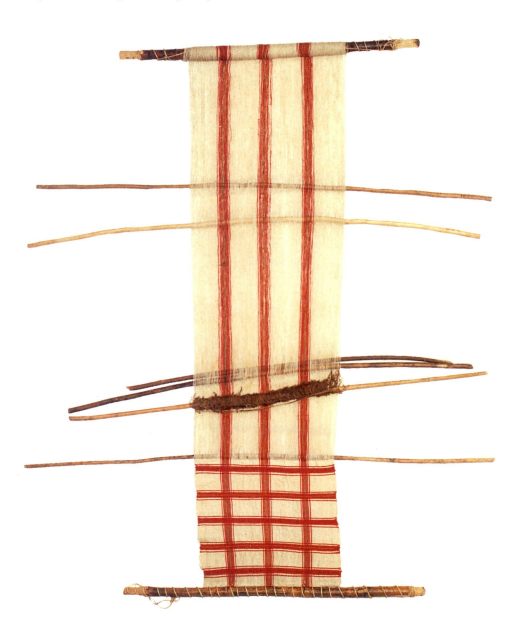

-117
VERPANTS, *sobre pantalón*
" X 22¾" 76.2 CM X 57.8 CM

arp: wool, singles, natural dark brown;
 epi, 8 epc
eft: wool, singles, natural dark brown;
 ppi, 11 ppc

readle-loomed, twill weave; nine pieces,
ont flap slit creates pockets, all hand-
itched.

nused textile. Cut-and-sewn garment.
itched and embroidered with 2-ply
aguey yarns; cotton-lined dark blue fabric
wn onto ends of pant legs and sides of
ont flap; three bone buttons sewn onto top
 waistband. Part of man's costume: 3-114,
 116, 3-118. (See Figure 60.)

HUEHUETENANGO
Todos Santos Cuchumatán
MAM

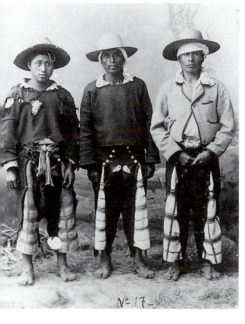

gure 60.
aya men from Todos Santos Cuchumatán,
aehuetenango. George Byron Gordon photo
chives, Peabody Museum of Archaeology and
hnology, Harvard University. 1901. H8607.

HUEHUETENANGO
Todos Santos Cuchumatán
MAM

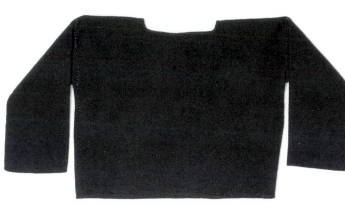

3-118
OVERSHIRT, *chaqueta*
20″ X 23″ 50.9 CM X 58.5 CM

Warp: wool, singles, natural dark brown;
26 epi, 11 epc
Weft: wool, singles, natural dark brown;
18 ppi, 7 ppc

Treadle-loomed, twill weave; three pieces,
seams hand-sewn; rectangular head hole cu
out; warps cut and hemmed.

Cut-and-sewn garment. Felted and hand-
stitched with 2-ply maguey yarns. Part of
man's costume: 3-114, 3-116, 3-117.

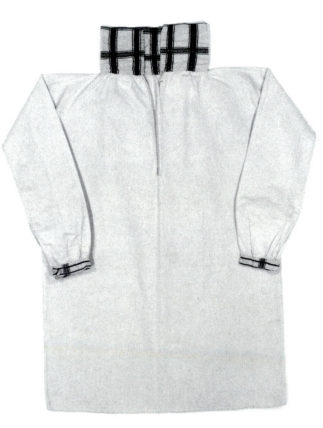

3-114
SHIRT, *camisa*
32½″ X 23½″ 81.2 CM X 58.5 CM

Warp: cotton, singles, white, red (alizarin),
green, orange; 44 epi, 20 epc (treadle-
loomed), 60 epi, 24 epc (backstrap-loomed)
Weft: cotton, singles, white; 2 singles, red
(alizarin), green, orange; 42 ppi, 17 ppc
(treadle-loomed), 31 ppi, 12 ppc (backstrap-
loomed)

Body and sleeves: treadle-loomed *manta*,
balanced plain weave; three pieces, warps
cut and hemmed; head hole cut out and slit
sleeves slit at ends, seams hand-sewn.
Collar and cuffs: backstrap-loomed balance
plain and weft-faced twill weaves; hand-
sewn to shirt body.

For collar and cuffs, warp and weft stripes
create plaid effect.

Red dye is alizarin (Carlsen). Cut-and-sewn
tailored piece, sleeves attached to body at
sides. Collar and cuffs are two layers of
cloth so that when one side wears out, it is
turned over and the other side is exposed.
Part of man's costume: 3-116, 3-117, 3-118.
Example in the Smithsonian National
Museum of Natural History, 201088, part o
man's costume, collected in 1899, seems to
be identical.

Carlsen, pers. com. 1987

See 3-116

-115
HIRT, *huipil*
9" X 39" 99 CM X 99 CM

arp: cotton, singles, white, red (alizarin),
een, orange; 54 epi, 21 epc
eft: cotton, singles, white; 2 singles, red
lizarin), green, orange; 27 ppi, 11 ppc
applementary weft: cotton, 2 singles, red
lizarin), orange, green; over 4–7 warps

ackstrap-loomed, warp-predominant and
eft-faced twill weaves, single-faced
applementary weft brocading; three pieces,
l end-selvedges loom-finished, hand-sewn
ont, back, and side seams; head hole cut
at; collar of commercial cloth and silk
bbon, tucking at neck, four silk taffeta
aedallions on front, back, and shoulders.

arrow warp stripes, thick, wide weft
ripes create plaid effect. Small geometric
rms.

Lawn ruffle around neck" (O'Neale:
g. 103a). Red dye is alizarin (Carlsen). A
milar, earlier piece collected in 1899 is in
ae Smithsonian National Museum of
atural History, 201089; no horizontal red
ands of supplementary weft brocading, and
o supplementary weft geometric forms.

'Neale 1945; Carlsen, pers. com. 1987

ee 3-114, 3-116

3-116
UNDERPANTS, *pantalón*
38" X 33¼" 96.5 CM X 84.5 CM

Warp: cotton, singles, white, red (alizarin),
green, orange; 57 epi, 23 epc
Weft: cotton, 2 singles, white, red (alizarin),
green, orange; 21 ppi, 9 ppc
Supplementary weft: cotton, 2 singles, red
(alizarin), green, orange; over 3 warps

Backstrap-loomed, warp-predominant and
weft-faced twill weaves, single-faced
supplementary weft brocading; eight pieces
sewn together, opening at front; cut warps
at both ends create ¾" fringe at waist.

Narrow warp stripes, thick, wide weft
stripes create plaid effect. Small geometric
forms.

Red dye is alizarin (Carlsen). There is a
similar textile in the Smithsonian National
Museum of Natural History, 201087,
purchased in 1899. Supplementary weft
geometric forms placed in different areas.
Cut-and-sewn piece; extra piece of cloth for
crotch. No waistband. Basic costume the
same in 1935. Still worn in 1988. Part of
man's costume: 3-114, 3-117, 3-118.

Carlsen, pers. com. 1987

See 3-114, 3-117

HUEHUETENANGO
Todos Santos Cuchumatán
MAM

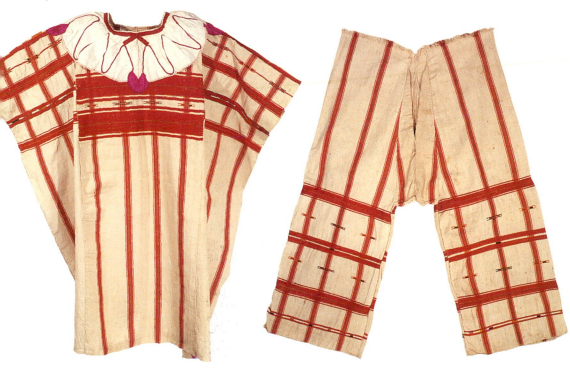

QUEZALTENANGO
Almolonga
K'ICHE'

3-16
SHOULDER CAPE, *perraje*
38" X 54" 97 CM X 137 CM

Warp: cotton, 2 singles, white; 2-ply, red, dark blue; 23 epi, 12 epc
Weft: cotton, 2 singles, white; 20 ppi, 8 ppc
Supplementary weft: cotton, 9–15 singles, red; 3-ply, lavender (*purpura*); silk floss, yellow, white; over 2–6 warps

Backstrap-loomed, balanced plain weave, single-faced supplementary weft brocading; two pieces, two end-selvedges loom-finished, two ends hemmed; two pieces joined together with a decorative *randa* in fishbone stitch.

Warp striping, geometric forms: chevrons, hexagons.

"For native woman" (Eisen). "Fine example of color, design, texture, and silk. An Eisen specimen giving evidence that general style of striping and arrangements of motives have persisted over a period of years" (O'Neale: 113). O'Neale thought that warp stripes of alternating red and dark blue were *jaspe* or *ikat*. Lavender cotton is dyed with *purpura* (Carlsen). Lavender cotton may have been dyed as singles and then plied (Howe). Probably a woman's *cofradía* shawl (Deuss).

Eisen 1902b; O'Neale 1945; Carlsen, pers. com. 1987; Howe, pers. com. 1988; Deuss, pers. com. 1990

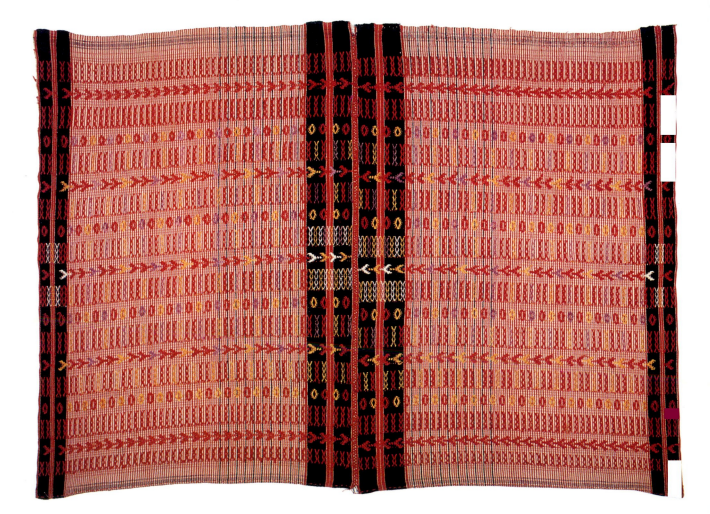

-20
RIDLE, MAN'S, *faja*
9" x 14½" 252 CM X 37 CM

'arp: cotton, 2 singles, red; 20 epi, 8 epc
'eft: cotton, 3 singles, red; 2 singles,
:llow, green; 28 ppi, 12 ppc
.pplementary weft: cotton, 8 singles,
:llow, green; over 2–3 warps

:ckstrap-loomed, balanced plain weave,
ngle-faced and two-faced supplementary
eft brocading; one piece; 5" of unwoven
arps with two woven rows serve as a fringe
1 one end; other end-selvedge is loom-
nished but without fringe.

'eft stripes. Chevrons and curvilinear
.otifs.

.oloring relates to 3-19, which is catalogued
. *huipil* cloth so may be a woman's belt.
wo woven rows would keep cut warps
om unraveling. For comments see 3-19.

:e 3-19, 3-21

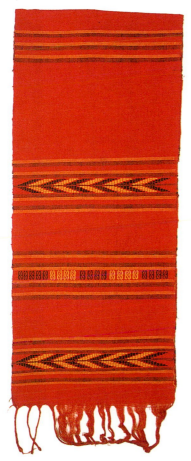

3-21
BRIDLE, MAN'S, *faja*
126" x 11" 320 CM X 28 CM

Warp: cotton, 2 singles, yellow; 26 epi,
12 epc
Weft: cotton, 2 singles, yellow; 20 ppi,
14 ppc
Supplementary weft: silk floss, magenta,
royal blue, blue-green; over 2 warps

Backstrap-loomed, balanced plain weave,
single-faced supplementary weft brocading;
one piece; four woven rows, 7½" of unwoven
warps serve as fringe at each end.

Three rows of hourglass and chevron motifs
on each end.

"Sash belts of yellow cotton brocaded in
colored silks with aid of pattern sticks"
(O'Neale: Fig. 121b). "Men's *bandas* have
red ground" (Deuss). This sash may be from
another village but purchased in Concepción
Chiquirichapa. For comments see 3-19.

O'Neale 1945; Deuss, pers. com. 1988

See 3-19, 3-20

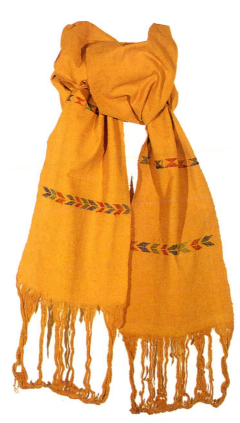

QUEZALTENANGO
Concepción Chiquirichapa
MAM

QUEZALTENANGO
Concepción Chiquirichapa
MAM

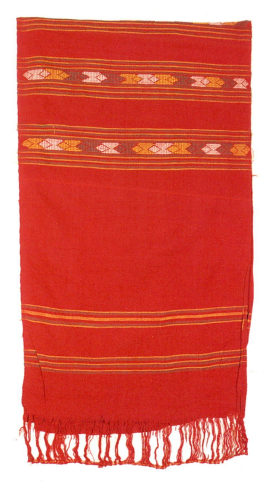

3-19
CLOTH, *huipil*
76" X 20" 194 CM X 51 CM

Warp: cotton, 2 singles, red; 28 epi, 12 epc
Weft: cotton, 2 singles, red, yellow, green;
36 ppi, 14 ppc
Supplementary weft: cotton, 6 singles,
white, yellow, green; over 2 warps

Backstrap-loomed, balanced plain weave,
two-faced supplementary weft brocading;
one piece; four rows of plain weave and 4" o
unwoven warps as fringe on one end; other
end is loom-finished but without fringe.

Weft stripes. Hourglass and diamond forms
in five single bands.

Probably not *huipil* cloth because of bound
fringe on one end. Woven ends keep fringe
from unraveling. Probably cut before
wearing.

See 3-20, 3-21

QUEZALTENANGO
Quezaltenango
K'ICHE'

3-54
APRON, CHILD'S, *delantal*
17½" X 17" 44.5 CM X 43.2 CM

Warp: cotton, singles, red (alizarin), yellow;
2 singles, dark blue; 34 epi, 14 epc
Weft: cotton, singles, red (alizarin), dark
blue, *jaspe*—dark blue and white; 2 singles,
yellow, light blue; 45 ppi, 18 ppc

Treadle-loomed, plain weave, one piece;
warps cut and hemmed; pleated.

Plaid and chevron *jaspe* patterns.

Waistband of treadle-loomed plaid cloth, tie
of commercial tape; unusual example of cut
and-sewn tailored garment, all hand-sewn.
Red cotton dyed with alizarin (Carlsen).

Carlsen, pers. com. 1989

-57

PRON, *delantal*

0½" X 34" 129.5 CM X 88 CM

arp: cotton, singles, red; 2 singles, green;
 epi, 16 epc
eft: cotton, singles, red, medium blue,
ght green, *jaspe*—dark blue and white; silk
oss, magenta, gold, purple, yellow; 35 ppi,
4 ppc
pplementary weft: silk floss, yellow,
hite, green

readle-loomed, balanced plain and twill
eaves, two-faced supplementary weft
ocading; one piece, warps held in place by
ain-weave rows on both ends, weft yarns
rried up one side-selvedge.

rt of larger piece. For comments see 3-50.

e 3-50

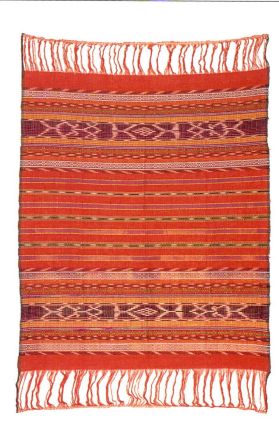

-180

PRON, *delantal*

7½" X 35½" 95.3 CM X 90.2 CM

arp: cotton, singles, red, yellow, blue;
 epi, 13 epc
eft: cotton, singles, green, *jaspe*—white
nd dark blue; 50 ppi, 20 ppc

readle-loomed, plain weave; one piece, cut
arps at both ends; weft yarns carried up
e side-selvedge.

arp and weft stripes create a plaid effect;
spe designs are geometric in form.

ndians of Quezaltenango" (Eisen). Yardage
ay have been used as a skirt. Pristine
ndition. May have been woven in
otonicapán for use in Quezaltenango. Use
 predominantly green unusual in Maya
spe cloth.

sen 1902b

e 3-183 (Huehuetenango, Huehuetenango)

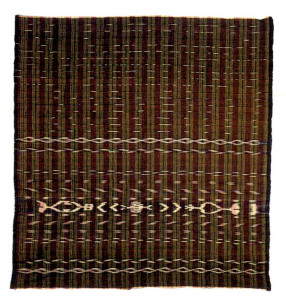

QUEZALTENANGO
Quezaltenango
K'ICHE'

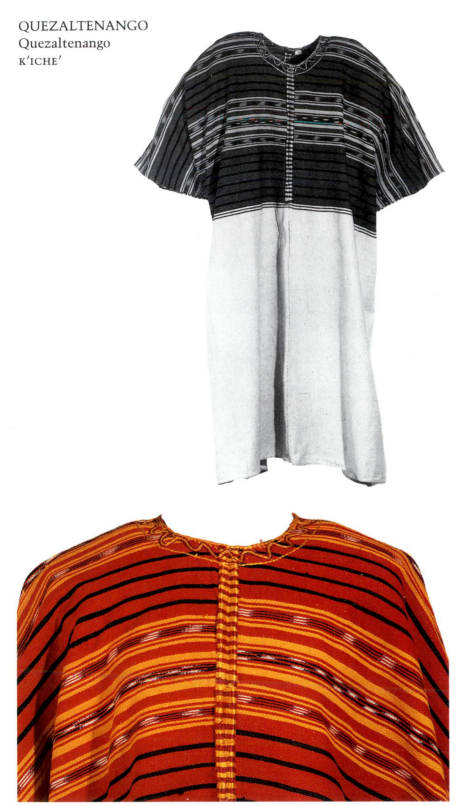

3-43
BLOUSE, *huipil*
44" X 47" 112 CM X 120 CM

Warp: cotton, singles, white; 28 epi, 13 epc
Weft: cotton, singles, *jaspe*—dark blue and
white; 2 singles, white, dark blue, red,
yellow; 56 ppi, 22 ppc

Draw-loomed, plain and weft-faced twill
weaves; two pieces joined at front, back, and
side seams with buttonhole-stitched *randa*;
warps cut and hemmed; head hole cut out
and embroidered with chain stitching.

Solid-colored and *jaspe* horizontal stripes of
varying widths.

Made on draw loom. O'Neale calls this
textile a more ordinary type of *huipil* made
in home workshops called *fábricas* in
Spanish in the city; lengths were sold in
market (O'Neale: 293). "Weavers said that
this *huipil* was old style" (Deuss). In 1988,
lengths were sold all over the highlands.
Elaborate darn below dark blue striping in
white background. Red and yellow silk floss
used for front and back *randas* and neck
decoration. (See Figure 61.)

O'Neale 1945; Deuss, pers. com. 1988

Figure 61.
A group of Maya. Woman on left wearing a *huipil*
that resembles 3-43, acquired in the town of
Quezaltenango. George Byron Gordon photo
archives, Peabody Museum of Archaeology and
Ethnology, Harvard University. 1901. H8456.

-64

LOUSE, *huipil*

3" X 30" 109.2 CM X 76.2 CM

Varp: cotton, singles, white; 2 singles, red;
op, 31 epi, 13 epc
Veft: cotton, singles, white; top, 30 ppi,
3 ppc
upplementary weft: cotton, 4–8 singles,
:d, yellow, green, lavender, dark blue; silk
oss, purple, lavender, gold, pink; over 4–7
arps

op: backstrap-loomed, balanced plain
reave, supplementary weft brocading; two
ieces, end-selvedges loom-finished, sewn
ogether at front, back, and side seams; head
ole rounded and cut out, ¾" below neck is
7" slit, white silk neck piece with points
mbroidered with chain stitch. Bottom:
eadle-loomed *manta*, weft predominant,
ree pieces sewn together and to the top,
ottom, cut warps.

ne central band of geometric designs, two
ide bands of zigzags on either side. Evenly
aced dots and geometric forms on rest of
uipil. Several rows of red wefts on bottom
:lvedges (weaver's mark).

Bought in Quezaltenango" (Eisen).
Completely different from today"
ehmann). Backstrap-woven *huipil* sewn
ito treadle-loomed pieces with warps used
orizontally; small tuck made on one side
match other side for bilateral symmetry.
or comments see 3-240 (San Martín
lotepeque, Chimaltenango).

sen 1902b; Lehmann 1962

:e 3-46, 3-240 (San Martín Jilotepeque,
himaltenango)

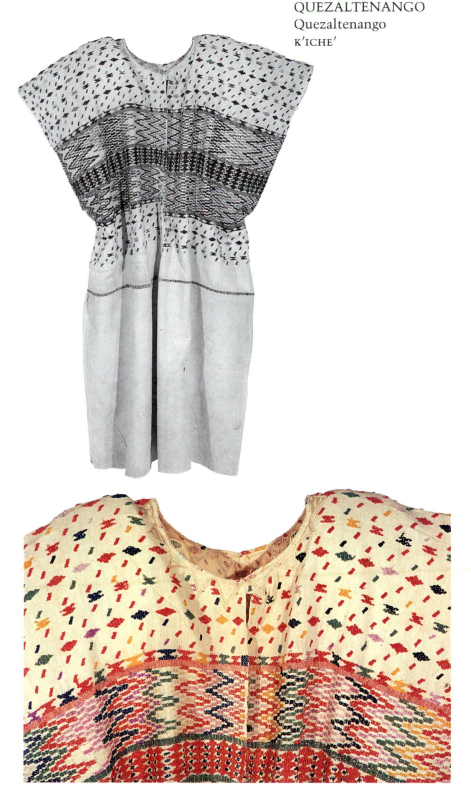

QUEZALTENANGO
Quezaltenango
K'ICHE'

3-58
HEADBAND, *cinta*
65" x ½" 165.2 CM X 1.3 CM

Warp: cotton, commercially spun, 2 singles
white; 32 epi, 12 epc
Weft: cotton, 2 singles, medium blue, dark
blue; 82 ppi, 29 ppc

Treadle-headband-loomed, double-faced
twill weave; one piece, warps cut, tied; silk
floss attached at ends.

Weft stripes, magenta and gold silk floss at
ends.

"Four harness treadle loom used by weavers
of Totonicapán headbands. Loom lacks warp
and cloth beams. Tension maintained
between peg in ground and stick through
weaver's belt by retying knot to take up an
amount equal to warp length let out"
(O'Neale: Fig. 19h). "Still used for ends of
braids" (Deuss). Woven in Totonicapán by
professional weavers called *cinteros* for
specific towns.

O'Neale 1945; Deuss, pers. com. 1988

See 3-76, 3-77, 3-84

3-76
HEADBAND, *cinta*
65" x ½" 166.5 CM X 1.3 CM

Warp: cotton, commercially spun, 2 singles
white; 28 epi, 11 epc
Weft: cotton, 2 singles, red, yellow, green,
medium blue; 74 ppi, 30 ppc

Treadle-headband-loomed, double-faced
twill weave; one piece; warps cut, tied; silk
floss attached at ends.

Weft stripes; magenta and gold silk floss at
ends.

"Headbands of Totonicapán-type from
different communities" (O'Neale: Fig. 118f).
For comments see 3-58.

O'Neale 1945

See 3-58, 3-77, 3-84

-77
HEADBAND, *cinta*
65" x ½" 165.2 CM X 1.3 CM

Warp: cotton, commercially spun, 2 singles,
white; 30 epi, 12 epc
Weft: cotton, 2 singles, red, yellow, medium
blue, dark blue; 76 ppi, 28 ppc

Treadle-headband-loomed, double-faced
twill weave; one piece, warps cut, tied; silk
floss attached at ends.

Thin weft stripes of alternating colors;
magenta and gold silk floss tied at ends.

Woven in Totonicapán. Headband is
identical to 3-84 except for the color of the
silk floss at ends. For comments see 3-58.

See 3-58, 3-76, 3-84

-84
HEADBAND, *cinta*
65" x ½" 165.2 CM X 1.3 CM

Warp: cotton, commercially spun, 2 singles,
white; 24 epi, 11 epc
Weft: cotton, singles, red; 2 singles, yellow,
dark blue, medium blue; 40 ppi, 14 ppc

Treadle-headband-loomed, double-faced
twill weave; one piece, warps cut, tied; silk
floss attached at ends.

Thin weft stripes; brown silk floss tied at
ends.

Cotton warps are mercerized, brittle to the
touch.

See 3-58, 3-76, 3-77

QUEZALTENANGO
Quezaltenango
K'ICHE'

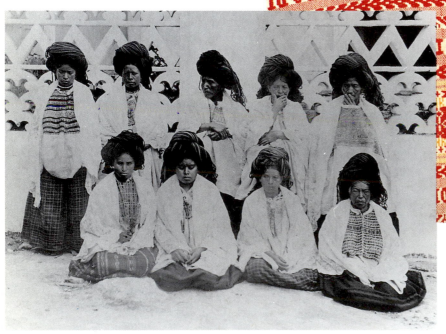

3-53
SHIRT, *huipil*
44″ X 47″ 111.8 CM X 119.5 CM

Warp: cotton, 2 singles, white; 33 epi,
13 epc
Weft: cotton, 2 singles, white, red, yellow;
25 ppi, 11 ppc
Supplementary weft: cotton, 3 singles, red,
yellow, green
Embroidery: silk floss, yellow, red

Draw-loomed, balanced plain weave, two-
faced supplementary weft brocading; two
pieces, warps cut and hemmed; front and
back joined in buttonhole stitch with silk
floss at center seams and with cotton
for side seams; head hole cut out and
embroidered with chain stitching.

Geometric forms in horizontal bands.

"Iconography still used on cofradía napkins
(Deuss). Pristine condition. For comments
see 3-43. (See Figure 62.)

Deuss, pers. com. 1988

See 3-69

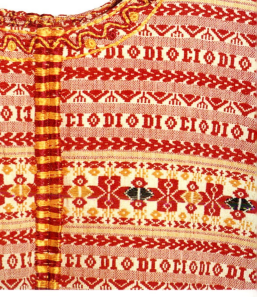

Figure 62.
Cofradía members, Mixco, Guatemala. Some of
the women are wearing *huipiles* that resemble
3-53 and 3-69, acquired in the town of
Quezaltenango. George Byron Gordon photo
archives, Peabody Museum of Archaeology and
Ethnology, Harvard University. 1901. H8610.

-69
SHIRT, *huipil*
42" X 49" 106.7 CM X 124.5 CM

Warp: cotton, 2 singles, white; 34 epi, 13 epc
Weft: cotton, 2 singles, white, red (alizarin),
yellow; 25 ppi, 10 ppc
Supplementary weft: cotton, 4 singles, dark
blue; silk floss, yellow, red (cochineal)
Embroidery: silk floss, gold, lavender, green,
red

Draw-loomed, balanced plain weave, two-
faced supplementary weft brocading; two
pieces, warps cut and hemmed; joined by
silk buttonhole-stitched *randa* on top half of
front, back, and sides; front and back seams
hand-sewn to bottom; head hole cut out,
surrounded by embroidery on 1"-wide band.

Weft stripes, supplementary weft bands of
abstract forms with silk highlights.

Red dyes: cotton, alizarin; silk, cochineal
(Carlsen). Head hole is quite small in
diameter. Pristine condition. For comments
see 3-53. (See Figure 62.)

Carlsen, pers. com. 1987

See 3-53

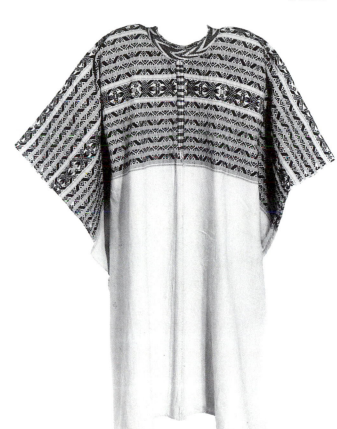

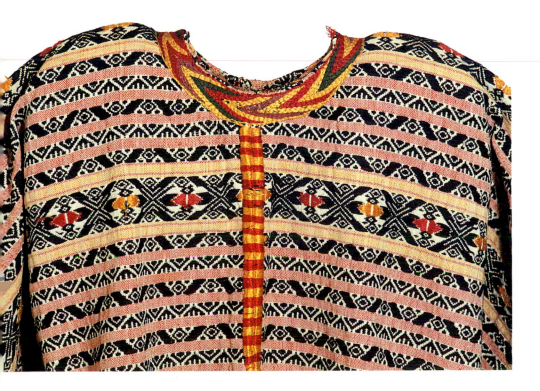

QUEZALTENANGO
Quezaltenango
K'ICHE'

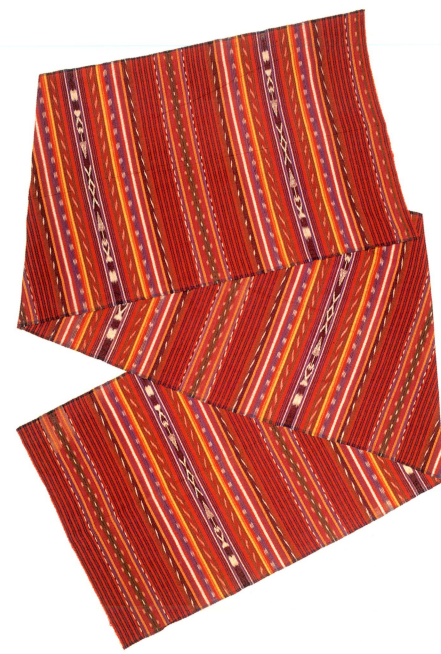

3-51
SKIRT, *enagua*
180" x 36" 456 CM X 92 CM

Warp: cotton, singles, red; 36 epi, 14 epc
Weft: cotton, singles, red, *jaspe*—dark blue
and white; 2 singles, white, purple, light
blue, yellow, green; 42 ppi, 18 ppc

Treadle-loomed, balanced plain weave; one
piece, warps cut.

Solid-colored and *jaspe* stripes of varying
colors.

"Probably made on an old loom" (Lehmann
Pleated skirts have been associated with
Quezaltenango (Rowe: 106), although
wraparound skirts may also have been worn
Red dye alizarin (Carlsen). "Since all skirts
in the nineteenth century were indigo with
or without stripes, or indigo and white *ikat*,
this textile is probably yardage. Some
weavers were exporting yardage abroad in
that period" (Deuss). There are several
examples of brightly colored treadle-woven
yardage in long lengths that may have been
used for skirts in the George Byron Gordon
collection made in 1901 in the Peabody
Museum, Harvard University, 01-40-20/C-
3006, 01-40-20/C-3007.

Lehmann 1962; Rowe 1981; Carlsen, pers.
com. 1987; Deuss, pers. com. 1988

138
KIRT, *enagua*
)″ X 51″ 202.2 CM X 129.5 CM

arp: cotton, 2 singles, white, brown
xcaco), dark blue, red; 25 epi, 10 epc
eft: cotton, singles, brown (*ixcaco*),
edium blue; 2 singles, white, dark blue,
llow; 30 ppi, 12 ppc

ackstrap-loomed, balanced plain weave;
vo pieces, warps cut and hemmed, joined
· whipping stitch.

arp and weft stripes create a plaid effect.

Used by Indians″ (Eisen). Eisen probably
ught this textile in Quezaltenango and
ought it was a woman's skirt or *enagua*.
Iowever, in Momostenango, Totonicapán,
xtiles like this example were used by men
a poncho and by women as a shoulder
rap. Everyone had one. Now they serve as
irial sheets″ (Deuss).

sen 1902b; Deuss, pers. com. 1988

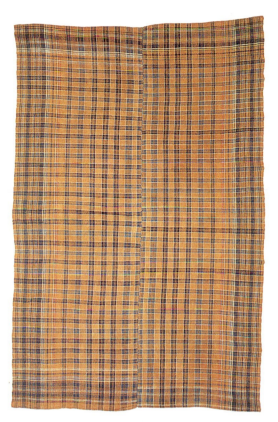

QUEZALTENANGO
Quezaltenango
K'ICHE'

85
AISTBAND, CHILD'S, *faja*
7½″ X 1¾″ 171.5 CM X 4.5 CM

arp: cotton, commercially spun and hand-
ied, 2-ply singles, white, dark blue, red,
een; 103 epi, 40 epc
eft: cotton, commercially spun and hand-
ied, 4 singles, green; 30 ppi, 12 ppc
pplementary weft: wool, 3 singles, red,
irple, yellow, green; cotton, 10 singles,
llow

ickstrap-belt-loomed, warp-faced plain
eave, single-faced supplementary weft
ocading; one piece, cut warps braided into
3½″ and a 5½″ braid.

orizontal bands of animal (deer, horse,
g), human, and geometric forms.

milar iconography in example collected by
eorge Byron Gordon in 1901 in the
abody Museum, Harvard University, 01-
20/C-3029. Woven in Totonicapán for use
Quezaltenango. For comments see 3-96,
97 (Totonicapán, Totonicapán).

e 3-70, 3-91, 3-92, 3-96, 3-97 (Totonicapán,
itonicapán)

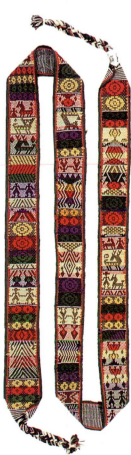

QUEZALTENANGO
Quezaltenango
K'ICHE'

3-87
WAISTBAND, MAN'S, *banda*
74" x 3¼" 188 CM X 8 CM

Warp: cotton, commercial, 4 singles hand-plied, white; three 3-ply, red; 8 singles, green, yellow, dark blue; ends 36 epi, 14 epc
Weft: cotton, commercial, 4 singles hand-plied, white; 8 singles, green; ends 10 ppi, 4 ppc

Backstrap-loomed and sprang; one piece, warps cut, twisted, and knotted, creates two 10¼" fringes.

Colored vertical stripes, white center section

"Loose fishnet weave" (Eisen in O'Neale: 199). "Woven heading strip at ends. Near center, two other sections of weaving prevent twining loosening" (O'Neale: Fig. 83c). O'Neale persuaded an old woman from San Juan Chamelco, Alta Verapaz, to stay away from market so that O'Neale could observe her making a belt (ibid.: 199–200). A loom bar is placed through loops at both ends; one end is fastened to a long stake driven into the ground, the other one to the waist attached to a cord, with no belt. This technique is now known as sprang, but in O'Neale's day it was known as twining.

O'Neale 1945

See 3-89; 3-222, 3-227, 3-230
(Huehuetenango, Huehuetenango)

3-89
WAISTBAND, MAN'S, *banda*
72" x 2¾" 182 CM X 6.5 CM

Warp: cotton, commercial, 4 singles hand-plied, white; three 3-ply, red; 8-ply, green, dark blue; ends 32 epi, 12 epc
Weft: cotton, commercial, 4 singles hand-plied, white; 8-ply, green; ends 10 ppi, 4 ppc

Backstrap-loomed and sprang; one piece, warps cut, twisted, and knotted, create two 10½" fringes.

Colored vertical stripes, white center stripe

For comments see 3-87.

See 3-87; 3-222, 3-227, 3-230
(Huehuetenango, Huehuetenango)

50

WRAPPER, *perraje*

8" x 34½" 224 CM X 88 CM

Warp: cotton, singles, red; 2 singles, green;
0 epi, 16 epc

Weft: cotton, singles, red, medium blue,
ight green, *jaspe*—dark blue and white; silk
oss, yellow, magenta, gold, red, purple; 35
pi, 14 ppc

upplementary weft: silk floss, green, royal
ue, white, yellow; over 2–6 warps

Treadle-loomed, balanced plain weave and
will weaves, two-faced supplementary weft
ocading; one piece, warps cut, weft yarns
rried up one side-selvedge; ten woven
ws bind 8" of unwoven warps that serve as
nges on both ends.

Stripes of varying widths. Abstract *jaspe*
designs in two wide and several thinner
stripes. Supplementary weft block designs.

"Could be used by *ladinas* and *indígenas*"
(Deuss). Some of the silk weft floats are
integrated into the structure of the cloth.
The two ends of the fabric are densely
decorated. More than one textile could have
been woven on the same warp; white wefts
may divide individual pieces. An apron,
3-57, may have been woven from the same
warp. Not town-specific.

Deuss, pers. com. 1988

QUEZALTENANGO
Quezaltenango
K'ICHE'

SAN MARCOS
Comitancillo
SPANISH

3-218
SHAWL, *rebozo*
100" x 30½" 254 CM X 77.5 CM

Warp: cotton, singles, red, yellow, green; 49 epi, 19 epc
Weft: cotton, singles, red; 42 ppi, 17 ppc

Treadle-loomed, balanced plain weave; one piece, cut warps are knotted into macramé fringes 10" long.

Stripes of varying widths in alternating warps of red and yellow.

The Eisen catalogue reads "Comitán, Chiapas, Mexico"; it is written in a different handwriting. For comments see 3-201 (Huehuetenango, Huehuetenango). (See Figure 63.)

See 3-201 (Huehuetenango, Huehuetenang)

Figure 63.
"Indians with jars. Salama" (Eisen 1902c). Women are wearing *rebozos* or shawls that resemble 3-201, acquired in the town of Huehuetenango, and 3-218, acquired in Comitancillo, San Marcos. Photo by Gustavus A. Eisen. 1902.

212

ADDLE BAG, *alforja*

" x 9½" 78.8 CM X 24.1 CM

arp: cotton, 3–4 plied singles, red, dark
ue, yellow, green; 63 epi, 25 epc
eft: cotton, 15–17 singles, red, dark blue;
opi, 3 ppc

ckstrap-loomed, warp-faced plain weave;
e piece, loom-finished selvedges create
ops, drawstrings through both ends;
mmercially woven cotton trim on sides of
g; warp yarns in sprang create one 11"
ndle in center of textile.

ulticolored warp stripes and sprang
ndle: red and dark blue yarns plied
gether create a *jaspe* effect.

"Interesting specimen in Eisen Collection
described because of its rarity. Band 52 by 10
inches partly woven, partly twined; terminal
20 inches on each end plain weaving; center
12 inches twined by methods that give
variety in texture; ends folded up on
themselves into two 10" pockets, red cords
run through warp loops to close openings;
heavy weft at center prevents twining from
release; edges bound with factory-made
tape, probably of German manufacture"
(O'Neale: 273).

O'Neale 1945

See 3-264 (Tutuapa)

SAN MARCOS
Malacatán
SPANISH

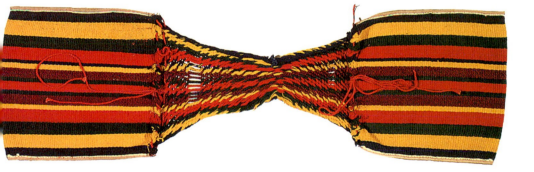

261

LT, BACKSTRAP, *cinta*

" x 4½" 78.9 CM X 11.5 CM

ber: *pita* cording, 2-ply

oven and plaited.

his type of belt is used for a backstrap
om.

SAN MARCOS
San Miguel Ixtahuacán
MAM

SAN MARCOS
Tutuapa
SPANISH

3-259
NET OR DOUBLE BAG, *red*
36″ x 15″ 91.5 CM x 38 CM

Fiber: 2-ply *pita* cording, natural tan

Knotless netting, very loose hourglass pattern, one-piece bag with draw string at both ends.

Larger, looser knotting than in other bags. For comments see 3-67 (Sololá, Sololá).

See 3-160 (Soloma, Huehuetenango)

3-264
SADDLE BAG, DOUBLE, *matate*
40″ x 10½″ 101.6 CM x 26.7 CM

Warp: maguey, hand-plied, 2-ply singles, tan, copper; 19 epi, 8 epc
Weft: maguey, hand-plied, 2-ply singles, tan; 7 ppi, 3 ppc

Backstrap-woven, warp-predominant plain weave; one piece, both end-selvedges looped, draw strings through both ends; stitched on folded selvedges and side seams; warp yarns are braided in the middle creating an 11″ handle between the two bags.

Two thin warp stripes on each side of bags.

Unused. Weft yarns loosely plied. In form, except for handle construction, similar to 212 (Malacatán). An example in the Smithsonian National Museum of Natural History, 301999, purchased in 1918, is similar in size with more elaborate colored warps. Called *alforjas*. For comments see 3-212 (Malacatán).

See 3-212 (Malacatán)

-143
OWEL OR WRAP, *toalla*
7″ x 16½″ 170.2 CM X 42 CM

Warp: cotton, 2 singles, white, red; 51 epi,
1 epc
Weft: cotton, 2 singles, white, red, green,
ellow; 22 ppi, 9 ppc
upplementary weft: cotton, 5 singles,
ellow, over 1–7 warps

ackstrap-woven, warp-predominant plain
weave, single-faced supplementary weft
rocading; one piece, both end-selvedges
oom-finished.

Varp stripes, subtle weft stripes.
upplementary weft brocading creates a
ingle geometric design.

"Near Quiché" (Eisen). Only one single-
aced supplementary weft brocaded design;
nay be a weaver's mark. Town now called
antiago Atitlán.

isen 1902b

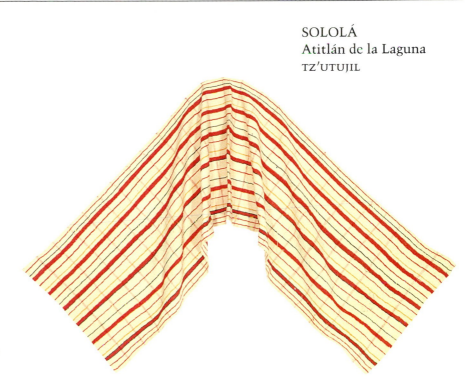

-68
AG, *matate*
4″ x 16″ 35.5 CM X 40.7 CM

iber: wool, singles, natural white

nitted; three pieces, border design at top;
wo straps attached to body by hand-sewing;
horter strap is knitted in same pattern as
order and has coiled loop ending; longer
trap woven in warp-faced pattern, warps
wisted and knotted, creating a fringe. No
eams.

'wo horizontal stripes approximately 2½″
vide created by changing from one natural
vhite yarn to another; knots inside the bag
ndicate this change.

Made of wool" (Eisen). "Knitted on two
netal needles by men; a double knot stitch
s used which gives the bag a strong
noisture resistant texture" (Schevill: 52).
Vell worn.

isen 1902b; Schevill 1986

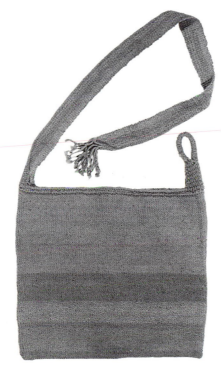

ee 3-67 (Sololá)

SOLOLÁ
Nahualá
K'ICHE'

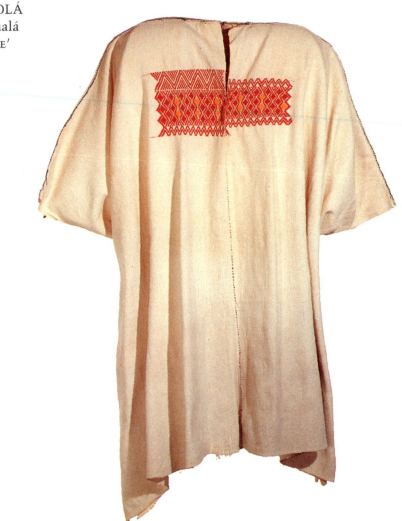

3-38
GARMENT, *huipil*
36" x 48" 91.5 CM x 122 CM

Warp: cotton, 2 singles, white; 32 epi, 14 ep
Weft: cotton, 2 singles, white; 19 ppi, 8 ppc
Supplementary weft: cotton, 8–12 singles,
red, yellow; over 1–22 warps

Backstrap-loomed, warp-faced plain weave,
single and two-faced supplementary weft
brocading; two pieces joined by cotton
thread in plain stitch; both end-selvedges
are loom-finished.

Various geometric designs and bird motifs.
Designs placed in blocks on chest, shoulder
and upper-back areas.

"Near Totonicapán" (Eisen). "Nahualá
garments distinguished by fine tailoring of
seams; necklines are cut round, but front
seams left open part way and edges turned
back to form lapels" (O'Neale: 281). "The
Nahualá *huipil* is one of the few in
Guatemala where the front and back are
different" (Rowe: 74). Rowe also mentions
the contrast between simpler designs found
on the Eisen *huipil* and more complex
designs of the 1930s. Tuck at shoulder in
dark blue cotton is a decorative element.
Probably *cofradía huipil*; relates to 3-45.
(See Figure 64.)

Eisen 1902b; O'Neale 1945; Rowe 1981

See 3-45

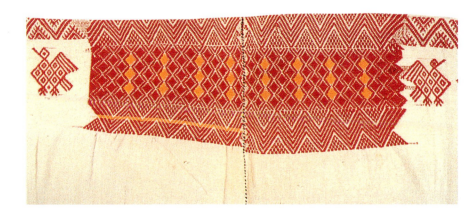

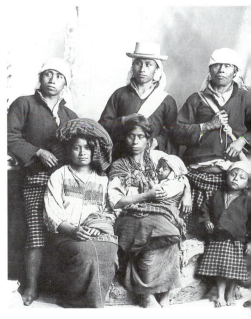

Figure 64.
A group of Maya from Nahualá, Sololá. Special
Collections, California Academy of Sciences,
San Francisco. 1902.

-83
EADBAND, *cinta*
o″ x 1″ 177.5 CM X 2.5 CM

Varp: cotton, commercially spun, 2 singles,
white; 23 epi, 10 epc
Veft: cotton, singles, red, orange; wool,
ngles, red; 102 ppi, 41 ppc

readle-headband-loomed, double-faced
will weave; one piece, warps cut, tied; silk
oss attached to ends.

hick weft bands of color at both ends.

urchased "near Totonicapán" (Eisen).
Voven in Totonicapán for use in Nahualá.

isen 1902b

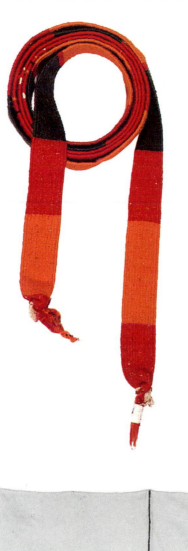

-45
EADCLOTH, MAN'S, *xute/tzute*
4½″ x 42½″ 113 CM X 108 CM

Varp: cotton, 2 singles, white; 20 epi, 8 epc
Veft: cotton, 2 singles, white; 22 ppi, 9 ppc
upplementary weft: cotton, 8–20 singles,
:d (alizarin), yellow; over 2–14 warps

ackstrap-loomed, balanced plain weave,
vo-faced supplementary weft brocading;
vo pieces, two end-selvedges loom
nished, two ends, warps cut, rolled, and
emmed; two pieces joined by buttonhole-
:itched *randa*.

ouble-headed eagles in center blocks with
:ometric borders. One red weft yarn in
hite background may be weaver's mark.

)ld style ceremonial headdress for men.
oday's style (1936) the same" (O'Neale:
.g. 107a). Red dye is alizarin (Carlsen).
robably woven as one piece, cut in half and
:wn together; double-headed eagles upside
)wn on one side. Supplementary weft yarn
1ds woven into plain weave; this style is
sed for the *cofradía* costume and relates to
·38. This style became popular again in
1e 1980s. Weaving workshops produced it
ith varying colors of supplementary weft
1rns for sale and for ceremonial use. (See
.gure 64.)

'Neale 1945; Carlsen, pers. com. 1987

:e 3-38

SOLOLÁ
Nahualá
K'ICHE'

SOLOLÁ
San Lucas Tolimán
KAQCHIKEL

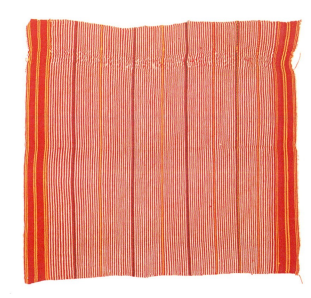

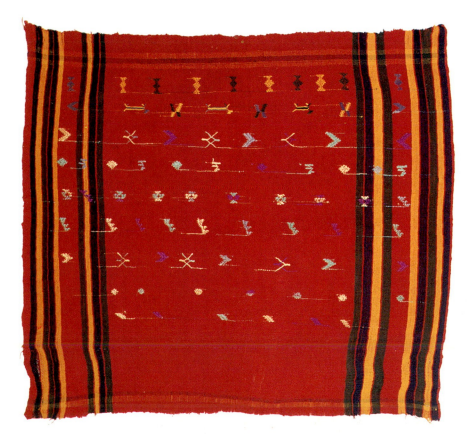

3-152
TOWEL, BABY'S, *toalla*
17″ x 18½″ 43.2 CM X 45.7 CM

Warp: cotton, 2 singles, white, red, yellow, green; 71 epi, 29 epc
Weft: cotton, 2 singles, red; 21 ppi, 9 ppc

Backstrap-loomed, warp-faced plain weave; one piece, both end-selvedges loom-finished

Thin warp stripes.

The joining is 1″ wide and quite loose.

See 3-151, 3-153

3-153
GARMENT, *toalla*
29″ x 32″ 73.7 CM X 81.3 CM

Warp: cotton, 2 singles, red (alizarin), dark blue, yellow, green; 58 epi, 24 epc
Weft: cotton, 2 singles, red (alizarin), dark blue, yellow; 21 ppi, 8 ppc
Supplementary weft: cotton, 4–6 singles, green, yellow (2 shades), medium blue; silk floss, ivory, aqua, purple, light blue; over 3–14 warps

Backstrap-loomed, warp-predominant plain weave, single-faced supplementary weft brocading; end-selvedges loom-finished.

Wide warp stripes on both sides; weft stripe on top and bottom may be weaver's mark; geometric forms. Streamers created by supplementary weft brocading yarns appear as a design motif.

"Motives similar to those on *huipil*" (O'Neale: 271). "Long streamers at beginning and ending of length of yarn identify technique as brocading" (ibid.: 109c,d). "Atypical" (Lehmann). Red cotton dyed with alizarin (Carlsen). "A *servilleta*" (Arriola de Geng).

O'Neale 1945; Lehmann 1962; Carlsen, pers. com. 1987; Arriola de Geng, pers. com. 1989

See 3-151, 3-152

-151

HIRT, *huipil*

9½" x 28½" 3.7 CM X 72.5 CM

Varp: cotton, 2 singles, white, dark blue,
ght blue, red (alizarin); 56 epi, 22 epc
Veft: cotton, 2 singles, white; 26 ppi, 10 ppc
upplementary weft: cotton, 2–9 singles,
ark blue, blue-green (indigo), red (alizarin),
ellow, light blue; over 2–11 warps

ackstrap-loomed, warp-predominant plain
eave; single-faced supplementary weft
rocading; two pieces, four end-selvedges
om-finished, joined at sides, front, and
ack seams; head hole cut out, silk taffeta
ointed neck piece and medallions on front
nd back.

arious geometric forms: solid
upplementary weft–brocaded block across
nest area.

Free-standing brocade motives with
haracteristic long streamers" (O'Neale:
g. 88b). Green and red cotton yarns are
yed with indigo plus and alizarin
espectively (Carlsen). "Plus" relates to
nother element in dye bath. Streamers are
upplementary weft yarns carried under
arps that show through. Coarse joining.

'Neale 1945; Carlsen, pers. com. 1987

ee 3-152, 3-153

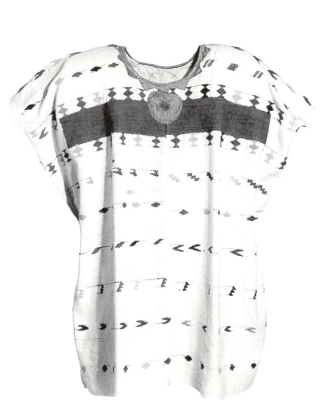

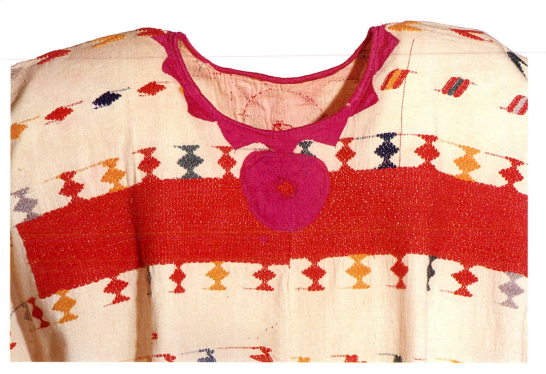

SOLOLÁ
Sololá
KAQCHIKEL

3-67
BAG, *matate*
16½″ x 18″ 42 CM X 45.5 CM

Fiber: 2-ply *pita* cording, natural tan

Knitted; five pieces; two straps are sprang, attached to body by knotless netting; long strap is coiled at tip, short strap has coiled loop; a twisted strand with coils 1″ and 4″ from bottom is attached to top border, no seams.

"Native bag made of *pita*" (Eisen). Knotless netting: a single element technique which must by its structural nature be made with yarn or strand of limited length, a series of variously connected loops which rely on the adjoining loops in order to maintain their orientation and preserve the textile unit (Dickey: 7–8). Sprang: "the process of constructing a fabric by manipulating a set of parallel yarns that are fixed at both ends or wound continually around two poles" (Kent: 298). "Knitting: an interlooping technique using a single element in a series of loops. Pointed rods or needles are utilized" (Schevill: 128). Well-used bag. *Pita* is the vegetal fiber of the century plant (*agave americana*).

Eisen 1902b; Dickey 1964; Kent 1983; Schevill 1986

See 3-68 (Nahualá)

3-14
CLOAK, *capote*
46″ x 22″ 116.8 CM X 55.9 CM

Warp: wool, singles, natural dark brown; 21 epi, 9 epc
Weft: wool, singles, natural dark brown; 15 ppi, 6 ppc

Treadle-loomed twill weave; three pieces, cut warps at back create a 1½″ fringe, other warps cut and hemmed; head hole cut out.

"*Capote* of native" (Eisen). Unused textile. Cut-and-sewn garment. Oval head hole. Sleeves half sewn; side and underarm seam of garment not joined. The back of the garment is 5″ to 7″ longer than the front.

Eisen 1902b

-136
MULTIPURPOSE CLOTH, *servilleta*
2" x 30" 81.3 CM X 76.2 CM

Warp: cotton, commercially spun, singles,
brown; 40 epi, 16 epc
Weft: cotton, commercially spun, 2 singles,
white, brown, dark blue; 36 ppi, 14 ppc

Treadle-loomed, balanced plain weave, two-
faced supplementary weft brocading; one
piece, warps cut, colored weft yarns carried
up onc side-selvedge.

Weft stripes with block patterns.

Brown cotton is commercially spun and an
effort has been made to simulate natural
brown cotton or *ixcaco* (Howe).

Howe, pers. com. 1988

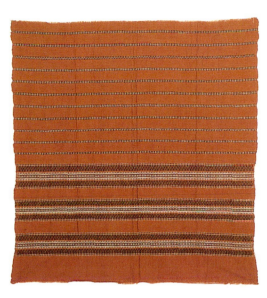

TOTONICAPÁN
Momostenango
K'ICHE'

-137
WAISTBAND, MAN'S, *banda*
100" x 6½" 254 CM X 15.3 CM

Warp: cotton, 2 singles, white; 17 epi, 7 epc
Weft: cotton, singles, white, dark blue; 108
ppi, 40 ppc

Backstrap-loomed, plain weft-faced weave;
one piece, warps cut and hemmed, weft
yarns carried up one side-selvedge.

Weft stripes of varying widths.

"Yarns battened to give tapestry texture"
(O'Neale: Fig. 121c). Weft stripes are rare on
bandas; more common are warp stripes and
solid colors. Relates to type worn by men
in Tenejapa and San Andrés Larrainzar,
Chiapas, Mexico. A similar textile, 3-123,
was exchanged with the American Museum
of Natural History, 65-3284, in 1907.

O'Neale 1945

See 3-179, 3-182

TOTONICAPÁN
Momostenango
K'ICHE'

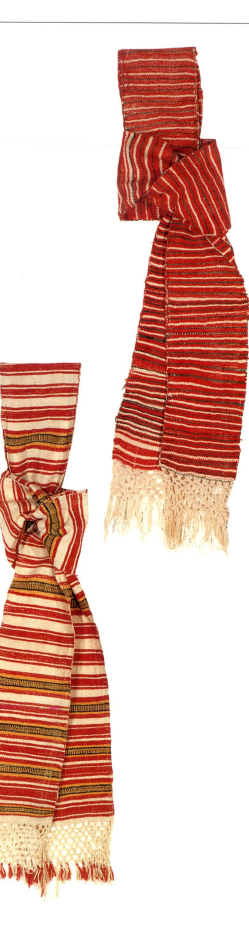

3-179
WAISTBAND, MAN'S, *banda*
101" X 5" 256.6 CM X 12.7 CM

Warp: cotton, 2 singles, white; 16 epi, 6 epc
Weft: cotton, 2 singles, white, red, green;
35 ppi, 14 ppc

Backstrap-loomed, balanced and weft-
predominant plain weaves; one piece, cut
warps at both ends knotted in square knots
creating two 4½" fringes; weft yarns carried
up one side-selvedge.

Thick and thin alternating horizontal
stripes.

"Knotted fringes, rare on men's belts"
(O'Neale: Fig. 121e). For comments see
3-137.

O'Neale 1945

See 3-137, 3-182

3-182
WAISTBAND, MAN'S, *banda*
104" X 5½" 264.2 CM X 14 CM

Warp: cotton, 2 singles, white; 18 epi, 7 epc
Weft: cotton, 2 singles, white, red (alizarin),
green, yellow; 36 ppi, 14 ppc

Backstrap-loomed; balanced and weft-
predominant plain weaves; one piece, cut
warps at both ends are knotted creating two
4" fringes; weft yarns carried up one side-
selvedge.

Weft stripes of varying widths.

Red dye is alizarin (Carlsen). For comments
see 3-137 and 3-179.

Carlsen, pers. com. 1987

See 3-137, 3-179

arp: cotton, commercially spun, 2 singles,
hite; 25 epi, 10 epc
eft: cotton, commercially spun, 2 singles,
hite; 25 ppi, 10 ppc
nbroidery: cotton, 3-ply, lavender
nthetic); silk floss, purple, yellow, rose,
rk rose, turquoise, black; silk, 2-ply,
irple, pink-orange, yellow

readle-loomed, balanced plain weave; two
eces, warps cut and hemmed, joined at
ont, back, and side seams with overcast
itching; head hole cut out, elaborately
nbroidered with satin French knots,
ain, and overcast stitching; chain-stitch
ecorative trim attached to facing.

owers, geometric motifs.

Near Totonicapán" (Eisen). Synthetic dye
Carlsen). "Used by San Cristóbal
otonicapán, San Andres Xecul; later in
antel, Santa Maria Chiquimula; same
ound cloth up to 1940s. *'Kemeron' huipil*;
anta called *'kem'*; woven in San Andres
ecul; thicker than the *'manta* Cantel' and
sed for men's clothing" (Deuss). Treadle-
omed, commercial cloth used; embroidery
ry labor-intensive. Lavender dye on cotton
s run on white cloth. Solid effect of neck
nbroidery, colorful and rich. (See
gure 65.)

sen 1902b; Carlsen, pers. com. 1987;
euss, pers. com. 1988

3-44
BLOUSE, *huipil*
45¾" x 47½" 116.5 CM X 121 CM

TOTONICAPÁN
San Cristóbal Totonicapán
K'ICHE'

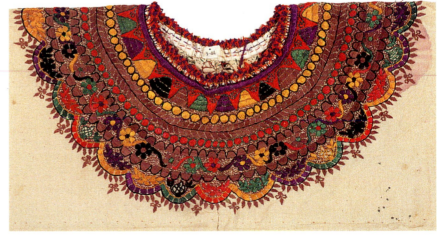

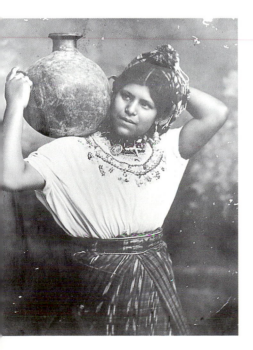

Figure 65.
Olaya of San Cristóbal, Totonicapán. Taken in
Quezaltenango. Hearst Museum of Anthropology
photo archives. Photo by James K. Piggott. 1895.
This same image appeared on a postcard that is
part of the Herbert J. Spinden photo archives,
Haffenreffer Museum of Anthropology. Collected
in the 1920s.

TOTONICAPÁN
Totonicapán
K'ICHE'

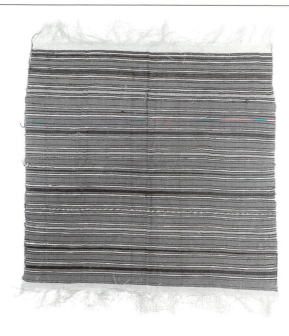

3-28
APRON, GIRL'S, *delantal*
23" X 19½" 59 CM X 49.5 CM

Warp: cotton, singles, white; 24 epi, 11 epc
Weft: cotton, singles, brown (*ixcaco*), white
2–7 singles, orange, dark blue, green, red,
light blue (faded); 32 ppi, 14 ppc

Backstrap-loomed, balanced plain and weft-
faced twill weaves; one piece, cut warps
create 2" fringes at both ends, weft yarns
carried up one side-selvedge.

Stripes of varying widths.

Four white and three red singles used in one
narrow twill stripe; gives *jaspe* effect. Sizing
(*atole*) used for warps.

See 3-24, 3-26, 3-27

3-27
APRON, GIRL'S, *delantal*
34" X 19½" 86 CM X 49.5 CM

Warp: cotton, singles, white; 24 epi, 12 epc
Weft: cotton, singles, brown (*ixcaco*);
2 singles, dark blue, light blue (faded);
40 ppi, 16 ppc

Backstrap-loomed, weft-faced twill weave;
one piece, cut warps create a 2" fringe on
one end; other end is cut and folded back;
weft yarns carried up one side-selvedge.

Uniform stripe patterning.

Looks like 3-26, identified by Eisen as a
perraje for a child. Similar in dimensions.
"Stripe sequence town-specific; may be
Cantel or San Francisco el Alto" (Deuss).
One single red yarn hand-sewn in center,
1¾" above fringe. Three vertical ridges
formed by error in placement of heddles on
twill shed stick. Warps stiffened with sizing
(*atole*).

Deuss, pers. com. 1988

See 3-24, 3-26, 3-28

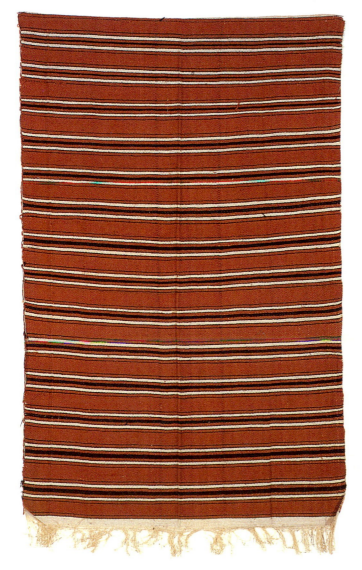

32

PRON, GIRL'S, *delantal*

." x 19¾" 86.5 CM X 50 CM

arp: cotton, singles, white; 28 epi, 12 epc
eft: cotton, singles, brown (*ixcaco*), white;
singles, dark blue, yellow, red, green, light
ue; 44 ppi, 16 ppc

ckstrap-loomed, weft-faced twill weave;
e piece, cut warps create 3" fringe on one
d, on other end short cut warps.

ripes of varying widths.

his textile is very similar to 3-27. Warps
zed with stiffening (*atole*).

e 3-24, 3-26, 3-27

23

PRON, *delantal*

" x 25" 89 CM X 63.5 CM

arp: cotton, 2 singles, white; 15 epi, 6 epc
eft: cotton, singles, white, natural brown
caco), dark blue, yellow, red, green,
spe—white and dark blue, yellow and dark
ue, red and dark blue; 128 ppi, 52 ppc

eadle-loomed, balanced plain and weft-
ced rep and twill weaves; one piece, cut
arps on one end create one 2½" fringe, on
her end short, cut warps; weft yarns
rried up one side-selvedge.

ripes of varying widths, some with *jaspe*
rns, in random abstract designs.

)f native woman" (Eisen). "Foot loom
oven lengths for apron not new" (O'Neale:
4). No dye on brown cotton (Carlsen).
ense weft setting and tightly beaten action
sulted in a strong, serviceable textile.
spe plain-weave stripes combined with
lid-colored twill and plain-weave stripes
eate an unusually active textile. Uniform
bing indicates use of reed on treadle loom
beating. Straight side-selvedges, treadle-
omed product. (See Figure 58.)

sen 1902b; O'Neale 1945; Carlsen, pers.
m. 1989

e 3-30A, 3-30B

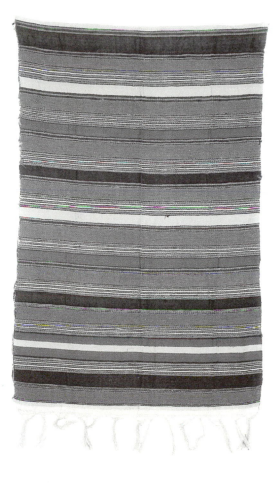

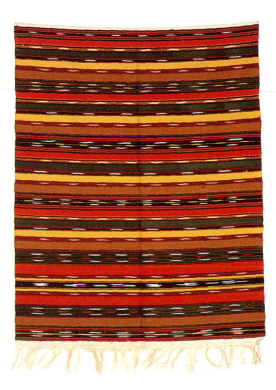

TOTONICAPÁN
Totonicapán
K'ICHE'

3-61
APRON, *delantal*
34½" x 24½" 87 CM X 62.3 CM

Warp: cotton, singles, white; 29 epi, 12 epc
Weft: cotton, singles, brown (*ixcaco*);
2 singles, red, yellow, green, mauve, dark
blue; 4 singles, yellow; silk floss, purple,
royal blue, green, magenta, yellow, teal/
aqua, red; 44 ppi, 18 ppc
Supplementary weft: silk floss, purple, royal
blue, yellow, aqua, green, red, magenta; over
1–7 warps

Treadle-loomed, balanced plain and
weft-faced twill weaves, single-faced
supplementary weft brocading; one piece,
one end warps cut and hemmed, two 14" ties
attached, other warps cut and twisted to
create a 1" fringe.

Weft stripes. Geometric designs, words, and
numbers: "Teresa B. Feliz año 1900."

"Probably name of owner. Certain obvious
difficulties in the loom weaving overcome
by freehand weaving" (O'Neale: Fig. 71l).
A single green and yellow thread used
together, resembles *jaspe.* Ties made of
backstrap-loomed cloth. One of the few
textiles in the collection with a date woven
into it.

O'Neale 1945

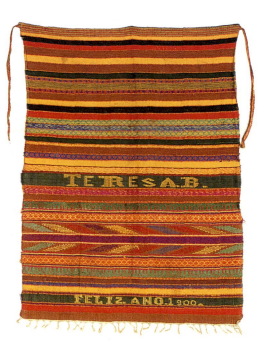

3-30A *(opposite page)*
BED COVERING, *sábana*
95" X 41½" 242 CM X 105.5 CM

Warp: cotton, 2 singles, white; 16 epi, 6 epc
Weft: cotton, singles, white, brown, red; 2
singles, two shades of yellow, two shades o[f]
green, dark blue, orange, *jaspe*—yellow and
dark blue, white and dark blue, orange and
dark blue (green); 144 ppi, 60 ppc

Treadle-loomed, balanced plain and weft-
faced rep and twill weaves; two pieces, cut
warps hemmed at both ends, hand-sewn
together.

Solid-colored stripes of varying widths;
narrow *jaspe* stripes; wide *jaspe* stripes wit[h]
chevrons, plants, and abstract forms.

"Pine tree motif" (O'Neale: Fig. 48d).
"Important piece. Probably made on old
loom" (Lehmann). "Formerly *perraje*
style: *serapado* style weaving" (Deuss).
"*Serapado* style" may refer to serape-style
cloth (Pancake). There are similar strip
arrangements, sett, and yarns in 3-23, 3-30[A]
and 3-30B. Variations in *jaspe* patterns and
widths of stripes. Color play between two
shades of yellow and green.

O'Neale 1945; Lehmann 1962; Deuss, pers.
com. 1988; Pancake, pers. com. 1990

See 3-23, 3-30B

3-39 *(opposite page, far right)*
BED COVERING, *sábana*
79" X 52" 200 CM X 132 CM

Warp: cotton, singles, white; 36 epi, 14 epc
Weft: cotton, singles, red, yellow, dark blue[,]
medium blue; 2 singles, green, red; 72 ppi,
30 ppc

Treadle-loomed, weft-faced twill weave; tw[o]
pieces, warps cut and hemmed, two pieces
hand-sewn together.

Stripes of varying widths.

Feels lightweight; contrasts with 3-23, 3-
30A, 3-30B, also treadle-loomed, striped
cloths, same yarns, but those textiles are
woven in a weft-faced rep weave. (See
Figure 66.)

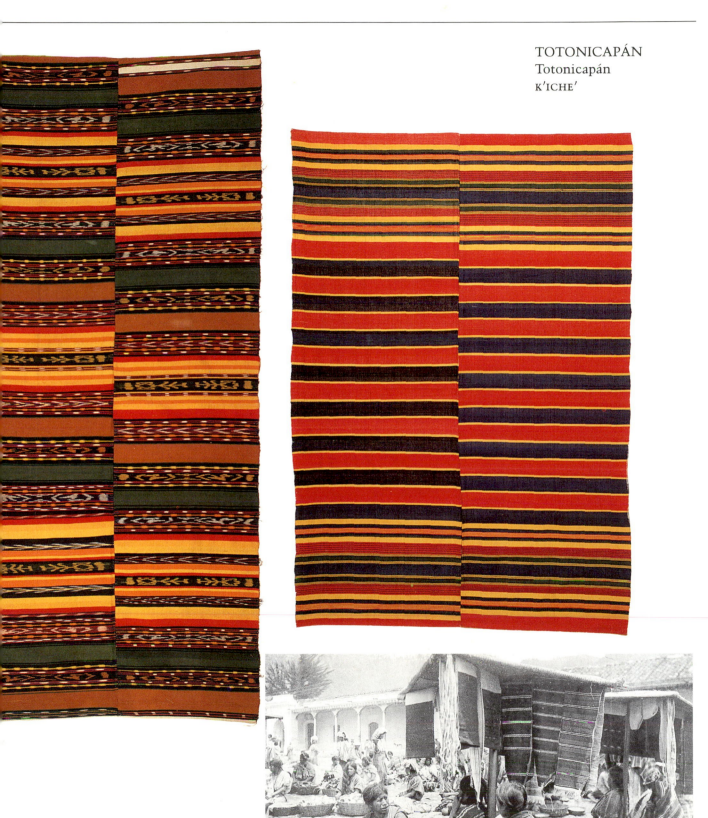

gure 66.
Plaza of Totonicapán" (Eisen 1902c). Striped
ibanas resemble 3-39. Photo by Gustavus A.
.sen. 1902.

TOTONICAPÁN
Totonicapán
K'ICHE'

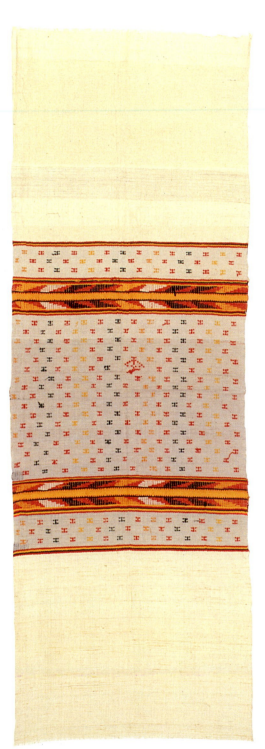

3-47
BLOUSE CLOTH, CHILD'S, *tela de huipil*
58¼" X 19" 148 CM X 48.3 CM

Warp: cotton, singles, white; 24 epi, 10 epc
Weft: cotton, singles, light blue; 2 singles, white, yellow, red, green; 33 ppi, 13 ppc
Supplementary weft: cotton, 6 singles, dark blue, light blue, green, yellow, red; over 2–6 warps

Treadle-loomed, balanced plain and weft-faced twill weaves, supplementary weft brocading; one piece, warps cut.

Weft stripes, small geometric designs evenly spaced on decorated part of cloth. Odd design in center may be weaver's mark.

"May have been for a child" (Deuss). Beating erratic, may be work of beginning weaver. This textile shows San Martín Jilotepeque stylistic influence. See 3-144, 3-246, 3-247 (San Martín Jilotepeque, Chimaltenango).

Deuss, pers. com. 1988

22
LOUSE, *huipil*
¾" x 40½" 100.5 CM X 103 CM

TOTONICAPÁN
Totonicapán
K'ICHE'

arp: cotton, singles, white; 34 epi, 14 epc
eft: cotton, singles, white; 46 ppi, 18 ppc
pplementary weft: cotton, 2–6 singles,
d, green, yellow; over 3 warps

eadle-loomed, balanced plain and weft-
ced twill weaves, two-faced supplementary
eft brocading; two pieces, cut warps, rolled
ms on bottom, hand-sewn side seams;
agenta silk taffeta neck piece with points,
nbroidered with silk chain stitch; slit neck
ith one button.

pper third of front and back is made
 of weft-faced stripes with bands of
pplementary weft–brocaded geometric
rms.

Motives though not all distinctive of
cality, nevertheless so put together as to
 easily identified. Ten examples in Eisen
llection; old ones coarser than weavings
 1936" (O'Neale: 304). "Old type"
ehmann). A few brown fibers are spun into
hite wefts. (See Figure 67.)

'Neale 1945; Lehmann 1962

e 3-49

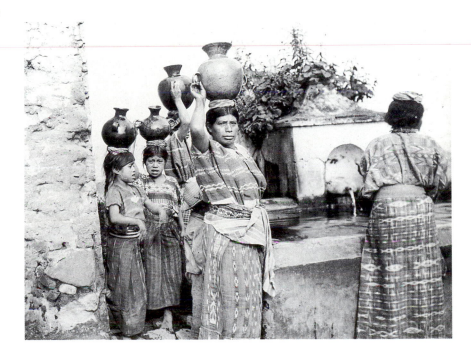

gure 67.
t a fountain. Totonicapán" (Eisen 1902c).
omen are wearing *huipiles* that resemble 3-22
d 3-49. Photo by Gustavus A. Eisen. 1902.

TOTONICAPÁN
Totonicapán
K'ICHE'

3-42
BLOUSE, *huipil*
42" x 36½" 107 CM X 91.5 CM

Warp: cotton, singles, white; 32 epi, 12 epc
Weft: cotton, singles, white; 2 singles, white, dark blue, faded light blue, red, orange, dark yellow, yellow, green, faded purple; 54 ppi, 21 ppc
Supplementary weft: cotton, 4 singles, red, green, orange, medium blue; silk floss, light yellow, green, purple, turquoise; over 1–5 warps

Treadle-loomed, balanced plain and weft-faced twill weaves, single-faced supplementary weft brocading; two pieces, warps cut and hemmed, two pieces hand-sewn together at front and side seams; head hole cut out, cobalt blue taffeta silk neck piece with points, embroidered with silk feather stitch; slit at neck with one button.

Narrow stripes, geometric forms.

Spun red silk in decorative stitching on neck piece dyed with synthetic (Carlsen). "Woven in Totonicapán for use by *cofradía* in Santa Lucia Utatlán, Sololá" (Deuss). Probably a ceremonial textile due to amount of silk utilized. Weft striping is similar to that of 3-39.

Carlsen, pers. com. 1987; Deuss, pers. com. 1988

See 3-48

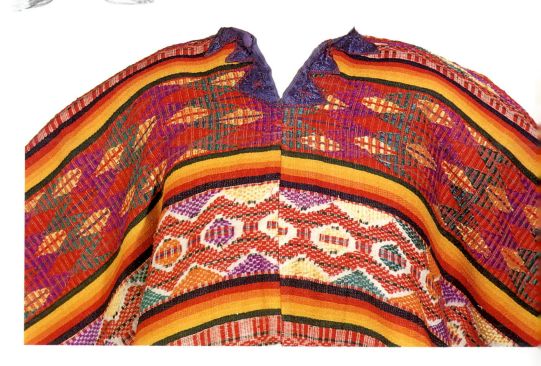

Warp: cotton, singles, white; 30 epi, 13 epc
Weft: cotton, singles, white; 2 singles, white, green, orange, red (alizarin), lavender; silk floss, single with single yellow cotton yarn; 46 ppi, 18 ppc
Supplementary weft: cotton, 4 singles; silk floss, yellow, purple, aquamarine; over 1–5 warps

Treadle-loomed, balanced plain and weft-faced twill weaves, supplementary weft brocading; two pieces, warps cut and hemmed, joined at front, back, and side seams; head hole cut out, black velvet neck piece in points, commercial trim hand-sewn, crochet fringe, slit neck with one button.

Narrow stripes of alternating colors; zigzags, geometric forms.

Red dye used on cotton is alizarin (Carlsen). Carlsen photographed a similar *huipil* from Santa Lucia Utatlán in 1980. He thinks it is a recently made replica of the older style; it is now in a Japanese collection. It probably was copied from an older example. Cloth feels light, indicating much use. For comments see 3-42.

Carlsen, pers. com. 1987, 1990

See 3-42

3-48
BLOUSE, *huipil*
42″ x 35½″ 107 CM X 90 CM

TOTONICAPÁN
Totonicapán
K'ICHE'

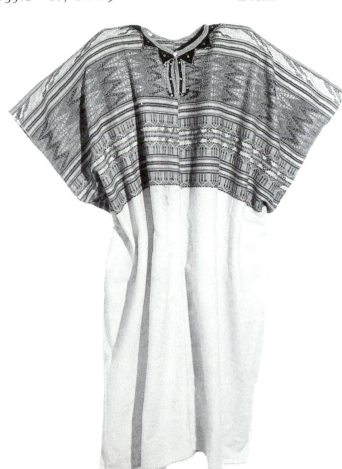

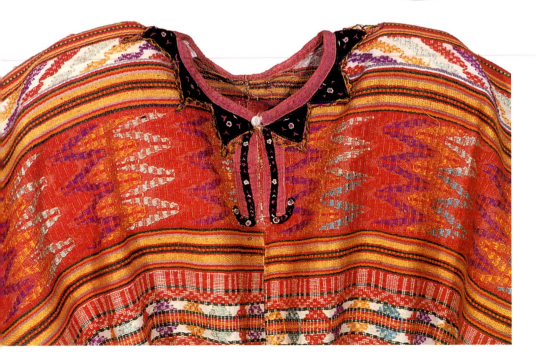

TOTONICAPÁN
Totonicapán
K'ICHE'

3-49
BLOUSE, *huipil*
42" x 38" 107 CM x 96 CM

Warp: cotton, singles, white; 32 epi, 14 epc
Weft: cotton, singles, white; 2 singles, white, red, yellow, green; 36 ppi, 16 ppc
Supplementary weft: cotton, 6 singles, yellow, green, red; over 3 warps

Treadle-loomed, balanced plain and weft-faced twill weaves, two-faced supplementary weft brocading; two pieces, cut warps, rolled hems on bottom, joined at front, back, and side seams with overcast stitching; head hole cut out, rolled, and hemmed.

Stripes of varying widths; geometric and abstract plant forms.

Changing from two single white wefts to a single in the supplementary weft brocading contrasts with weft-faced twill stripes. For comments see 3-22. (See Figure 67.)

See 3-22

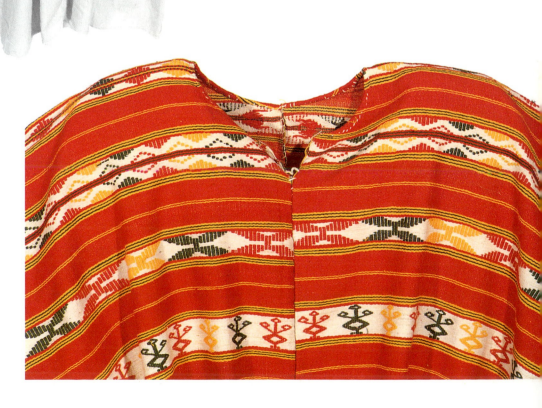

Warp: cotton, singles, white; 38 epi, 15 epc
Weft: cotton, singles, white, brown (*ixcaco*);
singles, green, red, white, yellow; spun
silk, singles, turquoise (synthetic), violet;
17 ppi, 23 ppc
Supplementary weft: cotton, 6 singles,
white, red, light yellow, dark blue, green,
yellow; over 2–4 warps

Treadle-loomed, balanced plain and weft-
faced twill weaves, single-faced supplemen-
tary weft brocading; two pieces, cut warps
hand-sewn; dark brown silk taffeta neck
piece with points, embroidered with silk
chain stitch in flowered patterns; slit at
neck with one button.

Weft stripes. Supplementary weft brocade
designs of small and large diamonds,
triangles, zigzags (two types).

Brocaded two-color diamonds "represent
more ambitious attempts by treadle-
loom weavers in Totonicapán" (O'Neale:
fig. 73ss). Turquoise-blue spun silk is of
synthetic dye (Carlsen). Two sides not
perfectly matched as in 3-66. Unusual to use
silk as wefts in basic web.

O'Neale 1945; Carlsen, pers. com. 1987

See 3-66

3-37
GARMENT, *huipil*
40" x 36½" 102 CM X 93 CM

TOTONICAPÁN
Totonicapán
K'ICHE'

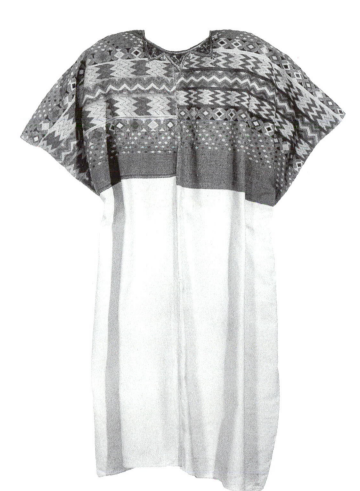

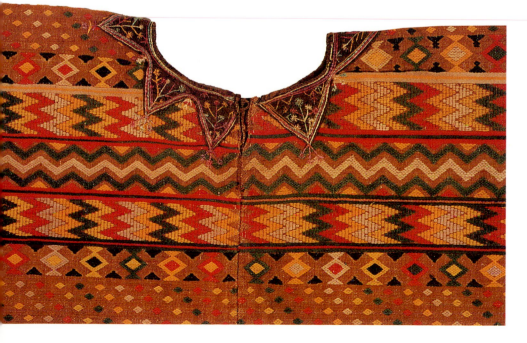

TOTONICAPÁN
Totonicapán
K'ICHE'

3-71
HEADBAND, CHILD'S, *cinta*
33½" X ½" 85.1 CM X 1.3 CM

Warp: cotton, commercially spun, 2 singles;
white; 30 epi, 13 epc
Weft: cotton, 2 singles, white; silk floss,
magenta, yellow, royal blue, orange, black,
green, purple; 102 ppi, 40 ppc
Tassels: body—silk floss, magenta, royal
blue, black, white; ends—silk, 2-ply, black,
red, yellow

Treadle-headband-loomed, two-faced twill
weave; one piece, cut warps tied, two 4½"
silk floss tassels attached to ends.

Weft band stripes, geometric forms.

Looped overcast stitch creates ornamental
tassels with a hard core; loose silk strands at
ends; cotton warps are mercerized.

See 3-75

3-75
HEADBAND, CHILD'S, *cinta*
33½" X ½" 85.1 CM X 1.3 CM

Warp: cotton, commercially spun, 2 singles;
white; 35 epi, 14 epc
Weft: cotton, 2 singles, white; silk floss,
magenta, yellow, royal blue, orange, black,
green, purple; 112 ppi, 44 ppc
Tassels: body—silk floss, purple, green,
magenta; ends—silk, 2-ply, black

Treadle-headband-loomed, two-faced twill
weave; one piece, cut warps tied, two 4½"
silk floss tassels attached each end.

". . . patterned with simple abstract forms i
all colors" (O'Neale: Fig. 188). For commen
see 3-71.

O'Neale 1945

See 3-71

72

HEADBAND, *cinta*

110" X 1½" 279.4 CM X 3.8 CM

Warp: cotton, commercially spun, 4 singles,
white; 25 epi, 10 epc
Weft: cotton, singles, white, red, green,
dark blue, yellow; 2 singles, white, green,
medium blue; silk floss, singles, yellow;
 ppi, 28 ppc
Tassels: silk floss, brown; silk, 2-ply singles,
 own

Treadle-headband-loomed, two-faced twill,
basket, and tapestry weaves; one piece, cut
warps tied, two 15" tassels attached to both
ends.

Weft bands of various colors. Eccentric wefts
create various geometric and animal forms
 rds and deer?); brown silk floss on tassels.

Tapestry technique has a much greater
flexibility [than brocading] in that it is akin
 embroidery. One reason for this is that
the weaver uses no sword in tapestry, and as
 esult, his lines of weft are not forced to
 rizontal positions at right angles to the
 arp. The Totonicapán headbands are full of
 ustrations of what Crawford (1915:91) has
 aptly called 'eccentric' wefting. The word
 as adopted to describe the angles taken by
 e wefts in the ancient Peruvian tapestries"
 Neale: 152). "Woman's ribbon has usual
 otives: rabbit, duck, bird, and geometric
 ms all like those familiar in today's
 bons" (ibid.: Fig. 118k). Mercerized
 tton warps; yellow cotton wefts are laid in
 th yellow silk floss in same shed. Tassels
 e of silk floss with wire-wrapped maguey
 rns in four figure eights. Each of these
 ures has one small bunch of silk floss in
 e middle and spun silk attached to the
 ds. Very ornamental tassels.

Neale 1945

 e 3-74, 3-78, 3-88

TOTONICAPÁN
Totonicapán
K'ICHE'

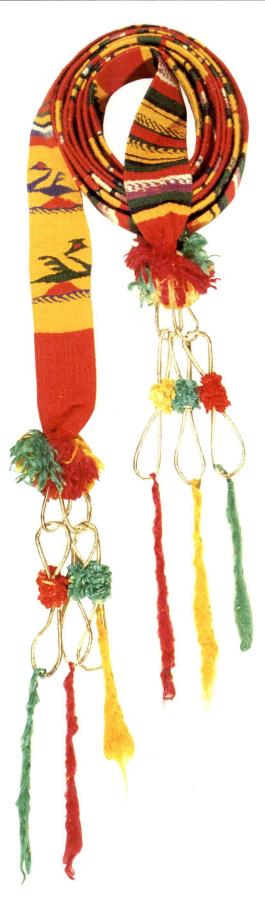

3-74
HEADBAND, *cinta*
110″ x 1½″ 279.4 CM X 3.8 CM

Warp: cotton, commercially spun, 3 singles
white; 21 epi, 8 epc
Weft: cotton, singles, white, red, dark blue,
green, yellow; 2 singles, white, red, dark
blue, medium blue, purple, green, yellow;
160 ppi, 63 ppc
Tassels: silk floss, magenta, turquoise,
yellow

Treadle-headband-loomed, two-faced twill
and tapestry weaves; one piece, cut warps
tied, two 10″ tassels attached to both ends.

Weft bands of various colors; eccentric weft
create various geometric and animal design
(birds, deer, or antelope).

Mercerized cotton warps. Design O'Neale
describes as a rabbit looks more like a deer
or antelope. Tassels have two small wire-
covered maguey loops and three figure
eights. Silk floss attached to ends, not spun
silk. For comments see 3-72.

O'Neale 1945

See 3-72, 3-78, 3-88

-78
HEADBAND, *cinta*
13″ x 1⅜″ 287 CM X 3.5 CM

Warp: cotton, commercially spun, 3 singles,
white; 25 epi, 11 epc
Weft: cotton, singles, white, red, green, dark
blue; 2 singles, white, red, green; silk floss,
yellow, purple, royal blue; 151 ppi, 60 ppc
Tassels: silk floss, yellow, purple, turquoise,
magenta, red, white, gold; silk, 2-ply singles,
white, gold, yellow, medium blue, magenta

Treadle-headband-loomed, two-faced twill,
basket, and tapestry weaves; one piece, cut
warps tied, two 14″ tassels attached to both
ends.

Weft bands of various colors. Eccentric wefts
create bands of various geometric and
animal (rabbit, swan) designs.

Mercerized cotton warps. Four wire-covered
maguey loops, five figure eights. For com-
ments see 3-72.

See 3-72, 3-74, 3-88

-80
HEADBAND, *cinta*
1″ x 1¼″ 205.8 CM X 3.2 CM

Warp: cotton, commercially spun, 2 singles,
white; 26 epi, 11 epc
Weft: cotton, singles, white, red, yellow,
green, dark blue, medium blue; 2 singles,
white, purple, dark blue, medium blue,
green; silk floss, royal blue; wool, singles,
red; 112 ppi, 44 ppc

Treadle-headband-loomed, two-faced twill
and basket weaves; one piece, cut warps
tied, 4″ silk floss tied at ends.

Weft bands of alternating colors at two ends,
solid color in center; contrast between solid,
basket-weave, and two-colored twill bands.
Magenta and gold silk floss tied at ends.

"The red center style. . . . If the headband is
a means of exhibiting the weaver's skill and
taste, that becomes an important factor
in its making . . ." (O'Neale: 152). For
comments see 3-72.

O'Neale 1945

See 3-90

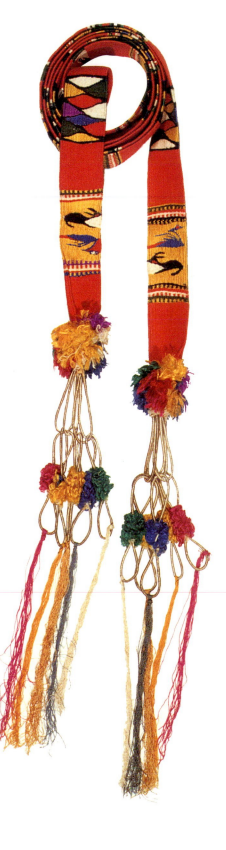
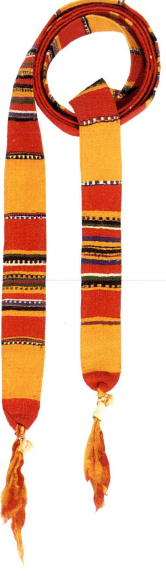

TOTONICAPÁN
Totonicapán
K'ICHE'

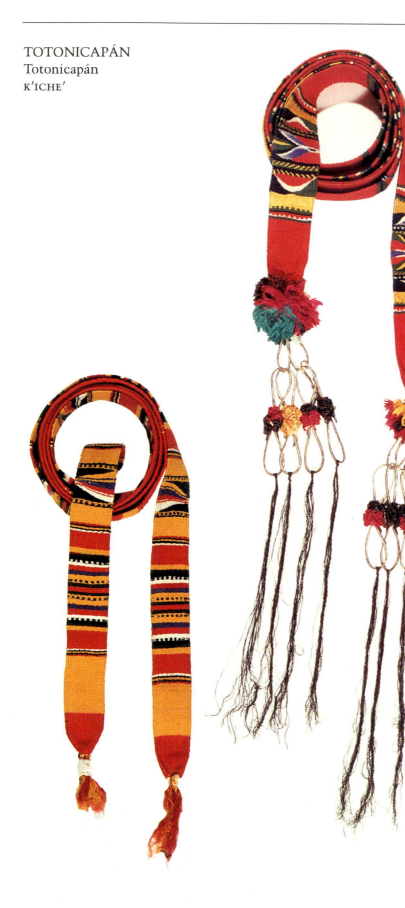

3-88
HEADBAND, *cinta*
108" X 1⅜" 274.4 CM X 3.5 CM

Warp: cotton, commercially spun, 4 singles,
white; 27 epi, 11 epc
Weft: cotton, singles, red, green; 2 singles,
white, red, green, dark blue, medium blue;
silk floss, yellow; 106 ppi, 40 ppc
Tassels: silk floss, magenta, black, turquoise,
yellow, gold; silk, 2-ply, singles, black

Treadle-headband-loomed, two-faced twill,
basket, and tapestry weaves; one piece,
cut warps tied, two 14" tassels attached to
both ends.

Weft bands of various colors; eccentric wefts
create various geometric and animal designs.

Mercerized cotton warps. Two wire-covered
maguey loops form four figure eights. For
comments see 3-72.

See 3-72, 3-74, 3-78

3-90 *(left)*
HEADBAND, *cinta*
79½" X 1¼" 202 CM X 3.3 CM

Warp: cotton, commercially spun, 2 singles,
white; 20 epi, 8 epc
Weft: cotton, singles, white, red, yellow,
green, dark blue, medium blue; wool,
2 singles, red, yellow; 129 ppi, 51 ppc

Treadle-headband-loomed, two-faced twill,
basket, and tapestry weaves, one piece, cut
warps tied, 2" and 2½" silk floss tied at ends.

Curvilinear abstract designs. Magenta and
gold silk floss tied at ends.

For comments see 3-80.

See 3-80

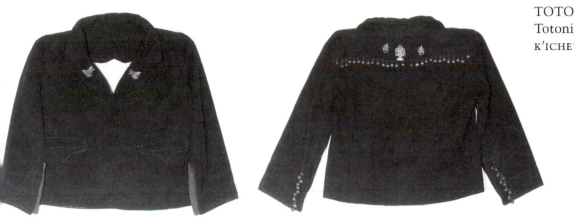

TOTONICAPÁN
Totonicapán
K'ICHE'

-8
ACKET, *cotón*
9½" x 18" 49.5 CM X 45.8 CM

Varp: wool, commercially spun, black
Veft: wool commercially spun, black

Commercial cloth (imported), twill weave;
even pieces, machine-stitched, all warps
ut and hemmed or stitched; head hole cut
ut, front pieces folded over, attached to
ack collar to form lapels; two slits in front
reate pockets, outside stitching forms a
oint, a metal bird on each lapel, metal balls
n cuffs and across back, two metal flowers
nd one metal pot on back. Lined with
ommercial cotton cloth on inside; cuff
aps lined with commercial red wool cloth.

extured cloth with subtle zigzag (twill)
esign.

Of *martoom*. . . . Ancient type" (Eisen).
Cut-and-sewn garment. Part of man's
eremonial costume: 3-1, 3-2, 3-3, 3-4, 3-6,
-7. Waxed copper alloy ornamental balls
vith silver wash attached by an inside
tring. Large flower pot on back made of
rass with silver wash and a zinc-enriched
urface. Small flowers in back of copper-
ilver alloy (Brown). Densely felted cloth
nakes warp and weft count impossible.
See Figure 68.)

Eisen 1902b; Brown, pers. com. 1988

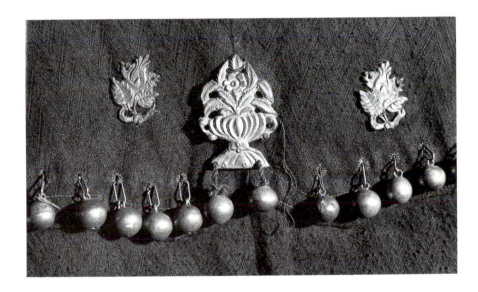

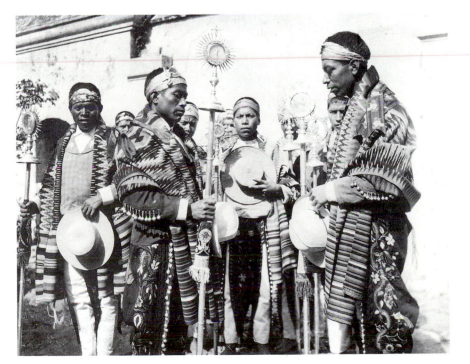

Figure 68.
Indian *Martooms*, as the last" (Eisen 1902c).
Photo by Gustavus A. Eisen. 1902.

TOTONICAPÁN
Totonicapán
K'ICHE'

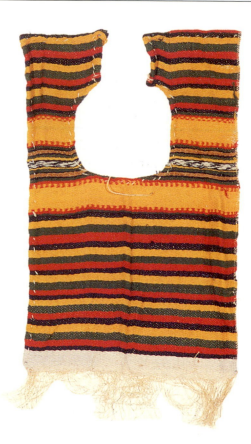

3-81
OVERGARMENT, CHILD'S, *gavacha*
12" X 7" 30.5 CM X 17.8 CM

Warp: cotton, singles, white; 25 epi, 11 epc
Weft: cotton, singles, brown (*ixcaco*), dark
blue; 2 singles, red, light blue, green, yellow
7 singles, light and dark blue; 43 ppi, 17 pp

Backstrap-loomed, weft-faced twill weave;
one piece, one end warps cut to create a 1½
fringe; other warps and one side-selvedge
cut and hemmed; head hole cut and
hemmed.

Weft stripes.

Warps have been stiffened with sizing
(*atole*). May have been part of a large textile
like 3-26; one stripe of four rows of twill in
dark and light blue yarns creates an effect o
jaspe. Brown yarn in natural color, *ixcaco*.

See 3-26, 3-82

3-82
OVERGARMENT, CHILD'S, *gavacha*
14" X 9½" 36 CM X 24 CM

Warp: cotton, singles, white; 24 epi, 10 epc
Weft: cotton, singles, brown (*ixcaco*), dark
blue; 2 singles, light blue, yellow, green, red
58 ppi, 23 ppc
Supplementary weft: cotton, 2 singles, red,
dark blue; over 6 warps

Backstrap-loomed, plain and weft-faced twi
weaves, supplementary weft brocading; one
end warps cut to create a 3" fringe, other en
and one side-selvedge cut and hemmed, wef
yarns carried up one side-selvedge, head hol
cut and hemmed.

Weft stripes, block weaves.

This textile and 3-81 look like bibs and
could have been worn over plain shirts of
commercial cloth. Very unusual dress
elements.

See 3-81

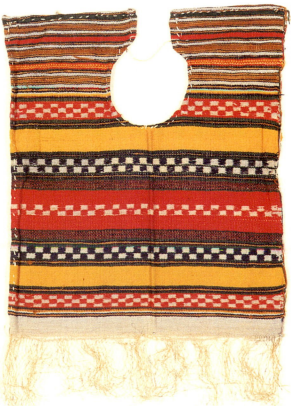

6

VERPANTS, *pantalón*

"X 30" 88.9 CM X 76.2 CM

arp: wool, commercially spun, singles,
ack; 44 epi, 18 epc
eft: wool, commercially spun, singles,
ack; 50 ppi, 20 ppc
mbroidery: spun silk, 2-ply multiple
agles, orange, violet, purple, magenta,
ua, green, royal blue, yellow, turquoise,
nk, gold, ivory, red

ommercial cloth (imported?), balanced
ain weave; nine pieces, all seams machine-
tched, metal ornaments attached down
ngths of pant legs; pant legs extensively
mbroidered, buttons on waistband, two
ckets on front lined with commercial
oth inside.

ulticolored embroidered flowers on pant
gs. Zigzag appliqué down pant legs and
ound bottoms created by laying black
ool cutouts over peach commercial cloth
ckground.

. . of *martoom*. . . . The cut is ancient
namentation Spanish type" (Eisen). "Style
th front flap and back ties resembles
ghteenth or early nineteenth century
ropean-style overpants; front flap folded
wn with ornamental buttons is a
sunderstanding; originally three button
p; outside buttons fastened; embroidery
en in contemporary Salamancan folk
ess" (Maeder). Copper alloy ornamental
lls with silver wash attached to pant legs;
lls waxed. Buttonholes, like bars opposite
balls, made of silver-copper alloy, of
known proportions. Mexican national
blems also of silver-copper alloy. Buttons
bone and metal. Pants may be reworked.
uld be navy serge pants (Brown). Cut-and-
wn garment. Part of man's ceremonial
stume: 3-1, 3-2, 3-3, 3-4, 3-7, 3-8. Holes in
istband for ribbons but none are present.
e Figure 68.)

en 1902b; Brown, pers. com. 1988;
eder, pers. com. 1989

3-7, 3-9

TOTONICAPÁN
Totonicapán
K'ICHE'

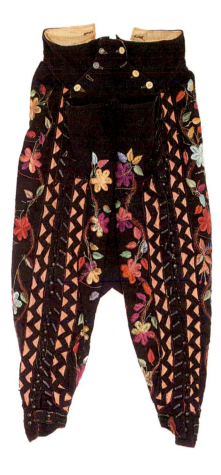

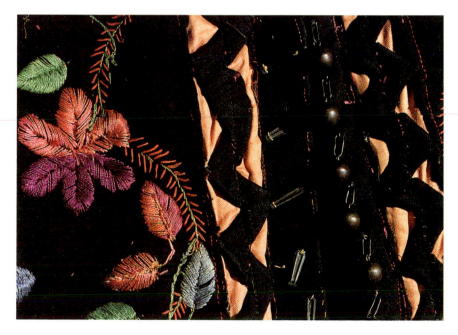

TOTONICAPÁN
Totonicapán
K'ICHE'

3-7
OVERPANTS, *pantalón*
38" X 31" 96.5 CM X 78.8 CM

Warp: wool, commercially spun, singles, black; 42 epi, 16 epc
Weft: wool, commercially spun, singles, black; 55 ppi, 21 ppc
Embroidery: spun silk, 2-ply, multiple singles, white, red, orange, magenta, light green, dark green, yellow, light blue, ivory, purple, aqua, medium blue, light olive

Commercial cloth (imported?), balanced plain weave; seven pieces, all seams machine-stitched, two pockets on front, flaps folded down, metal flower pot on each flap, metal ornaments down lengths of pant legs, buttons on front of waistband, back of waistband drawn closed by three imported silk ribbons, pant legs heavily embroidered with silk thread, lined with magenta silk cloth and commercial cotton cloth.

Multicolored embroidered flowers, birds, and bells on pant legs. Separate piece of embroidery on cuffs of pant legs (leaves). Zigzags down pant legs and around cuffs created by laying black wool cutouts over a background of magenta silk cloth. Silk ribbons—light blue, green, and yellow embroidery.

Buttons on waistband made of Bakelite and metal (alloy). For comments see 3-6, 3-8. (See Figure 68.)

See 3-6, 3-9

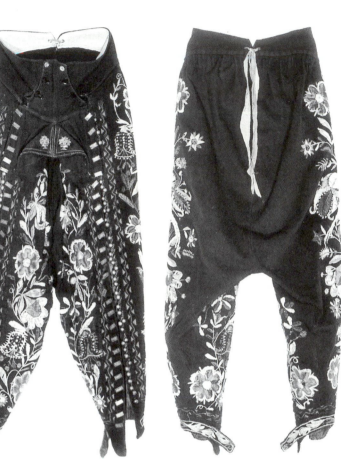

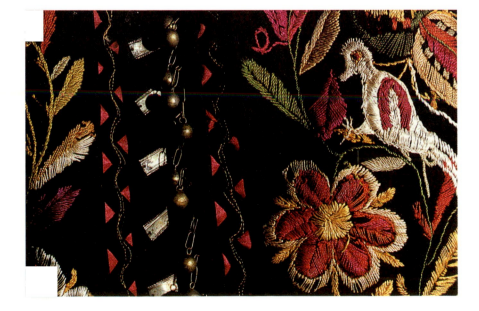

9

VERPANTS, *pantalón*

" x 32" 94 CM x 81.3 CM

arp and weft: commerical imported green
k velvet

nbroidery: spun silk, 2-ply, multiple
ngles, white, yellow, rose-red, red
nthetic), ivory, purple (synthetic), violet,
d-orange, aqua, gold, orange, pink, faded
een, magenta, medium blue

ommercial cloth, eight pieces, all seams
achine-stitched, two pockets on front with
ps, four buttons on front of waistband,
ck of waistband drawn closed with
string of plant fiber, pants heavily
nbroidered with silk thread, lined with
mmercial cotton and wool cloth on inside,
ter edges trimmed with silk cloth on
side.

ulticolored embroidery of flowers and
wer pots. Appliqué zigzags down pant legs
d around cuffs created by laying cutouts of
een velvet over a red wool cloth
ckground.

Of *martoom"* (Eisen). Red and purple silk
ed with synthetic (Carlsen). Cut-and-sewn
rment. Finely made garment, very worn.
obably the prototype for 3-6, 3-7. Inner red
ool serves as background for hand-sewn
zags; gives appliqué effect. Three buttons
waistband of metal alloy, one of shell.
p right side of pants hand-stitched closed.
ded colors are on outside, inside bright.
e Figure 68.)

sen 1902b; Carlsen, pers. com. 1987

e 3-6, 3-7

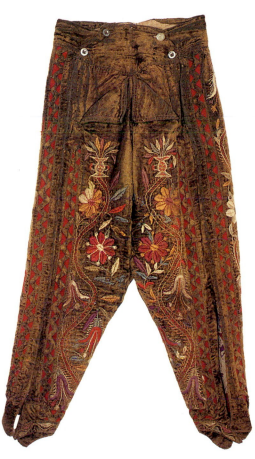

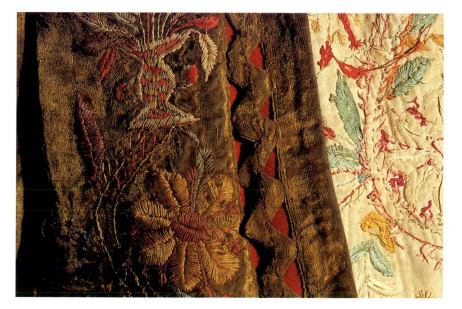

TOTONICAPÁN
Totonicapán
K'ICHE'

3-1
SERAPE, *sarape*
86″ x 47½″ 218.5 CM X 120.7 CM

Warp: cotton, 4–6 singles, white; 13 epi, 5 epc
Weft: wool, singles, white, black, royal blue, medium green, dark green, gray, red, purple, violet, gray (faded lavender, synthetic), yellow, orange, burgundy; 53 ppi, 21 ppc

Treadle-loomed, plain weft-faced and dovetailed tapestry weaves; two pieces, warps cut and trimmed with commercial cotton cloth.

Weft stripes of varying widths on bottom edges, geometric patterns (zigzags), hourglass shapes, triangles, in tapestry weave, large lozenge in center. Sides bordered with different patterns.

In his paper on the *cofradías* of the Indians of Guatemala, Eisen discusses examples 3-1 to 3-4: "To properly analise [sic] the ornamentation would require a book by itself . . . of *Martoom*. . . . Used by *Cofradia de Iglesia*, about 20 years old" (Eisen). In a letter to E. Gifford (June 1938), Eisen wrote "I knew nothing about the value of antique at that time, but I have since learned that the four serapes would be worth many time my expenses of the trip . . . the painstaking care exhibited accomplished results not surpassed, so far as I know, by any of the other highland weavings." "Technologically these [the four serapes, 3-1 to 3-4] are not unlike weaving done today at Chichicastenango but texturally they resemble nothing so much as the characteristic tapestry headribbons made in quantity at Totonicapán" (O'Neale: 215). Colors are faded. Large shawl, no head opening. Reversible tapestry. Wefts had to be lifted t see original colors. For more comments see 3-3. (See Figure 69.)

Eisen 1902b, 1938; O'Neale 1945; Carlsen, pers. com. 1987

See 3-2, 3-3, 3-4

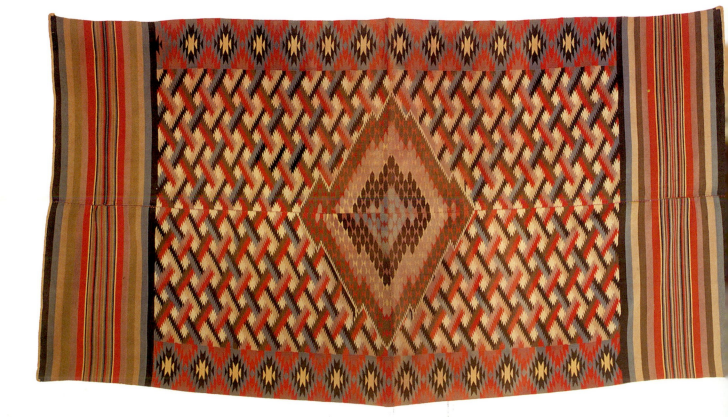

arp: cotton, 4–6 singles, white; 13 epi,
epc

eft: wool, singles, faded magenta, aqua,
ht blue, black, yellow, red, violet; 55 ppi,
ppc

eadle-loomed, plain weft-faced and
vetailed tapestry weaves; two pieces,
arps cut and tied.

ick weft stripes along bottom edges.
rge triple lozenges in center of garment,
me designs resemble corn stalks,
xagons. Sides bordered with diamond
signs. Rest of garment covered with
zags.

ld" (Eisen). One serape, 3-5, was
changed with the American Museum of
tural History, 3258, in 1907. It was
mmissioned by Eisen and "made by the
t member of the same family" (ibid.). To
worn as a shawl, no head opening. For
mments see 3-1, 3-3. (see Figure 69.)

sen 1902b

e 3-1, 3-3, 3-4

3-2
SERAPE, *sarape*
86" X 45" 218.5 CM X 114.3 CM

TOTONICAPÁN
Totonicapán
K'ICHE'

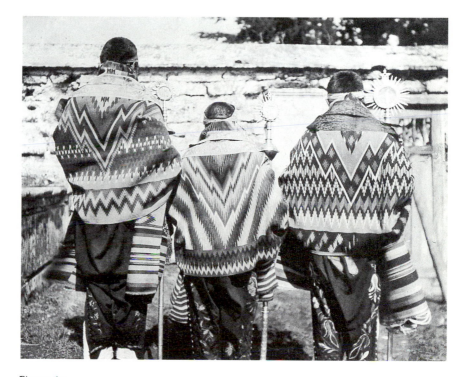

Figure 69.
"Indian *Martooms*, as the last" (Eisen 1902c).
Photo by Gustavus A. Eisen. 1902.

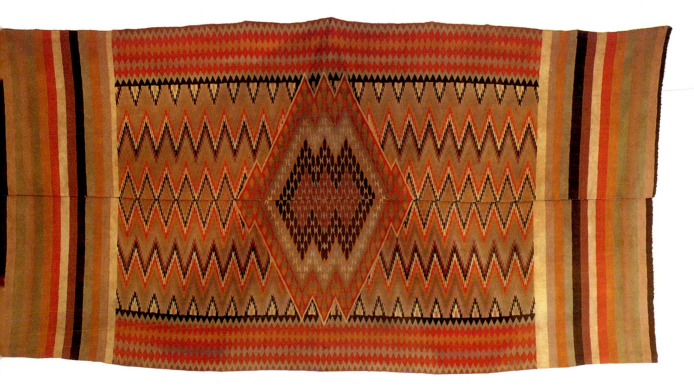

TOTONICAPÁN
Totonicapán
K'ICHE'

3-3
SERAPE, *sarape*
90" x 47" 228 CM X 119 CM

Warp: cotton, 4–6 singles, white; 15 epi;
6 epc
Weft: wool, singles, white, red, yellow,
green, purple (synthetic); 50 ppi, 20 ppc

Treadle-loomed, plain weft-faced and
dovetailed tapestry weaves; two pieces,
warps cut and trimmed with yellow silk
taffeta, two pieces hand-sewn together,
seams left open in center for neck hole,
imported silk ribbon attached to neck.

Horizontal stripes on top and bottom,
lozenge in center, small diamonds and
serrated tapestry-woven patterns throughout
garment.

Head opening trimmed with imported
ribbon (Austrian?); meant to be worn as a
poncho. Colors are brighter than other three
serapes; not as well worn. The technique,
color range, and design arrangement
strongly resemble the Saltillo serape,
common in the mid-nineteenth century in
Mexico. This style influenced the weaving
of Navajo and Hispanic weavers in the
Southwest. One could postulate that the
style was brought to the Southwest by
Guatemalan weavers as well. For comment
see 3-1.

See 3-1, 3-2, 3-4

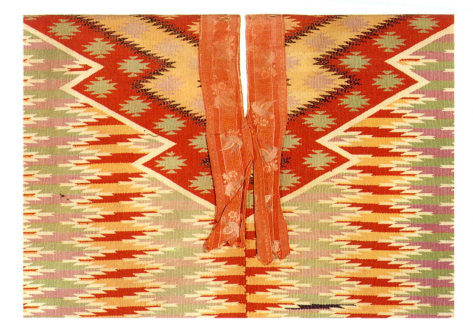

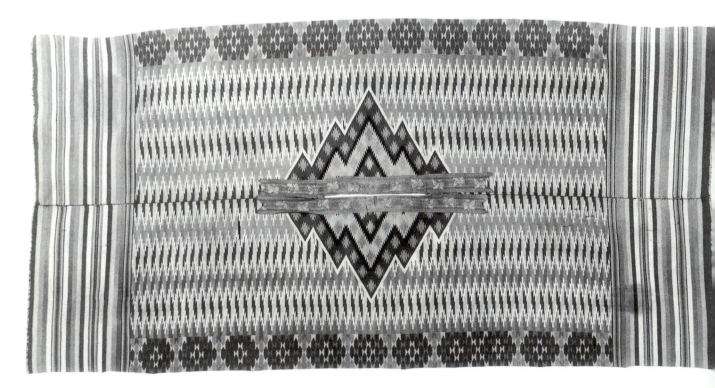

arp: cotton, 4–6 singles, white; 12 epi,
epc
eft: wool, singles, white, royal blue, black,
een, purple, violet, orange, pink; 49 ppi,
ppc

readle-loomed, plain weft-faced and
ovetailed tapestry weaves; two pieces,
arps cut and trimmed with red silk taffeta,
o pieces hand-sewn together, seams left
en in center for neck hole, trimmed with
ng wide silk ribbons with embroidery.

eft stripes of varying widths at ends of
rment. Large central lozenge outlined by
o more lozenges similar to those in 3-1;
de borders with large diamond designs.

The above 4 [3-1 to 3-4] were made by one
mily, they are not made anymore" (Eisen).
his textile was exchanged with the Design
epartment in O'Neale's day; probably for
e in classroom analysis. Relocated now
ith Eisen collection. Meant to be worn as
poncho like 3-3. Much of the silk taffeta
lvedge trim has been worn away. For
mments see 3-1.

sen 1902b

e 3-1, 3-2, 3-3

3-4
SERAPE, *sarape*
98" x 47½" 250 CM X 120.7 CM

TOTONICAPÁN
Totonicapán
K'ICHE'

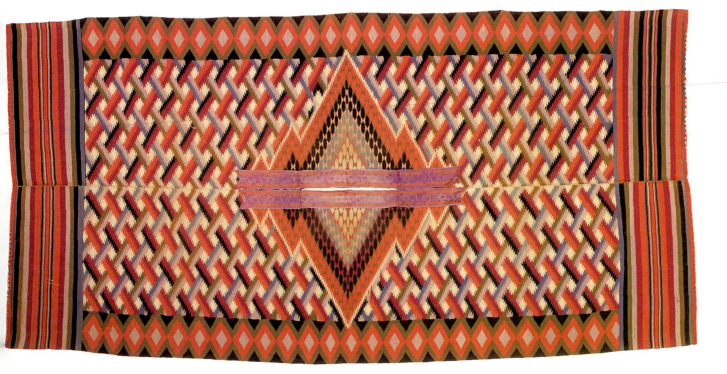

TOTONICAPÁN
Totonicapán
K'ICHE'

3-30B
SHAWL, *perraje*
77" x 24½" 195.6 CM X 62 CM

Warp: cotton, 2 singles, white; 15 epi, 6 epc
Weft: cotton, singles, white, brown;
2 singles, dark blue, yellow, green, red,
jaspe—white and dark blue, yellow and dark
blue, red and dark blue; 132 ppi, 56 ppc

Treadle-loomed, balanced plain and weft-
faced rep and twill weaves; one piece, cut
warps create two 5½" fringes, weft yarns
carried up one side-selvedge.

Stripes of varying widths; narrow stripes in
jaspe yarns with abstract designs; two wide
stripes and *jaspe* yarns with diamonds of
varying shapes.

Very similar to 3-23 with addition of
two 1¾"-wide *jaspe* stripes. See 3-23
for comments.

See 3-23, 3-30A

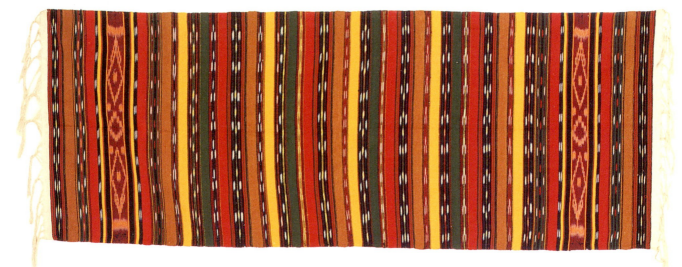

3-31
SHAWL, *perraje*
38¼" x 43½" 97 CM X 110 CM

Warp: cotton, 2 singles, white, red, dark
blue; 52 epi, 22 epc
Weft: cotton, 2 singles, red; 17 ppi, 7 ppc

Backstrap-loomed, warp-faced plain weave;
two pieces, one end-selvedge loom-finished
other end warps cut, rolled under, and
hemmed, two pieces joined by buttonhole-
stitched *randa*.

Warp stripes.

Decorative *randa* includes yellow and
magenta silk and gold cotton. Eisen
probably purchased this textile in
Totonicapán. However, Krystyna Deuss
located it in Chichicastenango because of
warp-faced stripes, color (red), and *randa*
(Deuss).

Deuss, pers. com. 1988

-63
HAWL, *perraje*
6" x 22½" 91.5 CM X 57 CM

Jarp: cotton, 2 singles, white; 17 epi, 7 epc
Teft: cotton, singles, white, red, dark blue;
singles, white, green, yellow, orange,
aspe—white and dark blue, yellow and
ark blue; silk floss, green, purple; 139 ppi,
6 ppc

readle-woven, balanced plain and two-
ded weft-faced twill weaves; one piece, cut
arps create a 3" fringe; wefts carried up one
de-selvedge.

Teft stripes of varying widths. *Jaspe*
ometric and plant forms and a
ombination of letters.

arps stiffened with sizing (*atole*). Dense
eft setting and tightly beaten action
esulted in a strong, serviceable textile.
etters may spell out the weaver's name:
sidro Tzunum." *Jaspe* designs are similar
 all stripes except in the two wide ones.
lain-weave stripes of silk floss expand the
idth. An exciting textile.

e 3-23, 3-30A, 3-30B

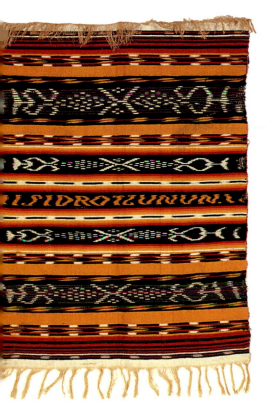

3-59
SHIRT, *huipil*
46" X 40" 116.8 CM X 101.7 CM

Warp: top—cotton, 2 singles, green; 34 epi,
14 epc; bottom—cotton, commercially
spun, singles, white; 57 epi, 22 epc
Weft: top—cotton, 2 singles, green; 34 ppi,
14 ppc; bottom—cotton, commercially
spun, singles, white; 46 ppi, 19 ppc
Supplementary weft: cotton, 5–6 singles,
red, dark blue; silk floss, yellow, purple,
lavender; wool, hot pink; over 1–5 warps

Top: backstrap-loomed, balanced plain
weave, single-faced supplementary weft
brocading; two pieces, all end-selvedges
loom-finished, front, back, side seams hand-
sewn; head hole cut and hemmed, slit at
front. Bottom: treadle-loomed, balanced
plain weave; three pieces sewn together, all
warps cut and hemmed.

Bands of geometric and zigzag forms.
Individual geometric forms.

"Upper part of stick-loom woven *huipil*.
Brocading in silks of various colors on green
ground. Style of brocading duplicated in
later treadle-loom weavings" (O'Neale:
Fig. 95c). Figure 86 in O'Neale text presents
the San Martín Jilotepeque *huipiles* in
the wrong order: figures noted here are
corrected ones. May have been worn in
Quezaltenango. Zigzag-patterned bands
across chest and upper chest area reflect San
Martín Jilotopeque–style influence. A
similar textile, 3-238, was exchanged with
the American Museum of Natural History,
65-3282, in 1907. Resembles a *huipil*
collected by George Byron Gordon in
1901, in the Peabody Museum, Harvard
University, 01-4040/C-3019. Green may be
cofradía-specific.

O'Neale 1945

See 3-65

TOTONICAPÁN
Totonicapán
K'ICHE'

TOTONICAPÁN
Totonicapán
K'ICHE'

3-60
SHIRT, *huipil*
39" x 40" 99 CM X 101.6 CM

Warp: cotton, singles, white; 31 epi, 13 epc
Weft: cotton, singles, white; 2 singles white,
red, yellow, green; 40 ppi, 15 ppc
Supplementary weft: cotton, 8 singles, red,
green, yellow, blue; over 3 warps

Treadle-loomed, balanced plain and weft-
faced twill weaves, two-faced supplementary
weft brocading; two pieces joined at front,
back, and underarms; warps cut and
hemmed; head hole cut out, slit at front,
velvet neck piece.

Weft stripes, geometric forms.

Button on neck piece is missing. Front of
garment sewn together with pink silk floss.
For comments see 3-22. (See Figure 67.)

See 3-22, 3-49

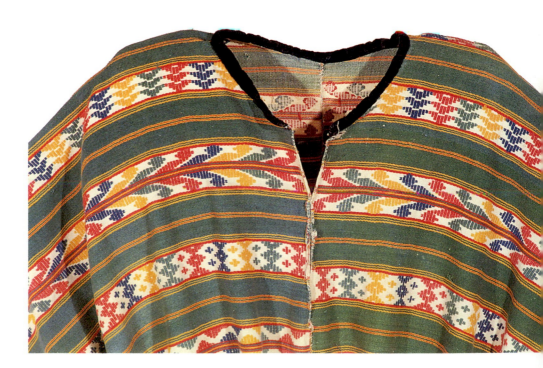

arp: top—cotton, 2 singles, green; 27 epi,
epc; bottom—commercially spun cotton,
ngles, white; 48 epi, 18 epc
eft: top—cotton, 2 singles, green; 31 ppi,
ppc; bottom—commercially spun cotton,
ngles, white; 50 ppi, 20 ppc
pplementary weft: cotton, 4–5 singles,
hite; yellow, dark blue, red; wool, hot
nk, purple; over 1–5 warps

op: backstrap-loomed, balanced plain
eave, single- and double-faced
pplementary weft brocading; two pieces,
l end-selvedges loom-finished, joined at
ont, back, and side seams; neck hole cut
it and slit, pointed silk neck piece
nbroidered with chain stitch. Bottom:
eadle-loomed, balanced plain weave; one
ece, end-selvedge (actually side-selvedge)
om-finished, side seams hand-sewn.

nds of chevrons, zigzags; several small
ometric motifs on front may be weaver's
arks.

ackstrap-loomed *huipil* sewn onto treadle-
omed cloth with warps used horizontally.
ell-worn piece. This textile shows San
artín Jilotepeque–style influence. Green
ay be *cofradía*-specific. For comments see
59.

e 3-59

3-65
SHIRT, *huipil*
44" x 28" 112 CM X 71.2 CM

TOTONICAPÁN
Totonicapán
K'ICHE'

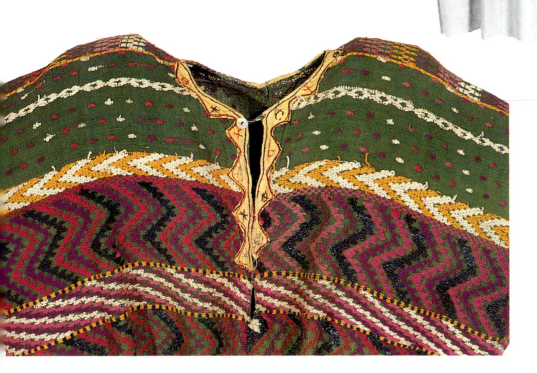

TOTONICAPÁN
Totonicapán
K'ICHE'

3-66
SHIRT, *huipil*
41" x 39" 104 CM x 99 CM

Warp: cotton, singles, white; 34 epi, 14 epc
Weft: cotton, singles, white, brown (*ixcaco*)
5 singles, red and dark blue used together; 7
singles, red; silk floss, white; 45 ppi, 18 ppc
Supplementary weft: cotton, 3 and 7 singles
green, lavender; silk floss, white, dark
brown, magenta; over 3 warps

Treadle-loomed, balanced plain and
weft-faced twill weaves, single-faced
supplementary weft brocading; two pieces,
warps cut and hemmed; front, back, and
underarm seams hand-sewn; head hole cut
out, slit at neck, black silk neck piece with
points, embroidered with chain stitching.

Zigzag panels, geometric forms.

"The brown is the natural color of the
variety of the cotton" (Eisen). "Unusually
restrained colors" (O'Neale: Fig. 95b). One
blue and four red wefts used together
resemble *jaspe.* This textile shows San
Martín Jilotepeque influence. For comments
see 3-37.

Eisen 1902b; O'Neale 1945

See 3-37

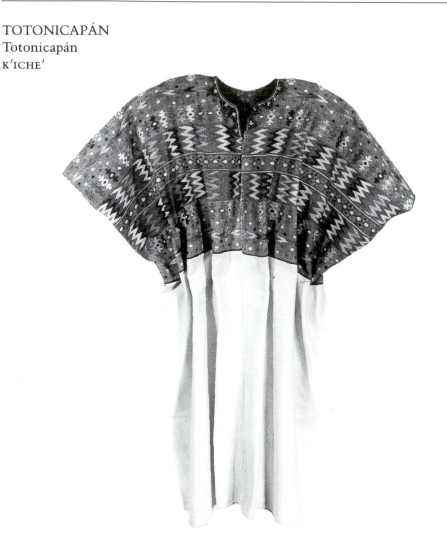

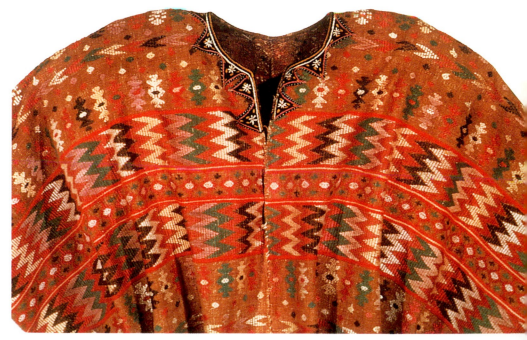

-147
HIRT, *huipil*
9½" x 40" 100.4 CM X 101.6 CM

Varp: cotton, singles, white; 35 epi, 14 epc
Veft: cotton, singles, white; 2 singles, red;
lk floss, yellow; 49 ppi, 21 ppc

readle-loomed, balanced plain and weft-
ced twill weaves; two pieces, warps cut;
ead hole cut out, slit at front, pointed
lack wool neck piece with embroidery.

op half of *huipil* is solid twill with thin
ripes of yellow silk floss. Neck piece
itched with purple (synthetic) silk.

. . *huipil* treadle loom woven in twill
pestry technique" (O'Neale: Fig. 97a). (See
gure 67.)

'Neale 1945

TOTONICAPÁN
Totonicapán
K'ICHE'

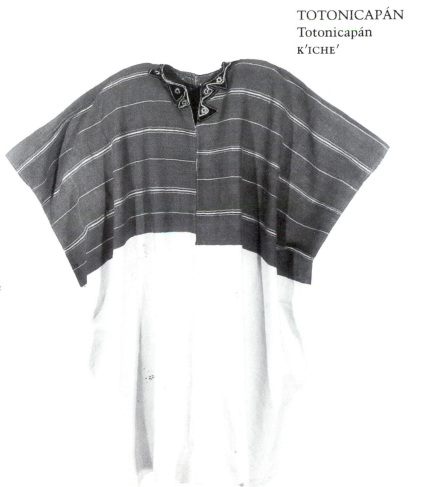

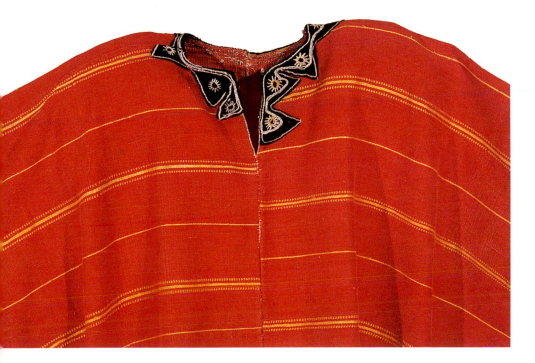

TOTONICAPÁN
Totonicapán
K'ICHE'

3-40
SHOULDER CLOTH, *perraje*
101″ X 28½″ 256 CM X 72 CM

Warp: cotton, singles, red; 38 epi, 16 epc
Weft: cotton, 2 singles, red; 38 ppi, 16 ppc
Supplementary weft: silk floss, singles,
purple, aqua, yellow, light blue, white; over
4–5 warps

Treadle-loomed, balanced plain and twill
weaves, two-faced supplementary weft
brocading; one piece, warps cut, rolled, and
hemmed; supplementary weft yarns carried
up one side-selvedge.

Warp stripes of varying lengths; *jaspe* weft
stripes on two ends with the words "canta
paloma."

"Ikat lettering" (Lehmann). O'Neale though
that some weavers may put their name into
ikat stripes.

O'Neale 1945; Lehmann 1962

-70

AISTBAND, WOMAN'S, *faja*

6″ x 2¾″ 244 CM X 7 CM

arp: cotton, commercially spun and hand-
ied, 2-ply, white, red, dark blue; 111 epi,
5 epc
eft: cotton, commercially spun and hand-
ied, 4-ply, white; 30 ppi, 12 ppc
upplementary weft: wool, 2, 3, and 4
ngles, red, yellow, purple, dark green; over
–18 warps

ackstrap-belt-loomed, warp-faced plain
eave, single-faced supplementary weft
rocading; one piece, warps cut or looped to
eate two eight-strand braids, 5½″ and 6″.

ich variety of human, animal, bird (double-
eaded eagles), and geometric forms in
peated horizontal bands.

Made by a professional. Identical style and
motives in old-time and later belts. All
colors appropriate. Woven by women; strong
belts, good for wear long after the floats of
decorative yarn have disappeared. To make
a standard Totonicapán belt demands
knowledge of a fairly large repertoire of
design elements and experience in forming
them by manipulation of the warps
(O'Neale: 158, 245, Fig. 119d). Similar
iconography, double-headed eagles, in
example collected by George Byron Gordon
in 1901, in the Peabody Museum, Harvard
University, 01-4020/C-3029. This technique
of supplementary weft brocading under warp
floats produces iconographic outlines on
back of belt.

O'Neale 1945

See 3-91, 3-92, 3-96, 3-97

TOTONICAPÁN
Totonicapán
K'ICHE'

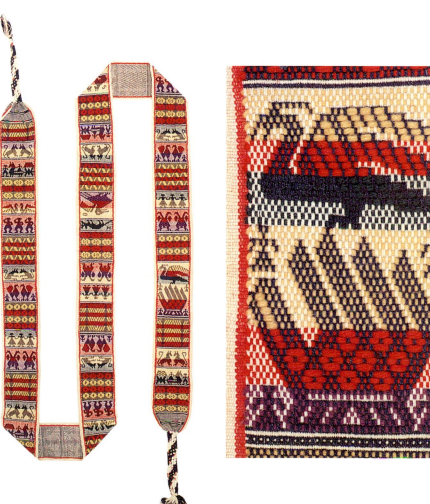

TOTONICAPÁN
Totonicapán
K'ICHE'

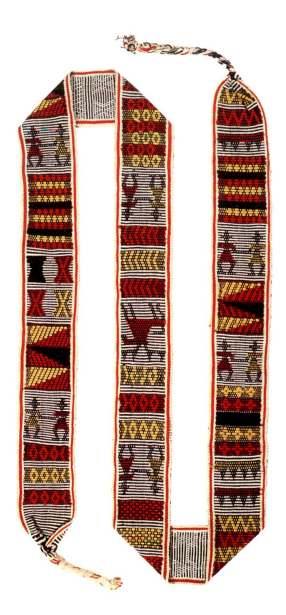

3-92
WAISTBAND, WOMAN'S, *faja*
91" X 3" 231 CM X 7.5 CM

Warp: cotton, commercially spun and hand-
plied, 2-ply, white, red; 4-ply, dark blue;
80 epi, 32 epc
Weft: cotton, commercially spun and hand-
plied, 4 singles, white; 16 ppi, 7 ppc
Supplementary weft: wool, two 2-ply, red,
yellow, dark green; over 5–18 warps

Backstrap-belt-loomed, warp-faced plain
weave, single-faced supplementary weft
brocading; one piece, warps looped and
braided into two multistrand braids, 4½" an
6½".

Large reindeer, men, geometric forms in
repeated horizontal bands.

For comments see 3-70, 3-91.

See 3-70, 3-91, 3-96, 3-97.

91
WAISTBAND, WOMAN'S, *faja*
5½" X 3" 220 CM X 7.5 CM

Warp: cotton, commercially spun and hand-
tied, 2 ply, white, red; 4 ply, dark blue;
5 epi, 40 epc
Weft: cotton, commercially spun and hand-
tied, 4 singles, white; 17 ppi, 8 ppc
Supplementary weft: wool, two 2-ply, red,
yellow, dark blue; over 5–18 warps

Backstrap-belt-loomed, warp-faced plain
weave, single-faced supplementary weft
brocading; one piece, warps looped and
braided into two multistrand braids, 8½"
and 5½".

Horizontal bands of baskets, women and
geometric and animal forms repeated.

This textile and 3-92 may have been woven
by the same professional weaver because of
similarity in iconography, colors, and design
layout. For comments see 3-70.

See 3-70, 3-92, 3-96, 3-97

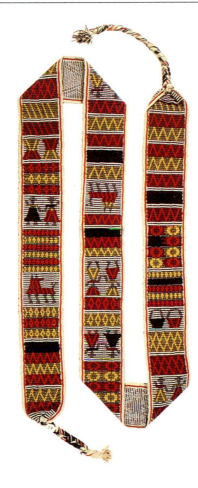

TOTONICAPÁN
Totonicapán
K'ICHE'

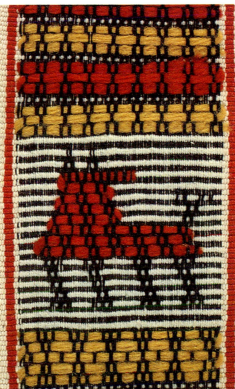

TOTONICAPÁN
Totonicapán
K'ICHE'

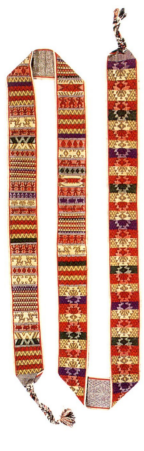

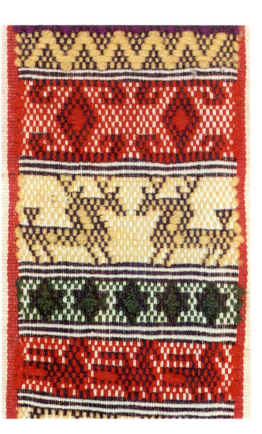

3-96
WAISTBAND, WOMAN'S, *faja*
100½" x 2¾" 256 CM X 7 CM

Warp: cotton, commercially spun and hand-plied, 2-ply, white, red, dark blue; 119 epi, 48 epc
Weft: cotton, commercially spun, hand-plied, 4-ply, white; 30 ppi, 12 ppc
Supplementary weft: wool, 2 and 4 singles, purple, yellow, red, green; over 5–18 warps

Backstrap-belt-loomed, warp-faced plain weave, single-faced supplementary weft brocading; one piece, looped warps cut, braided into two multistrand braids, 6" and 3½".

Warp stripes on both sides; warp floats create outlines of animal (horse or reindeer) human, and geometric forms that are filled in by supplementary weft brocading in horizontal bands on one half; other half repeats the same geometric form.

For comments see 3-70.

See 3-70, 3-91, 3-92, 3-97

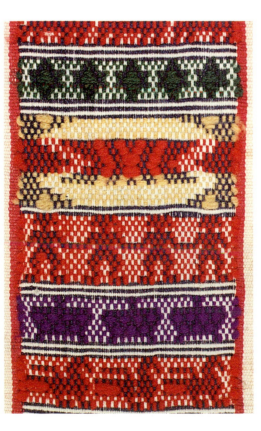

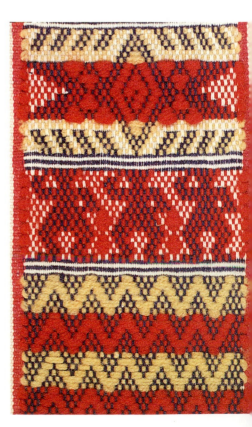

ckstrap-belt-loomed, warp-faced plain
eave, single-faced supplementary weft
ocading; one piece, looped warps at both
ds cut, form braids 5″ and 6½″.

orizontal bands of animal (dog, fox, crab,
acock), human, and geometric forms.

eces of dark blue carrying cord attached
white warp yarns; yarn is plied over a
rrying cord under tension, transferred to
arping board or loom; warps looped and
otted for color changes; a few knots
sible on back of weaving (Howe, Davis).
milar iconography, large diamonds, in
ample collected by George Byron Gordon
1901, in the Peabody Museum, Harvard
niversity, 01-4020/C-3029. For comments
e 3-70.

owe, pers. com. 1988; Davis, pers. com.
89

e 3-70, 3-91, 3-92, 3-96

3-97
WAISTBAND, WOMAN'S, *faja*
98″ x 2½″ 245 CM x 6.4 CM

Warp: cotton, commercially spun and hand-
plied, 2-ply, white, red, green, dark blue;
109 epi, 42 epc
Weft: cotton, commercially spun and hand-
plied, four 2-ply, green; 24 ppi, 10 ppc
Supplementary weft: wool, 2 and 4 singles,
red, magenta, purple, yellow, green, dark
green; over 5–18 warps

TOTONICAPÁN
Totonicapán
K'ICHE'

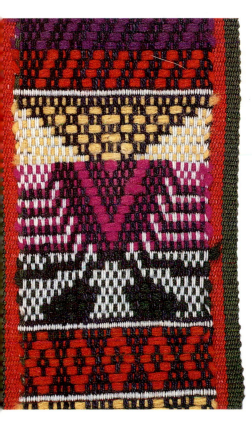

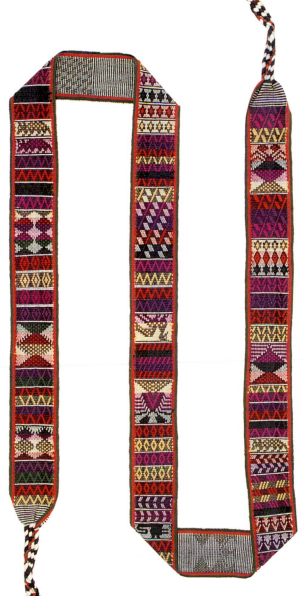

TOTONICAPÁN
Totonicapán
K'ICHE'

3-98
WAISTBAND, WOMAN'S, *faja*
63″ x 2″ 160.1 CM X 5.1 CM

Warp: cotton, 2-ply, white, red, dark blue;
63 epi, 25 epc
Weft: cotton, 5 singles, white; 12 ppi, 5 ppc

Backstrap-belt-loomed, warp-faced plain
weave; one piece, warps looped and braided,
create two 4″ braids.

Warp stripes on both sides; warp floats
create a checkered design in center of
textile.

"The checks are developed by means of
the plain weave, but the planning, which
represents an unusual amount of interest in
the result, was done during the warping. . . .
[The belts] are somewhat softer than the
usual belts of this width" (O'Neale: 158).
"Old style, no more; recognized by the old
people as the old style in San Gabriel
Pansuy, Baja Verapaz, San Pedro Laguna,
Sololá, and villages in Huehuetenango"
(Deuss). Pieces of hair caught in weaving.
(See Figure 70.)

O'Neale 1945; Deuss, pers. coms. 1988,
1989

See 3-99, 3-100

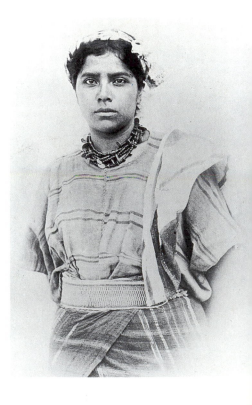

Figure 70.
Maya woman wearing a belt that resembles
3-98, 3-99, and 3-100, acquired in the town
of Totonicapán. George Byron Gordon photo
archives, Peabody Museum of Archaeology and
Ethnology, Harvard University. 1901. N28340.

99

'AISTBAND, WOMAN'S, *faja*

½" x 2" 156.4 CM X 5.1 CM

arp: cotton, 2-ply, white, red, green,
llow; 76 epi, 30 epc
eft: cotton, 6 singles, white; 13 ppi, 5 ppc

ckstrap-belt-loomed, warp-faced plain
eave; one piece, warps looped and braided
to two 4½" braids.

verall effect is red and yellow checks.

r comments see 3-98. (See Figure 70.)

e 3-98, 3-100

3-100

WAISTBAND, WOMAN'S, *faja*

61" x 2¼" 154 CM X 6 CM

Warp: cotton, 2-ply, white, red, green;
66 epi, 26 epc
Weft: cotton, 10 singles, white; 13 ppi, 5 ppc

Backstrap-belt-loomed, warp-faced plain
weave, one piece, warps looped and braided
into two 4½" braids.

Overall effect is red and white checks.

For comments see 3-98. (See Figure 70.)

See 3-98, 3-99

TOTONICAPÁN
Totonicapán
K'ICHE'

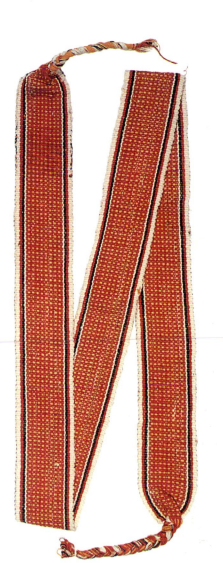

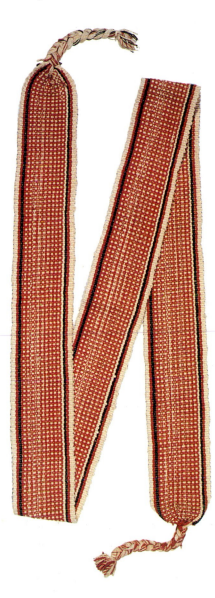

TOTONICAPÁN
Totonicapán
K'ICHE'

3-24

WRAP FOR CHILD, *perraje*
42¾" x 21½" 109 CM X 54.5 CM

Warp: cotton, singles, white; 25 epi, 10 epc
Weft: cotton, 2 singles, light blue, faded
light blue, dark blue, red, yellow, green;
4 singles, light blue and dark blue; 64 ppi,
26 ppc

Backstrap-loomed, balanced plain and weft-
faced twill weaves, weft stripes, one piece,
cut warps create a 2" fringe at each end; weft
yarns carried up one side-selvedge.

Stripes of varying widths.

Dark and light blue yarns used in six stripes
of four rows of twill, which are set off by
two to four rows of plain weave; each twill
stripe is divided by six rows of red and
yellow plain weave; additional stripes of red
and faded light blue plain and twill weaves.
The variety of striping and alternating
weaves makes this piece one of great
interest.

See 3-26, 3-27

3-26

WRAP FOR CHILD, *perraje*
39½" x 20¾" 100 CM X 53 CM

Warp: cotton, singles; white; 28 epi, 12 epc
Weft: cotton, singles, brown (*ixcaco*), light
and faded blue; 2 and 4 singles, dark blue;
2 singles, green, red, yellow; 64 ppi, 20 ppc

Backstrap-loomed, weft-faced twill weave;
one piece, cut warps create a 2" fringe at
each end; weft yarns carried up one side-
selvedge.

Stripes of varying widths.

Two stripes of four rows of twill of dark and
light blue yarns create an effect of *jaspe*.
Brown cotton gives rich look to cloth.
Similar layout of stripes at two ends; regular
color sequencing of other stripes. Warps
stiffened with sizing (*atole*). A few rows of
plain weave at one end.

See 3-24, 3-27, 3-28

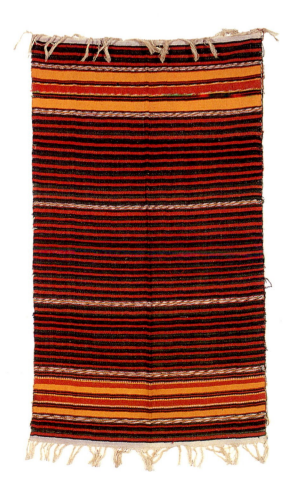

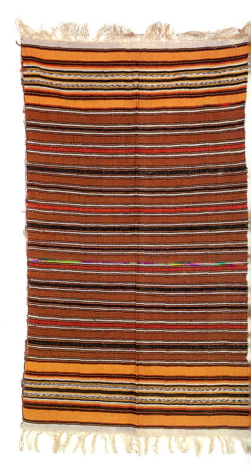

Classification of Textiles and Textile-Related Objects in the Eisen Collection by Function and Type

INTRODUCTION

The style, shape, and size of costume elements do not remain the same over time. Change is an ongoing process that relates to various factors: the availability of materials, the conservative nature of the community as expressed through clothing, the amount of labor and time involved, the fashion impulse, the skill of the artisans, and external pressures.[1] As a modern textile scholar, I was surprised to come across so many textiles that are familiar and can be identified as to department, town, or village. Some of the styles, colors, materials, and techniques are similar to those still current. On the other hand, some costume elements no longer exist. Why did some styles disappear, while others persist in a transformed form? Some styles have been transformed into new styles and shapes with iconography associated with distant communities.[2]

In this appendix, I discuss the general features of each textile type and mention unusual attributes of particular items. The classifications are broad and not all the individual textile forms are mentioned. Complete annotated citations for each textile and object appear in Chapter 6, the catalogue section, which is arranged geographically by department and town as given by Eisen. In Figure 80, I note for each classification, when possible, the continuities, discontinuities, or transformation in Maya textile forms, iconography, and techniques by comparing the Eisen textiles from 1902 with those in use in the 1980s. In Figure 106, special attention is given to women's *huipiles*, as this garment is well represented by thirty-seven examples. For a few textiles, comparisons with older examples with similar provenance in museum collections are noted. The data are derived from several sources: the analyses of the Eisen collection, publications, my recent fieldwork in Guatemala, and consultation with colleagues.[3]

One may ask: Why discuss textiles from the 1980s in a discourse about a collection made in 1902? The response asks another question: Why and how does change occur in the design elements of textiles produced by indigenous peoples, in this case, the highland Maya of Guatemala? Other Guatemalan textile scholars have asked these same questions. In 1936, Lila M. O'Neale (1945) looked at the changes that had occurred since Eisen collected in 1902. In the 1950s, Hilda Schmidt de Delgado Pang visited towns that O'Neale had documented as well as others to look at evolution in Maya dress since the mid-1930s (1963). Ann Pollard Rowe traced changes in Maya dress over a century (1981). In 1978, I collected textiles for the Haffenreffer Museum and subsequently wrote a collections catalogue about the museum's Guatemalan textile collections, which range mostly from the early 1960s to the late 1970s. Innovations in textile design had occurred within that relatively short time frame (1986). The literature

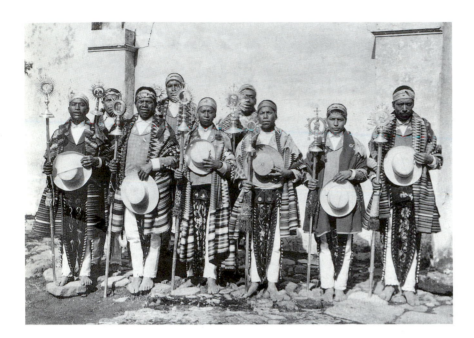

Figure 71.
"*Martooms* of the church, Totonicapán" (Eisen 1902c). Photo by Gustavus A. Eisen. 1902.

on Guatemalan Maya cloth and clothing contains well-illustrated publications for further scrutiny (Pettersen 1976, Bjerregaard 1977, Bunch and Bunch 1977, Anderson 1978, Dieterich, Erickson, and Younger 1979, Sperlich and Sperlich 1980, Deuss 1981, Barrios 1983, Conte 1984, Asturias de Barrios 1985, Dieseldorff 1984, Mayén 1986, Schevill 1986, Mejía de Rodas and Miralbés de Polanco 1989, Arriola de Geng 1989, and Vecchiato 1989).

COMPLETE COSTUMES

1902

Eisen purchased several complete Maya costumes including a few outstanding *cofradía* men's costumes from Totonicapán.[4] These costumes were worn by the *martooms* or *mayordomos*, who were second in the hierarchy to the *alcaldes*. Costume elements include four *sarapes* (3-1, 3-2, 3-3, 3-4), three *pantalones* or overpants (3-6, 3-7, 3-9), and one *cotón* or overshirt (3-8). Eisen was so impressed with the color and beauty of these ensembles that he photographed the *martooms* as a group and then individually (Figures 71, 72). He also photographed the women's group or *capitanes* (Figure 73), but he did not purchase one of their elaborate overblouses. In all there are six men's costumes: two from Chichicastenango (Figure 74), two from Totonicapán (Figure 71), and one each from Todos Santos Cuchumatán (Figure 75) and Soloma (Figure 76).

The women's costumes are incomplete because of the exchanges already mentioned with the American Museum of Natural History. I assembled some complete costumes, however, by incorporating textiles from other Hearst Museum collections with the same provenance and date of collection. Late nineteenth- and early

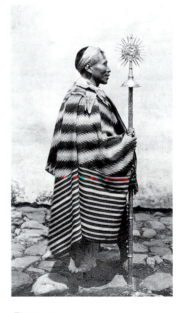

Figure 72.
"An Indian *Martoom*, Totonicapán" (Eisen 1902c). Photo by Gustavus A. Eisen. 1902.

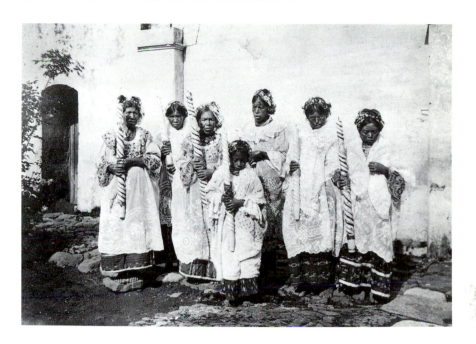

gure 73.
Capitanes of the Church, Totonicapán" (Eisen
02c). Photo by Gustavus A. Eisen. 1902.

twentieth-century photographs provided additional guidelines to ensure the accuracy of the costume ensembles. These costumes are from Chichicastenango (Figure 74), San Cristóbal Totonicapán (Figure 77), Quezaltenango (Figure 78), and San Martín Jilotepeque (Figure 79). Other partial ensembles are from Totonicapán and Todos Santos Cuchumatán.

A man's basic dress (3-195, 3-197; Figure 76) from Soloma is typical of what most Maya men wore in their homes and when they went to work on the coastal plantations. These cut-and-sewn garments, a shirt and pants, are made of treadle-loomed or water power–loomed commercial cloth called *manta*, which was inexpensive and could be purchased in the markets. The rest of the ensemble includes a *kapishay* or overshirt (3-112, 3-113), a *matate* or shoulder bag (3-160), and a sombrero (3-313).

1980s

The *cofradía* costumes of the Totonicapán *martooms* are no longer in use.[5] Although most men from Chichicastenango wear Western-style dress with a few elements of *traje,* the complete man's costume continues to be worn by some older residents, and it has become the *cofradía* costume. Todos Santos Cuchumatán men's contemporary dress styles represent a continuity with the nineteenth-century style, albeit with some modifications. The white cotton man's dress from Soloma in the Eisen collection is still worn in Huehuetenango, Comalapa, and San Martín Jilotepeque and by migrant plantation workers.

The Chichicastenango woman's costume also represents a continuity with earlier styles, while the styles of San Cristóbal Totonicapán have changed dramatically (Figure 80).

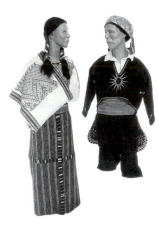

Figure 74.
Man's and woman's costume,
Chichicastenango,
El Quiché.

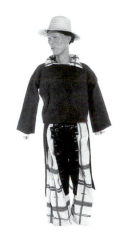

Figure 75.
Man's costume,
Todos Santos Cuchumatán,
Huehuetenango.

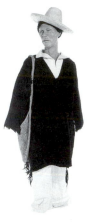

Figure 76.
Man's costume,
Soloma,
Huehuetenango.

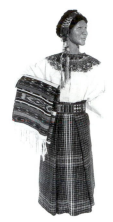

Figure 77.
Woman's costume,
San Cristóbal Totonicapán,
Totonicapán.

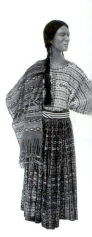

Figure 78.
Woman's costum
Quezaltenango,
Quezaltenango.

APRONS

1902

Eisen's interest in everyday ethnographic costume elements led him to purchase twenty-one aprons or *delantales* or *gavachas.* Some examples are of the cut-and-sewn variety, while others are simply large pieces of unsewn yardage. Most of them are of treadle-loomed *jaspe* cloth. Historic photographs reveal that the indigenous peoples tucked large strips of treadle-loomed *jaspe* cloth into their belts as aprons.

A group of three backstrap-loomed aprons acquired in Totonicapán (3-27, 3-28, 3-32) are woven in weft-faced twill weave. Cut warps form fringes on each end, and weft bands are made of predominantly white, dark blue, and natural brown (*ixcaco*) cotton with some bands of other colors. There are other textiles in the collection that are similar but are called shawls, towels, or napkins (3-24, 3-26, 3-135; Figure 81). A fourth example (3-23) is treadle-loomed with weft-faced bands of plain and twill weaves in natural brown and multicolored and *jaspe* yarns. There is a bed covering (3-30A) and a shawl (3-30B) of similar cloth woven in *serapado*, or serape-like, style.[6]

An unusual example from Totonicapán (3-61) is a treadle-loomed apron with cotton and silk weft yarns and silk floss in the supplementary weft brocading. The weaver brocaded her name, "Teresa A.," the word "Feliz," and the year "año 1900" into two of the horizontal stripes. O'Neale commented "probably name of owner. Certain obvious difficulties in the loom weaving overcome by freehand weaving" (O'Neale 1945:71l).[7] Perhaps because of the technical problem of weaving the letters in proportion to each other,

TYPE	Continuity	Discontinuity	Trans
Aprons	X		X
Bags	X		
Bed coverings	X		X
Belts, men's	X	X	
Belts, women's	X	X	X
Blankets	X		
Children's dress	X	X	
Hats	X		
Hatbands		X	
Headbands, headribbons	X		X
Headcloths, men's	X		
Headcloths, women's	X		
Huipiles	X	X	X
Jackets	X	X	
Looms	X		
Multipurpose cloths	X		X
Pants, overpants	X	X	
Raincoats		X	
Saddle bags	X		
Serapes, overgarments	X	X	
Shawls	X	X	X
Shirts, overshirts	X		
Skirts	X		X
Spindles	X		

Figure 80.
Continuity, discontinuity, and transformation in
textile types: 1980s.

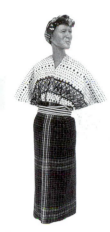

gure 79.
'oman's costume,
n Martín Jilotepeque,
himaltenango.

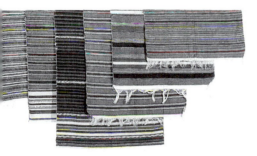

gure 81.
prons, Totonicapán.

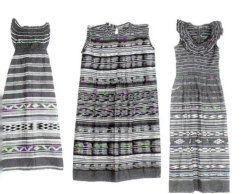

gure 82.
rons, Huehuetenango.

it is one of the few textiles in the collection with the date woven into it. Considering all the silk utilized and the amount of supplementary weft brocading, it was probably the weaver's most precious dress element.

Several aprons from Huehuetenango have pockets (3-176, 3-178). The pocket fabric differs from that of the apron. The pockets are large, and one cannot discern if they are located on the inside or outside of the garment. Another apron or *gavacha* (3-181) is made of *jaspe* treadle-loomed fabric with a smocked bib attached at the waist. Two more *gavachas* (3-129, 3-185) are made of *jaspe* yardage in an elaborate cut-and-sewn style (Figure 82). One has a frilled neck piece. Each is a full-length garment on one side with a bib front on the other. O'Neale thought that this style was worn by *ladinas* (1945:266). They may also have been used by the Maya women.

1980s

Most aprons worn in the highlands today have been transformed into cut-and-sewn, machine-stitched garments replacing single pieces of backstrap- or treadle-loomed pieces of cloth. The contemporary *gavachas* with bib tops in checkered cotton worn in San Pedro Sacatepéquez, San Marcos, as overdresses bear some resemblance to the elaborate *gavachas* in the Eisen collection. Single pieces of cloth continue to function as aprons.

BAGS

1902

Men made and wore shoulder bags. Some bags are knitted or crocheted, while others are produced by knotless netting or linking techniques with sprang-interlinked straps. Women do not use bags of this kind; instead, they wrap their possessions in carrying cloths or place them in pockets. The bag men use is rectangular in shape with straps attached to it. Sizes of bags vary and indicate function and town of origin. There are several Spanish words for bags: *matate, bolsa, morral,* and *red.* The latter means "net" and is used for carrying loads.

There are two examples of knitted bags in the Eisen collection (Figure 83). One example from Nahualá (3-67) is of white handspun wool. With two metal needles and a double-knot stitch, the knitter creates a strong, waterproof, and durable bag. One strap is knitted in the same stitch, and the other is woven. The other example from Sololá (3-68) is of two-ply *pita* or maguey. The bag is knitted in the same technique as the woolen one. The difference is that two sprang straps are looped to the body of the bag. No seams are visible in either example.

There are six bags of knotless netting. Four of them (3-158, 3-159, 3-257, 3-265) are alike in shape, materials, and construction (Figure 84). One example (3-257), however, is smaller, and the *pita* is

quite silky. Two other examples (3-160, 3-259) are more loosely knotted, resembling nets to carry loads (Figure 85).

1980s

Men's bags, due to their functional properties, represent a continuity of style, materials, and techniques. One can still buy a knotless-netted *red* or a double-stitch knitted woolen *matate.* Thanks to the recent cooperative production of crocheted bags or *morrales*, in the style of Todos Santos Cuchumatán bags, these textiles are currently available in a range of colors and sizes. No example of this style of *morral* exists in the Eisen collection.

Figure 83.
Men's bags, Sololá, Nahualá, Sololá.

BED COVERINGS

1902

Three bed coverings (3-30A, 3-39, 3-140), called *sábana* or *sabanilla*, are part of the Eisen collection. Of treadle-loomed cloth, they vary in size and could have served other functions. One Totonicapán example (3-30A) of plain and twill two-sided *serapado* weaves comprises various *jaspe*-dyed and solid-colored yarns as weft bands.[8] Two large pieces are sewn together with no effort to match bands. Other textiles, a shawl and an apron (3-23, 3-30B), are also of *serapado*-style cloth. A smaller bed covering (3-39), also two pieces sewn together, is of lighter-weight cloth, and the solid-colored weft bands do not contain *jaspe* yarns. The example from Huehuetenango (3-140) is the largest of the three, and it may have been used as a wraparound skirt. Weft stripes are solid-colored, and the geometric designs of *jaspe* yarns are noticeably different from those of the Totonicapán example.

Figure 84.
Men's bags *(clockwise from upper left)*, Santa Eulalia, Huehuetenango; Santa Cruz del Quiché, Chichicastenango, Nebaj, El Quiché.

1980s

Bed coverings are available in various weaving towns including Chichicastenango and Zacualpa. They are popular tourist items but do not resemble the styles woven earlier in the century. The bed covering sold in Chichicastenango is available in other highland markets. It is actually a patchwork quilt made up of squares of treadle-loomed cloth, some of which have been overdyed with purple. One suspects the influence of outside marketing consultants who encouraged the weavers to use typical designs while increasing the size of the textile. A commercial item is created that has authentic patterning and is hand-woven on the backstrap loom. Bed coverings of *serapado*-style cloth are no longer available. Other types of bed coverings are produced on the Jacquard loom for use by the Maya and *ladinos* within Guatemala. Jacquard-woven bed coverings were probably in use when Eisen was there, but he may have thought they were of European rather than indigenous origin and, for that reason, did not collect any examples.

Figure 85.
Men's bags, Soloma, Huehuetenango; Tutuapa, San Marcos.

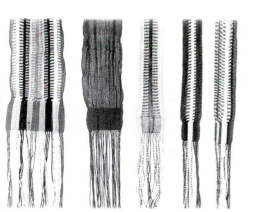

Figure 86.
Men's belts, Quezaltenango, Huehuetenango.

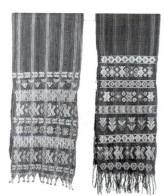

Figure 87.
Men's belts, Nebaj, El Quiché.

MEN'S BELTS

1902

Eisen collected fourteen men's belts. He listed them as waistbands or bridles for men, which in Spanish are called *fajas* or *bandas*. All examples are cotton and, with one exception, they are all backstrap-loomed or plaited in sprang technique.

Five belts with backstrap-loomed ends (3-87, 3-89, 3-222, 3-227, 3-230), from Huehuetenango and Quezaltenango, have a fishnet, stretchy texture typical of the sprang technique (Figure 86). This style was commonly found in many parts of the highlands. A bridle is defined as headgear for a horse; perhaps in Eisen's time this term also meant a man's belt. Two examples called *fajas* from Quezaltenango (3-20, 3-21) are quite long and could have served as head coverings. Other belts with similar dimensions from Nebaj (3-33, 3-34) have elaborate supplementary weft brocading with iconography that was shared by the neighboring town of San Juan Cotzal (Figure 87).

Three belts from Momostenango (3-137, 3-179, 3-182) contrast with the other examples. All three Momostenango belts are woven with weft-faced stripes and two examples have knotted fringes, a style also worn by the Maya men of San Andrés Larrainzar, Chiapas, Mexico (Schevill 1986:73).

The *faja* from Chichicastenango (3-29), which is part of the complete man's costume, is a belt of simple warp stripes with knotted fringes. An example from Huehuetenango (3-220) is unlike all the others. This belt of treadle-loomed commercial cloth has commercial wool yarns as fringe; it could have served as a headcloth as well as a belt.

1980s

The fishnet-style belt was still in use in the 1960s, but as a hatband. This style of belt is no longer available. Large, supplementary weft–brocaded waistbands are still worn. The iconography of the Nebaj belts resembles that of the older examples.

The contemporary Chichicastenango belt is more ornate than the Eisen example. Supplementary weft brocading in silk and other yarns has transformed the belt, while the basic shape and color retain a continuity with the past.

WOMEN'S BELTS

1902

Eisen collected twenty-seven women's belts, waistbands, or girdles, which are also called *bandas* or *fajas*. All examples are backstrap-loomed.

Eleven belts purchased in Huehuetenango (3-169, 3-189, 3-191–3-193, 3-198, 3-210, 3-225, 3-226, 3-229, 3-231) are woven with

maguey wefts that made them stiff and durable. Warp-stripe patterns of certain colors may be town-specific. For example, some belts (3-193, 3-210, 3-225, 3-226, 3-231) have white vertical center stripes while the other examples have no white centers (Figure 88).

Two belts (3-170, 3-223) also have maguey wefts, and warp floats are manipulated to create animal and human forms with checkered designs (Figure 89).

The black-and-white warp-striped woolen belts from Chichicastenango (3-95, 3-124) were woven for women by professional male weavers. Men also embroidered onto these belts the motifs and colors that were popular in their town or village. This style of belt was sold throughout the highlands. Eisen acquired a similar example in San Antonio Las Flores, Guatemala (Figure 90).

A similar type of belt was woven by women for sale in Aguacatán (3-233, 3-234; Figure 91). Eisen listed these textiles as girdles. The weavers came from towns or villages in the *altiplano* and were children of migrants from San Francisco El Alto and Momostenango. The black-and-white vertical stripes are narrower than those woven in Chichicastenango.

There are three belts with distinctive checkered center patterns (3-98, 3-99, 3-100; Figure 92). Eisen purchased these examples in Totonicapán, but they were also popular in San Gabriel Pansuy, Baja Verapaz, San Pedro Laguna, and Sololá, and in Huehuetenango.

Five belts or *fajas*, purchased in Totonicapán, are excellent examples of the local styles (3-70, 3-91, 3-92, 3-96, 3-97). Another example (3-85), acquired and intended for use in Quezaltenango, resembles the Totonicapán belts and was probably woven there (Figure 93).

1980s

Maguey belts are still in use in the highlands. Krystyna Deuss wrote: "Stiff maguey belts are still made in the Toto area and there are lots for sale every market day in Toto, San Cristóbal, and San Francisco. They are also taken to sell in other villages. I've seen stalls in San Juan Ostuncalco, Cubulco—every village in effect where merchants travel to. They are also made by weavers in San Pedro Laguna. The traditional belt of Santa Cruz Quiché is also a maguey based belt in simple stripes now worn only by a few old women" (pers. com. 1989).

The Comitancillo belts resemble those in the Eisen collection. The images are larger, and there is no center vertical stripe. Some belts with color-striped combinations are similar to those in the Eisen collection (3-191, 3-192, 3-198, 3-229), but the wefts are not maguey. A group known as Dignity Crafts is encouraging Guatemalan refugees in Mexican camps to produce belts of similar warp stripes and colors but with cotton instead of maguey wefts. These belts are marketed in the United States and represent a transformed textile form that relates to the older styles.

The checkered-pattern belt style has persisted into the 1990s and is a popular style throughout the highlands. The Totonicapán-

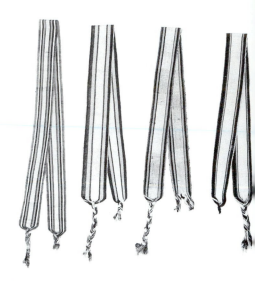

Figure 88.
Women's belts, Huehuetenango.

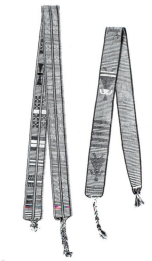

Figure 89.
Women's belts, Huehuetenango.

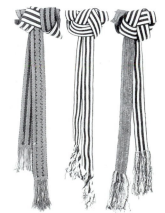

Figure 90.
Women's belts, San Antonio Las Flores, Guatemala *(left)*; Chichicastenango, El Quiché *(center and right)*.

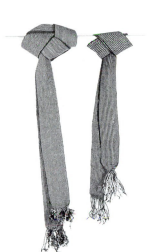

igure 91.
omen's belts, Aguacatán, Huehuetenango.

Figure 91.
Women's belts, Aguacatán, Huehuetenango.

Figure 92.
Women's belts, Totonicapán.

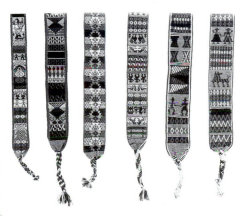

Figure 93.
Women's belts, Totonicapán.

style belts are still popular, and the weaving technology is unchanged. New materials and designs have appeared. Two classes of belts are now available: those for use by the indigenous peoples and those for sale to tourists and for export.

BLANKETS

1902

In Chichicastenango Eisen purchased three shoulder blankets or *chamarros*, which are part of the man's costume (3-12, 3-121, 3-122). Eisen called them *zarapes* (serapes), since one of their multiple uses was as a shoulder covering. These rectangular treadle-loomed textiles, with tapestry-inlay geometric designs and yarns colored with natural dyes of cochineal and indigo, served also as rain coverings and to carry burdens.

1980s

The shape, design, and size of these blankets have persisted to present times—an impressive continuity. Examples are part of most museum collections of Guatemalan textiles because of their visual appeal. Synthetic dyes to create the blue, red, and black yarns are now in use. The overdyed black yarn has replaced the combination of natural black and white sheep's wool that, when woven, created a checkerboard effect.

CHILDREN'S DRESS

1902

A less thorough collector might have overlooked examples of children's dress entirely. Eisen, however, did not; indeed, there are eleven examples in the collection.

Two unusual examples from Totonicapán are called *gavachas*, or aprons. Eisen also catalogued each as a child's shirt, or *huipil*. Made out of small pieces of cloth from worn-out *tzutes* (similar to 3-26), these tiny garments were probably bibs for babies.[9] Eisen purchased two girls' headbands (3-71, 3-75) from the same department (Figure 94). These textiles resemble the women's headbands but are not as elaborate in design or rich in materials. The design layout includes geometric forms and horizontal bands of multicolored cotton and some silk floss. Tassels of silk floss with silk strands are attached to both ends.

A *huipil* from Chichicastenango (3-155) is a recycled man's backstrap-loomed *tzute* or headcloth. (Maya weavers never waste cloth!) The upper half of the garment is made from a *tzute* similar to another example in the collection (3-52) with a head hole cut out. The bottom half consists of other backstrap-loomed pieces of cloth sewn

together; some areas have been patched. The person who created this textile wanted to reuse the *tzute* with its labor-intensive supplementary weft brocaded designs, and thus transformed it into a child's garment. Eisen probably purchased this textile from the owner and not in a market, or it may have been a gift.[10]

Three girls' *huipiles* derive from San Martín Jilotepeque (Figure 95). They resemble closely the women's style of that town, but they are made of one piece of backstrap-loomed cloth. The San Martín–style girls' *huipiles* will be discussed in the section on *huipiles.*

In Aguacatán Eisen collected another *huipil* (3-200). It is made of commercial cloth with commercial red cloth trim at the neck and cuffs. The garment is machine-stitched and is unused. The red trim appears on other *huipiles* from Aguacatán (3-199, 3-202). These *huipiles* may also have been girls' garments (Figure 96).

Eisen found an unused child's *gavacha* (3-205) in Huehuetenango. It resembles the women's *gavachas* or aprons from this area.

1980s

Changes in adult costumes are reflected in children's clothing because they wear the everyday style worn by their parents. The production of bibs and aprons similar to those in the Eisen collection seems to have been discontinued. Children's headbands are still being produced in Totonicapán. The child's *huipil* in Aguacatán continues to be made of commercial cloth and trim.

The presence of patched and worn garments in other Hearst Museum Guatemalan textile collections is evidence that Maya women value backstrap and treadle-loomed cloth, probably for the time and therefore the cost invested in its production.[11] No cloth is wasted, and patches are often made with care and attention.

HATS AND HATBANDS

1902

The collection contains nine hats or sombreros, five of which were purchased in Jacaltenango, Huehuetenango, a hat-making center for the region. All of them are made of twisted palm fiber, twill-plaited into strips and sewn together with cotton thread by men (Figure 97).

Figure 94.
Children's headbands, Totonicapán.

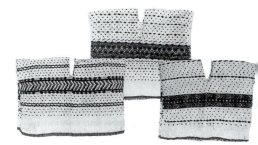

Figure 95.
Children's *huipiles*, San Martín Jilotepeque, Chimaltenango.

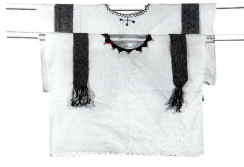

Figure 96.
Women's *huipiles* and belts, Aguacatán, Huehuetenango.

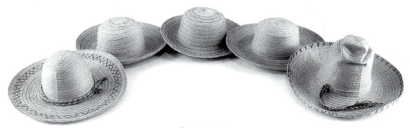

Figure 97.
Men's hats, Jacaltenango, Huehuetenango.

Three examples are similar (3-315, 3-316, 3-317). Hats also can be town-specific. This style of hat was worn in Todos Santos Cuchumatán by both men and women. The two other sombreros (3-312, 3-314) are partially decorated with cotton thread stitching around the outer edges of the brims, with colored and natural cotton hatbands. The peaked, higher crowns of these sombreros are different from the others that come from Jacaltenango.

There are two other hats: one from Soloma (3-313) and the other from Chichicastenango (3-107); the latter has a black silk ribbon hatband. Both examples are part of complete men's costumes from these towns.

Two natural palm fiber hatbands from Huehuetenango (3-162, 3-168) were probably made by a specialist, a man who was adept at folding and braiding this fiber. One hatband (3-167) has purple-colored fiber at one end, while the other is made entirely of natural-colored fiber.

1980s

Hats are still produced in Jacaltenango and in other areas. Over the years, the styles worn by men and women in Todos Santos Cuchumatán have altered slightly in shape and type of hatband. The current hatband in use is of leather with colored commercial tape wrapped around it. *Cofradía* members in Chichicastenango continue to wear a hat style similar to the Eisen example. Straw hats have plain commercial ribbon hatbands. The plaited palm fiber hatbands have been replaced by woven cotton ones.

HEADBANDS

1902

Totonicapán, a prosperous weaving center in the late nineteenth century, was known for the belts, headbands, and other textiles produced there. Weavers created long, rectangular headbands, also called head- or hair ribbons, for home use and for sale. Tapestry-woven headband or *cinta* designs, colors, and design layouts were town-specific. Professional weavers and weaving families known as *cinteros* produced headbands in a variety of styles associated with specific villages or towns throughout the highlands.[12]

There are seventeen women's and two children's headbands in the collection. A style popular in Quezaltenango was narrow with horizontal stripes of solid colors (3-58, 3-76, 3-77, 3-84; Figure 98). Silk floss was attached to the warp ends as a decorative element. These examples were purchased in Quezaltenango but woven in Totonicapán.

Another style of headband (3-80, 3-90), longer and wider than those already described, was woven with a solid red center and weft-faced designs on both ends (Figure 99). A plainer version of this red-centered style, without any weft designs, was woven for

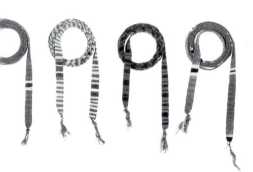

Figure 98.
Women's headbands, Quezaltenango.

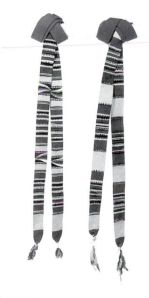

Figure 99.
Women's headbands, Totonicapán.

use in Nahualá (3-83), and another style was produced for use in Chichicastenango (3-86). These red-centered examples also had strands of colored silk floss tied to the warp ends.

Four other headbands (3-72, 3-74, 3-78, 3-88), woven in Totonicapán for use there and in nearby towns and municipalities, contain weft designs rendered in the eccentric-weft technique (Figure 100). This technique allows the weaver to create rounded animal and bird forms, which are placed next to geometric forms and solid-colored horizontal bands. Decorative tassels of silk floss with wire-wrapped maguey yarns are interlooped to form figure eights. Long strands of spun silk decorate the figure eights.

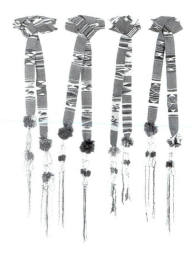

Figure 100.
Women's headbands, Totonicapán.

1980s

Families of weavers or *cinteros* continue to create headbands for sale. Since the 1950s, the women of Totonicapán no longer wear headbands for everyday dress. McEldowney, writing about the locative traditional-functional forms in the 1930s, comments that headbands were produced for more than twenty-five communities. In the 1970s only six or seven styles were woven (McEldowney 1982:2). This reduction indicates a trend away from the wearing of town-specific dress toward regionalized standard dress occurring throughout the highlands. Nevertheless, this production represents a continuity and a relationship with the past. Tourists are attracted to these beautiful textiles that fit into a suitcase and will decorate a wall at home.

The red-centered style, created for use in Nahualá and other towns, became the town-accepted style for Santiago Atitlán around 1910. A variation was an exceptionally long red section. Still worn in Santiago Atitlán, the red-centered style is woven in Totonicapán. When wrapped around the head, it resembles a halo or an ancient headdress seen on Maya sculptures and ceramics from the Classic Period—a continuity of almost two millennia! The significance of the headband as an icon today is indicated by the fact that a woman from Santiago Atitlán in *traje* appears on the twenty-five-cent Guatemalan coin.[13]

The other form of headband available for purchase is the "tourist" *cinta*. Tapestry-woven with simpler and more standardized designs, it is popular as a belt and not as a headband. Weaving cooperatives are creating large quantities of these belts in a variety of colors for export. Bracelets are also woven in the same technique with similar designs and colors.

MEN'S HEADCLOTHS

The headcloth or headdress, called *tzute* in the Maya languages, is an important element of men's dress. In the Classic Period (A.D. 300–900), Maya men also wore headcloths (Figure 101). The manner of wearing varies and may, therefore, be locative. The turban style is popular in Chiapas, Mexico. Another style requires folding the *tzute* diagonally and wrapping it around the head. The tassels fall on the

eaddresses from the murals of Bonampak.

gure 102.
aya man, Chichicastenango, El Quiché. Photo
 Margot Schevill. 1988.

gure 103.
adcloths, Chichicastenango, El Quiché.

shoulders. This so-called pirate style is common in many Guatemalan towns and may have been influenced by a Spanish mode of dress brought to the New World (Figure 102). Men who dance the *fandangos de huessar* in Granada, Andalucia, Spain, wrap their heads with cloths in this manner (Herrera Escudero 1984 : 149). In other Maya towns, large headcloths are worn around the shoulders like a shawl.

1902

Eisen noted that, in Totonicapán, the *alcaldes* wore narrow, red bands around the forehead in the Greco-Roman style. His photographs reveal that the *martooms* also wore headbands. In San Juan Sacatepéquez, Guatemala, the *alcaldes* wore "shawl cloths" that were "simply tied around the head, held together with a large knot at the back of the head, while the ends of the cloth are allowed to hang freely down the sides, reaching nearly to the knees" (Eisen 1903c). In San Martín Sacatepéquez, Chile Verde, the headdress was "a long and narrow cloth tied around the head, and allowed to fall freely down along the back" (ibid.).[14]

Eisen acquired eight headcloths including a group of five exceptionally fine examples from Chichicastenango (3-36, 3-41, 3-52, 3-56, 3-142; Figure 103).[15] One can observe the variety of dimensions, iconography, color, and decorative elements in these examples, all from the same town and woven within a few years of each other. Four have white backgrounds, while only one has a red background with narrow white stripes. Within ten years, red with narrow indigo-dyed vertical stripes was the fashionable color combination for Chichicastenango headcloths. White was reserved for the ceremonial examples (Schevill 1985). One headcloth (3-142) is smaller than the rest and was probably intended for ritual purposes, such as handling the monstrance. This example has highly valued silk in the weft stripes, the silk tassels, and the *randa*.

Two more examples come from Nahualá (3-45) and Nebaj (3-217). The Nahualá headcloth is larger than those from Chichicastenango and could be worn as a shoulder covering. It was part of a *cofradía* costume. A unique feature of the Nebaj example is

the four-inch fringe on each end, which implies that it too may have been worn on the shoulders. All the headcloths were woven on the backstrap loom.

1980s

In most highland towns, men combine elements of typical clothing or *traje típico* with Western-style shirts, pants, and jackets. Two costume elements, the headcloth and the belt, however, have survived. The reasons may relate to custom or have practical purposes, for the Maya believe that outdoors the head should be covered. A sombrero is often worn on top of the headcloth, which absorbs the body sweat. As for the belt, a hand-woven one is probably cheaper than a commercially produced one. In Nahualá there is a continuity with styles worn in 1902. Workshops produce for sale headcloths like the Eisen example. The double-headed eagle image is brocaded with silk or cotton. These textiles are vigorously marketed abroad. A weaver in Nahualá told me that they are also worn for ceremonial purposes, since the men there still wear typical clothing. The men of Chichicastenango wear headcloths with Western-style clothing. A variety of styles are produced for the town and also for sale at the regional market.[16] Older styles have been revived, and some iconographic imagery, like the double-headed eagle, has become abstracted over time (Schevill 1985).

WOMEN'S HEADCLOTHS

1902

Although women also cover their heads outside their residences, the collection contains only one example (3-35) of a woman's headcloth that Eisen identifies as a shawl or *xute* (*tzute*). It is from Chichicastenango, and it was part of a complete woman's costume.[17] Women's headcloths do not have tassels. The weaver enjoys considerable artistic freedom in creating these textiles, while other elements of dress may conform more closely to the community's accepted styles. The headcloths may be of simple stripes or brocaded images, such as the double-headed eagle or a multilegged animal in this example, rendered on the backstrap loom in an imaginative fashion. Other cloths discussed under the category of multipurpose cloths may also have served as headcloths.

1980s

Headcloths continue to be an important part of women's dress. They are available in backstrap-loomed and treadle-loomed cloth and in a variety of colors and motifs. The shape—usually two rectangular pieces of cloth sewn together—has persisted, while town-specific iconographic images change over time. Headcloths are practical and serviceable in a society where paper and plastic goods are quite

expensive. These cloths are not particularly popular with tourists since, for the most part, they are not elaborately brocaded as are *huipiles* or belts. Weavers of headcloths and multipurpose cloths have not responded to the pressures of foreign tastes. They continue to create aesthetically pleasing cloths. Some styles resemble those in the Eisen collection, while others represent new and innovative design possibilities.

HUIPILES

The *huipil*[18] is the most personal, communicative, and significant part of a woman's dress. Thirty-six examples from thirteen towns in the northwestern highlands are represented in the collection. I will, therefore, briefly describe the shape, technique, neck treatment, color, materials, and iconography. In the 1980s section, I will compare these features in the older and contemporary garments. Ten *huipiles* were purchased in Totonicapán; nine in San Martín Jilotepeque, three of which are for girls; four in Quezaltenango; two each in Chichicastenango, Mixco, and Aguacatán; and one each in San Cristóbal Totonicapán, San Lucas Tolimán, Todos Santos Cuchumatán, Rabinal, San Juan Sacatepéquez (Guatemala), Nahualá, and Patzún (Figure 106).

1902

Of the ten Totonicapán *huipiles*, six have already been discussed in relation to the fashion impulse (Chapter 1). Four *huipiles* (3-37, 3-59, 3-65, 3-66) relate to the San Martín Jilotepeque style, popular in Totonicapán and elsewhere. Two other examples (3-42, 3-48) were woven for *cofradía* wear in faraway Santa Lucia Utatlán. The other four examples are of two pieces of treadle-loomed cloth, probably produced by men weavers. Three *huipiles* (3-22, 3-49, 3-60) are similar in design layout and motifs. Solid-colored horizontal bands of red or green alternate with bands of geometric designs. Head holes are cut out, and each one has a different neck treatment. The remaining example (3-147) relates to one of the Quezaltenango *huipiles* (3-43) and may have been woven for use in that town. It is without design motifs and is woven with twill weft-faced bands of red and yellow silk and cotton.

The six women's *huipiles* from San Martín Jilotepeque (3-46, 3-240, 3-243–3-245, 3-249) are backstrap-loomed and share similar design layouts, materials, techniques, and colors (Figure 104).

Three examples of the San Martín Jilotepeque girls' *huipiles* (3-144, 3-246, 3-247; Figure 95) are of one piece of backstrap-loomed cloth. Each one has a broad horizontal band across the chest although the motifs and colors vary. As with the women's style, small dots of single-faced supplementary weft brocading are situated on the surface of the garment. Four rows of red wefts are part of the loom-finished selvedges. This style can be compared with that of another San Martín Jilotepeque girl's *huipil* that was collected before 1883 and is

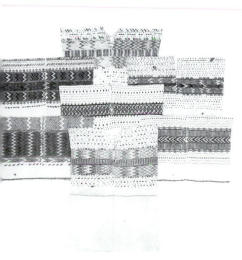

ure 104.
men's *huipiles*, woven in San Martín
tepeque, Chimaltenango; one *huipil* (3-64)
pted for use in Quezaltenango, Quezaltenango.

in the Smithsonian National Museum of Natural History collections, 72943 (Figure 105). It is somewhat smaller in size than the Eisen examples. Of particular interest are the single-faced supplementary weft–brocaded geometric motifs, a decorative band across the chest, and colored wefts on the bottom. These features also appear in the Eisen textiles. The individual motifs in the Eisen examples, however, are much smaller and resemble dots. They are evenly placed all over the *huipil.* In all examples, zigzag designs occupy the central bands, and the color palette is basically the same. The backgrounds are white.

This comparison with a textile woven a few years earlier supports the notion of continuity in highland Maya textile design and layout. The central band of the Smithsonian textile relates in design to a particular Eisen example, 3-247, and is similar to a *huipil* collected in 1901 by George Byron Gordon in the Peabody Museum, Harvard University, 01-40-20/c-3013. The Peabody example may have come from the same weaving center where Eisen purchased his examples.

Three of the four *huipiles* acquired in Quezaltenango are treadle-loomed.[19] Two examples (3-53, 3-69) are similar in design layout, neck treatment, and embroidered silk *randas* that join the two rectangular pieces of cloth. The motifs are also similar but the colors are different. These *huipiles* may have been intended for the *cofradía.* The *huipil* (3-43) that resembles the Totonicapán example (3-147) was the everyday style available in yardage lengths in many highland markets (O'Neale 1945:293). It differs from the Totonicapán example in that *jaspe* yarns are combined with solid-colored ones to create weft stripes. The *randa* and neck decorations are of red and yellow silk floss. The backstrap-loomed *huipil* (3-64) was probably woven in San Martín Jilotepeque. The owner added treadle-loomed cloth to the bottom in order to conform to the accepted Quezaltenango fashion (Figure 104).

The Chichicastenango *huipiles* are of three pieces of backstrap-loomed cloth. One (3-17) is white, and the other (3-145) is woven with *ixcaco* and a few white cotton weft stripes. Two-faced supplementary weft brocading richly decorates the upper central panel and the shoulder areas. A stylized double-headed eagle is rendered in red and yellow cotton and silk floss. Two black taffeta medallions appear on the shoulders. The head hole is cut out and decorated with black taffeta points. The two Mixco examples (3-239, 3-242) are of two treadle-loomed pieces of cloth. The supplementary weft brocading is two-faced. One example has wide bands of zigzag and geometric designs, and the other includes a variety of small geometric and animal and bird designs. The predominant coloring of the cotton designs is lavender and dark blue. The head holes have not been cut out. In contrast to the hand-loomed *huipiles*, those of Aguacatán (3-199, 3-202) are of two pieces of treadle-loomed *manta* and machine-stitched. The head holes are decorated with red cotton embroidery. The bottom of one example (3-199) is finished with pointed selvedges. There is also one small girl's *huipil* (3-200) of similar construction and materials in the collection.

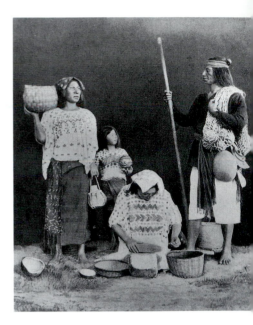

Figure 105.
Family group of Maya-K'iche' [Achí]. Smithsonia
exhibit photograph. 1901.

The Patzún example (3-241) is of two pieces of backstrap-loomed, predominantly red-and-white-striped cloth. The head hole is cut out and embroidered with silk floss of various colors, and silk taffeta medallions are placed below the embroidered areas on the center front and back. The *huipil* from San Lucas Tolimán (3-151) is of two pieces of backstrap-loomed cloth with single-faced supplementary weft brocading. The prominent solid red band across the chest is a significant design feature. Multicolored geometric designs are sparingly placed on the entire garment. The head hole is cut out and decorated with a magenta silk taffeta neck piece. Medallions of the same material are on the front and back below the neck piece. The Nahualá example is of two pieces of backstrap-loomed cloth with two-faced supplementary weft–brocaded areas across the upper chest and back centers and shoulder areas. The rest of the garment, including the neck opening, is unadorned. Geometric designs and bird motifs appear in red and yellow cotton.

The Todos Santos Cuchumatán example (3-115) is of three pieces of predominantly red-and-white-striped backstrap-loomed cloth. Single-faced supplementary weft–brocaded horizontal blocks of red adorn the upper chest area. Red horizontal bands create a plaid effect. The head hole is cut out and decorated with a collar of commercial cloth and silk ribbon. Four silk taffeta magenta medallions appear on the front and back below the collar and on the shoulders. Comparing this textile with an example collected in 1899 in the Smithsonian National Museum of Natural History collections, 201089, one notes the addition in the Eisen garment of horizontal red bands and small geometric figures to the central design areas. Otherwise the design layout, shape, and colors are similar.

Elaborate embroidery of multicolored silk floss and cotton creates a collar of floral and geometeric designs on the *huipil* from San Cristóbal Totonicapán (3-44), which is made of two pieces of thick white treadle-loomed commercial cloth. The backstrap-loomed *huipil* from San Juan Sacatepéquez, Guatemala (3-141), is also of two pieces. Bands of two-faced supplementary weft–brocaded, predominantly red and purple geometric forms on the shoulders, with large and small bird and animal forms elsewhere, decorate the garment. Red wefts appear in the bottom selvedges. The head hole is cut out and ornamented with silk and cotton overcast stitches. Another *huipil* (3-130) was purchased in Rabinal. It is of three pieces of backstrap-loomed cloth with large and small two-faced supplementary weft–brocaded motifs in red, yellow, green, and blue-green. The head hole is cut out and hemmed (Figure 105).

1980s

Huipiles continue to be worn throughout the highlands. Research in museum collections has revealed the subtle and sometimes dramatic changes that have occurred in each decade relating to shape, technique of production, neck treatment, colors and materials employed, and iconography of *huipiles* from each provenance. The most obvious changes in *huipil* style and manufac-

TOWN	Shape	Technique	Neck Treatment	Color	Materials	Iconography
Totonicapán (10)	T	C, treadle D, backstrap	T	T	C, T	T
San Martín Jilotepeque (9)	C	C	T	T	C	C+
Quezaltenango (3)	T	C	T	T	C	C+, T
Chichicastenango (2)	C	C, T	C	C+	C+, C	C, T
Mixco (2)	D	D	D	D	D	D
Aguacatán (2)	C	C	C, T	C	C, T	C+
Patzún (1)	C	C	C	C+	C, D	C+
San Lucas Tolimán (1)	T	C	T	T	C	C, T
Nahualá (1)	C	C	C	C+	C+	C+
Todos Santos Cuchumatán (1)	C	C	C	C+	C+	C+
San Cristóbal Totonicapán (1)	T	T	C	T	C+	T
San Juan Sacatepéquez (1)	C	C	C	T	C+	C+
Rabinal (1)	NA	NA	NA	NA	NA	NA

C = continuity
C+ = additional colors
 materials,
 enlarged images
D = discontinuity
T = transformation
NA = not applicable

Figure 106.
Continuity, discontinuity, and transformation in *huipil* styles: 1980s.

ture have occurred in Totonicapán and Quezaltenango, where the trend over the last twenty years has been toward a regional style and away from town-specific styles (Figure 106). The dimensions of the garments have changed, giving way to shorter, narrower *huipiles* that are tucked into skirts. More of the body shape is revealed by narrow belts, tightly wrapped around the waist, and by tucks and pleats in the *huipil*. Some of the older, larger garments in the Eisen collection may have been *sobre huipiles* or overblouses reserved for ceremonial use. In most cases, the design layout has moved from a simpler, less brocaded garment to a more densely decorated one. Ornamental silk taffeta medallions are now reserved for ceremonial or *cofradía* garments.

In Totonicapán, the regional style is a single width of draw-loomed cloth, woven by men and some women in factories.[20] A square head hole is cut out and decorated with an embroidered neckband. A variety of styles of cloth and neckbands are available in the markets. Tucks are taken in the shoulder area for fit. The designs are of multicolored two-faced supplementary weft brocade, and there are no longer weft bands of contrasting designs. The individual styles represented in the Eisen collection are no longer created and have been transformed into the currently popular style.

The San Martín Jilotepeque weavers continue to work on the backstrap loom and create *huipiles* of two pieces with single-faced supplementary weft–brocaded geometric designs. The neck and sleeves now are embroidered or decorated with separate embroidered neck pieces. The color palette has radically changed: the background

is no longer white but predominantly dark blue, and designs are woven with silk and cotton, depending upon use, in purples, pinks, and other colors. The *huipil* is now covered with weft bands of designs, so that the background is not visible—a transformation. Weavers continue to place colored wefts in the bottom, loom-finished selvedges.

The Quezaltenango *huipiles* are now woven on draw looms in Totonicapán by men and women production weavers. The current style requires three widths; two-faced supplementary weft brocading and embroidered floral designs create a colorful *huipil* that has a regional connotation. Head holes are square and decorated with embroidered neck pieces as in Totonicapán. A continuity with the earlier styles (3-43) is noted by the use of weft *ikat* bands combined with patterned ones. The iconography of two of the Eisen examples (3-53, 3-69) continues to be woven into *cofradía* napkins and towels.

The Chichicastenango style continues to require three pieces of backstrap-loomed cloth. Weavers have added an extra shed stick for two-faced supplementary weft brocading to facilitate and speed up the labor-intensive pickup technique that created diagonal alignment. Vertical ridges in the design areas are now visible. The head hole is cut out and decorated with cloth neck pieces; the black silk taffeta medallions appear on the *huipiles de cofradía*, which resemble the Eisen examples. Medallions no longer appear on the everyday styles. *Ixcaco* is scarce and costly, so weavers now dye white cotton brown. Other background colors are popular too. A dramatic transformation has taken place. The current style features floral designs taken from cross-stitch pattern books and large zigzag designs in brightly colored synthetic and cotton yarns, which now cover most of the *huipil*.

The use of *traje*, including *huipiles*, has ceased in Mixco, which is now predominantly *ladino*.

Town-specific styles continue in some locations. The Aguacatán style resembles the earlier one but is more ornate in surface decoration. The *huipil* is made of commercial cloth with embroidered designs. Collars have been added, and rickrack and other commercial trims decorate the surface. The Patzún ceremonial style is easily recognizable and does relate to the earlier example. It consists of two pieces of backstrap-loomed cloth in red and multicolored vertical stripes. The neck and upper area are decorated with machine and hand embroidery in large floral designs. Decorative medallions are no longer the fashion.

The San Lucas Tolimán style is a single piece of backstrap-loomed cloth, and the garment is much shorter than the earlier style. A variety of background colors are acceptable. The neck is finished with a simple velvet or other commercial cloth trim. Single-faced supplementary weft–brocaded zigzag bands continue to decorate the chest area. This feature represents a continuity with the Eisen example. The entire surface is covered with small animal and geometric forms. As a whole, however, the current style bears little resemblance to the style popular in 1902.

In contrast, one of the contemporary Nahualá *huipil* styles resembles the earlier style. Two pieces of backstrap-loomed cloth

are required. The neck opening is unadorned, and two-faced supplementary weft–brocaded designs in geometric and animal and bird forms are placed on the upper chest and back and shoulder areas. A few more colors have been added to the basic red and yellow previously in use. In addition to cotton, silk in red, orange, and magenta are preferred, even though the color is not dye-fast and, when washed, leaves a colored stain on the white background. The size of the woven motifs has enlarged. Several other styles are woven and worn in Nahualá.

Another continuity is represented by the Todos Santos Cuchumatán *huipil*, which could be associated readily with the Eisen example. Three pieces of backstrap-loomed cloth of red, white, and multicolored stripes create a large, unfitted garment. The head hole is cut out and decorated with a collar and other trims, including rickrack. Single-faced supplementary weft–brocaded blocks of color and zigzag and other geometric forms of wool and synthetic yarns are placed in the upper chest and back areas.

The San Cristóbal Totonicapán *huipil* has been transformed from a town-specific example into a regional style, and is worn throughout the highlands. Made of one piece of commercial cloth in a wide range of colors, the garment is smaller than those made previously. The neck openings are round or square, and, for a time, collars were fashionable. Now the necks are hand- or machine-embroidered directly onto the cloth in large, colorful floral designs in a variety of stitches.

The San Juan Sacatepéquez, Guatemala, *huipil* style is far removed from the Eisen example, with the exception of the neck treatment. The head hole is enlarged and embroidered. Although several different styles are worn, none has a solid white background. Two pieces of backstrap-loomed cloth in multicolored stripes are decorated with large four-legged animals and geometric designs in two-faced supplementary weft brocading.

The *huipil* purchased in Rabinal is totally different from the contemporary town-specific style. In 1902, however, this style may have been worn in Rabinal. *Huipiles* similar to the Eisen example are still woven and worn by old women in Tucuru, Alta Verapaz, and represent yet another continuity with the past.

JACKETS

1902

There are four men's jackets or overshirts, called *cotones* or *chaquetas*, in the collection. Two are from Chichicastenango (3-11, 3-154). Eisen called one of them a jacket and the other a man's overshirt. Both garments are parts of complete men's costumes. One example (3-154) is well worn while the other jacket (3-11) appears to be a new, unused textile. Three pieces of treadle-loomed natural black wool in a twill weave are sewn together by a professional tailor.[21] The

owner of the garment embroiders sun motifs and other designs in orange and magenta silk floss on the front and sleeves. The neck edge also is embroidered, and dark blue silk taffeta medallions are sewn onto the center fronts. The standing collar is of dark blue wool. The older example (3-154) has a pocket on the inside of the front. There are plied silk and cut wool warp fringes on the back bottom selvedges.

Another garment (3-8) is part of the *martoom cofradía* costume of Totonicapán. It is more elaborately tailored than the Chichicastenango jackets. Made of seven pieces of commercial twill-woven black wool cloth, this example has a back collar, lapels, and two pockets in the front. The garment is lined with commercial cotton cloth. Metal ornaments of waxed copper alloy in a silver wash are hand-sewn to the back and front of the garment.

The men of Todos Santos Cuchumatán wear a short overshirt called *chaqueta* (3-118) of black treadle-loomed twill wool over their shirt. Three pieces are hand-stitched together. A rectangular head hole is cut out and hemmed.

1980s

Although the elaborate men's costumes of the Totonicapán *martooms* are no longer in use, older men in Chichicastenango continue to wear *traje* for *cofradía.* Some even wear it on a daily basis. Waiters in two prominent hotels also wear *traje.* The jacket resembles the Eisen examples with the addition of large flowers in satin and chain stitch in bright pinks, reds, and oranges, along with stylized sun motifs. Other embroidered motifs of dark blue yarn are placed on the cuffs and bottom of the jacket, which has a front opening secured with two embroidered clasps. The Todos Santos–style overshirt has been replaced with an open-front jacket, sometimes in denim, or a longer, older-style *kapishay.*

LOOMS

1902

Eisen was interested in the process of cloth production as well as in the finished textiles. He purchased five backstrap looms with weaving in process to document some special techniques. Three looms contain partially completed belts of which there are completed examples in the collection. One has a skirt in process, and the other has cloth for a child's dress.[22] All loom parts are included, although, over time, some of the shed sticks have become disengaged from the cotton heddles. The town of Huehuetenango, like Totonicapán, was a belt-weaving center. On looms two partially woven, vertically striped, and multicolored cotton belts are in process (3-171, 3-288; Figure 107). The wefts are maguey. The third backstrap belt loom (3-278; Figure 107) has special interest. The techniques are sprang, which is hand-manipulated plaiting, and plain weave in vertical multicolored cotton stripes.

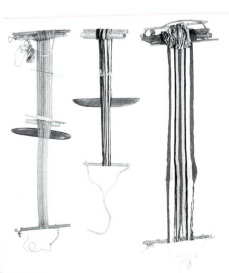

Figure 107.
Looms, Huehuetenango.

A piece of cloth in the town-specific pattern of Todos Santos Cuchumatán is on another loom (3-128; Figure 108). The warps are stiff because the weaver sized them with *atole* or corn water. A woman's skirt in dark blue cotton is in process on a loom from Aguacatán (3-292; Figure 108).[23] These warps also are stiff, and there are white specks on the cloth from the *atole*.

To further document backstrap weaving, Eisen acquired a backstrap (3-261) in San Miguel Ixtahuacán. Made of *pita* cording, it is woven and plaited.

1980s

Backstrap weaving continues to be the main mode of textile production for most women and some men. The process persists in spite of its labor-intensive nature. New materials and decorative techniques are available to the weavers. The looms, however, still are made of bamboo and wood. Backstraps of *pita* cording, like the Eisen example, can be purchased in most highland markets.

Figure 108.
Looms, Todos Santos Cuchumatán, Aguacatán, Huehuetenango.

MULTIPURPOSE CLOTHS

1902

There are several groups of women's multipurpose cloths that consist of rectangular textiles of various sizes, which are identified as *toallas* (towels), *servilletas* (napkins), or *delantales* (aprons, discussed above). All these textiles are made of one piece of cloth. Six examples (3-23A, 3-184, 3-186, 3-188, 3-134, 3-237) were purchased in Huehuetenango. Five of these are pictured in Figure 109. They are treadle-loomed in plain and twill weaves with two-faced supplementary weft–brocaded bands in white and multicolored cotton yarns. The loom-controlled patterning creates a checkerboard effect in combination with solid-colored horizontal bands. All cloths have cut-warp fringed selvedges. One example (3-184) has *jaspe* weft yarns that are tie-dyed to indicate the name Martín Vasquez, who may well be the weaver. Another cloth (3-194) resembles those from Huehuetenango in most features. It is, however, probably town-specific since the supplementary weft yarn is not multicolored but predominantly dark blue.

Two examples from San Lucas Tolimán (3-152, 3-153) are identified as a baby towel and a woman's garment. Both cloths are backstrap-loomed single pieces of cloth. One of them (3-152) has thin warp stripes of predominantly red-and-white cotton. The other textile (3-153) has a red background with multicolored warp stripes and single-faced supplementary weft–brocaded small geometric forms. Three other towns are represented by one backstrap-loomed cloth each. The Aguacatán, Huehuetenango, example (3-216) has multicolored, white, and *ixcaco* cotton, while the cloth from Atitlán de la Laguna (Santiago Atitlán) has red-and-white vertical stripes. Eisen collected another example (3-135) in Huehuetenango, which is

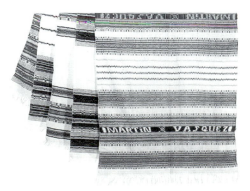

Figure 109.
Multipurpose cloths, Huehuetenango.

unlike the group discussed above and relates to five shawls and apron cloths from Totonicapán (3-24, 3-26–3-28, 3-32). The weft stripes of white, dark blue, and *ixcaco* cotton are in plain and twill weaves. A treadle-loomed cloth was acquired in Momostenango; the weft bands of dark blue and white float on a brown background of dyed cotton.

1980s

Weavers continue to produce a variety of multipurpose cloths for home use. The contemporary styles are varied and change every few years. New styles from towns represented in the collection are unrelated in color and motifs. White multipurpose treadle-loomed cloths, however, similar in design layout and colors to the Huehuetenango group but larger in size continue to be woven in that town and in Totonicapán. These cloths are available throughout the highlands.

PANTS AND OVERPANTS

1902

Two pairs of men's pants or *pantalones* (3-10, 3-150) were acquired in Chichicastenango and were tailored by professionals. Part of a complete men's dress, the pants are knee-length. One example (3-150) may be older than the other pair (3-10), which seems unused. The construction and materials are similar: eight pieces of treadle-loomed black cloth in twill weave are hand-sewn together. Unusual features include two flaps at the sides adjacent to the pockets, and the sun and floral embroidered motifs on the flaps. Men embroidered these garments in multicolored silk floss.

Single examples from two towns in Huehuetenango—Todos Santos Cuchumatán (3-116) and Soloma (3-197)—are also cut-and-sewn garments and are parts of complete men's dress. They are not as elaborately tailored as the Chichicastenango examples. The Todos Santos example is made of eight pieces of backstrap-loomed cloth with warp and weft stripes in red cotton. An example collected in 1899 in the Smithsonian National Museum of Natural History collections, 201087, is quite similar except that single-faced supplementary weft–brocaded motifs are placed in different areas of the pants. The Soloma example is made of five pieces of treadle-loomed white *manta* hand-sewn together. The style is generic and is worn by men throughout Guatemala.

Overpants or *sobre pantalones* were worn over plain white pants, similar to the Soloma example, in various highland towns including Todos Santos Cuchumatán, where the Eisen example (3-117) originated. Nine pieces of treadle-loomed dark brown wool in a twill weave are hand-stitched by a tailor. The front of the pants is split in a style of Spanish origin that resembles leather chaps worn by horsemen. Small pockets are placed behind the front flaps. Simple embroidered slits are of maguey yarn, and the two halves are joined in the front with bone buttons.

Three elegant overpants (3-6, 3-7, 3-9) are part of the *martoom* costume from Totonicapán. One well-worn example (3-9) is made of green silk velvet, probably imported. Eight pieces are machine-stitched, and the garment is lined with commercial cotton and red wool. There is no collection information about the manufacture of these overpants, which are embroidered on the front and back with floral motifs in multicolored spun silk. Other ornamental features indicate that this garment may have originated in Europe and was the prototype for the other two examples (3-7, 3-6), which resemble each other. The overpants are made of commercial black wool cloth; seven and nine pieces of cloth, respectively, are machine-stitched and lavishly hand-embroidered with multicolored spun silk. The garments are lined with commercial cloth, and both the fronts and backs are decorated. In addition to the embroidered floral motifs, copper alloy ornamental balls in a silver wash ornament the vertical pant openings.

1980s

As with the Chichicastenango jackets, the pants continue to be manufactured. Men still embroider floral and sun motifs on the flaps, although colors are brighter and motifs more elaborate than formerly. The contemporary Todos Santos pants resemble those in the Eisen collection but, contrary to the trend of designs moving from simple to complex, the pants are no longer plaid but have vertical red-and-white stripes without brocaded motifs. White pants, similar to the Soloma pair, and others that are more tailored are still worn in many parts of the highlands.

Overpants are part of the men's dress in Todos Santos, but the length varies from short to full length. The Totonicapán *cofradía* overpants are no longer available.

SADDLE BAGS

1902

There are two backstrap-loomed saddle bags or *alforjas*, both from the department of San Marcos, used for mule cartage (Figure 110). The Malacatán example (3-212) is one long multicolored cotton piece that is folded into two bags with the center plaited in sprang technique. The other saddle bag from Tutuapa (3-264), which Eisen calls a double *matate*, is longer and of hand-plied maguey. The warp yarns are braided to form the center section between the two bags. Some of the warp yarns are painted with a tan and copper-colored substance.

1980s

Mule saddle bags of *pita* cording are still produced. Techniques vary, and there are a variety of styles available.

Figure 110.
Saddle bags, Malacatán, Tutuapa, San Marcos.

RAINCOATS

1902

In the travel articles about his journey in 1882, Eisen noted the ingenious way men protected themselves from the rain. He acquired four raincoats or *soyacales* from Huehuetenango (3-126, 3-127, 3-289, 3-290), and he photographed men wearing them. Strips of bulrushes are arranged in a semicircle and hand-stitched together with two-ply *pita* fiber. Because of the fragility of these garments, only one example (3-126) was analyzed. It is described in the catalogue section.

1980s

When plastic bags and sheets became available in the highlands, the bulrush raincoats disappeared. Men use plastic bags or tarps for protection during the frequent downpours.

SERAPES, OVERGARMENTS

1902

Of the nine serapes or *sarapes* and overgarments in the collection, four examples, (3-1–3-4), worn by the *martooms* of the Totonicapán *cofradía*, are treadle-loomed in plain weft-faced and dovetailed tapestry weaves. Two pieces of cloth are sewn together. The bright multicolored geometric designs in wool on a cotton warp create a dazzling effect. Two serapes (3-3, 3-4) have neck slits trimmed with imported silk ribbon. The other two garments (3-1, 3-2) are worn like blankets over the shoulders.

Two examples, one from Aguacatán (3-214) and the other from Nebaj (3-213), are made of two pieces of backstrap-loomed cloth with warp stripes. Both of them are listed as *sarapes*, but they are not worn over the head like ponchos. The Aguacatán textile is designated as a woman's wrap, and it has dark blue, white, and multicolored warp stripes. The Nebaj *sarape* is a man's wrap with only dark blue and white stripes. At first impression, these garments appear similar, and it may be that Eisen purchased an Aguacatán-style serape in Nebaj.

An important part of men's dress was a cut-and-sewn overgarment or cloak of black treadle-loomed wool. Eisen catalogued them as *kapishays* or *capotes*. Three overgarments acquired in Sololá (3-14) and Soloma (3-112, 3-113) are part of the collection. They are similar in some features: all are of three pieces of cloth and have a warp fringe on the bottom of the back of the garment. The underarm seams are not sewn. They differ in the shape of the neck. The Sololá cloak has a rounded neck while the Soloma overshirts have V-necks.

1980s

The Totonicapán serapes were old at the time of purchase, and Eisen was told that they were no longer being produced.[24] Variations

of the Aguacatán-style warp-striped wrap in dark blue, white, and yellow continue to be woven. Men in San Martín Sacatepéquez (Chile Verde) and San Juan Atitán still wear *kapishays* over their *traje*. *Kapishays* continue to be worn in other highland towns.

SHIRTS

1902

Two men's shirts or *camisas* were acquired in Huehuetenango: one from Soloma (3-195) and the other from Todos Santos Cuchumatán (3-114). Both examples are part of complete costumes and are cut-and-sewn garments. The Soloma shirt contains fourteen pieces of treadle-loomed *manta* hand-sewn together. The collar, cuffs, set-in sleeves, and placket opening are carefully tailored. The body and sleeves of the Todos Santos example are of treadle-loomed *manta*, while the collar and cuffs are backstrap-loomed in plain and twill weaves. Warp and weft bands of red, white, and other colored cotton yarns create a plaid effect. The collar and cuffs are two-sided so that when one side wears out, it can be turned around.

1980s

Modified versions of both of these shirts are still worn. Some white shirts are made by professional tailors, and ready-made, factory-produced shirts also are available. For Todos Santos, the shirt has multicolored warp stripes at the center. The collar and cuffs are still two-sided and much larger than in the Eisen example. They are densely brocaded with multicolored cotton and wool.

SHAWLS

1902

There are eleven shawls, called *perrajes* or *rebozos*, from four departments. Like multipurpose cloths, shawls are an important element of both Indian and *ladino* women's dress. The largest group of six garments was acquired in Totonicapán. All the shawls but one are made of a single piece of cloth. Two examples (3-24, 3-26) are similar to the aprons and multipurpose cloths discussed above (3-27, 3-28, 3-32) and are backstrap-loomed with plain and weft-faced twill bands of multicolored, white, and *ixcaco* yarn. Two other shawls (3-30B, 3-63) are woven in *serapado* style on a treadle loom with plain and twill weft-faced bands of multicolored, white, and *jaspe* yarns. They are similar to a large bed covering (3-30A). One other treadle-loomed *perraje* (3-40) has plain and twill weft bands. An unusual feature, which gives the cloth a shimmering look, is two-faced multicolored supplementary weft brocading in silk floss. *Jaspe* cotton yarn has been tied and dyed to create the words "canta paloma" in the

woven cloth. Another shawl purchased in Totonicapán (3-31) contrasts with those already discussed. Two pieces of backstrap-loomed, predominantly red cotton cloth with warp stripes are joined with a decorative silk *randa*. This shawl seems similar to styles worn in Chichicastenango and may have originated there.

A treadle-loomed shawl from Quezaltenango (3-50) contains plain and twill bands with multicolored silk floss supplementary weft brocading. Silk yarns also appear in the weft. There is an apron (3-57) of similar cloth and possibly of the same web. The other example from Quezaltenango was backstrap-loomed in Almolonga (3-16) and has town-specific colors and motifs. This textile was intended for ceremonial or *cofradía* wear. Two pieces of red, white, and blue warp-striped cotton are sewn together. Small single-faced supplementary weft–brocaded geometric motifs of cotton and silk floss ornament the entire garment.

Another example (3-253) was acquired in Santa Barbara, Huehuetenango. It is a piece of backstrap-loomed wool cloth with white and brown stripes. Another shawl, which Eisen called a *rebozo* or *mantilla*, terms more common in Mexico (3-201), is made of treadle-loomed, predominantly red cloth with a long macramé fringe. There is a similar shawl (3-218), also called a *rebozo*, that Eisen acquired in Comitancillo, San Marcos. These two shawls may have been woven in Mexico and brought into Guatemala by traders (Figure 111).

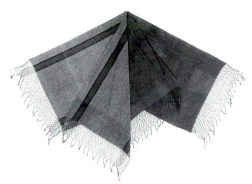

Figure 111.
Shawls, Huehuetenango, Huehuetenango; Comitancillo, San Marcos.

1980s

Shawls continue to be worn by both indigenous and *ladina* women. The Totonicapán and Quezaltenango styles discussed above have been replaced with treadle- and backstrap-loomed *jaspe* shawls. The current style in both towns had solid-colored bands of cotton and silk that alternate with indigo *jaspe* cotton stripes. One seldom sees words or names in *jaspe* as in the Eisen examples. The warp ends are knotted to form a decorative fringe.

The town-specific *cofradía* shawl woven in Almolonga shares the shape and dimensions of the Eisen example. Large, multicolored, single-faced supplementary weft–brocaded geometric forms, however, completely cover the background cloth, which is no longer striped but solid red. Only a long fringe of warps is visible. *Rebozo*-style shawls in several varieties are still produced and worn in the highlands.

SKIRTS

1902

There are only four skirts or *enaguas* in the collection. In this time period, the most popular style was of treadle-loomed, indigo-dyed cotton woven in both solid and plaid patterns. In some areas indigo warp and weft *jaspe* was the new style. Eisen did not collect the indigo skirts. Perhaps they did not appeal to his aesthetic tastes.[25]

Two examples were acquired in the town of Quezaltenango, where women wore a pleated style rather than the more common wraparound version. These skirts, however, are large pieces of cloth and are not pleated. One treadle-loomed garment (3-51) is made of red warps and bands of multicolored and *jaspe* wefts, while the other example (3-138) is made of two pieces of backstrap-loomed cloth. Warps and wefts of white, *ixcaco*, dark blue, red, and yellow create a plaid effect.

The two remaining skirts are similar although each was purchased in a different town. One example (3-187) is part of a woman's costume from Soloma. Five pieces of treadle-loomed cloth are joined to make a tube shape. Predominantly of red cotton, the skirt has narrow weft bands of yellow and *jaspe* yarns. A very similar skirt (3-219), purchased in the town of Huehuetenango, appears unused. This skirt yardage, woven in Salcajá, Quezaltenango, was popular in other highland towns.

1980s

Treadle-loomed skirt yardage comes mostly from Totonicapán. Warp and weft *ikats* in bright colors are popular, and there are a variety of combinations available. In Momostenango, cloths similar to the brown and dark blue plaid skirt purchased in Quezaltenango were transformed from skirts to shoulder warps and ponchos for women and men and, more recently, to burial sheets. Red yardage similar to that in the skirts from Huehuetenango is worn as a skirt in Nebaj but is no longer worn in Soloma and in the other towns where these skirts once were the fashion.

SPINDLES

1902

Eisen acquired six spindles or thread holders called *malacates*, all from Huehuetenango (Figure 112). Three examples from the town of Huehuetenango (3-172—3-174) and one from Aguacatán (3-287) are long, slender pieces of wood with a ceramic bead functioning as a whorl. These objects were used for spinning cotton. To produce *pita* and wool fibers, wooden whorls were placed on the other spindles from Huehuetenango (3-175) and Aguacatán (3-281).

1980s

Hand-spinning of cotton and wool yarns has been discontinued in most parts of the highlands. Commercially spun yarns are easily available and relatively cheap. *Pita* cording, however, for nets, bags, and other utilitarian objects, is still hand-twisted or spun.

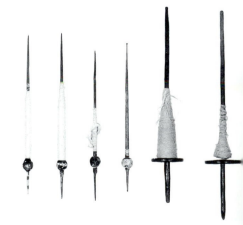

Figure 112.
Spindles, Aguacatán, Huehuetenango, Huehuetenango.

CONCLUSION

In summary, the dress worn by the Maya in the 1980s has not changed drastically in comparison to the textiles in the Eisen collection. Certain costume elements, such as the ceremonial dress of the *martooms*, have disappeared from use, and male *traje* is no longer worn in a number of towns. For textile types, as presented in Figure 80, continuities far outweigh discontinuities or transformations. Maya women continue to wear *traje*, although they may no longer actually produce it themselves. Old styles coexist with transformed ones. Certain garments, like sprang belts and bulrush raincoats, are no longer available. Headbands are a continuity and a transformation, for there is a special class of them made for sale to outsiders.

Huipiles (Figure 106), however, continue to change. In some communities, certain features survive while others have been transformed. Additional fibers and colors and some additional techniques have become available. Always eager for new materials, weavers have taken advantage of new design possibilities. For the most part, the shape of the *huipil* and the technique of construction have persisted. The shape and decoration of the neck opening and iconography have undergone change and transformation. Only in one community from which Eisen collected has the *huipil* ceased to be worn entirely.

As suggested at the beginning of this section, other published sources present the changes and transformations wrought over the past century within a community system. The Eisen collection serves as a baseline or point of reference for comparative research. It presents a synchronic view of the Maya textile tradition in 1902.

The "Cofradia" of the Indians of Guatemala

BY GUSTAV EISEN [*written in 1903*]*

NOTE FOR THE FIRST PAGE.
The writer spent some ten months in 1902 in Guatemala on a mission by Mrs Ph. A. Hearst in order to study some points of special interest pertaining to the indians of Guatemala. Many of the costumes shown in the illustrations are now deposited in the Ethnological Museum of the University of California.

One of the most interesting features of indian life in Guatemala pertains to religious ceremonies. The indians of Central America and Mexico are all held within the folds of the catholic church, and in ceremonies and exterior devotion are devout catholic worshipers. The traveller in Guatemala is struck not only with the great number of churches in the country, but also with the care with which they are kept. The most conspicuous object in every village is the parish church. It is always situated on the most elevated place and generally surrounded by an open space, the main part of which constitutes the market place or "plaza," the most important part in every spanish town. The labor that was once spent on these churches is remarkable, but more wonderful yet is the fact that they ever could have been built with no other labor than that of the native indians of the country. Compared with the beautiful architecture of the churches of the latin races of Europe, these of Guatemala are often humble, constructed of adobe instead of bricks and stone, and interiorly whitewashed instead of faced with marble, or covered with paintings. But they are nevertheless attractive and often handsome, well worthy of being perpetuated by photography and description. But there are no "Landmarks Clubs" in Guatemala and the state government has no department and no funds for the preservation of the religious monuments of the country. The churches, their maintenance and their preservation is left entirely with the padres and the indians. This refers principally to churches situated in the country the parishioners of which are nearly exclusively indians. Out of a population of one million and a quarter, the quarter only is of mixed latin race, while the million consists of almost purebred native indians, of the same races as occupied the country at the time of the spanish conquest.

The organisation of the indian church is most interesting and effective. In every village where there is a church—and there is one in almost every one of any size—the care of the church is given to a special fraternity, known as the "Cofradia" of the church. The traveller will have little difficulty in recognizing its members, especially in the more prosperous towns. My first acquaintance with the "Cofradia" was made in Totonicapan, one of the most ancient cities in Central America. The church in Totonicapan is dedicated to San Miguel but while the sanctity of the church is great and famous, the present appearance of the church is not prepossessing. The Cofradia of San Miguel is however the most famous one in Central

This is a reproduction of Eisen's typescript, with handwritten editing notations incorporated. Spelling and end punctuation have been changed in a few instances to avoid misunderstanding; capitalization is Eisen's.

America. When a few minutes after my arrival in Totonicapan I
passed the door of the church I was surprised to see half a dozen
indians in picturesque costumes lined up outside the entrance.
Though I had seen many beautiful indian costumes, I had not yet
encountered any which could approach those I now saw. The indians
were all very young men, some even as yet boys, all evidently
proud of their position and the attraction caused by their costume
[Figures 71, 72]. The latter consisted of a kind of knee breeches,
split open nearly to the hip along the exterior of each leg. These
pantaloons were of dark color in shades of green and brown, and very
tastefully, though loudly, embroidered with flowers, butterflies and
lines while along the edges hung numerous small silver bells. With
these pantaloons were worn jackets of the same material and of the
same gay ornamentation, and the edges were similarly lined with
silver bells. But the most interesting garment was a large zarape hung
over the shoulders, covering breast and back. Each zarape was
different as regards the pattern of its ornamentation. To properly
analise the ornamentation of these zarapes would require a book by
itself. In a general way they resembled those woven by the indians of
New Mexico and Arizona and used in their religious ceremonies, but
in detail they were vastly superior. With few exceptions they were
made of fine wool, a few were evidently of silk. In form the zarape
was rectagonal, in the shape of a shawl, with a slit in the center in
order to admit the head of the wearer. Around this opening was a
trapezoidal group of ornamentations forming an appropriate center
piece. At the edges of the zarape there ran a special ornamental
border, which was different for the long and short side respectively.
Between the border and the centerpiece was seen an intricate network
of lines, in some instances reminding of the arabic ornamentation so
often seen in Spain. But while the line ornamentation was intricate
and beautiful, the color of the garment was even more so, as it was
not only gorgeous and highly attractive, but the various colors were
harmoniously matched with great skill and taste. During my stay in
that city I had opportunity to examine 16 different zarapes, each one
of which differed from the others in pattern and color. Later I learned
that all these zarapes had been made by members of one single family
and that the art had been transmitted from father to son since
generations. The old master weaver had lately died, and I was told he
had been an imbecile in regard to everything else than weaving.

I soon found that the proper time to study these indians and
their habits was early in the morning at about seven, at the time mass
was out, as they would then perform certain ceremonies which might
prove interesting to a stranger. So next morning early I was on hand
with my little hand camera just as the bells were tolling and the
devotees returned from mass. I had not to wait very long before my
companion called out: here they come. In the meantime I had been
informed that these indians all belonged to a special society known as
the "Cofradia de la Iglesia" and that the members were both men and
women. The women were called "capitanes" or captains. The men
consisted of two ranks. The higher members were known as "alcaldes"

while the lower ones were called "martooms." It was the martooms which had attracted my attention the day before; the capitanes and the alcaldes I now saw for the first time. As the last of the general worshipers departed from the church the "capitanes" suddenly made their appearance. They consisted of about eleven women of pure indian type, varying in age from 12 to 60 years [Figure 73]. Over the guipil and the nagua—the two garments corresponding to skirt and to waist—each capitan wore a pure white, but highly embroidered cloak, somewhat in the shape of a mantilla. Some of the capitanes wore besides white embroidered collars of the same nature as the mantilla and attached to it, but others wore only the mantilla. Each capitan held in her hand an enormous candle made of white wax, exteriorly twisted and otherwise ornamented with gold and the various colors of the rainbow. Outside of the church the capitanes arranged themselves in two rows and after simply bowing to each other, and mumbling some indistinct prayers they divided in two groups, which parting, returned home in different directions. I should have mentioned that the headdress of the capitanes consisted in a long and narrow silk band, woven in many bright colors, and at the ends ornamented with long silken tassels. The whole was twisted together with the hair forming a narrow kind of a turban. A few minutes later the balance of the cofradia came out of the side entrance of the church. The first ones to come were the alcaldes to the number of eleven. They were all middle aged men dressed in the general costume of the ladino—that is pantaloons, and short coats of modern cut. On their heads they wore panama hats, in their hands they carried the "escuras"[1] or religious staffs. The only characteristic garment consisted in an immense cloak thrown over the shoulders of each. These cloaks resembled in cut and pattern the so called spanish cloaks, with large collars and reaching almost to the ground. Most of these cloaks were made of blue or brown velvet, lined with velvet of different colors and pattern. The alcaldes arranged themselves in a single file outside the side entrance of the church. They were quickly followed by an equal number of martooms, all dressed in the same gorgeous costumes I had seen the day before. I have just stated that the alcaldes wore panama hats, but this was not strictly true, as when they first came out of the church they were all bareheaded except for a narrow, red band, worn around the forehead in the greco-roman style. The hats of the alcaldes were carried for them by the martooms, each one of which held in his left hand the hat of his superior alcalde. The alcaldes had arranged themselves in front of the church door, facing the church, and the martooms now placed themselves in a single row in front of the alcaldes. An interesting ceremony was now begun, consisting in deep and repeated bowing of the martooms, while the alcaldes mumbled some ceremonial prayers. At the end of the ceremony the martooms remained bowed down for probably five minutes, while each of the alcaldes in turn touched the forehead of each one of the martooms, who in turn reverently kissed the hands of the alcaldes. The ceremony ended by the handing over of the hats to the alcaldes, who in turn gave the escuras in charge of their respective

martooms. The alcaldes now divided in two groups, each group
preceded by its martooms started for their respective homes. The
whole ceremony was gone through with the greatest reverence, and
the ecstatic expression on the faces of the martooms was most
marked. The same ceremonies were performed every morning at the
same time, the only difference being that sometimes there were
present more martooms and more alcaldes than at other times. The
alcaldes seem to correspond in some respects to the elders in some
other denominations. They have charge of the welfare of the church,
and collect money for the maintenance of the church and padre. They
have charge of the church festivals and of the many processions and,
last but not least, of the saints. In some parishes the saints are not
kept in the church but in separate buildings. In some places the
majority of the saints were in a room or in a cottage together, while
the principal saint dwelled in a house of his own. Such for instance
was the case in Mixco, where the patron saint of the church had a
house all to himself. The house which was situated at some distance
from the church had been donated many years ago by some pious
devotee of more than ordinary means. The martooms though the
most gorgeously dressed are inferior in rank to the alcaldes, whose
servants they are. Their work is to keep the church in order, to
sweep the floor, to dust the saints and to see that their dresses are
presentable, to wait on the cura and to do menial work around the
church and parsonage.

The members of the cofradia are selected by the cura from a long
list of applications. The members are elected for one year, but may
remain longer. They must furnish their own costumes and food, and
they receive no pay. On the contrary they must pay for the fireworks
used daily in the ceremonies, and they must count upon to spend
each some five hundred dollars during their year of service, a large
sum which they work years to accumulate. But the honor of being a
member of the cofradia is considered very great. As soon as selected
the member is at once considered as among the very foremost in the
community, and in rank higher than anyone outside of the fraternity.
It is the greatest ambition of every indian to some time or other be
able to join the cofradia of the church. No one can however become a
member until he can convince the cura that he can command the
necessary money. One of the capitanes told me: for years we save the
money in order to buy the costume and then we work for years more
in order to get together the necessary coin to support us and the
church while our tenure lasts.

While the cofradia is at present an institution of the church,
it is almost certain that its origin dates back of the conquest. If
the cofradia had been a comparatively modern institution it seems
probable that it would have been similar in all the various churches
of the country. But such is not the case. For instance I found no
martooms in any other church than in that of Totonicapan. And what
was even stranger the curas in other parishes did not know of their
existence. There are also many other differences. In my opinion the
cofradia is simply the remnant of the ancient priesthood, who after

the introduction of the new religion by the spaniards, was made to serve the new church. I am led to this belief from the very curious ceremonies of the cofradia of the town of Chimaltenango, situated about a days travel on horseback from Guatemala, the capital. After one of the processions was finished I followed the cofradia to its home several blocks away. There had been some kind of a feast and the usual saints had been carried early in the morning through the streets and they were now carried back to their special house which was also the house of the cofradia. A block from this house the procession which by this time consisted of only indians, was met by a number of women and children who accompanied the saints to the entrance of the house. Here another lot of women stood ready expectantly with small baskets full of sugar beads. As the saints were halted outside the gates, the women scattered handfuls of the sugar beads among the crowd, and there became at once a general scramble both among men, women and boys to get hold of as many beads as possible. The women held out their aprons, while the men and boys held their hats high up in the air in order to catch the falling beads. At last the procession reforms and enters the yard surrounding the house. With many ceremonies and with much care the saints are taken from the "andas" or low tables upon which they had been carried, and returned indoors. After this followed the blessing of the women. The women had no dress to distinguish them from the other indian women, but apparently they belonged also to the cofradia. At a sign from the principal alcalde of the cofradia the women kneeled down in a long row on the ground. There were some ten in all. Behind the women stood their little children, some playing with their mother's hair, other[s] unconcernedly gazing on. In the meantime seven of the alcaldes arranged themselves in two rows in front of the women. Now the principal alcalde stepped forward and bending over one of the women touched her forehead with the escura, all the while mumbling some prayer. The same was proceeded with every woman, and the same ceremony was then repeated by each one of the seven alcaldes present. After the blessing ceremony was over, a kind of sacramental feast was begun. The many indian[s] present scattered themselves about the corridors of the buildings seating themselves on chairs or benches or simply squatting on the ground. Now the women brought dishes with soup and tortillas distributing them among the indians who had taken part in the procession. When all were eating the principal alcalde assisted by one or two more came out from the house of the saints, each one of them holding an "escura" in the left hand. With the escura the alcalde touched the forehead of each one of the indians, all the time mumbling some prayer. The meaning of the ceremony was not entirely clear and I found no one who could explain it. I asked the cura afterwards, but he simply shook his head, and said that it was probably "some old ceremony of no value." But he was certain that neither of the ceremonies which I had just witnessed had been inaugurated by the catholic church. But the most interesting ceremony was yet to be seen. After the feast was over, the members of the cofradia entered the house of the saints and began a

general dance. During the previous ceremonies I had remained standing outside as a silent spectator, but when I now pressed forward in order to look through the door, the chief alcalde beckoned to me to enter. I was assigned a seat on a bench and offered to partake of a glass of (not at all bad) comiteco. The room was small, perhaps ten feet wide by twenty feet long. The saints were placed along the short walls. On one of the walls there hung two portraits, one a lithograph of the Christ, the other a much smaller photograph. Probably in order to test my religious belief the alcalde pointed to the larger one and asked if I could tell what it represented. Upon hearing that I understood it to represent Christ he expressed his satisfaction and then pointing to the photo asked: but who is this. I told him I thought it looked like the president of the republic, but that I was not quite sure. At this he seemed much flattered and smilingly pointing to his chest, said: "it is I." Then the dance commenced in earnest. Each one of the indians danced by himself, now and then bowing before some one of the saints. The dance consisted in taking a few steps forwards and then a few steps backwards, alternately resting on each foot. Every few minutes cups of aguardiente [were] passed around, but the cups were small, and no great intoxication resulted.

The dance lasted several hours, possibly through the day. At last I asked permission to take their photos in order that one might be hung up adjoining the two illustrations already on the wall. The result is seen in the adjoining picture [Figure 1], where the chief alcalde is standing in the center of the group holding the "escura" or holy, ceremonial staff.

A few miles from Guatemala city there is a small town called Mixco, inhabited almost exclusively of indians. The Mixco women are known all over Guatemala on account of their robust nature, and there are few among the upper classes in Guatemala who [have] not had a Mixco nurse during babehood. The cofradia in Mixco is characteristic and very interesting. Twice a week the women members of the cofradia serve the church and the resident cura. At half past six in the morning they met at the convent, and when all had arrived proceeded to a spring some little distance from the village. The spring of "Panzalique" is famous for its pure and cool water. But situated deep down in a canyon it has to be brought to the village in crockery jars, carried by the fairer sex. So twice a week the women of the cofradia filled their jars in the limpid waters of Panzalique and then walked in procession to the cura's drinking pila [communal trough for washing clothes], and emptied them there. After the work was over the "capitanes" assembled in the hallway, or corridor of the convent in order to perform their usual departing ceremonies. First they marched outside the convent, and lined themselves up in two rows. Then one of them entered the door, and posting herself to the right, was reverently saluted by the next one to enter. The third one to enter had then to salute two, the fourth one to enter saluted three and so on. The salutation consisted in bowing deeply, and remaining bowed for several minutes until the one saluted had finished saying a certain number of prayers. The ceremony always

ended by the kissing of the hands by one another. The costume of these women was quite striking. The usual nagua formed the skirt, while the waist consisted of a richly embroidered "guipil." But the headdress was the most striking part. It consisted in a large number of twisted cords, in the colors yellow, red and black, the whole must have weighed about two pounds, and when twisted up among the hair looked like a large turban.

The women in Mixco are never accustomed to carry any burdens on their heads, like women from other places of the republic, but they carry everything by means of a strap across the shoulders. They all hold that it is greatly injurious to carry anything on the head. However that may be certain it is that the women of Mixco are stronger than the women from any other place in Guatemala, but they lack the elegant bearing which is characteristic of all the other indian women of the country.

The words alcaldes and martooms are not used in this place, all the male members of the cofradia being known as "major domos," the plural of "majordomo." The major domos of the cofradia of Mixco seemed much inferior as regards moral worthiness to the women. They were as often drunk as sober, and their probable experiences in the capital did not seem to have done them any good. I was told that the men in Mixco were not to be trusted and that they as a rule were great thieves. My own experience however was very different. Through the kindness of the alcalde of the village I was furnished with two Mixco indians as servants, and they travelled with me all through Guatemala for nearly half a year. I must say that more faithful men have never been in my employ and I found them both willing and honest.

The dress of the major domos of Mixco was rather picturesque though in artistic sense inferior to the one worn in Totonicapan. It consisted of white pantaloons and white shirt. Over the latter was worn a short poncho like cloak or cape, consisting of a square piece of black velvet, embroidered with yellow silk ribbons. The poncho was furnished with a slit in the center admitting the head of the bearer. As headdress was worn the inevitable panama hat.

In the small town of San Juan Sacatepequez, situated some fifteen miles from Mixco, the alcaldes of the church dress in an even more picturesque manner. The pantaloons worn are cut in the old style, that is they are split open along the outside of the leg, and reach only to the knees. With these pantaloons are worn jackets reaching the waist, and embroidered with black narrow cords and bands. The jackets are made from scarlet red cloth, sometimes striped with white. As headdress is worn large shawls made of red cloth, embroidered with yellow. These shawl cloths are simply tied around the head, held together with a large knot at the back of the head, while the ends of the cloth are allowed to hang freely down the sides, reaching nearly to the knees. A somewhat similar dress is worn by the indians of San Martin Chile Verde, near Quezaltenango. Their over garment consists in what is called a "kapishay." The kapishay is made from a single piece of brown, coarse cloth. In the center is an opening for the head, while on the sides are similar openings for the

arms. The kapishay reaches generally below the knees, while at the waist it is held steady by a narrow cloth of bright color known as faja. The headdress of the San Martin indians consists in a long and narrow cloth tied around the head, and allowed to fall freely down along the back. Seen at a little distance these indians look like arabs, though their dress is far more elegant than the general arab dress. These indians are the most picturesque ones in the whole of central america, and it is deeply to be regretted that their village is one of the many which was first destroyed by the big earthquake of last year, and then later on covered over with from five to eight feet of sand during the eruption of Santa Maria.

Notes

CHAPTER 1. THE COMMUNICATIVE NATURE OF CLOTH AND CLOTHING

1. "Fashion, in dress, [is] the prevailing mode affecting modifications in costume." *New Columbia Encyclopedia*, 1975.
2. Mary Helms wrote that, for the Cuna women, wearing typical dress is an expression of group cohesion and morality. Cuna men do not wear typical clothing. In the Cuna *congreso*, only men speak out; women listen. However, when women interact in the marketplace with foreigners, the act of wearing *molas* or blouses and other dress elements speaks to the community-oriented values of the Cuna.
3. This symposium, "Current Topics in Ethnographic Cloth and Costume from Middle America and the Central Andes of South America," was held at the Haffenreffer Museum of Anthropology, Brown University, in Bristol, R.I., in March 1987. A 1991 publication, *Textile Traditions of Mesoamerica and the Andes*, edited by Margot Blum Schevill, Janet Catherine Berlo, and Edward B. Dwyer, was based on most of the papers delivered and some additional articles.
4. I have applied semiotician Roland Barthes's suggestion for exploring the communicative aspects of dress presented in *The Fashion System* (1983) elsewhere (Schevill 1986: 1–2). This holistic approach organizes garments into three categories: image clothing or that which is photographed or drawn; written clothing, that which is described in texts; and real clothing or the garment itself.
5. See Susan B. Kaiser, *The Social Psychology of Clothing and Personal Adornment* (1985); Mary Ellen Roach and Joanne Bubolz Eicher, *Dress, Adornment and Social Order* (1965); Linda Welters, *Women's Traditional Costume in Attica, Greece* (1988); Beverly Gordon, "The Woodland Indian Bandolier Bag: Cultural Adaptation and Efflorescence" (1989).
6. See *Threads; Handwoven;* and *Shuttle, Spindle, and Dyepot,* among others.
7. See Pat Hickman, *Innerskins/Outerskins: Gut and Fishskin* (1987); a video by Joyce Ronald Smith, *White Fur Clouds* (1989), among others.
8. Art historians teaching in departments focused on Euramerican art needed to address the challenges posed by teaching courses in tribal or primitive art. They have contributed to the "new" art historical method and thought. Ruth Phillips (1989) has eloquently addressed this issue.
9. See Alison Lurie, *The Language of Clothes* (1981); Janet Catherine Berlo, "Beyond *Bricolage*: Women and Aesthetic Strategies in Latin American Textiles" (1991); Lee Anne Wilson, "Nature Versus Culture: The Image of the Uncivilized Wild-Man in Textiles from the Department of Cuzco, Peru" (1991), among others.
10. Margaret Conkey discussed the vicissitudes of material culture research in an essay, "Historical and Theoretical Premises," in *Perspectives on Anthropological Collections from the American Southwest*, a volume of articles that resulted from a symposium at Arizona State University, edited by Ann Lane Hedlund (1989). Conkey maintained that material culture studies have been central to art history, archaeology, and primitive technology studies, but only marginal to anthropological inquiry. Since humans are simultaneously materialists and symbolists, their works should be viewed in a living context. Raymond Thompson and Nancy Parezo, in the same volume, demonstrated that material culture studies have not died out, but have been subsumed under the broad umbrella of anthropological discourse.

 It heartens this anthropologist to learn that symposia on this topic are occurring and that anthropologists, archaeologists, and museum professionals are discussing these issues.

11. See George W. Stocking, Jr., *Victorian Anthropology* (1987), for a historical overview of ethnological thought from 1750 to 1890.

12. Scholars working in other Maya towns that existed at the time of the conquest have reported on symbolic meanings related to Maya cosmology as told to them by religious leaders but not by weavers. Sheldon Annis (1987) points out that San Antonio Aguas Calientes came into existence after the conquest and, therefore, did not have the preconquest religious patterns and cosmological belief systems that existed in towns like Chichicastenango, Santiago Atitlán, and Cobán.

13. This project produced part of the data that Annis incorporated into his publication *God and Production in a Guatemalan Town* (1987).

14. I gave a paper on this topic as part of a panel, "Photograph Elicitation for the Purpose of Object Documentation" at the American Anthropological Association meetings in November 1989. The title is "'I Don't Do That One!': Maya Weavers of Guatemala and Yurok-Karok Weavers of Northwestern California Talk about Their Designs."

15. McCracken's data were derived from three categories of interviews with ten North American subjects who viewed forty slides of individuals in nonethnic clothing in downtown Vancouver, British Columbia. Applying a structural-linguistic analysis to his data, he reached the conclusions stated in his essay. It would be interesting to see what data he would have obtained from interviews with indigenous consultants who looked at slides of individuals from the consultant's place of origin who were dressed in typical clothing. With this kind of data, would he have reached the same conclusions?

16. See Schevill 1989b, 1990, 1991a, 1991b. I am continuing to gather data about the symbolic meanings of the double-headed eagle image in Maya textiles and elsewhere. Recent fieldwork in Chichicastenango confirmed that, for the older generation who wore and wove textiles with the abstracted image of a double-headed eagle on them, the image was identified as *kot* or the double-headed eagle in K'iche' (Schevill 1988). The annotated citations in the catalogue section of this book contain whatever relevant information I could glean from published and unpublished sources, personal communications, historical photographs, and contemporary analogies where they were appropriate.

17. "Deeper meaning" is a term introduced into language theory in the 1950s by Noam Chomsky.

18. Pancake explained that the existing computer programs function well for quantitative but not for qualitative retrieval (pers. com. 1991).

19. Pancake gave a paper, "Interpreting the Text of Guatemalan Ethnographic Dress: Syntax and Semantics," on a panel entitled "The Woven Word" at the International Congress of Americanists in Amsterdam in June 1988, from which I am quoting. The published reference in the bibliography of this book is the same paper but in Spanish. I look forward eagerly to Pancake's research results, which I hope will be published in the near future.

20. A version of this section appeared in *Latin American Art*, Fall 1989, and in a paper I delivered at the Costume Society meetings in Denver in May 1989. Poet James Schevill commented that "fashion is not only what dazzles and creates a sensation, it is the living cloth of special identities" (pers. com. 1989).

21. Although postconquest chroniclers wrote about the absence of silk in the New World, it seems that wild silk may have been spun and woven on a small scale in Oaxaca and Puebla, Mexico (Sayer 1985:129). By 1600, there were centers in these areas and in Tlaxcala where guilds of silk weavers were using Chinese silk (Borah 1943:89). See Chapter 3.

22. The weaving terminology is explained in the Glossary of Weaving Terminology.

23. There are four San Martín Jilotepeque–style *huipiles*, acquired in 1901 and evidently purchased in Quezaltenango, that are part of the George

Byron Gordon collection, now in the Peabody Museum, Harvard University, 01-4020/c:3012, 3013, 3016, 3021. They, however, do not have treadle-loomed cloth added to them as does 3-64.

24. Krystyna Deuss bought a San Martín Jilotepeque–style *huipil*, probably woven in the 1920s, from a trader in Totonicapán with cloth added to the bottom to create the style favored in that town. The neck also was decorated with embroidery (Deuss, pers. com. 1990).

25. The photograph is from the George Byron Gordon collection in the Peabody Museum, Harvard University. The collection was bought in Guatemala City in 1901 by Gordon. Exact dates and provenances of these photographs are not available. There are two green *huipiles*, 01-4020/c:3015, 3019 in the collection that are similar in design and possibly background color to the one worn by the woman in the photograph.

26. Olga Arriola de Geng, pers. com. 1989.

27. It has been assumed that treadle-loom weavers were usually men. I address this issue in Chapter 5. As with the backstrap-loom weavers, they too were experimenting with textile design, combining features from other areas to create new forms.

28. Krystyna Deuss, pers. com. 1989. Olga Arriola de Geng (pers. com. 1989) and Robert Carlsen (pers. com. 1990) also agree that this style was worn in Santa Lucía Utatlán. They do not know where it was woven.

29. Barthes quotes from Jean Paul Sartre, *The Critique of Dialectical Reason*, in reference to three levels of relationships between costume and wearer (Barthes 1983:fn. 256).

30. Disguise—to hide or obscure the real nature of; to change costume. *Webster's New World Dictionary of the American Language*, College Edition (1968).

31. These comments by Cohen were part of a paper delivered at the symposium "Current Topics in Ethnographic Costume and Cloth from Middle America and the Central Andes of South America," held at the Haffenreffer Museum, Brown University, in March 1987. The title of the paper is "The Study of Ethnographic Textiles in Peru: A Personal View."

32. John Cohen, pers. com. 1990. Back in the field in 1989, Cohen photographed this festival in his film *Carnival in Q'eros*. During the editing process, he became aware of the transformational use of dress by the Q'eros. Cohen currently is editing two films focused on Andean music. He said, "It is hard to convey differences in music. Costume is a huge indicator. All issues of music are represented in dress."

33. A photograph, p. 125 in Jean-Marie Simon's book *Guatemala: Eternal Spring, Eternal Tyranny* (1987), shows a cadet at the Politécnica Military Academy explaining to the other cadets that different textile patterns are associated with a particular town. Unfortunately, Simon does not record his actual words.

34. The entire document appears as Appendix B.

35. Etymological and archival research has revealed that *martoom* is a corruption of the Spanish term *mayordomo* used in other *cofradía* hierarchies in Guatemala. Olga Arriola de Geng, pers. com. 1989.

36. These serapes are of great interest and are discussed in detail in Chapters 2 and 6.

CHAPTER 2. THE EISEN GUATEMALAN TEXTILE COLLECTION

1. For North America see Shepard Krech III, *A Victorian Earl in the Arctic* (1989); Barbara Hail and Kate Duncan, *Out of the North* (1989); Diana Fane, Ira Jacknis, and Lise Breen, *Objects of Myth and Memory* (1991), among others.

2. In a paper delivered at the symposium "Out of the North," at the Haffenreffer Museum, Molly Lee commented that most nineteenth-

century collectors were women (1991). In addition to the Fourth Earl of Lonsdale, Eisen, and the Reverend Henry Th. Heyde, other male collectors include William Randolph Hearst, who, in 1900, collected two hundred Navajo textiles through the Fred Harvey Company's Indian Department (Blomberg 1988). For discussions on a number of early collections of American material, see *The Early Years of Native American Art History*, edited by Janet Catherine Berlo (1992).

3. At the symposium "Collecting the Pre-Columbian Past" at Dumbarton Oaks, Washington, D.C., in October 1990, Elizabeth Boone spoke about the tastes and preferences of Robert Woods Bliss. Why did he collect Pre-Columbiana? Because it was new. Why did he select the pieces he did? "A rhythm here, a form there."

4. See Chapter 3, which consists of a brief biography of Gustavus A. Eisen.

5. Eisen made collections for the Smithsonian National Museum of Natural History, the California Academy of Sciences, and the University of Uppsala.

6. Letter to President Wheeler, September 1902. Accession Files 47 and 61. Hearst Museum of Anthropology, University of California at Berkeley.

7. The jade debate occupied many scholars in the late nineteenth century. See Frederick W. Putnam, *Central American Jades* (1886) and the Frederick W. Putnam archives, Peabody Museum of Archaeology and Ethnology, Harvard University.

8. *Ladinos* are persons of mixed blood who speak Spanish, follow Spanish customs, and wear European clothing; they are also known as *mestizos*. Ralph Beals suggested that an Indian in Guatemala is a person who identifies himself or herself as Indian, while Christopher Lutz suggests that historically the *ladinos* were all persons of mixed descent including persons of part-African ancestry (pers. com. 1990).

 The Maya Indians, in spite of the poverty and hardships they still endure, continue to attract the attention of outsiders who seldom study the *ladino* societies. Some upper-class *ladinos* have a patronizing attitude about the Maya, upon whom they are dependent for labor. Other *ladinos*, however, are serious students of Maya cultural life, and they have established a museum, the Museo Ixchel del Traje Indígena, to preserve Maya indigenous dress and *costumbre*. In spite of this interest, the indigenous peoples have suffered tremendous losses in population as a result of the violence perpetrated against them. This violence is ongoing. See Robert M. Carmack, *Harvest of Violence* (1988).

9. See Chapter 3 for a discussion of Eisen's interest in the Maya, his work with T. J. Goodman on hieroglyphs, and the manuscript he sent to the Smithsonian Institution.

10. *"Pero debe recordarse que los indígenas norteamericanos eran salvajes, mientras que aquí en Centroamérica eran en un alto grado mucho más civilizados que los propios españoles"* (Eisen 1986b:429).

11. Phoebe Hearst (1842–1919) almost single-handedly provided funding and other forms of support to create the University of California at Berkeley. After her husband, George Hearst, died in 1891, she returned to California from Washington, D.C. In 1897 Dr. Benjamin Ide Wheeler appointed her a regent of the University of California, and she became involved in the development of a comprehensive plan for the campus. Over 60,000 items in the Hearst Museum collections were donated by Mrs. Hearst or came from her collections upon her death. The Eisen project is just one of many that she supported. An exhibition in her honor opened at the Hearst Museum in 1989.

 Heber Bishop, a New York jade collector, antique dealer, and perhaps a diffusionist, suggested the Guatemalan expedition to Zelia Nuttall. She knew Eisen and his qualifications, hence his selection.

12. Letter written in June 1938 to Edward Gifford. Records of the University of California Department of Anthropology and the Museum of Anthropology, University Archives, the Bancroft Library.

13. It seems that Eisen purchased the *huipiles* from the markets; the Maudslays, however, did not encounter *huipiles* for sale. Instead they endeavored to buy these textiles directly from women. Since the women did not own more than one everyday *huipil*, it meant selling the garment "off their backs," an action that was vigorously objected to by them (Maudslay and Maudslay 1899:72).

14. Born in Totonicapán in 1846, one year earlier than Eisen's year of birth, García Elgueta was an archaeologist, linguist, and self-taught historian. While young, he visited Costa Rica and other Central and South American countries and registered as a soldier on the Republican side in Mexico at the time of Maximilian. Back in Guatemala in 1863, he was very active in politics. Because of his military activities, García Elgueta was promoted to colonel. He authored a major portion of the book *Un pueblo de los Altos* (1897), which focuses on the cultural patterns and languages of the indigenous peoples of Totonicapán. He died in 1912. (Jorge Luis Arriola, pers. com. 1989).

 García Elgueta sent pre-Columbian Maya ceramics to the Chicago World Exposition; they are now in the California Academy of Sciences, San Francisco. A piece of paper with García Elgueta's name in Eisen's handwriting is in the Eisen archives at the California Academy of Sciences and relates to this ceramic collection.

 In 1938, when Eisen was ninety-one, he wrote to Edward Gifford: "I spent a year in Guatemala and with the assistance of Manuel García Elgueta, the learned Kakchiquel half breed indian, found the native jadeite, in a river near Totonicapán." In fact the linguistic group was the K'iche', not Kaqchikel. Travelers were often confused about the Maya linguistic groups. In the George Byron Gordon photo archives at the Peabody Museum, Harvard University, each photograph has the words "Quiché Indians" inscribed. In addition to K'iche' speakers, there is a wide range of linguistic groups represented in these photographs. Records of the University of California Department of Anthropology and the Museum of Anthropology, University Archives, The Bancroft Library.

15. See Appendix B, "The 'Cofradia' of the Indians of Guatemala." This brief but vivid description may be one of the earliest and most complete extant about this topic. The combination of this essay, Eisen's photographs of the *martooms* and *capitanes* in Totonicapán and the textiles in the collection comprise an artifact of great ethnographic value.

16. For example, some of the information provided in Lila M. O'Neale's *Textiles of Highland Guatemala,* based on her 1936 fieldwork and museum research, photo archives, and extrapolation from contemporary sources, provides additional documentation.

17. This holds true for the Fourth Earl of Lonsdale's Subarctic collection located in the Museum of Mankind, London. See Krech (1989).

18. Rudolph Frederick Haffenreffer III bought the Subarctic and Northwest Coast collections from Mrs. Emma Shaw Colcleugh. See Hail and Duncan (1989).

19. Department of Anthropology Records, University of California Archives, The Bancroft Library.

20. Eisen was convinced that he had found jade. It was of various colors: dark green, gray green, and gray. He thought a chemical analysis was needed. Back in San Francisco in 1905, he sent a sample to a jade expert, Fred Kunz, who was head of Tiffany's in New York City. He agreed with Eisen and Eisen wanted to make a public announcement. Alfred L. Kroeber, curator of the Museum of Anthropology, wanted a second opinion. He informed Eisen that Mrs. Hearst was not satisfied. Professor Lawson, a colleague of Kroeber's and possibly a geologist, examined another sample found in the Río Blanco near Calchitán, Huehuetenango, which Eisen called "the most important piece."

Lawson called it diopside and muscovite. The latter imparts a greenish color. This was another disappointment for Eisen. Letters from Eisen to Phoebe Hearst (1902d, 1905). Letter from Kroeber (1905). Bancroft Library, University of California at Berkeley. In reality, Eisen had found jade. The New World variety is actually nephrite; the Old World variety is jadeite. There are many jade sources in Guatemala, and jade objects are popular tourist items.

21. Department of Anthropology Records, University of California Archives, The Bancroft Library.

22. Researchers, such as Ann P. Rowe, Robert Carlsen, myself, and others, who have looked at this collection, have attempted to correct some of Heyde's provenances of collection or origin. There is no publication of the Heyde collection as a whole.

23. Putnam became professor of anthropology and the first director of the Museum of Anthropology at the University of California at Berkeley. He was part of the university advisory committee that included, in addition to Phoebe Hearst and Zelia Nuttall, Franz Boas, Alice Fletcher, and John C. Merriam.

 Heyde wrote to Putnam on several occasions. In one letter Heyde mentions a little history he had written on the Quiché nation, "before and at the conquest, her costumes, country etc. as it was then and it is now at present time." He wrote the manuscript in German but he mentions a poor English translation. Heyde suggested that Putnam might help to publish it, and he offered to send him the "division of contents and all the other particulars." Research efforts have turned up little additional information on Heyde, apart from the correspondence cited. The financial arrangements involved with the sale of his collection did not go smoothly, but eventually $500 was the price agreed upon. There is no documentation to attest to Heyde's actually receiving and cashing the bank draft mentioned in the correspondence (1895, 1896, 1901).

24. Letter by Kroeber to Wissler; Anthropology Department Archives, American Museum of Natural History.

25. I photographed and analyzed the Eisen textiles in the American Museum of Natural History collections and have noted these textiles in the annotated catalogue section. I came across a comment in Eisen's letter to Gifford in 1938 about one of the exchanged textiles—a serape of a *martoom* from Totonicapán, 65-3258. The textile resembles the four old specimens in Hearst Museum collections, but the colors are brighter and it is unused. Scholars have assumed that this textile was similar in age to the other serapes. Eisen, however, commissioned this textile for himself, but somehow it was mixed in with the whole collection and was selected by Kroeber for exchange.

26. Fiber artist Joanne Segal Brandford was a graduate student in the University of California Decorative Art department in the 1960s, long after O'Neale's death in 1948. We discussed the origin of the Totonicapán serapes, one of which had been integrated into the Decorative Art collections by O'Neale. The faculty thought that these textiles might have been woven in Mexico because of style relationships to Saltillo serapes. The serape has been reintegrated into the Eisen collection and has its original number, 3-4 (Joanne Brandford, pers. com. 1985). The Decorative Art faculty was unaware of the fact that Eisen had commissioned a fifth serape in Totonicapán from "an old Indian, it was intended for use by myself, and home use, but by mistake it was packed up with the rest. It is easily distinguished because the yarn was dyed with modern aniline dyes, but the pattern was based upon an old garment" (letter to Gifford in 1938, Department of Anthropology Records, University of California Archives). Carlsen analyzed the dyes in one serape, 3-1, and discovered that they were aniline (Robert Carlsen, pers. com. 1987).

27. Von Tempsky commented on the facial differentiations between coastal and mountain people as did Eisen. One chapter focuses on Santa Catarina Ixtahuacán, Sololá, including descriptions of dress, religious beliefs, and the relationship between the Indian priest and the village priest. Perhaps Eisen was acquainted with this work before going to Guatemala.

28. The presence of these textiles, fresh from the weaver's loom, has confused other researchers. While I was analyzing the collection in the fall of 1988, I invited Guatemalan textile experts and other interested scholars to see it, and they were always surprised. One very knowledgeable person asked me if I was sure that some of the unused textiles were actually part of the collection, since the style and freshness resembled that of contemporary examples.

CHAPTER 3. GUSTAVUS A. EISEN: 1847–1940

1. See S. G. Hägglund, *Korsbaneret* (1941). Translated from the Swedish by Gulli Kula, to whom I am indebted for translations of other Swedish articles and works about Eisen and Strindberg.

2. Letter to Mr. Bernard on April 3, 1939. Fresno County Historical Society Archives, Fresno City & County Historical Society, Fresno, California.

3. Throughout this chapter, I quote verbatim from Eisen's letters.

4. With the exception of his very early years, I refer to Eisen as "Gustavus A." In 1916, shortly after his arrival in the United States, Eisen changed his name to Gustavus A. In a letter to Alice Eastwood he wrote, "Please notice the name. I have made a change as I do not sympathize with the Kaiser and Von Bissing." Special Collections, California Academy of Sciences. This collection will subsequently be referred to as SCCAS.

5. Archival research, as yet, has not revealed the specific nature of Eisen's early bad health.

6. Strindberg portrayed Eisen's solitary character in one of his short stories, "Frön Fjärdingen och Svart bäcken" or "Town and Gown" in English (1912). Eisen, a member of a circle of Strindberg's friends at the University of Uppsala, appears as "the one who sits alone" or the recluse, a characteristic that remained part of Eisen's personality throughout his life.

7. Published and unpublished works and letters by Eisen referred to in the text are listed in the Bibliography. For a complete bibliography of Eisen's works see *Svenskt Biografiskt Lexikon* 12:544–552 (1949).

8. See August Gustaf Eisen, "The Raisin Industry. A Practical Treatise on the Raisin Grapes, Their History, Culture and Curing" (1890), among other publications on raisins.

9. See August Gustaf Eisen, *Fig Culture, Edible Figs: Their Culture and Curing* (1897). Eisen also introduced the alligator pear, which originated in Guatemala, to California.

10. In 1965, Douglas Strong, in an unpublished article, "The Significance of Gustavus Eisen and the California Academy of Sciences in the Establishment of Sequoia National Park," questioned both Eisen's claim to have been solely responsible for the founding of the park and the role played by the railroad. Strong wrote that the Southern Pacific Railroad Company supported the park's initial establishment and enlargement in order to block potential competition from lumber production, which would have conflicted with the profitable import of lumber from northern California. This article is part of the author's unpublished dissertation, "A History of Sequoia National Park" (1964). SCCAS. Also in the Special Collections is a paper by Eisen, "Sequoia National Park."

11. Eisen called the park he envisioned "Nevada Park."

12. During his early years at the Academy, Eisen also wrote an opera libretto based on Mexico at the time of the conquest and a dramatic text for Carlos Troyer, a composer and librarian at the Academy. These manuscripts were found in J. T. Goodman's papers, most of which were turned over to the Peabody Museum of Archaeology and Ethnology at Harvard University. The opera librettos were in the hands of Alfred Kroeber, then director of the Museum of Anthropology, University of California at Berkeley. Kroeber was a curator at the Academy during the year (1902) that Eisen was in Guatemala. The librettos are now in the SCCAS.

13. The Smithsonian Institution had published an earlier manuscript, *On the* Oligochaeta *Collected During the Swedish Expeditions to the Arctic Regions in the Years 1870, 1875, and 1876* (1879); the new manuscript was published in Sweden in 1881 (Eisen 1881b).

14. Letter written on December 5, 1881. Smithsonian Institution Archives, Record Unit 28, Office of the Secretary, Spencer F. Baird, 1879–1882. The Spencer F. Baird Collection will subsequently be referred to as SFBC.

15. Eisen must have maintained a research appointment, for, elsewhere in his correspondence, he mentions his association with the Academy until the fire of 1906 and the destruction of his papers.

16. The majority of Eisen's papers, which were written prior to 1906 and housed in the Academy, were destroyed in the fire that followed the 1906 earthquake. I have drawn from letters and Eisen's account of his 1882 journey to Guatemala, which was originally published in *Ymer*, the journal of the Swedish Society of Anthropology and Geography. The article was published in two parts: number 6 (1886) and number 7 (1887). Athos Barés translated it into Spanish for publication in *Mesoamérica* with the title "Un viaje por Guatemala."

17. It is not clear how Eisen financed this trip. Perhaps he used his salary from the Academy or money saved from his Fresno salary. Money was always a problem for him.

18. In his travel writings about this trip, Eisen commented that the "best families" were in exile because of the political situation in Guatemala. Some of these families were living in San Francisco. No doubt some of his letters of introduction came from this source and perhaps from Baird (Eisen 1886).

19. Eisen was familiar with the literature on the Maya, including the Dresden Codex, the chapter about Copán in *Recordación Florida* by Don Francisco Antonio de Fuentes y Guzmán (1932–1933), and other works.

20. Maps were always a problem, as accurate ones for Guatemala did not exist in the 1880s. The Maudslays published a map that may have been accessible to Eisen for the 1902 expedition (1899). See Figure 20 for a map of Guatemala and Figures 21–22 for the possible routes that Eisen took during his 1902 expedition. These maps are based on the railroad map of the early 1900s and another small map that he carried with him. SCCAS.

21. Eisen's travel routes are similar to those taken by Sir Percival and Lady Anne Maudslay during their trip in 1894 (Maudslay and Maudslay 1899).

22. None of the botanical illustrations from this trip have survived. The only drawings that still exist are those that accompanied the article "On Some Ancient Sculpture from the Pacific Slope of Guatemala" (1888) and those of the ruins at Copán and Quiriguá, presented in 1938 as a gift to Erwin Paul Dieseldorff. The Howard-Tilton Memorial Library, Special Collections Department, Tulane University, New Orleans. The Erwin Paul Dieseldorff Archives, Mayan Studies Papers, Part XI. This collection will subsequently be referred to as EPDA.

23. The Central Mexican presence on the west coast and elsewhere in Guatemala was further explored by Otto Stoll in *Zur Ethnographie der Republik Guatemala* (1884). Stoll was one of the first to focus on Maya

languages. Pipil, the language of the Aztec traders, along with Maya languages, was spoken in Salamá, San Augustín Acasahuastlán, Tocoy, and Escuintla, where the sculptures were. Stoll wrote of Eisen as his friend (p. 14) and discussed Eisen's trip to Central America to make copies of these sculptures for publication. Stoll also wrote of possible migrations of the Toltecs.

24. This letter was dated June 13, 1882. SFBC.
25. Ibid.
26. A letter to Baird on December 17, 1882. SFBC.
27. In his research capacity for the Academy, Eisen made a collection of earthworms for the institution.
28. A letter to Eisen in July 1883. SFBC.
29. Eisen, writing to Dieseldorff on December 16, 1939, thought that an archaeologist had stolen his illustrations and thereby prevented the publication of his manuscript. EPDA.
30. Manuscript in the J. T. Goodman archives at the Peabody Museum of Archaeology and Ethnology, Harvard University.
31. Maudslay tried to interest the Academy in publishing Goodman's calendrical chapter. This did not come to pass.
32. Eisen's skill as a photographer is apparent in the photographs taken during the 1902 expedition, some of which are presented throughout this book. In contrast to the formal posed quality of the photographs by Eadweard Muybridge or those in the George Byron Gordon collection at the Peabody Museum of Archaeology and Ethnology, Harvard University, which were taken indoors in front of painted backdrops, Eisen used his hand-held camera in the field. Often the subjects—both Maya and *ladinos*—are looking directly at the camera. The landscapes are full of detail.
33. See Appendix B.
34. See the discussion of Phoebe Hearst in Chapter 2 and note 11 of Chapter 2.
35. See Helen Laird, *Carl Oscar Borg and the Magic Region* (1986), for further information about Phoebe Hearst's circle, Eisen, and his relationship and travels with Carl Oscar Borg.
36. There is only one handwritten letter from Mrs. Hearst in the Academy Special Collections. Written on August 30, 1907, from Hacienda del Pozo de Verona, her ranch in Pleasanton, California, it refers to Eisen's invitation, which was gracefully declined. He offered to show her the exhibit at her home and she accepted with pleasure. The letter may be in Phoebe Hearst's own hand. The Bancroft Library, University of California at Berkeley, has a large collection of letters written to Phoebe Hearst, which includes numerous letters from Eisen. The letters contain handwritten notes by Hearst or her secretary, and then the secretary would respond. This collection will subsequently be referred to as BLUCB.
37. Eisen's attempts to publish *Tales of the Moors and Christians: Alhambra, Spain* and *Under Crescent and Cross*, two manuscripts based on folk tales he collected during his European and Egyptian travels, were unsuccessful, in spite of the contacts Phoebe Hearst and her friends made with New York publishers such as Houghton Mifflin Company. It seems that the manuscript of *Tales of the Moors and Christians: Alhambra, Spain* was lost. One editor thought the tales in *Under Crescent and Cross* were more like fairy tales than Moorish legends: "These several things give us pause, naturally, all the more in view of the fact that the writer has yet to make his reputation as an author outside of scientific circles as we understand." Gustaf A. Eisen Archives of Uppsala Universitetbibliotek, Sweden.
38. There are several suitcases of Eisen's glass slides taken during his European travels in the SCCAS. The travel letters are in the Phoebe Apperson Hearst correspondence file, BLUCB.

39. Scientific matters also occupied Eisen's time. He studied public aquariums in European cities, because a wealthy San Franciscan, Dr. Harry L. Teves, was planning to build one for the Academy. Because of the earthquake and fire in 1906, however, Eisen's plan could not be implemented—another disappointment.
40. There is a special file devoted to the correspondence between Alice Eastwood, a botanist and Academy member, and Eisen. SCCAS.
41. Letter to Mrs. Hearst, November 3, 1912. BLUCB.
42. Letter to Mrs. Hearst, July 10, 1913. BLUCB.
 It is not clear if Phoebe Hearst totally discontinued her support, as Eisen traveled for another year before leaving for New York City. They continued to correspond after his arrival about contacts that she and her friends were making for him in the publishing world.
43. Quotes are from letters written in 1919 and 1920. SCCAS.
44. Eisen wrote a long, comprehensive, but undated letter to F. M. MacFarland, the president of the Academy, outlining the Sequoia Park situation, the intrigue and actors involved, biographical material on his years in Fresno and San Francisco, and his vindication of the role he played in the creation of the park. In a P.S. he mentions that his bad writing is due to his left eye. The letter, however, is typed with his signature, perhaps by Evelyn Kouchakji, as he was living with the Kouchakjis by then. The date is probably 1938. He concludes the letter with these words: "I learned much from my friends, biologists in Stam[n]ford and used it to the best advantage . . . Thanks for all those glorious ten years of my life!!!" SCCAS.
45. Letter written September 4, 1941. SCCAS.
46. I am quoting verbatim from Dieseldorff's letters.
47. Letter written on August 8. EPDA.
48. Compare Eisen's memories of his Guatemalan experience with his remarks to Baird in 1883 when he called Guatemala "stagnant." These excerpts are from letters written on January 3, October 2, and December 16, 1939. EPDA.
 Eisen was a believer in the spirit world and the "unseen," as was Dieseldorff. The letters contain descriptions of contacts with the "unseen."

CHAPTER 4. THE LATE NINETEENTH-CENTURY GUATEMALAN MAYA IN HISTORICAL CONTEXT: PAST AND FUTURE RESEARCH

1. For the best recent work on Maya pottery production, see Ruben E. Reina and Robert M. Hill II, *The Traditional Pottery of Guatemala*, 1973. Serious monographs (much less mention in other works) on postconquest Maya domestic architecture and furnishings are rare. On the published and unpublished writings of Gustav Eisen see later in this chapter and elsewhere in the book. The classic work coauthored by Alfred Percival and Anne Cary Maudslay is *A Glimpse at Guatemala*, published in London in 1899.
2. Oliver La Farge, "Maya Ethnology: The Sequence of Cultures," 1940, p. 290. For a valuable discussion of La Farge's model and later responses to it, see Robert M. Carmack, "Spanish-Indian Relations in Highland Guatemala, 1800–1944," 1983, pp. 215–252, especially pp. 216–217.
3. Lesley Byrd Simpson and Sherburne F. Cook, *The Population of Central Mexico in the Sixteenth Century*, 1949; Sherburne F. Cooke and Woodrow Borah, *Essays in Population History*, 1971–1979. Simpson, Cook, and Borah, once or now affiliated with the University of California at Berkeley, are known collectively as the Berkeley School by supporters and detractors of their findings.
4. La Farge, "Maya Ethnology," p. 290. The definitive work on early *encomienda* in Guatemala is Wendy Kramer, *The Politics of Encomienda Distribution in Early Spanish Guatemala, 1524–1544*, 1990.

5. Even if the Spanish legislation *had* applied in Guatemala, the Maya would have been forced to continue to pay tribute. Why? Because the Spanish legislation ended tribute payments *only* to individual colonists, not to the Crown, to whom virtually all *encomienda* had reverted by 1700. As for *repartimiento* duties, these continued in areas of Guatemala where Spanish settlement was concentrated and Indian labor was in great demand.

6. "Western highlands," "Indian highlands," and "Indian Guatemala" are used interchangeably to describe Guatemala's central and western highlands, areas that have remained overwhelmingly Indian since the Spanish conquest. These areas correspond to Murdo MacLeod's "Indian west," in contrast to his "*ladino* east." See Murdo MacLeod, "Ethnic Relations and Indian Society in the Province of Guatemala, ca. 1620–ca. 1800," 1983.

7. See W. George Lovell, *Conquest and Survival in Colonial Guatemala*, 1985, p. 91, on secularization in the Cuchumatanes; Christopher H. Lutz, *Historia sociodemográfica de Santiago de Guatemala, 1541–1773*, 1982, p. 215, n. 25, on a more accelerated form of secularization around Santiago; Adriaan C. van Oss, *Catholic Colonialism*, 1986, pp. 137–144, for a more general and complete description of the process and its consequences.

8. Quote from Archbishop Figueredo y Victoria, 1754; cited in van Oss, *Catholic Colonialism*, p. 144.

9. Miles L. Wortman, *Government and Society in Central America, 1680–1840*, 1982, pp. 172–183.

10. Wortman, *Government and Society*, p. 178 and passim. On earlier loss of Indian lands to indigo production, see Murdo MacLeod, *Spanish Central America*, 1973, p. 222.

11. La Farge, "Maya Ethnology," p. 291.

12. La Farge, "Maya Ethnology," p. 291.

13. Wortman, *Government and Society*, p. 173.

14. La Farge, "Maya Ethnology," p. 291.

15. *Ladinos* in late seventeenth- and eighteenth-century Guatemala were persons of mixed (Indian, Spanish, and African) descent, often persons whom it was increasingly hard to label either "mestizo" or "mulatto." The word *ladino* later came to include all non-Indian nonelites. See Lutz, *Historia sociodemográfica*, app. 4, pp. 433–434 and passim; Arturo Taracena Arriola, "Contribución al estudio del vocablo 'ladino' en Guatemala," 1982a, pp. 89–104; Severo Martínez Peláez, *La patria del criollo*, 1970, pp. 257–440.

16. MacLeod, *Spanish Central America* and "Ethnic Relations and Indian Society," pp. 189–214; Wortman, *Government and Society*; Christopher H. Lutz and W. George Lovell, "Core and Periphery in Colonial Guatemala," 1990.

17. Lutz and Lovell, "Core and Periphery."

18. Linda Newson, *The Cost of Conquest*, 1986, pp. 3–7; MacLeod, "Ethnic Relations and Indian Society," pp. 193–194, 197–198, 202, and passim; and Christopher H. Lutz, "La población no española y no indígena" (forthcoming).

19. For a summary, see Lutz and Lovell, "Core and Periphery"; for a major region of the highland periphery, the Cuchumatán highlands, see Lovell, *Conquest and Survival*.

20. These spellings of two of more than twenty Maya language groups in Guatemala are based on the new alphabets developed by indigenous linguists in cooperation with the recently established Academia de las Lenguas Mayas. See the useful linguistic map by Narciso Cojtí and text by Margarita López Raquec in Proyecto Lingüístico "Francisco Marroquín" and Museo Ixchel de Traje Indígena, *Idiomas de Guatemala y Belice*, 1988.

21. For a discussion of some of the variables that determined community

survival or destruction, see Lutz and Lovell, "Core and Periphery." Precisely when and if the non-Indian population surpassed the Indian population in any particular region has yet to be documented for the colonial period.

22. MacLeod, *Spanish Central America*, pp. 291, 308, 325. MacLeod does not specifically mention 5,000 feet, just lands at higher elevations.

23. Lutz and Lovell, "Core and Periphery"; Lovell, *Conquest and Survival*, pp. 108–111.

24. For an early example from the 1530s, see Wendy Kramer, W. George Lovell, and Christopher H. Lutz, "Fire in the Mountains," 1991, Table 2.

25. Margot Schevill, pers. com. June 4, 1989.

26. Wortman, *Government and Society*, pp. 242, 257; Ralph Lee Woodward, Jr., "Social Revolution in Guatemala," 1971, pp. 43–70, especially p. 49. State control of tobacco production failed in the mid-1820s as a result of clandestine production and sales; see Wortman, *Government and Society*, pp. 238–239.

27. J. C. Cambranes, *Coffee and Peasants*, 1985b, p. 28. A more complete, Spanish-language edition was published as *Café y campesinos en Guatemala*, 1985a. For a more optimistic view of cochineal production as the domain of poor *ladino* landowners throughout the highlands, see sources cited by Jim Handy, *Gift of the Devil*, 1984, pp. 58–59. Data on San Antonio's *nopaleros* (cochineal producers) are from an 1840s census in the parish archive of San Miguel Dueñas.

28. Wortman, *Government and Society*, p. 291.

29. See the very useful discussion of some aspects of this debate in E. Bradford Burns, *Eadweard Muybridge in Guatemala, 1875*, 1986, pp. 132–133, n. 48. Also see the early, balanced work by Woodward, "Social Revolution in Guatemala."

30. E. Bradford Burns, *Eadweard Muybridge* and *The Poverty of Progress*, 1986.

31. Burns, *Eadweard Muybridge*, p. 7. Indians have remained numerically dominant in the army under the military regimes of the 1970s and 1980s.

32. Burns, *Eadweard Muybridge*, p. 7.

33. Burns, *Eadweard Muybridge*, p. 8.

34. Cambranes calls the coffee industry "capitalist agriculture with forced labor." See his *Café y campesinos*, pp. 138–165.

35. Manning Nash, "The Impact of Mid–Nineteenth Century Economic Change upon the Indians of Middle America," 1970, pp. 170–183, especially p. 176.

36. The Maudslays, writing in the 1890s, note of the Antigua area that "it is only of late years that coffee has been cultivated on this plain; in earlier times the preparation of cochineal was the chief industry, and where coffee-trees are now growing there formerly stood rows of nopal cactus on which the cochineal insect lived." Alfred Percival and Anne Cary Maudslay, *A Glimpse at Guatemala*, p. 27.

37. See Cambranes, *Coffee and Peasants*, pp. 98–110 and passim.

38. Cambranes, *Coffee and Peasants*, pp. 98–110 and passim. Eisen traveled through many areas of Guatemala in the early 1880s and again in 1902. After his second visit he wrote: "The magnificent forests are rapidly disappearing. At the time of my first visit to Guatemala, the slopes of the volcanoes facing the Pacific were yet covered with them. In vain did I now hunt for these marvelous productions of a tropical nature in places where formerly they had attracted my attention. They had been cut and burnt, and sugar plantations or coffee *fincas* have taken their place, or herds of cattle pasture upon fields of *zacate* or forage. In twenty years more, the Pacific coast will have no more primeval forest to show." Gustav Eisen, "Notes during a Journey in Guatemala," 1903b, p. 16.

39. For a useful summary of this period, see Handy, *Gift of the Devil*, chap. 3, aptly titled "Barrios and the Coffee Economy: Order, Progress and the Assault on Indian Land."

40. See Figure 35, taken from Cambranes, *Coffee and Peasants*, pp. 8–9; and maps in Douglas C. Madigan, "Santiago Atitlán, Guatemala," 1976, pp. 116, 122. The Madigan map (no. 8) shows where on the *boca costa* coffee was cultivated in the 1970s.

41. Southern Guatemala (roughly Guatemala today minus the Petén) is estimated to have had a total indigenous population of about 2 million in 1520. The entire country had a population of about 1.2 million in 1880 and 8 million in 1985. For the 1520 estimate, see W. George Lovell and William R. Swezey, "The Population of Southern Guatemala at Spanish Contact," 1982, pp. 71–84; for the 1880 figure, see Ralph Lee Woodward, Jr., "Population and Development in Guatemala," 1983, p. 7, and Guatemala, *Censo General . . . de 1880*, 1881; and for 1985, see Tom Barry and Deb Preusch, eds., *The Central American Fact Book*, 1986, p. ix.

42. David McCreery, "Debt Servitude in Rural Guatemala, 1876–1936," 1983, p. 739.

43. Cambranes, *Coffee and Peasants*, pp. 309–318 and passim. For "Estado cafetalero," see Cambranes, *Café y campesinos*, p. 611.

44. McCreery, "Debt Servitude," p. 739.

45. For an excellent description of clandestine, semilegal farming, see Shelton H. Davis, *Land of Our Ancestors*, 1970.

46. For the ingenious equation McCreery uses to arrive at this figure, see "Debt Servitude," p. 758.

47. The first official published Guatemalan census (1880) shows a total population of 1,224,602. Indians made up 844,744 or 69 percent and *ladinos* 379,828 or 31 percent of the country's total population. A look at departmental totals suggests that 687,384 of those 844,774 Indians, or 82 percent, lived in the highlands in 1880. Guatemala, *Censo General . . . de 1880*, Cuadro Núm. 1, p. 441.

48. Taracena Arriola, "Les origines du mouvement ouvrier au Guatemala," 1982b; Cambranes, *Aspectos del desarrollo económico y social de Guatemala*, *Coffee and Peasants*, and *Café y campesinos*, 1975; Robert M. Carmack, *Historia social de los Quichés*, 1979; David McCreery, *Desarrollo económico y política nacional*, 1981, "Coffee and Class," 1976, "'An Odious Feudalism,'" 1986, and "Debt Servitude, 1983."

49. In addition to citations in the previous note, see Madigan, "Santiago Atitlán." A list of ninety-nine coffee *fincas* where workers from Santiago Atitlán were required to work off their indebtedness appears in app. 9, pp. 329–333. Also see Chester Lloyd Jones, *Guatemala*, 1940.

50. Among the many studies by Carol A. Smith, see "Regional Analysis in World-System Perspective," 1987, and "Beyond Dependency Theory," 1978. For a fine summary of Smith's work on the coffee boom's impact on market systems, see Carmack, "Spanish-Indian Relations," pp. 228–230. Carmack's works on the K'iche' are collected in *Historia social de los Quichés*.

51. John Swetnam, "What Else Did Indians Have to Do with Their Time?" 1989.

52. Pursuing this course is difficult work. Magnus Mörner deals with the problems of studying "anonymous people" living in a rural setting in *Historia social latinoamericana*, 1979, pp. 7–21. McCreery is now writing up a major work on land tenure and labor supply from about 1760 to 1940, and Cambranes is bringing his detailed account of coffee and peasants into the twentieth century.

53. In the twentieth century, as Protestant sects have grown in numerical importance, Catholic church registers have come to contain a diminishing number of entries. The civil registers are thus increasingly important.

54. For a better idea of the extent and organization of these materials, see Christopher H. Lutz and Stephen Webre, "The Archivo General de Centro América," 1985.

55. For an especially rich source with photographs and color plates of textiles, see Maudslay and Maudslay, *A Glimpse at Guatemala.* For another valuable kind of source, a life story, see Santiago Yach, "Autobiography of Santiago Yach," Sol Tax, ed., 1979. Unpublished accounts are much harder to find but are nevertheless plentiful in libraries and private collections all over Western Europe and North America.

56. José María Navarro's *Memoria de San Miguel Dueñas* was published in Guatemala in 1874 by Imprenta de Luna. The basis of the summary here is a condensation published in 1961, "Precursores de los estudios etnológicos en Guatemala."

57. Dueñas, San Antonio, San Andrés Ceballos, Santiago Zamora, Santa Catarina Barahona, and San Lorenzo El Cubo comprised the parish.

58. *Cabildo* buildings and town schools often served as overnight, make-shift pensions for foreign travelers such as Eisen and the Maudslays. If these unofficial uses of town facilities caused any disruptions, our sources were not about to reveal them. Margot Schevill, pers. com. May 1990.

59. Navarro's exact phrase was: "Son trabajadores, pero el roce inmediato de la Antigua y Ciudad Vieja los vuelve viciosos." Navarro, "Precursores," p. 153.

60. Irma Otzoy, *Identity and Higher Education among Mayan Women,* 1990; Kay B. Warren, *The Symbolism of Subordination,* 1989, especially the introduction to the 1989 edition; John Mamoru Watanabe, *We Who Are Here,* 1984. An especially useful statement on this subject is Irma Otzoy and Enrique Sam Colop, "Identidad étnica y modernización entre los mayas de Guatemala," 1990.

61. More recently numerous authors have studied the San Antonio *huipil,* among them Sheldon Annis, *God and Production,* 1987; Cherri M. Pancake and Sheldon Annis, "El arte de la producción," 1982; and Virginia Lathbury, *Textiles as the Expression of an Expanding World View,* 1974. Eisen did not collect any textiles from San Antonio Aguas Calientes, only a *soplador* or woven (reed) fan used to fan domestic cooking fires. Margot Schevill, pers. com. May 1990.

62. Information from the early 1890s comes from a landholding census published in 1891 by the Ministerio de Fomento, kindly provided by David McCreery.

63. The work of Carmack, McCreery, Cambranes, and Davis, cited else-where in this chapter, comes to mind. Also, see the comprehensive monograph by Jean Piel, *Sajcabaja: Muerte y resurrección de un pueblo de Guatemala, 1500–1970,* 1989, which is especially strong for the nineteenth and twentieth centuries.

CHAPTER 5. TEXTILE PRODUCTION

1. My research in other museum collections and private collections of this time period has uncovered textile genres that are not represented in the Eisen collection, such as saints' clothing, which can be found in the collections of the Museo Ixchel in Guatemala City, and examples of the open white-on-white gauze weaves from Alta Verapaz that are found in most collections. Eisen traveled in this area on his earlier trip in 1882 but did not return there in 1902.

2. Though Maya weavers are known to have used the draw loom imported from China and the Jacquard loom from France, no textiles created on these looms were collected by Eisen. By the 1880s, looms powered by water produced *manta* at a factory at Cantel, Quezaltenango.

3. For a more complete description of loom preparation and weaving see Lila M. O'Neale 1945, Lena Bjerregaard 1977, Marilyn Anderson 1978, Norbert Sperlich and Elizabeth Katz Sperlich 1980, and Agustín López López 1982.

4. The weavers of San Antonio Aguas Calientes, where I studied backstrap weaving in 1978, called this shed *La Madre.* Applied to the difficult shed, this term is an expletive and does not refer to the mother of a family!

5. The women of San Antonio Aguas Calientes call the treadle loom a *máquina* or machine.

6. Krystyna Deuss calls this loom a ribbon loom, and she discusses three types (1981 : 66). Margaret McEldowney refers to them as tapestry hair-ribbon looms (1982 : 28, 29). Lila M. O'Neale calls them "treadle looms for belts and headbands" (1945 : 36). In the catalogue section, I use the term "headband" for *cinta* and identify the loom as a headband loom.

7. All of the Eisen headbands and some of the belts were collected in Toto-nicapán. Krystyna Deuss noted that, in the 1970s, there were two other types of ribbon looms in use in San Sebastián Huehuetenango and Santiago Atitlán, Sololá. The latter closely resemble and probably derive from the Totonicapán loom. The San Sebastián loom is simpler, with only two harnesses, and the loom parts are made of roughly hewn pieces of wood. Men are the headband weavers in San Sebastián and in Santiago Atitlán, and both men and women weave headbands and belts in Totonicapán (Deuss 1981 : 66).

8. For a complete description of embroidered textiles and techniques, see Olga Arriola de Geng (1989).

9. See *The Techniques of Sprang* by textile expert Peter Collingwood (1974).

10. Synthetic fibers such as rayon and acrylic yarns are used by contemporary Maya weavers. Eisen's collecting time period predated the use of such fibers.

11. O'Neale comments on *hizote (yucca elephantipes Rege)*, which was finer than maguey and preferred by men for finger-looped bags (O'Neale 1945 : 22). One of the bags in the Eisen collection, whose texture is silkier than that of the others, may be of *hizote* (3-257).

12. Irmgard Weitlaner Johnson to Sayer (1985), pers. com., no date given.

13. Dr. Virginia Ahrens is pursuing research on some of the other colors, such as yellow and orange, that Carlsen and Wenger avoided in their project. As a consultant to the Museo Ixchel in Guatemala City, she introduced dye testing, and she is investigating the importation of synthetic dyes to Guatemala after World War I. The records of dye houses in Germany, which had a monopoly on supplying dyes to Guatemala, were destroyed during World War II (pers. coms. Robert Carlsen, 1988; Virginia Ahrens, 1990).

14. Anne Cary Maudslay (Maudslay and Maudslay 1899 : 27) described a cochineal plantation as follows:

> In earlier times the preparation of cochineal was the chief industry, and where coffee-trees are now growing there formerly stood rows of nopal cactus on which the cochineal insect lived. This fluffy-looking creature, which exudes a crop of crimson fluid when crushed, could not survive the wet season without protection, so a framework of rough sticks, divided into many compartments like a plate-rack, was arranged under shelter all along the garden walls, and in each of these compartments one of the flat branches of the nopal cactus was lodged before the rains began, bearing a number of cochineal insects sufficient to repopulate the whole plant as soon as the dry weather came round again. The value of this crop disappeared with the introduction of aniline dyes and the successful cultivation of cochineal in the Canary Islands, and the coffee-plant then took the place of the

cactus and has again brought some measure of prosperity to
the planters.

15. In the 1980s, Robert Carlsen and David Wenger undertook a systematic research on blue, red, and purple dyes in Guatemalan textiles located in documented museum collections. They applied three analytical methods: solution spectrophotometry, chemical "extraction" tests, and thin-layer chromatography (Carlsen and Wenger 1991). To my knowledge, no other scientific approach to Guatemalan textile dye analysis had occurred prior to their investigation. Southwest textile expert Kate Peck Kent commented that for prehistoric southwestern fabrics the identification of color sources was a problem. A long-term cooperation between dye chemist, botanist, and archaeologist was required (Kent 1983:36). The same can be said for studies of ethnographic textiles of indigenous Latin America. Carlsen, an anthropologist who has focused on Guatemalan textiles and cloth production, learned dye chemistry and applied this knowledge to the analysis of ethnographic textiles.

16. Carlsen analyzed yarn from additional textiles for me when I was in residence at the Hearst Museum in the fall of 1988. This information appears in the catalogue section. The data referred to above derived from his visit to the Hearst Museum in 1987.

17. Krystyna Deuss, pers. com. 1988.

18. It is unsatisfactory to dye vegetal fibers with cochineal although it is possible. Red was a desired color. With the availability of alizarin, there was a proliferation of red cotton cloth and clothing as evidenced in museum collections. Men's *tzutes* from Chichicastenango that were woven prior to the twentieth century are predominantly white; within a few decades the desired color was red (Schevill 1985:37). After the 1930s, other red dyes became available. Carlsen and Wenger's research findings make possible the dating of undocumented alizarin-dyed red cotton textiles from the 1880s to the 1930s (Carlsen and Wenger 1991).

19. See Patricia Rieff Anawalt, "The Emperors' Cloak: Aztec Pomp, Toltec Circumstances" (1990). Contemporary textile researchers Virginia Davis and Pamela Scheinman successfully replicated designs that appeared on the cloak of an Aztec emperor from the Codex Ixtilxochitl. The designs were made by two resist-dye techniques, one of which may have been *jaspeado*.

20. For an excellent description of cotton and wool tie-dyeing, see O'Neale 1945:25–26.

21. I have written elsewhere of gender tasks in textile production among the Maya of Guatemala (1985). Including the information in this section, although it is not derived from early twentieth-century examples and therefore is not directly related to the Eisen textile collection, allows me to revise my earlier notions and call attention to misleading information about this topic that continues to be published and discussed.

22. For one example of women weaving on the coast, see Eadweard Muybridge's 1875 photograph in E. Bradford Burns's *Eadweard Muybridge in Guatemala, 1875* (1986:103). The George Byron Gordon photo archive at Peabody Museum, Harvard University, includes primarily posed photographs of costumed Maya in the photographer's studio.

23. Panels and symposia for various conferences, such as The Centre for Cross-Cultural Research on Women, University of Oxford, April 1989; American Anthropological Association meetings, New Orleans, December 1990; and the 47th International Congress of Americanists, New Orleans, July, 1991, focused on gender issues in relation to aspects of material culture, in particular cloth and clothing. Participants in the symposium "Gender Issues in the Creation and Use of Latin American Textiles," chaired by Cherri M. Pancake and Margot Blum Schevill, included research papers and reports by Pancake, Marsha C. Bol, Abby

Sue Fisher, Sharisse D. McCafferty, Geoffrey G. McCafferty, Beate Engelbrecht, Lynn Stephen, Margaret McEldowney, Krystyna Deuss, Oscar H. Horst, Schevill, Martha Amelia Ortiz, Stacy Schaefer, Katharine Siebold, Suzanne Baizerman, Carol V. Norton, Raquel Ackerman, Edwina Williams, and Lynn A. Meisch.

24. Although Geoffrey and Sharisse McCafferty have found no evidence for male spinners and weavers in pre-Columbian Mexico, Lynn Meisch discussed spinning and weaving practices in pre-Columbian Peru. Male backstrap weavers are represented on a Moche vase (A.D. 100–800), and, after the conquest, Guaman Poma de Ayala's illustrations and text reveal both women and men spinning, plying, and weaving (Meisch 1991).

25. See Cherri M. Pancake, "Gender Boundaries in the Production of Guatemalan Ethnographic Textiles" (1989), presented at the "Workshop on the Anthropology of Dress and Gender: Making and Meaning," sponsored by the Centre for Cross-Cultural Research on Women, University of Oxford, April 1989. Her work has informed my thinking in this section.

26. Deuss, however, presented recent field research in which she documented seven examples of crossovers in Guatemalan textile roles—that is, men doing "women's" work and vice versa—that have occurred over the past ten years (1991).

27. My 1978 field notes comment on the wife of a workshop owner outside of Antigua, who was a *ladina* and who spent several hours every day weaving on a treadle loom. I was told that she dyed the yarn that I saw hanging from the clotheslines (Schevill 1980:11). A recent *National Geographic* article includes a photograph of a Maya woman in *traje* from Totonicapán, who is pictured working at a large treadle loom (Garrett 1989:464).

28. Another aspect of textile production is tailoring. Little has been written about this important facet. Since it involves a sewing machine, advocates of the gender-specific model might imply that it was only men's work. Men in Chichicastenango do the tailoring of men's *traje*. In Sololá, women are responsible for the production of cotton cut-and-sewn garments, sometimes hand-sewn but often machine-sewn. In this town men do the tailoring of woolen jackets. These are but a few examples that support the community-specific notion.

29. Janet Catherine Berlo has looked at the use of new materials or new technologies by indigenous peoples that is stimulated by a need for autonomy and self-expression at a particular historical moment. See "Beyond *Bricolage*" in *Textile Traditions of Mesoamerica and the Andes*, Margot Blum Schevill, Janet Catherine Berlo, and Edward B. Dwyer, editors (1991).

30. In San Antonio Aguas Calientes and probably in some other towns, if a family produces a small amount of textiles for sale, it is more desirable to sell within one's home. Tourists may be invited to visit her family by a woman who is vending in a nearby town. This occasion is attractive to tourists and profitable for the family if the visitors buy textiles. In addition, the visitor may be offered treadle-loomed textiles from other locations or garments of family members or friends. My teacher is a particularly astute salesperson, and she has had commissions from abroad. I have interacted with the family for a decade, selling to local stores and friends the textiles they send to me and advising what would be marketable here as fashions move away from ethnic clothing.

31. Space limits me to two examples of anomalies in gender-specific textile production roles. I gave a paper, "Guatemalan Maya Dress and Its Creation: Gender and Ambiguity," at the American Anthropological Association meetings in December 1990. It was part of a panel entitled "The Engendered Subject: Practice and Representation in Mesoamerica." Sally and Richard Price have commented on the "canon of

Western thought that small-scale, non-literate societies exist somehow suspended in time and are extremely slow to change (unless impinged upon from the outside)" (1980:9). I spoke of this concept of the Maya as "timeless" and resistant to change and said that these ahistorical assumptions underestimate the creativity of native peoples and their ability to adapt and reshape their collective pasts. Other panelists explored similar ambiguities or role reversals in pre-Columbian and contemporary Mesoamerica. Colleagues who do fieldwork in Guatemala spoke to me afterward about crossovers in textile production tasks and in other contexts. Current research shared at the 47th International Congress of Americanists has provided more data to support the validity of a dynamic alternative, such as the one I have suggested, to the traditional taxonomic organizations of Maya dress and textile production roles. The American Anthropological Association session went beyond the discussion of biologically gender-defined roles and into the symbolic use of gender-associated dress, body adornment, and other imagery by the pre-Columbian peoples of Mesoamerica.

32. I will use pseudonyms for the family and the other male backstrap weaver I describe.

33. After my return to the United States in the late 1970s, I met another male weaver, Antonio, from San Antonio Aguas Calientes. He was traveling with members of his family and an American woman who had organized weaving demonstrations and lectures. Antonio is a highly accomplished weaver who learned from his mother and cousins. He subsequently moved to the United States and is a successful entrepreneur who imports art from developing countries, particularly those in Latin America.

34. There is an irony that has a cultural and gender-related source: perhaps Rafael could support himself in the United States as a backstrap-loom teacher and demonstrator, like Antonio. He and I gave a gallery talk at the Haffenreffer Museum. I presented the background of Maya textiles, and Rafael demonstrated at the loom. It was a very successful presentation. He told me, however, that at home the gender expectation is that men are treadle-loom weavers, not backstrap weavers. Women dressed in *traje* have opportunities to demonstrate weaving at the Museo Ixchel in Guatemala City and abroad. His mother recently was invited to demonstrate at a gallery in Southern California, and she wanted Rafael to accompany her and also weave. The gallery owner wanted him to wear *traje*, no longer worn in his town, in order to perpetuate the image marketed here and abroad of the "traditional" Maya men in *traje*. Since he was eager to return to the United States, he agreed. His mother obtained the appropriate dress, but at the last minute he was not able to come. Rafael values his skills in economic terms for the sake of his family but not in cultural terms. He is a victim of the gender-technology syndrome perpetuated abroad that has influenced and romanticized the approach the tourist industry takes regarding Maya weavers, their colorful dress, and gender-defined textile production.

35. Tracy Bachrach Ehlers, in a paper, "Artisan Production and the World System," delivered at the American Anthropological Association meetings in Phoenix, 1988, discussed the development of weaving cooperatives in another town on Lake Atitlán, San Antonio Palopo. One cooperative, Hilos del Lago, was started by a Peace Corps volunteer. As in San Juan La Laguna, treadle looms were introduced, and women learned to weave on them. This commercial weaving project, focused on belts and placemats, was successful because of a new road and tourism. Men gave up migratory plantation labor and became involved in the cooperative, which formerly had been run by the women. For various reasons, Hilos del Lago ceased to function, while another local weaving venture has been successful. Another cooperative was

organized and is run by a man. Piecework is subcontracted to weavers who can work in their homes. Designs are created for "New York" taste. Ehlers, in *Silent Looms: Women and Production in a Guatemalan Town* (1990), follows the demise of female family businesses or a system of cottage industries that concentrated on the production of textiles in San Pedro Sacatepéquez, San Marcos.

36. Pers. coms. Susan Redlich, 1990; Lee Ann Ward, 1990, 1991.

CHAPTER 6. THE EISEN GUATEMALAN TEXTILE CATALOGUE

1. Aldona Jonaitis, "Franz Boas, John Swanton, and the New Haida Sculpture at the American Museum of Natural History," in *The Early Years of Native American Art History*, ed. J. C. Berlo (1992). In footnote 6 she cites Jameson's public lecture to the State University of New York at Stony Brook Humanities Institute, "Spatial Equivalents: Post-Modern Architecture and the World Systems." He spoke about "wrapping" in the context of a 1950s house that an architect partially envcloped with new materials and new forms, creating a new building without dismissing or destroying the old one. Jonaitis reverses this process by "unwrapping" or removing the layers of interpretations of "the dominant group's perception of the culture which produced the artwork" in order to study the re-creation of Haida art by Charles Edenshaw for the American Museum of Natural History during the Jesup North Pacific Expedition (1897–1902).

APPENDIX A. CLASSIFICATION OF TEXTILES AND TEXTILE-RELATED OBJECTS IN THE EISEN COLLECTION BY FUNCTION AND TYPE

1. I explored these topics in my thesis (Schevill 1980).
2. I addressed this topic elsewhere while investigating the evolution of textile design in one particular costume element, the man's headcloth or *tzute*, from Chichicastenango (Schevill 1985).
3. I wish to acknowledge Krystyna Deuss's contributions to this section. We are engaged in an ongoing dialogue that started in 1988 via correspondence and visits, in both Berkeley and London. Ann Pollard Rowe's *A Century of Change in Guatemalan Textiles* (1981) traces costume evolution in eleven towns from the early 1900s to the 1980s. This research, in addition to the other research cited in this essay, has been most helpful to me in this book and my other books (Schevill 1985, 1986).
4. I have not repeated the department for each town mentioned unless there are two towns with the same name, not unusual for Guatemala. I have dropped the saints' names that precede the Maya names of towns if they are no longer in common usage.
5. I wonder if Eisen's purchase and thus appropriation of the *cofradía* costumes of the *martooms* contributed to the gradual disappearance of this special dress. It is clear from Eisen's photographs that there were at least ten serapes in use. With his purchase of four, six others remained as did the "old man" who still knew how to weave serapes.
6. Krystyna Deuss, pers. com. 1988. Other Guatemalan textile researchers are unfamiliar with this term, which translated may mean "serape-like' because of the weft-faced texture that completely covers the warps and creates a smooth textile (Pancake, pers. com. 1990).
7. If the weaver was a woman, as O'Neale suggests, this is an early example of a crossover in gender-defined roles in textile production.
8. Krystyna Deuss, pers. com. 1988.
9. I have never seen textiles like these; other researchers also thought they were unique.

10. In negotiations with weavers or shop owners, extra textiles are occasionally included with those that one wants to buy. Eisen purchased twenty-one textiles and costume elements in Chichicastenango.
11. The Hearst Museum received a collection in 1989—the Whittaker-Tellefson collection—of over 300 Guatemalan textiles manufactured from the 1920s to the 1970s. Many of these textiles have holes, patches, and other signs of wear and were still in use when collected.
12. Margaret Ross McEldowney's master of arts thesis, *An Analysis of Change in Highland Guatemalan Tapestry Hairribbons* (1982) focuses on this topic.
13. Christopher Lutz, pers. com. 1990.
14. Eisen, however, did not acquire headcloths from these areas.
15. Eisen actually purchased six headcloths from Chichicastenango. One example, 3-15, was exchanged with the American Museum of Natural History in 1907, 65-3272.
16. In my own collection, I have seven different styles woven over the past ten years. An older example from the 1930s was cut up into pieces and reconstructed into a shoulder-style bag by some enterprising entrepreneur. I was able to deconstruct it and to restore it to the original shape.
17. Eisen purchased two women's headcloths. The other one, 3-148, was traded to the American Museum of Natural History, 65-3275.
18. I prefer to use *huipil,* a term derived from Nahuatl, the language of the Aztecs that was adopted by the Maya; the term *blouse* communicates a cut-and-sewn garment. The *huipil* is not tailored but is worn tucked into a skirt with a belt wrapped around the waist.
19. One could postulate that, in 1902, treadle-loomed *huipiles* were produced in Totonicapán for Quezaltenango, as was the case from the 1930s to the 1980s. Eisen does not comment on this possibility.
20. The Spanish word is *fábrica* and is translated as "factory," but these weaving establishments or *tallers* resemble workshops, not modern factories in the Western sense. Sometimes the workshop is located in the weaver's home, and the owner hires other weavers.
21. Black wool treadle-loomed yardage is called *jerga* by the Maya. Christopher Lutz, pers. com. 1990.
22. The backstrap loom is discussed in more detail in Chapter 5.
23. This would have been the common type of everyday skirt popular in the highlands, as discussed in the section on skirts. There is not a complete example in the collection.
24. As already discussed, Eisen commissioned a serape for himself from an old male weaver, which is now part of the collections of the American Museum of Natural History. Museum research has uncovered similar serapes in the collections of the National Museum of the American Indian, donated in the 1930s. Mark Winter has seen other examples in museum collections (pers. com. 1990). One could hypothesize that production of the serape-style textile continued for several decades but was eventually discontinued. Tradle-loomed tapestry-woven rugs and blankets are produced by weavers in Momostenango, El Quiché.
25. Eisen did, however, collect a loom from Aguacatán with dark blue yardage, probably intended for a skirt. There is an indigo-and-white plaid skirt, 3-16423, in the Hearst Museum collections. The date of manufacture precedes 1906.

APPENDIX B. THE "COFRADIA" OF THE INDIANS OF GUATEMALA

1. *Escura* is not a Spanish word. It probably refers to the symbol or *escudo* on the *bastones de mano* (they are also called "monstrances"). These are clearly visible in Eisen's photographs of the Totonicapán *cofradía* (editor's note).

Glossary of Weaving Terminology

Appliqué: A technique for decorating cloth by stitching pieces of cut and shaped material onto the ground fabric.

Backstrap loom: A weaving apparatus with a continuous warp supported by two bars: a front bar tied to a support, and a back bar attached to a strap around the weaver's waist. Tension is controlled by the movement backward or forward of the weaver's body.

Balanced plain weave: The equal spacing of warp and weft yarns that are either identical or approximately equal in size and flexibility.

Basket weave: A plain weave structure of paired warps and wefts.

Batten: A piece of native wood, hand-carved, used to separate the sheds of the backstrap loom and to secure the weave.

Brocade, brocading: A term used for patterning with weft or warp floats in addition to the ground weave; these floats are not essential to the structure of the cloth.

Counterbalance loom: The type of treadle loom most commonly used in Guatemala, having either two or four harnesses tied by ropes to a roller at the top of the loom.

Double-faced: Term used for compound weaves whose faces are structurally identical, as contrasted with two-faced or single-faced. The Maya weave double-faced supplementary weft brocading, which is known as *marcador*.

Dovetailed tapesty: Wefts from adjacent design areas turn back alternately around the warp that is their common boundary. No slit is formed.

Eccentric-weft weave: A pattern created by wefts that deviate from the horizontal and from their normal right-angled relation to the warps.

Eye: The opening in a heddle.

Felting: The application of heat and moisture to fibrous material to create a fabric.

Harness: A long narrow frame that holds the heddles.

Heddle: The device used to lift chosen warp threads together in order to produce the shed, or space for the weft to pass through.

Ikat: A word of Malay origin; describes a method of resist or tie-dyeing done by binding warps or wefts at designated intervals, then immersing them in dye. When bindings are removed, patterns result from areas of yarns not penetrated by the dye.

Interlocking tapestry weave: Wefts from adjacent design areas link with each other each time they meet; no slit is formed.

Joining: A loosely woven area of a backstrap-woven textile indicating where the weaver joins the two parts of the woven web; a backstrap-loom weaver usually weaves eight to ten rows on one end of the backstrap loom and turns it around and weaves the cloth from the other end. This process leaves an area unwoven and difficult to weave tightly.

Knotless netting: An open-textured single-element fabric with meshes of fixed dimensions secured by loops.

Macramé: Fringe or trimming of knotted thread.

Open weave: One in which there is space between the warps and wefts; sometimes mistakenly called a gauze weave.

Pickup: A technique wherein a weaver picks up, by hand or with a pickup stick, warp or weft yarns to create patterns.

Plain weave: The simplest possible interlacing of warp and weft in unvarying alternation, over and under. It may be balanced, weft-faced, weft-predominant, warp-faced, or warp-predominant.

Plaiting: One set of element structures in which the elements interlink with adjacent ones.

Ply: A verb meaning to twist; in two-ply, two single threads have been twisted together.

Randa: A hand-stitched joining of two pieces of cloth with embroidery yarns.

Rep weave: Warp- or weft-faced plain weave.

Selvedge: The self-finished edge of a fabric, formed by the threads of one element turning around the threads of the other element.

Sett: Weaver's term for warp and weft count.

Shed: The space between the two levels of warps. In backstrap-loom weaving, the shed is made by lifting the alternate warps with the string heddle rod or by using the shed rod. In treadle-loom weaving, sheds are made by depressing the treadles.

Shuttle: A wooden or bamboo apparatus for carrying weft yarn through the shed from selvedge to selvedge.

Simple linking: Successive rows of running open loops are formed by a stitch that is known in sewing as overcasting or whipping.

Single-element: One continuous fiber that is manipulated to create a textile as in crochet or knotless netting.

Single-faced supplementary weft brocading: This term applies to patterning that appears on one side of the textile only.

Sprang: In a set of elements that are stretched between two cords or beams, the interworking can be accomplished at both ends simultaneously. Creates a stretchy textile.

Supplementary weft brocading: Extra wefts are used for patterning in addition to the ground weave; these wefts are not essential to the structure of the cloth.

Tapestry weave: Weft-faced plain weave characterized by the use of discontinuous warps for patterning.

Tie-up: Tying of horizontal levers attached to harnesses and treadles to treadles.

Treadle loom: An upright, stationary wooden structure for weaving introduced by the Spaniards. Warps extend over back and front beams and are held at rigid tension.

Twill weave: A weave that is characterized by a diagonal alignment of floats for which a minimum of three warp groupings is essential.

Two-faced supplementary weft brocading: Patterning that floats on the reverse side between pattern areas forming an inverse of the design on the other side.

Warp: Vertical threads that form the web.

Warp-faced: A fabric structure characterized by the close sett of the warps, completely covering the wefts.

Warp-predominant: A fabric in which warps outnumber the wefts but do not entirely conceal them.

Weft: Horizontal threads that form the web.

Weft-faced: A fabric structure that results when wefts are closely compacted over more widely spaced warps and completely cover the warps.

Weft-predominant: A fabric in which wefts outnumber the warps but do not entirely conceal them.

Bibliography

PERSONAL COMMUNICATIONS

Ahrens, Virginia, 1990
Arriola, Jorge Luis, 1989
Arriola de Geng, Olga, 1989
Brandford, Joanne Segal, 1985
Brown, Geoffrey, 1988
Carlsen, Robert, 1987, 1988, 1989, 1990
Cohen, John, 1990
Davis, Virginia, 1989
Deuss, Krystyna, 1988, 1989, 1990
Howe, Catherine, 1988
Lutz, Christopher, 1990
Maeder, Edward, 1989
Muncake, Cherri M., 1990, 1991
Redlich, Susan, 1990
Schevill, James, 1989
Schevill, Margot, 1989, 1990
Ward, Lee Ann, 1990, 1991
Winter, Mark, 1990

Adams, Marie Jeanne
1973 Structural Aspects of a Village Art. *American Anthropologist*
 75:265–279.
Anawalt, Patricia Rieff
1981 *Indian Clothing before Cortes.* Norman: University of
 Oklahoma Press.
1990 The Emperors' Cloak: Aztec Pomp, Toltec Circumstances.
 American Antiquity 55(2):291–307.
Anderson, Marilyn
1978 *Guatemalan Textiles Today.* New York: Watson-Guptill
 Publications.
Annis, Sheldon
1987 *God and Production in a Guatemalan Town.* Austin:
 University of Texas Press.
Arriola de Geng, Olga
1989 *Técnicas de bordados en los trajes indígenas de Guatemala.*
 Guatemala: Litografías Modernas.
Asturias de Barrios, Linda
1985 *Comalapa: Native Dress and Its Significance.* Guatemala
 City: Museo Ixchel del Traje Indígena.
1991 Woman's Costume as a Code in Comalapa, Guatemala. In
 Textile Traditions of Mesoamerica and the Andes, edited by
 Margot Blum Schevill, Janet Catherine Berlo, and Edward B.
 Dwyer. New York: Garland Publishing.
Barrios E., Lina E.
1983 *Hierba, montañas y el árbol de la vida en San Pedro
 Sacatepéquez, Guatemala.* Guatemala: Museo Ixchel del
 Traje Indígena.
Barry, Tom, and Deb Preusch, editors
1986 *The Central American Fact Book.* New York: Grove Press.
Barthes, Roland
1974 Elementos de semiología. In *La semiología,* 3d ed., edited
 by Roland Barthes, Claude Bremond, Tzevetan Todorov,
 and Christian Metz. Buenos Aires: Editorial Tiempo
 Contemporaneo.
1983 *The Fashion System.* Translated by Mathew Ward and Richard
 Howard. New York: Hill and Wang.
Berlo, Janet Catherine
1991 Beyond *Bricolage:* Women and Aesthetic Strategies in Latin
 American Textiles. In *Textile Traditions of Mesoamerica and
 the Andes,* edited by Margot Blum Schevill, Janet Catherine
 Berlo, and Edward B. Dwyer. New York: Garland Publishing.
Berlo, Janet Catherine, editor
1992 *The Early Years of Native American Art History: Essays on
 the Politics of Scholarship and Collecting.* Seattle: University
 of Washington Press.
Bjerregaard, Lena
1977 *Techniques of Guatemalan Weaving.* New York: Van
 Nostrand Reinhold.
Blomberg, Nancy J.
1988 *Navajo Textiles: The William Randolph Hearst Collection.*
 Tucson: University of Arizona Press.
Bogatyrev, Petyr
1971 *Function of Folk Costume in Moravian Slovakia.* The Hague,
 Paris: Mouton Publishers.

Borah, Woodrow
 1943 *Silk Raising in Colonial Mexico.* Ibero-Americana 20. Berkeley:
 University of California Press.
Broudy, Eric
 1979 *The Book of Looms.* New York: Van Nostrand Reinhold.
Bunch, Roland, and Robert Bunch
 1977 *The Highland Maya.* Visalia, Calif.: Josten's Publications.
Burns, E. Bradford
 1980 *The Poverty of Progress: Latin America in the Nineteenth
 Century.* Berkeley: University of California Press.
 1986 *Eadweard Muybridge in Guatemala, 1875: The Photographer
 as Social Recorder.* Berkeley: University of California Press.
Cambranes, J. C.
 1975 *Aspectos del desarrollo económico y social de Guatemala, a
 la luz de fuentes históricas alemanas, 1868–1885.*
 Publicación del Instituto de Investigaciones Económicas y
 Sociales (IIES). Guatemala: Universidad de San Carlos de
 Guatemala.
 1985a *Café y campesinos en Guatemala, 1853–1897.* Colección
 Realidad Nuestra, Vol. No. 12. Guatemala: Editorial
 Universitaria de Guatemala.
 1985b *Coffee and Peasants: The Origins of the
 Modern Plantation Economy in Guatemala, 1853–1897.*
 Stockholm: Institute of Latin American Studies.
Carlsen, Robert, and David Wenger
 1991 Myth versus Fact: The Actual Use of Dyes in Guatemalan
 Textiles. In *Textile Traditions of Mesoamerica and the
 Andes,* edited by Margot Blum Schevill, Janet Catherine
 Berlo, and Edward B. Dwyer. New York: Garland Publishing.
Carmack, Robert M.
 1979 *Historia social de los Quichés.* Seminario de Integración
 Social Guatemalteca, Publicación No. 38. Guatemala:
 Editorial José de Pineda Ibarra.
 1983 Spanish-Indian Relations in Highland Guatemala, 1800–1944.
 In *Spaniards and Indians in Southeastern Mesoamerica:
 Essays on the History of Ethnic Relations,* edited by Murdo J.
 MacLeod and Robert Wasserstrom. Lincoln: University of
 Nebraska Press.
 n.d. A Political Ethnohistory of Momostenango. Manuscript in
 possession of the author.
Carmack, Robert M., editor
 1988 *Harvest of Violence.* Norman: University of Oklahoma Press.
Clifford, James
 1988 *The Predicament of Culture.* Cambridge, Mass.: Harvard
 University Press.
Cohen, John
 1987 The Study of Ethnographic Textiles in Peru: A Personal View.
 Paper presented at "Current Topics in Ethnographic Costume
 and Cloth from Middle America and the Central Andes of
 South America," Haffenreffer Museum of Anthropology,
 Brown University, Bristol, R.I., March.
Collingwood, Peter
 1974 *The Techniques of Sprang.* New York: Watson-Guptill
 Publications.
Conte, Christine
 1984 *Maya Culture & Costume.* A catalogue of the Taylor
 Museum's E. B. Ricketson Collection of Guatemalan Textiles.
 Colorado Springs: The Taylor Museum of the Colorado
 Springs Fine Arts Center.

Cook, Sherburne F., and Woodrow Borah
1971–1979 *Essays in Population History.* Three volumes. Berkeley: University of California Press.

Crawford, Morris De Camp
1915 *Peruvian Textiles.* American Museum of Natural History, Anthropology Papers 12:53–104. New York.

Davidson, D. S.
1935 Knotless Netting in America and Oceania. *American Anthropologist* n.s. 37:117–134.

Davis, Shelton H.
1970 Land of Our Ancestors: A Study of Land Tenure and Inheritance in the Highlands of Guatemala. Unpublished Ph.D. dissertation, Department of Social Relations, Harvard University.

Delgado Pang, Hilda Schmidt de
1963 Aboriginal Guatemalan Handweaving and Costume. Ph.D. dissertation, Department of Anthropology, Indiana University.

Deuss, Krystyna
1981 *Indian Costumes from Guatemala.* Twickenham, Great Britain: CTD Printers.
1991 Reversal of Gender Roles in the Quezaltenango/Totonicapán Area of Guatemala. Report presented at the 47th International Congress of Americanists, Tulane University, New Orleans, La., July 7–11.

Dickey, Sandra Ferial
1964 A Historical Review of Knotless Netting in South America. Master of Arts thesis. Department of Decorative Art, University of California at Berkeley.

Dieseldorff, Dr. Herbert Quirin
1984 *X Balám Q'eu, El Pájaro Sol: El Traje Regional de Cobán.* Guatemala: Museo Ixchel del Traje Indígena.

Dieterich, Mary G., John T. Erickson, and Eric Younger
1979 *Guatemalan Costumes: The Heard Museum Collection.* Phoenix: The Heard Museum.

Drooker, Penelope
1981 *Hammock Making Techniques.* Sanbornville, N.H.: published by Penelope Drooker.

Early, John D.
1982 *The Demographic Structure and Evolution of a Peasant System: The Guatemalan Population.* Boca Raton: University Presses of Florida.

Ehlers, Tracy Bachrach
1988 Artisan Production and the World System. Paper presented at American Anthropological Association meeting, Phoenix, November.
1990 *Silent Looms: Women and Production in a Guatemalan Town.* Boulder, Colo.: Westview Press.

Eisen, Gustavus A. (August Gustav)
1879 *On the* Oligochaeta *Collected during the Swedish Expeditions to the Arctic Regions in the Years 1870, 1875, and 1876.* Smithsonian Institution 4.
1881a Letter to Spencer F. Baird. Smithsonian Institution Archives, Record Unit 28, Office of the Secretary, Spencer F. Baird, 1879–1882.
1881b *Eclipidrilidae and Their Anatomy. A New Family of the Limicolide* Oligochaeta. Uppsala.
1886 En resa i Guatemala. *Ymer* 6:89–107, 113–129.
1887 En resa i Guatemala. *Ymer* 7:145–178.
1888 On Some Ancient Sculpture from the Pacific Slope of

Guatemala. *Memoirs of the California Academy of Sciences* 2 (2):9–20.

1890 The Raisin Industry. A Practical Treatise on the Raisin Grapes, Their History, Culture and Curing. *Memoirs of the California Academy of Sciences* 3.

1897 *Fig Culture, Edible Figs: Their Culture and Curing.* U.S. Department of Agriculture, Division of Pomology, Bulletin, No. 5.

1902a Letter to President Wheeler. Department of Anthropology Records, University of California Archives, Bancroft Library.

1902b Notes Accompanying Guatemalan Catalogue. Manuscript. Berkeley: Hearst Museum of Anthropology.

1902c Photograph Album with Eisen's Own Photographs and Captions. Berkeley: Hearst Museum of Anthropology.

1902d Letter to Phoebe Hearst. Bancroft Library, University of California at Berkeley.

1903a The Earthquake and Volcanic Eruption in Guatemala in 1902. *Bulletin of the American Geographical Society* 35:325–352.

1903b Notes during a Journey in Guatemala, March to December 1902. *Bulletin of the American Geographical Society* 35:1–28.

1903c The "Cofradia" of the Indians of Guatemala. Unpublished manuscript. San Francisco: California Academy of Sciences.

1905 Letter to Phoebe Hearst. Bancroft Library, University of California at Berkeley.

1916 Letter to Alice Eastwood. Special Collections, California Academy of Sciences, San Francisco.

1923 *The Great Chalice of Antioch, on Which Are Depicted in Sculpture the Earliest Known Portraits of Christ, Apostles and Evangelists*, Vols. 1–2. New York: Kouchakji Frères.

1927 *Glass, Its Origin, History, Chronology, Technique, and Classification until the Sixteenth Century.* Assisted by Fahim Kouchakji. New York: W. E. Rudge.

1932 *Portraits of Washington.* New York: R. Hamilton & Associates.

1938 Letter to Edward Gifford. Department of Anthropology Records, University of California Archives, Bancroft Library.

1964 A History of Sequoia National Park. Special Collections, California Academy of Sciences, San Francisco.

1986a Un viaje por Guatemala. Translated by Athos Barés. *Mesoamérica* 11:155–173.

1986b Un viaje por Guatemala. Translated by Athos Barés. *Mesoamérica* 12:417–435.

1987 Un viaje por Guatemala. Translated by Athos Barés. *Mesoamérica* 13:205–242.

Emery, Irene
1966 *The Primary Structures of Fabrics:* Washington, D.C.: The Textile Museum.

Fane, Diana, Ira Jacknis, and Lise M. Breen
1991 *Objects of Myth and Memory: American Indian Art at the Brooklyn Museum.* Seattle: University of Washington Press.

Franquemont, Christine, and Edward Franquemont
1988 Learning to Weave in Chinchero. *The Textile Museum Journal* 26:55–78. Washington, D.C.

Fuente, Julio de la
1952 Ethnic and Communal Relations. In *Heritage of Conquest: The Ethnology of Mesoamerica*, edited by Sol Tax and members of the Viking Fund Seminar on Mesoamerican Ethnology. Glencoe, Ill. The Free Press.

Fuentes y Guzmán, Francisco Antonio de
 1932–1933 *Recordación Florida.* Three volumes. Biblioteca "Goa-
 themala," Vols. 6–8. Guatemala: Sociedad de Geografía e
 Historia de Guatemala.

García Elgueta, Manuel
 1897 *Un pueblo de los Altos: Apuntamientos para su historia.*
 Quezaltenango: Establecimiento Tipigráfico "Popular."

Garrett, Wilbur E., editor
 1989 La ruta maya. *National Geographic* 176 (4):424–479.

Goodman, J. T.
 1897 The Archaic Maya Inscriptions. Appendix in *Biología
 Centrali-Americána.* London: Taylor and Francis.

Gordon, Beverly
 1989 The Woodland Indian Bandolier Bag: Cultural Adaptation and
 Efflorescence. Paper delivered at the Costume Society
 Meetings. Denver.

Guamán Poma de Ayala, Felipe
 1980 *El primer nueva corónica y buen gobierno,* edited by John
 [1583–1615] Murra and Rolena Adorno. Translated by Jaime L. Urioste.
 Mexico, D.F.: Siglo Veintiuno.

Guatemala
 1881 *Censo General de la República de Guatemala levantado el
 año de 1880.* Guatemala: Establecimiento Tipográfico de "El
 Progreso."

Hägglund, S. G.
 1941 *Korsbaneret.* Rock Island, Ill.: Augustana Book Concern.

Hail, Barbara A., and Kate C. Duncan
 1989 *Out of the North: The Subarctic Collection of the
 Haffenreffer Museum of Anthropology, Brown University.*
 Bristol, R.I.: The Haffenreffer Museum of Anthropology.

Handy, Jim
 1984 *Gift of the Devil: A History of Guatemala.* Boston: South End
 Press.

Hedlund, Ann Lane, editor
 1989 *Perspectives on Anthropological Collections from the
 American Southwest: Proceedings of a Symposium.* Tempe:
 Arizona State University.

Helms, Mary
 1981 *Cuna Molas and Coclé Art Forms: Reflections on
 Panamanian Design, Style and Symbols.* Working Papers in
 the Traditional Arts 7. Philadelphia: Institute for the Study of
 Human Issues.

Hendrickson, Carol
 1991 Dress and the Human Landscape in Guatemala: The Case
 of Tecpán, Chimaltenango. In *Textile Traditions of
 Mesoamerica and the Andes,* edited by Margot Blum Schevill,
 Janet Catherine Bérlo, and Edward B. Dwyer. New York:
 Garland Publishing.

Herrera Escudero, María Luisa
 1984 *Trajes y bailes de España.* Madrid: Editorial Everest.

Herskovits, Melville J., and Frances S. Herskovits
 1934 *Rebel Destiny: Among the Bush Negroes of Dutch Guiana.*
 New York: McGraw-Hill.

Hess, B. B., and M. M. Ferree, editors
 1987 Introduction. In *Analyzing Gender: A Handbook of Social
 Science Research.* Newbury Park, Calif.: Sage Publications.

Heyde, Henry Th.
 1895 Letter to Frederick W. Putnam. Anthropology Department
 Archives, American Museum of Natural History.

1896 Letter to Frederick W. Putnam. Anthropology Department
 Archives, American Museum of Natural History.
1901 Letter to Frederick W. Putnam. Anthropology Department
 Archives, American Museum of Natural History.
Hickman, Pat
1987 *Innerskins/Outskins: Gut and Fishskin.* San Francisco: San
 Francisco Craft and Folk Art Museum.
Jonaitis, Aldona
1992 Franz Boas, John Swanton, and the New Haida Sculpture at
 the American Museum of Natural History. In *The Early Years
 of Native American Art History: Essays on the Politics of
 Scholarship and Collecting,* edited by Janet Catherine Berlo.
 Seattle: University of Washington Press.
Jones, Chester Lloyd
1940 *Guatemala: Past and Present.* Minneapolis: University of
 Minnesota Press.
Kaeppler, Adrienne L.
1979 Aspects of Polynesian Aesthetic Traditions. In *The Art of the
 Pacific Islands.* Washington, D.C.: National Gallery of Art.
Kaiser, Susan B.
1985 *The Social Psychology of Clothing and Personal Adornment.*
 New York: Macmillan Publishing Company.
Kent, Kate Peck
1983 *Prehistoric Textiles of the Southwest.* Santa Fe and
 Albuquerque: School of American Research Press.
Kramer, Wendy Jill
1990 The Politics of Encomienda Distribution in Early Spanish
 Guatemala, 1524–1544. Unpublished Ph.D. Dissertation,
 Department of History, University of Warwick, Great Britain.
Kramer, Wendy, W. George Lovell, and Christopher H. Lutz
1991 Fire in the Mountains: Juan de Espinar and the Indians of
 Huehuetenango, 1525–1560. In *Columbian Consequences,*
 Vol. 3, edited by David Hurst Thomas. Washington, D.C.:
 Smithsonian Institution Press.
Krech III, Shepard
1989 *A Victorian Earl in the Arctic.* London: The British Museum.
 Seattle: The University of Washington Press.
Kroeber, Alfred L.
1905 Letter to Gustavus A. Eisen. Bancroft Library, University of
 California, Berkeley.
1907 Letter to Clark Wissler. Anthropology Department Archives,
 American Museum of Natural History.
Kunz, George Frederick
1913 *The Curious Lore of Precious Stones.* Philadelphia and
 London: J. B. Lippincott Co.
La Farge, Oliver
1940 Maya Ethnology: The Sequence of Cultures. In *The Maya and
 Their Neighbors,* edited by Clarence L. Hay, Ralph L. Linton,
 Samuel K. Lathrop, Harry L. Shapiro, and George C. Vaillant.
 New York and London: D. Appleton-Century Company.
Laird, Helen
1986 *Carl Oscar Borg and the Magic Region.* Layton, Utah:
 Gibbs M. Smith.
Lathbury, Virginia Locke
1974 Textiles as the Expression of an Expanding World View: San
 Antonio Aguas Calientes. Master of Arts thesis, Department
 of Anthropology, University of Pennsylvania.
Laver, James
1949 *Style in Costume.* Boston: Houghton Mifflin.

Lee, Molly
 1991 Appropriating the Primitive: Turn-of-the-Century Collection and Display of Native Alaskan Art. *Arctic Anthropology* 28 (1):6–15.

Lehmann, Herbert
 1962 Comments written in the catalogue of the Eisen Guatemalan Textile Collection. Berkeley: Hearst Museum of Anthropology, University of California.

Lévi-Strauss, Claude
 1966 *The Savage Mind.* Chicago: The University of Chicago Press.

López López, Agustín
 1982 *Tejeduría artesenal (Manual).* Guatemala: Sub-Centro Regional de Artesanías y Artes Populares.

Lovell, W. George
 1985 *Conquest and Survival in Colonial Guatemala: A Historical Geography of the Cuchumatán Highlands, 1500–1821.* Kingston and Montreal: McGill-Queen's University Press.

Lovell, W. George, and William R. Swezey
 1982 The Population of Southern Guatemala at Spanish Contact. *Canadian Journal of Anthropology* 3/1 Fall:71–84.

Luján Muñoz, Jorge
 1988 *Agricultura, mercado y sociedad en el Corregimiento del Valle de Guatemala, 1670–80.* Cuadernos de Investigación, No. 2-88. Guatemala: Dirección General de Investigación, Universidad de San Carlos de Guatemala.

Lurie, Alison
 1981 *The Language of Clothes.* New York: Random House.

Lutz, Christopher H.
 1982 *Historia sociodemográfica de Santiago de Guatemala, 1541–1773.* Antigua Guatemala and South Woodstock, Vt.: Centro de Investigaciones Regionales de Mesoamérica.
 forthcoming La población no española y no indígena: Sus divisiones y evolución demográfica, 1700–1821. In *Historia General de Guatemala*, Vol. 3, general editor, Jorge Luján Muñoz.

Lutz, Christopher H., and W. George Lovell
 1990 Core and Periphery in Colonial Guatemala. In *Guatemalan Indians and the State: 1540–1988*, edited by Carol A. Smith. Austin: University of Texas Press.

Lutz, Christopher H., and Stephen Webre
 1985 The Archivo General de Centro América. In *Research Guide to Central America and the Caribbean*, editor-in-chief, Kenneth J. Grieb. Madison: University of Wisconsin Press.

McArthur, Harry S.
 1961 Estructura político-religiosa de Aguacatán. *Guatemala Indígena* 1 (2):41–56.

McCafferty, Sharisse D., and Geoffrey G. McCafferty
 1991 Spinning and Weaving as Female Gender Identity in Post-Classic Mexico. In *Textile Traditions of Mesoamerica and the Andes*, edited by Margot Blum Schevill, Janet Catherine Berlo, and Edward B. Dwyer. New York: Garland Publishing.

McCracken, Grant
 1988 *Culture and Consumption: New Approaches to the Symbolic Character of Consumer Goods and Activities.* Bloomington and Indianapolis: Indiana University Press.

McCreery, David
 1976 Coffee and Class: The Structure of Development in Liberal Guatemala. *Hispanic American Historical Review* 56 (3):438–460.

1981 *Desarrollo económico y política nacional: El ministerio de
 fomento de Guatemala, 1871–1885*. Guatemala: Centro de
 Investigaciones Regionales de Mesoamérica.
1983 Debt Servitude in Rural Guatemala, 1876–1936. *Hispanic
 American Historical Review* 63 (4):735–759.
1986 "An Odious Feudalism": *Mandamiento* Labor and
 Commercial Agriculture in Guatemala, 1858–1920. *Latin
 American Perspectives* 13 (1).

McEldowney, Margaret Ross
1982 An Analysis of Change in Highland Guatemalan Tapestry
 Hairribbons. Master of Arts thesis, Department of Nutritional
 Sciences and Textiles, University of Washington.

MacLeod, Murdo J.
1973 *Spanish Central America: A Socioeconomic History,
 1520–1720*. Berkeley: University of California Press.
1983 Ethnic Relations and Indian Society in the Province of
 Guatemala, ca. 1620–ca. 1800. In *Spaniards and Indians in
 Southeastern Mesoamerica: Essays on the History of Ethnic
 Relations*, edited by Murdo J. MacLeod and Robert
 Wasserstrom. Lincoln: University of Nebraska Press.

MacLeod, Murdo J., and Robert Wasserstrom, editors
1983 *Spaniards and Indians in Southeastern Mesoamerica: Essays
 on the History of Ethnic Relations*. Lincoln: University of
 Nebraska Press.

Madigan, Douglas C.
1976 Santiago Atitlán, Guatemala: A Socioeconomic and
 Demographic History. Unpublished Ph.D. dissertation,
 Department of History, University of Pittsburgh.

Martínez Peláez, Severo
1970 *La patria del criollo: Ensayo de interpretación de la realidad
 colonial guatemalteca*. San José, Costa Rica: EDUCA, 1983,
 9th ed.

Maudslay, Alfred Percival
1889–1902 *Biología Centrali-Americána*. London: Taylor and Francis.

Maudslay, Alfred Percival, and Anne Cary Maudslay
1899 *A Glimpse at Guatemala*. London: John Murray.

Mayén, Guisela
1986 *Tzute y jerarquía en Sololá*. Guatemala: Museo Ixchel del
 Traje Indígena.

Maynard, Eileen Anne
1963 The Women of Palin: A Comparative Study of Indian and
 Ladino Women in a Guatemalan Village. Unpublished Ph.D.
 dissertation, Department of Anthropology, Cornell
 University.

Meisch, Lynn A.
1991 The Missing Half: Pre-Hispanic and Contemporary Traditions
 of Andean Males as Spinners and Weavers. Paper presented at
 the 47th International Congress of Americanists, Tulane
 University, New Orleans, July 7–11.

Mejía de Rodas, Idalma, and Rosario Miralbés de Polanco
1989 *Change in Colotenango: Costume, Migration, and Hierarchy*.
 Guatemala City: Museo Ixchel del Traje Indígena.

Meyer, Michael
1985 *Strindberg: A Biography*. New York: Random House.

Morales Hidalgo, Italo
1982 *U Cayibal Atziak: Imágenes en los tejidos guatemaltecos*.
 Guatemala: Four Ahau Press.

Mörner, Magnus
1979 *Historia social latinoamericana (nuevos enfoques)*.
 Caracas–San Cristóbal: Universidad Católica Andrés Bello.

Morris, Walter F., Jr.
1980 Luchetik: *The Woven Word from Highland Chiapas.* San Cristóbal de las Casas, Mexico: Publicaciónes Pokok de la Cooperativo de Artesanas Indígenas, Sna Jolobil.
1985 Flowers, Saints, and Toads: Ancient and Modern Maya Textile Design Symbolism. *National Geographic Research* 1 (1):63–79.

Nash, Manning
1970 The Impact of Mid–Nineteenth Century Economic Change upon the Indians of Middle America. In *Race and Class in Latin America,* edited by Magnus Mörner. New York: Columbia University Press.

Navarro, José María
1874 *Memoria de San Miguel Milpas Dueñas.* Guatemala: Imprenta de Luna.
1961 Precursores de los estudios etnológicos en Guatemala. *Guatemala Indígena* 1 (3–4):137–153.

Newson, Linda
1986 *The Cost of Conquest: Indian Decline in Honduras under Spanish Rule.* Dellplain Latin American Studies, No. 20. Boulder, Colo.: Westview Press.

Niessen, Sandra A.
1991 Interpreting Indonesian Weaving Techniques. Paper presented to the 18th Annual Conference, Canadian Anthropology Society, University of Western Ontario, London, May.

O'Neale, Lila M.
1945 *Textiles of Highland Guatemala.* Publication 567. Washington, D.C.: Carnegie Institution of Washington.

Osborne, Lilly de Jongh
1935 *Guatemalan Textiles.* Publication 6. New Orleans: Middle American Research Institute.
1965 *Indian Crafts of Guatemala and El Salvador.* Norman: University of Oklahoma Press.

Otzoy, Irma
1988 Identity and Higher Education among Mayan Women. Master of Arts thesis, Department of Anthropology, University of Iowa, Iowa City.

Otzoy, Irma, and Enrique Sam Colop
1990 Identidad étnica y modernización entre los mayas de Guatemala. *Mesoamérica* 19:96–100.

Pancake, Cherri M.
1988 Nuevos métodos en la interpretación de textos gráficos: Aplicaciones de la 'teoría del lenguaje' a los textiles autóctonos de Guatemala. *Mesoamérica* 16:311–334.
1989 Gender Boundaries in the Production of Guatemalan Ethnographic Textiles. Paper presented at the "Workshop on the Anthropology of Dress and Gender: Making and Meaning," sponsored by the Centre for Cross-Cultural Research on Women, University of Oxford, April.
1991 Gender Boundaries in the Production of Latin American Textiles: How Real Are They? Paper presented at the 47th International Congress of Americanists, Tulane University, New Orleans, Louisiana, July 7–11.

Pancake, Cherri M., and Sheldon Annis
1982 El arte de la producción: Aspectos socio-económicos del tejido a mano en San Antonio Aguas Calientes, Guatemala. *Mesoamérica* 4:387–413.

Paul, Lois
1974 The Mastery of Work and the Mystery of Sex in a Guatemalan Village. In *Women, Culture and Society,* edited by Michelle

Zimbalist Rosaldo and Louise Lamphere. Stanford, Calif.:
Stanford University Press.

Pettersen, Carmen L.
1976 *The Maya of Guatemala.* Seattle: The University of
Washington Press.

Pfaffenberger, Byron
1988 Fetished Objects and Humanised Nature: Towards an
Anthropology of Technology. *Man* 23:236–252.

Phillips, Ruth B.
1989 Native American Art and the New Art History. *Museum
Anthropology* 13 (4):5–13.

Piel, Jean
1989 *Sajcabaja: Muerte y resurrección de un pueblo de
Guatemala, 1500–1970.* Translated by Eliana Castro Ponlsen.
Guatemala: Seminario de Integración Social Guatemalteca
and Mexico: Centre d'Études Mexicaines et
Centramericaines.

Pollock, Griselda
1988 *Vision and Difference: Femininity, Feminism and the
Histories of Art.* New York: Routledge.

Prechtel, Martin, and Robert S. Carlsen
1988 Weaving and Cosmos amongst the Tzutujil Maya of
Guatemala. *RES* 15:122–132.

Price, Sally
1984 *Co-wives and Calabashes.* Ann Arbor: The University of
Michigan Press.

Price, Sally, and Richard Price
1980 *Afro-American Arts of the Suriname Rain Forest.* Berkeley:
University of California Press.

Proyecto Lingüístico "Francisco Marroquín" and Museo Ixchel de Traje
Indígena
1988 *Idiomas de Guatemala y Belice.* Guatemala: Editorial Piedra
Santa.

Putnam, Frederick W.
1886 Central American Jades. *Proceedings of the American
Antiquarian Society,* n.s. 5:1–3. Semi-Annual Meeting,
April.

Reina, Ruben E.
1963 Chinautla, comunidad indígena guatemalteca. Estudio de las
relaciones entre la cultura de comunidad y el cambio
nacional. *Guatemala Indígena* 3 (1):31–150.

Reina, Ruben E., and Robert M. Hill II
1978 *The Traditional Pottery of Guatemala.* Austin: University of
Texas Press.

Roach, Mary Ellen, and Joanne Bubolz Eicher
1965 *Dress, Adornment and Social Order.* New York: John
Wiley & Sons.

Rodee, Marian
1986 *Weaving of the Southwest.* West Chester, Pa.: Schiffer
Publishing.

Rojas Lima, Flavio
1984 La simbología de lenguaje en la cofradía indígena. *Cuadernos
del Seminario de Integración Social Guatemalteca* 29.

Rosaldo, Michelle Zimbalist, and Louise Lamphere
1974 *Women, Culture, and Society.* Stanford, Calif.: Stanford
University Press.

Rowe, Ann Pollard
1981 *A Century of Change in Guatemalan Textiles.* New York:
The Center for Inter-American Relations. Seattle: The
University of Washington Press.

Sayer, Chloë
 1985 *Costumes of Mexico.* Austin: University of Texas Press.
 1988 *Mexican Textile Techniques.* Bucks, Great Britain: Shire
 Publications.

Schevill, Margot Blum
 1980 The Persistence of Maya Indian Backstrap Weaving in San
 Antonio Aguas Calientes, Sacatepéquez, Guatemala. Master
 of Arts thesis, Department of Anthropology, Brown
 University.
 1985 *Evolution in Textile Design from the Highlands of
 Guatemala.* Occasional Papers No. 1. Berkeley: Lowie
 Museum of Anthropology, University of California.
 1986 *Costume as Communication.* Studies in Anthropology and
 Material Culture. Volume 4. Bristol, R.I.: Haffenreffer
 Museum of Anthropology, Brown University.
 1988 The Double-Headed Eagle on Textiles of Indian America.
 Paper presented at the 46th International Congress of
 Americanists, Amsterdam, July.
 1989a "I Don't Do That One!": Maya Weavers of Guatemala and
 Yurok-Karok Weavers of Northwestern California Talk
 about Their Designs. Paper presented at the American
 Anthropological Association meetings, Washington, D.C.,
 November.
 1989b Living Cloth: Nineteenth-Century Mayan Huipiles. *Latin
 American Art* 1 (2).
 1990 Guatemalan Maya Dress and Its Creation: Gender and
 Ambiguity. Paper presented at the American Anthropological
 Association meetings, New Orleans, December.
 1991a Relations among Cloth, Clothing, and Their Creation: The
 Voices of a Guatemalan Maya Family. Paper presented at the
 47th International Congress of Americanists, Tulane
 University, New Orleans, July 7–11.
 1991b Introduction. In *Textile Traditions of Mesoamerica and the
 Andes: An Anthology,* edited by Margot Blum Schevill, Janet
 Catherine Berlo, and Edward B. Dwyer. New York: Garland
 Publishing.

Schneider, Jane
 1987 The Anthropology of Cloth. *Annual Review of Anthropology*
 16:409–448.

Schneider, Jane, and Annette B. Weiner
 1986 Cloth and the Human Experience. *Current Anthropology*
 April:178–184.

Schultze Jena, Leonhard Sigmund
 1946 *La vida y las creencias de los indígenas Quichés de
 Guatemala.* Translated by Antonio Goubaud Carrera and
 Herbert D. Sapper. Publicaciones Especiales del Instituto
 Indígenista. Guatemala: Tipografía Nacional.

Schwarz, Ronald A.
 1979 Uncovering the Secret Vice: Toward an Anthropology of
 Clothing and Adornment. In *The Fabrics of Culture,* edited by
 Justine Cordwell and Ronald A. Schwarz. The Hague:
 Mouton.

Simon, Jean-Marie
 1987 *Guatemala: Eternal Spring, Eternal Tyranny.* New York:
 W. W. Norton & Company.

Simpson, Lesley Byrd, and Sherburne F. Cook
 1949 *The Population of Central Mexico in the Sixteenth Century.*
 Ibero-Americana No. 31. Berkeley: University of California
 Press.

Smith, Carol A.
1978 Beyond Dependency Theory: National and Regional Patterns
 of Underdevelopment in Guatemala. *American Ethnologist*
 6 (3): 574–617.
1987 Regional Analysis in World-System Perspective: A Critique
 of Three Structural Theories of Development. *Review*
 10 (4): 597–648.
Smith, Joyce Ronald
1989 *White Fur Clouds.* Video. Providence: Joyce Smith.
Sperlich, Norbert, and Elizabeth Katz Sperlich
1980 *Guatemalan Backstrap Weaving.* Norman: University of
 Oklahoma Press.
Stephen, Lynn
1991 The Illusions of Gender: Flexibility in the Commercialization
 of Zapotec Weaving. Paper presented at the 47th International
 Congress of Americanists, Tulane University, New Orleans,
 July 7–11.
Stephens, John Lloyd
1841 *Incidents of Travel in Central America, Chiapas, and
 Yucatan.* Two volumes. London: John Murray.
Stocking, George W., Jr.
1987 *Victorian Anthropology.* New York: The Free Press.
Stoll, Otto
1884 *Zur Ethnographie der Republik Guatemala.* Zurich: Orell
 Fussli.
1958 *Etnografía de Guatemala.* Publicaciones del Seminario de
 Integración Social Guatemalteca. Guatemala: Editorial del
 Ministerio de Educación Pública.
Strindberg, August
1912 Från Fjärdingen och Svartbäcken. In *Samlade Schrifter*, Vol. 3.
 Stockholm: Albert Bonnvers Förlag.
Strong, Douglas
1964 A History of Sequoia National Park. Unpublished Ph.D.
 dissertation, Department of Social Science, Syracuse
 University.
Svenskt Biografiskt Lexikon
1949 Stockholm: A. Bonnier.
Swenson, Edgar
1935 Gustavus A. Eisen: Scholar and Benefactor. *The American
 Swedish Monthly* November: 11–13, 38–39.
Swetnam, John J.
1989 What Else Did Indians Have to Do with Their Time?
 Alternatives to Labor Migration in Pre-Revolutionary
 Guatemala. *Economic Development and Cultural Change*
 38 (1): 89–112.
Tambiah, S. J.
1977 The Cosmological and Performative Significance of a Thai
 Cult of Healing through Meditation. *Culture, Medicine, and
 Psychiatry* 1: 97–132.
Taracena Arriola, Arturo
1982a Contribución al estudio del vocablo 'ladino' en Guatemala (s.
 XVI–XIX). In *Historia y antropología: Ensayos en honor de
 J. Daniel Contreras R.*, edited by Jorge Luján Muñoz.
 Guatemala: Facultad de Humanidades, Universidad de San
 Carlos de Guatemala.
1982b *Les origines du mouvement ouvrier au Guatemala,
 1878–1932.* Thèse de doctorat de 3ième cycle. École des
 Hautes Études en Sciences Sociales, Paris.

Tedlock, Barbara, and Dennis Tedlock
1985 Text and Textile: Language and Technology in the Arts of the
 Quiché Maya. *Journal of Anthropological Research*
 41 (2): 121–146.

Turner, Terence S.
1980 The Social Skin. In *Not Work Alone: A Cross-Cultural View
 of Activities Superfluous to Survival*, edited by J. Cherfas.
 London: Temple Smith.

van Oss, Adriaan C.
1986 *Catholic Colonialism: A Parish History of Guatemala,
 1524–1821.* Cambridge: Cambridge University Press.

Vecchiato, Gianni
1989 *Guatemalan Rainbow.* San Francisco: Pomegranate Artbooks.

Von Tempsky, Gustav Ferdinand
1858 *Mitla. A Narrative of Incidents and Personal Adventures on a
 Journey in Mexico, Guatemala, and Salvador in the Years
 1853 to 1855 with Observations on the Modes of Life in
 Those Countries.* London: Longman, Brown, Green,
 Longmans & Roberts.

Warren, Kay B.
1989 *The Symbolism of Subordination: Indian Identity in a
 Guatemalan Town.* Austin: University of Texas Press.

Watanabe, John Mamoru
1984 We Who Are Here: The Cultural Conventions of Ethnic
 Identity in a Guatemalan Indian Village, 1937–1980.
 Unpublished Ph.D. dissertation, Department of Anthropology,
 Harvard University, Cambridge.

Weiner, Annette B., and Jane Schneider, editors
1989 *Cloth and Human Experience.* Washington, D.C.:
 Smithsonian Institution Press.

Welters, Linda
1988 *Women's Traditional Costume in Attica, Greece.* Návplion:
 Peloponnesian Folklore Foundation.

Who Was Who in America
1942 Chicago: A. N. Marquis Company.

Wilson, Lee Anne
1991 Nature versus Culture: The Image of the Uncivilized Wild-
 Man in Textiles from the Department of Cuzco, Peru. In
 Textile Traditions of Mesoamerica and the Andes, edited by
 Margot Blum Schevill, Janet Catherine Berlo, and Edward B.
 Dwyer. New York: Garland Publishing.

Witherspoon, Gary
1987 *Navajo Weaving Art in its Cultural Context.* Flagstaff:
 Museum of Northern Arizona.

Woodward, Ralph Lee, Jr.
1971 Social Revolution in Guatemala: The Carrera Revolt. In
 Applied Enlightenment: Nineteenth Century Liberalism.
 Middle American Research Institute, Publication 23. New
 Orleans: Tulane University.
1983 Population and Development in Guatemala, 1840–1879.
 Secolas Annals (Journal of the Southeastern Council on Latin
 American Studies), 14: 5–18.

Wortman, Miles L.
1982 *Government and Society in Central America, 1680–1840.*
 New York: Columbia University Press.

Yach, Santiago
1979 Autobiography of Santiago Yach, edited by Sol Tax. In
 Currents in Anthropology: Essays in Honor of Sol Tax, edited
 by Robert E. Hinshaw. The Hague: Mouton.

Figure Index

Catalogue Index